Enzo Carli

THE LANDSCAPE
IN ART

Edited by Mia Cinotti

WILLIAM MORROW AND COMPANY, INC

New York 1980

on page 2:
Giorgione, The Tempest.
Oil on canvas; 83 cm x 73 cm.
Venice, Accademia

Originally published in Italian
under the title *Il Paesaggio*

Contents on page 317

Biographies of landscape artists
GEMMA VERCHI

Picture research
FRANCESCA AGOSTINI
ADRIANA SAVORANI

Layout
PAOLO CAIELLI

Editorial secretary
MARCELLA GAFFURI

Translated from the Italian by
MARY FITTON

Book design, U.S. edition
SALLIE BALDWIN

Copyright © 1979 Arnoldo Mondadori Editore S.p.A., Milano
English translation copyright © 1980 Arnoldo Mondadori Editore,
S.p.A., Milano

ISBN 0-688-03678-3
Library of Congress Catalog Card Number 80-81667

Printed and bound in Italy by
Officine Grafiche di Arnoldo Mondadori Editore, Verona

Landscape painting has a long history, closely linked at every stage and in every form with that of visual art in general and its governing aims and conceptions as these have varied down the ages and from place to place. Man's response to nature—which is not always love of nature—is as old as civilization. It is what leads him to record his observation of the world around him. It inspired Homer, the Greek poets, and Virgil, but not until comparatively recent times did it inspire an independent branch of Western, as distinct from Oriental, art. Well into the seventeenth century, when creators of "pure" landscape were busy and popular and critics had to acknowledge the fact, their productions did not rate highly in the scale of painterly activity. The French architect and writer André Félibien, for example, put them next to the bottom, just ahead of flowers-and-fruit; and this even when, in a praiseworthy effort to do better, figures were included. The depressing image would be left behind at last, but a German novel of 1836 can still speak of "considerable opposition" when somebody suggested that genre or landscape pictures might hang in the new gallery at Berlin.

With few exceptions, such as the wall painting in villas of the Hellenistic period, landscape before the sixteenth century is an accessory of anecdote, no more than a background for protagonists human or divine. It is there to describe the surroundings of saints and Bible stories, or to enrich and glorify the lay subject with a more or less appropriate setting. Indeed, the setting is occasionally so rich and glorious that we are tempted to see it as a separate composition, apart from the foreground interest.

But a work of art is an indivisible whole and in isolating certain elements or passages we risk making a false or imperfect judgement. We may find it beautiful, it may give us pleasure, but we are not taking into account all the artist can or intends to accomplish, and his intentions are what matter. In landscape, then, we must try to understand how much is necessary description—

5

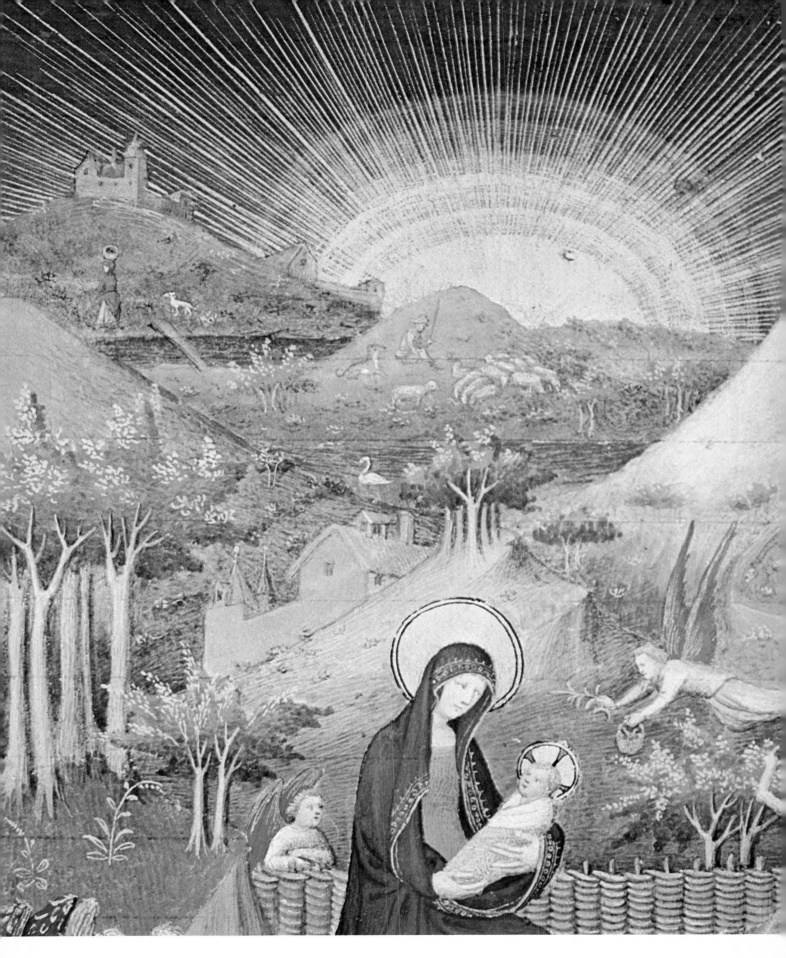

left: *Master of the Boucicaut Hours (possibly Jacques Coene of Bruges):* Flight into Egypt *(detail), from the* Book of Hours of the Maréchal de Boucicaut, *before 1416. Miniature; 25.5 cm x 19 cm. Paris, Musée Jacquemart-André, MS 2, fol. 90v.*

below: *Fra Angelico:* Agony in the Garden *(detail of one of thirty-three panels for a silver chest formerly in SS. Annunziata, Florence), c. 1450. Tempera on wood; 37 cm x 38.5 cm. Florence, Museo di San Marco.*

left: *Joseph Mallord William Turner:* The Morning After the Deluge, *c. 1843. Oil on canvas; 78.7 cm x 78.7 cm. London, Tate Gallery.*

following pages: *Emil Nolde:* Tropical Sun, *1914. Oil on canvas; 0.7 m x 1.04 m. Seebüll, Ada and Emil Nolde Foundation.*

perhaps only a basic, pictographic indication—of the scene, and how much the freer expression of his imaginative response to nature as well as to his subject. It is a delicate distinction and aesthetics do not enter into it, for one picture, a Duccio, for instance, will show landscape in a hallowed, conventional idiom and be a great masterpiece, while another, with more landscape and a fresher and more direct response to nature, is no such thing.

We have also to distinguish between pictures in which the landscape motifs are limited—sometimes to a single motif, such as a tree, a field, or a rock—or, even when the motifs are used repeatedly, they are detached from their natural surroundings—out of context, as it were; and those in which entire landscapes, or their essentials, are reproduced, though their chief purpose may be to give spatial unity, with actual or attempted realism. Obviously, the latter are what we really mean by "landscape pictures." Of the others it would be truer to say that they demonstrate an interest in, or awareness of, certain aspects of nature.

This book is not meant to be a full record of landscape painting; that would be a much larger enterprise. It seeks merely to offer in orderly review the genre's highest achievements and great turning points in different times and cultures. A glance at the illustrations will show how varied and splendid they are, from Giorgione's Tempest, *that foundation and forerunner of our way of painting and of looking, to a picture by Emil Nolde that seems to say, with the Swiss essayist Henri Frédéric Amiel a hundred years ago, "A landscape is a state of mind."*

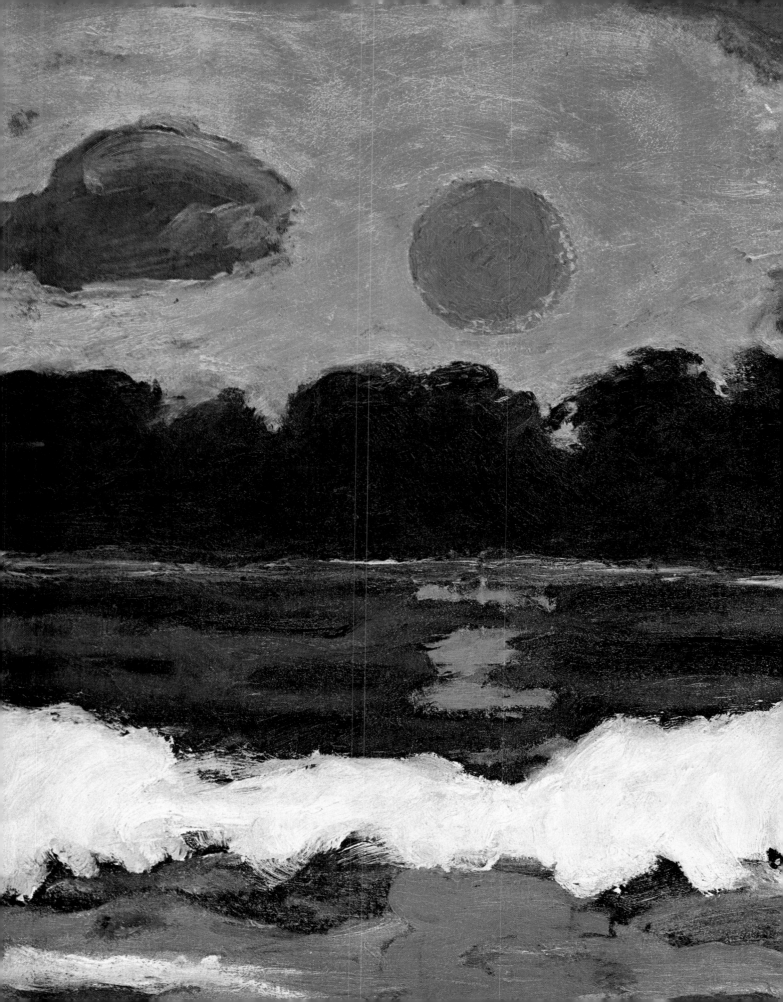

THE LANDSCAPE
IN ART

REFERENCES TO NATURE
From Babylon to Rome

Some 20,000 years ago, in what are termed "prehistoric" times, man made his first figure drawing. For many thousands of years before that, nature can have been no more to him than a collection of creatures that lived, moved, and could be hunted: the vast cycles of upper Paleolithic cave painting, the most splendid of which are at Altamira and Lascaux, include bison, bulls, oxen, stags, and other animals, but no suggestion of setting or background. The first simplified tree, or one of the first, appears in the post-Quaternary Mesolithic period, in the Cave of Doña Clotilde near Teruel in Spain. Then come what are possibly pines, pictured in the rock shelter of Alacon not far away. And the oldest views, if we may call them views, are later still, cut into the rock at Valcamonica, near Lake Garda in Italy, where topographical line drawings date from 2000 B.C. until the Roman era. These resemble geometrical diagrams, emphasized occasionally with a white filling. Different areas are dotted, or covered with a network of right-angled lines, perhaps to show cultivated and pasture land; there are tracks and waterways, and rounds and rectangles that stand for huts. They are simple, rough incisions, which, much as they tell us about the mountain communities of shepherds and farmers, are no more than practical memoranda. They cannot be considered in any way as the precursors of landscape art.

It is in the three great pre-classical civilizations of Mesopotamia, Egypt, and the Aegean that we meet landscape motifs which, if not deliberate artistic creations, are nevertheless art. The earliest Mesopotamian culture was that of the Sumerians, whose country lay between the Tigris and Euphrates rivers. Their cylinder seals of engraved stone, which date from the beginning of the third millennium B.C., were used to roll along clay tablets, and some have been found with trees, as well as men and animals, among the designs. A

. . . a painted wall with trees, and birds perching on the branches.

—Pliny the Younger describing his Tuscan villa, in Letters *V, 6*

Hellenistic art, Ulysses in the Land of the Laestrygonians *(detail), first century* B.C. *Part of the Hellenistic fresco series, the* Odyssey Landscapes, *from a house on the Esquiline. Rome, Vatican Library.*

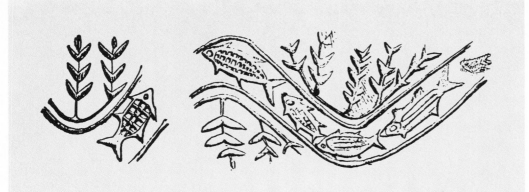

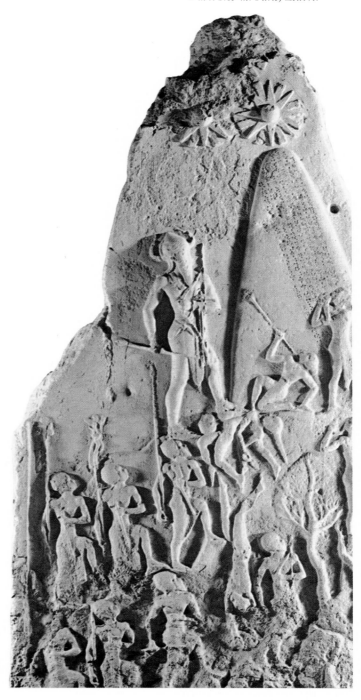

pair of oxen on a seal from Uruk (present-day Warka) face one another from left and right of a man, perhaps a shepherd, and feed from a bush with star-shaped flowers. The two halves of this strictly symmetrical, heraldic-looking design are set like reflections; even the flowers are set in matching positions, four to a side, and the bush is less a real bush than consummate, almost abstract, decoration. A later seal, from Susa, has a winding river full of fish and bordered with trees, shown upside down on the lower bank (page 14). More "natural" is the landscape on the *Victory Stela of Naram-Sin,* king of Akkad (page 14). The Akkadians were a Semitic people, who settled from 2350 to 2150 B.C. on the left bank of the Euphrates, in the region that was later called Babylon, and this stela, now in the Louvre, is one of the finest examples of their art that we possess. It is two meters (about six feet) high, carved in bas-relief on red sandstone, and it celebrates the victory of Naram-Sin over the Lullubi of the Zagros Mountains in western Persia. Four wavy vertical lines, rising from left to right, represent the mountain peaks and culminate in a conical shape above which hang the planets, symbolizing the heavenly powers. The king and his soldiers convey a marvellous, soaring sense of triumph, but for us the interest lies in the two twisted trees, their branches cut more deeply than the lighter mass of foliage, in the fact that the artist has broken away from the horizontals of previous tradition, and in his unifying treatment of a succession of crests and slopes.

The perpetual Mesopotamian topics of war and hunting easily lend themselves to landscape detail, as in the huge bas-reliefs that are the chief artistic legacy of the Assyrians, whose empire lasted until the fall of Nineveh in 612 B.C. A seventh-century alabaster relief, found in Sennacherib's palace at Nineveh (pages 16–17), shows a battle fought in marshy country against the Elamites. Expanses of water alternate with vegetation; fish swim in the reedy channels. There is no attempt at any illusion of depth, but the closely chiselled surface and almost calligraphic depiction of the nature motifs add up to a very convincing swamp, particularly where the fine undulating lines of water are visible through thinning clumps of reed.

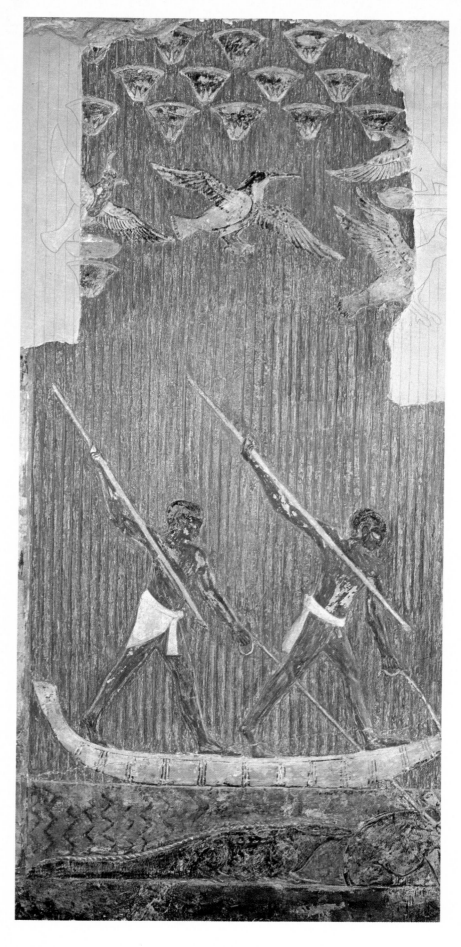

Hunt among the Papyrus,
*Egyptian wall painting of the Fifth
Dynasty, c. 2250* B.C., *from the
Mengee necropolis, Memphis.
Painted stone; 1.07 m x 0.51 m.
West Berlin, Staatliche Museen
Preussischer Kulturbesitz
(Egyptian Museum).*

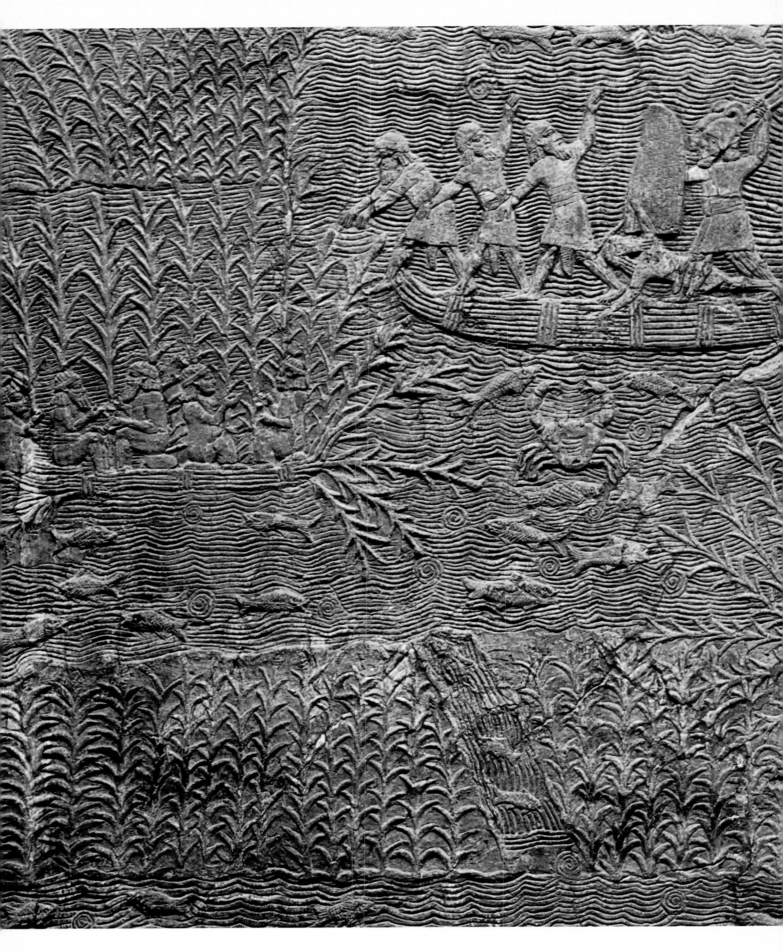

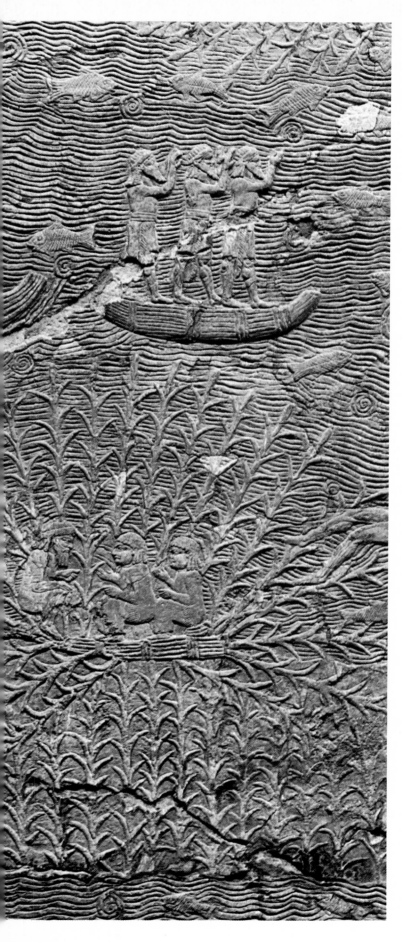

But before man could begin to appreciate landscape, or, rather, the elements that constitute a landscape, he had to put his mark on it. Only when he has planted his orchards and fruit trees and gardens does it become for him a source of delight to mind and senses; then it commands aesthetic appreciation and he makes pictures of it. We have, alas, no pictures of the Hanging Gardens of Babylon, counted with the Seven Wonders of the ancient world, but in Egyptian tomb painting of the Eighteenth and Nineteenth dynasties of the New Kingdom we see the ordered, magnificent gardens of the wealthy dead; the memory of their gardens, like that of their feasts and ceremonies, was to go with them on the journey. The largest and most detailed of such pictures is in the Tomb of the Vizier Rekhmire at Thebes (pages 18–19). With two files of slaves to haul the boat, he sails on an ornamental lake along whose straight sides are sycamores and date and doom palms in neatly graduated triple rows, all in outline, trunks converging toward the center. The whole composition is symmetrical as a carpet and the impression of real landscape is due less to the somewhat mechanical, if elegant, repetition of plants and trees than to the little figures here and there among them, assiduously gathering fruit and carrying water. In another similar tomb fresco of the same period in the British Museum the "natural" note is introduced with the fish, and the spruce, handsome ducks with a family of ducklings on the water.

The Homeric notion, expressed in the *Odyssey,* of a garden as the home of the gods may have suggested the decorative themes of flowers and trees in Crete, center of the Minoan civilization of the second millennium B.C. Some of the apartments in the palace at Knossos are so frescoed, and though we may have well-founded reservations as to the authenticity of the painted hedge on the throne-room walls, there are other mural fragments in the museum at Herakleion from this palace and from Hagia Triada, near Phaistos. Cats, birds, and monkeys seem alive, their movements caught, as it were, in midair; but the background of greenery is, by contrast, a series of limp though tasteful formalized plants, with variously shaped leaves at regular intervals.

More important—and the more so for being entirely unre-

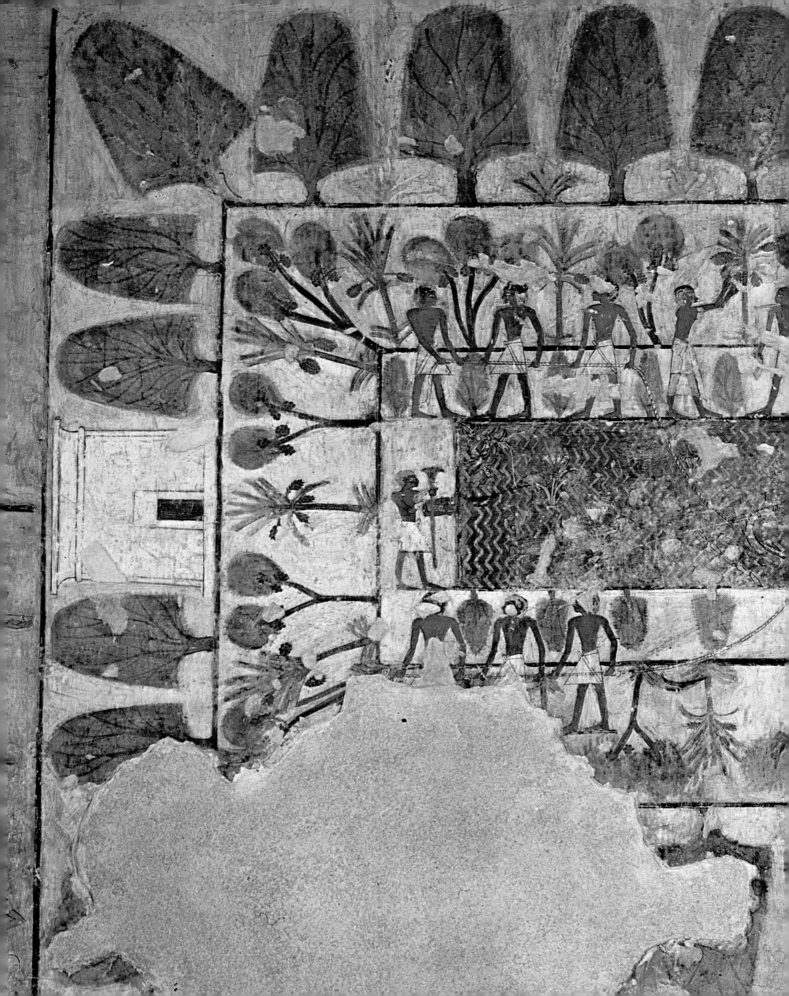

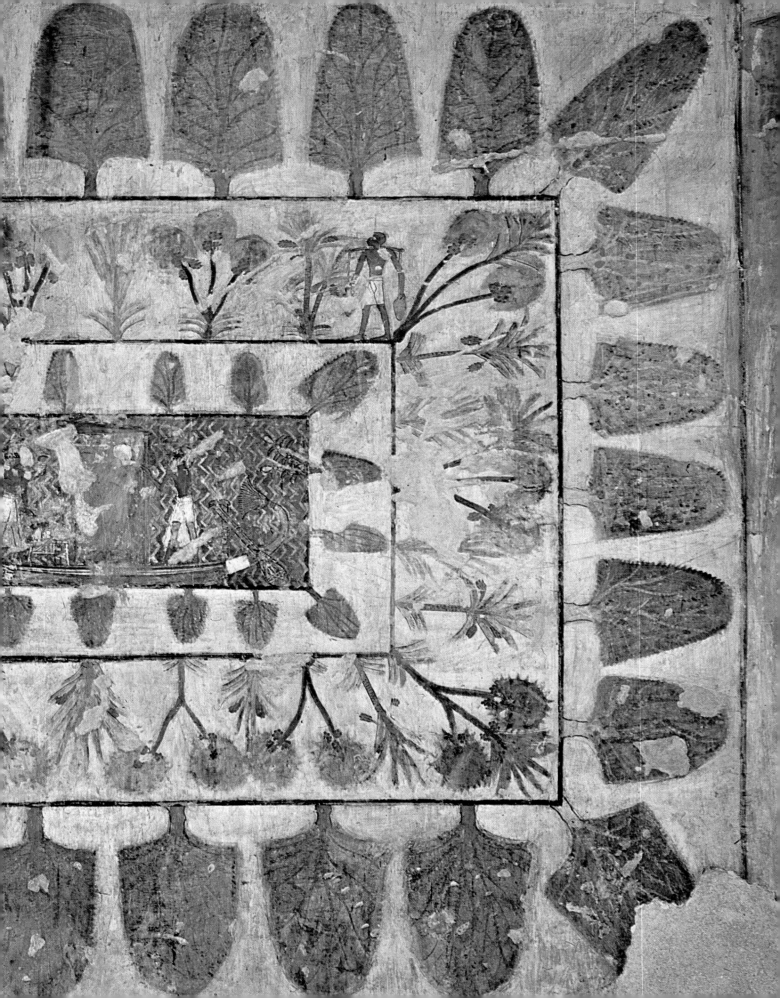

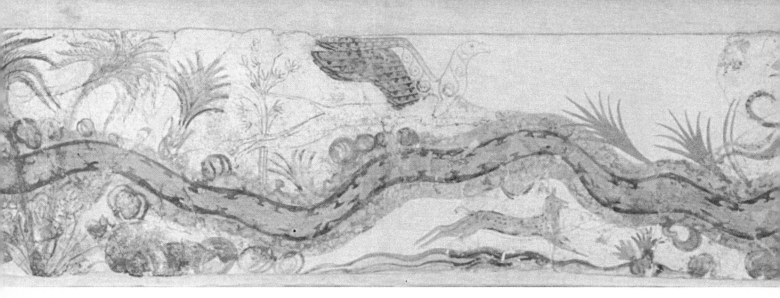

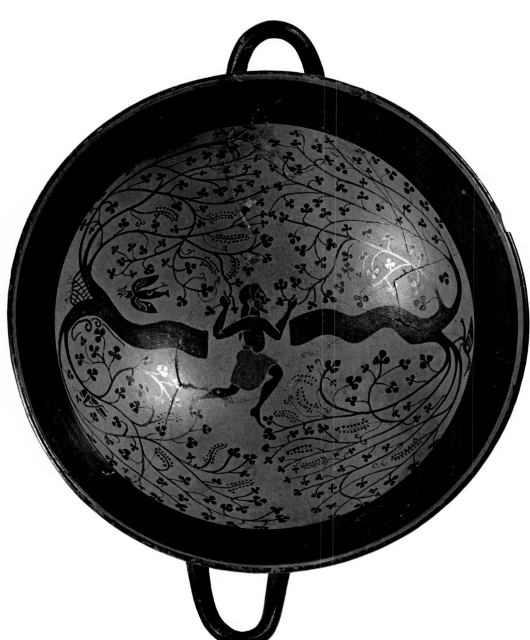

above: Tropical Landscape, *fragment of Aegean wall painting, end of sixteenth century* B.C., *from Santorini (ancient Thera); 0.21 m x 1.86 m. Athens, National Museum.*

right: Spring, *fragment of Aegean wall painting, end of sixteenth century* B.C., *from Santorini (ancient Thera); 1.84 m x 2.62 m. Athens, National Museum.*

left: The Fowler's Cup. *Archaic Greek, from Ionia, mid-sixth century* B.C.; *found in Etruria. Black painted earthenware on red background; height 15 cm, diameter 23 cm. Paris, Louvre (formerly in the Campana Collection).*

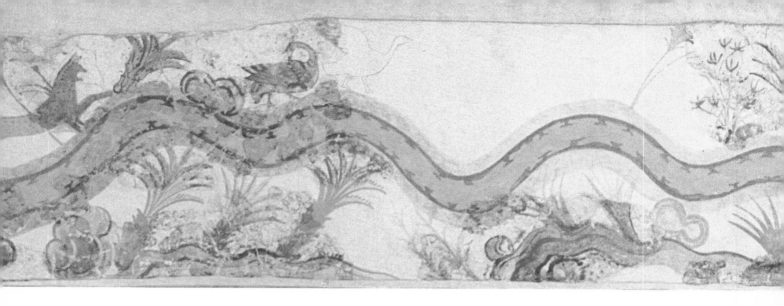

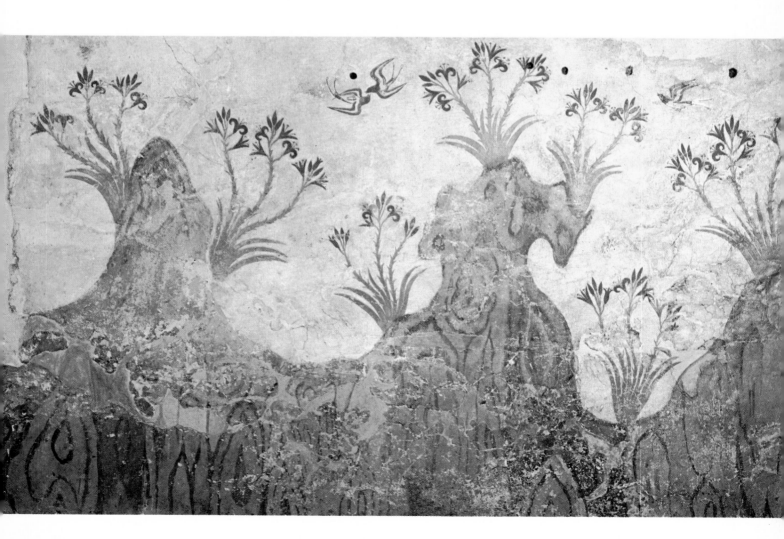

stored—is a landscape among the scraps of fresco from the sixteenth century B.C., found recently under the volcanic ash of Santorini, the ancient Thera, in the Cyclades. They are now in the National Museum at Athens (pages 20–21), fragile remnants painted with a naval expedition, a tropical scene with palm trees and other vegetation by a winding green-blue river, and, most exciting of all, Thera itself, in spring, before the eruption destroyed it. There are curious volcanic rocks, blue, red, and yellow, tufted with plants whose flowers, like red lilies, stand out against the sky, and swallows darting overhead.

The Minoan love of stylized tree forms reappears, in motifs of supreme calligraphic elegance, in Attic pottery of the Archaic period with its austere "landscape" touches. An amphora attributed to the Priam Painter, a late Archaic artist, twenty-nine of whose vases are known, shows seven girls bathing in a pool below a grotto framed by two trees, slender branches etched against a clear sky. This is in the Etruscan Museum at the Villa Giulia in Rome, and must date from between 530 and 500 B.C.. More delicate still, like embroidery, are the balanced, spreading branches that pattern the bowl of the Ionic *Fowler's Cup* in the Louvre, and surround the figure of a man snaring birds (page 20). Such objects are decorative masterpieces, but because decoration takes pride of

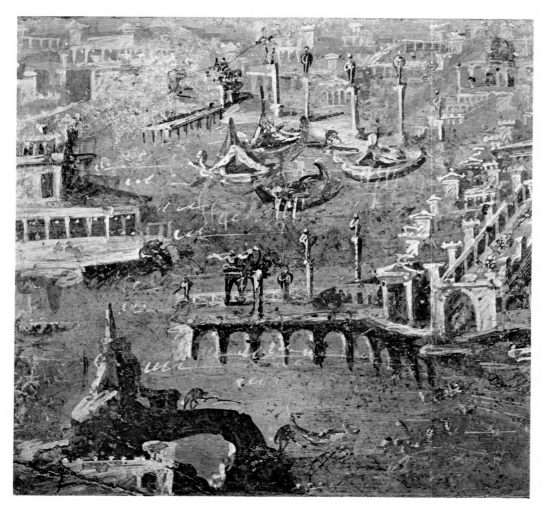

place over the observation of nature there is no shiver down the spine, or thrill of recognition; nothing of what we feel Alcaeus or Ibycus felt, and which still breathes in any broken line or fragmentary poem.

The great leap from these simple natural references to true landscape painting comes with Hellenistic art. Simple references had been present in Etruscan painting, though the frail bushes interspersed among the musicians, cupbearers, and so on in the Triclinium and Leopards tombs, the strange flowering trees where Achilles lies in wait for Troilus in the Tomb of the Bulls, or the thorny plants in the Fishing and Hunting tombs, all at Tarquinia, cannot qualify as landscape. But the

Homeric frescoes that once adorned a Roman house on the Esquiline Hill, and which were discovered and transferred to the Vatican in 1848, are Hellenistic painting at its most hauntingly beautiful (page 12). They are actually Roman, of about 50–40 B.C., but modern critics establish them as copies of Alexandrian originals of a hundred years before, and thus securely in the Hellenistic tradition.

Viewed through a fictive colonnade, scenes from Books X and XI of the *Odyssey* are set in a continuous panorama, fourteen meters (about fifteen yards) long. The tiny humans, Ulysses with his companions in the land of the Laestrygonians, in Circe's cave, and on the visit to Hades, seem swal-

lowed up in the vast landscape of ocher-coloured rocks, caverns, and lakes and seas. The deep valleys are in shadow; tall, contorted trees bend forward, leaves streaming as though in a violent gale, against a dark-blue sky; a chain of high mountains bars an apparently remote background. This mixture of realism and imaginative freedom produces an atmosphere of fantasy that wonderfully suggests the spell of far-off, legendary places.

Very different are the frescoes from the House of Livia at Primaporta, a country villa in her day, outside Rome (page 22). A deep, painted border of trees and plants ran around the walls of a sunken room, a green thicket with a sky in varying shades of blue and full of birds, that turned the enclosed space into an orchard, or a safe clearing in a wild wood. Nothing legendary or far off for the consort of Augustus.

The first and most remarkable of "pure" landscapes—landscapes, that is, entirely without narrative interest—are found in Campania, where imaginary "views" are frescoed in the Villa of Agrippa Postumus at Boscotrecase, the Villa Boscoreale (near Pompeii), and in houses at Pompeii and Stabiae (pages 23–24). The natural surroundings—or the assembly of small valleys and wide meadows, of gardens, orchards, trees and hills and water here presented as natural surroundings—are enhanced, if the location is sacred, with temples, shrines, and statues, or, if rural, with miniature people and animals. Such landscapes are idylls, flights of fancy, and the heightening and embellishment of reality can charge them with a subtle lyric quality. This remains even when the artist, or his patron, prefers to give emphasis to the practical works of man, as in the extraordinary harbour scene from Stabiae: what normal harbour ever had so many porticoes and arches of triumph, temples and statues and commemorative columns? The picture is strikingly fresh and sketchy, like others of its kind, with shapes built up in separate strokes of dense colour that give the whole thing a faintly incongruous air of Impressionism.

Landscape themes, more conventionally treated, also occur in floor mosaics. The *Great* and *Small Hunting Scenes* in the Roman villa at Piazza Armerina in central Sicily, probably made by North African craftsmen in the fourth century, contain thick trees and bushes with tiny leaves, sheets of lightly ruffled water, and temples perched on wooded hillsides, together with the hunters and beasts and fishing boats. Africa was itself a frequent inspiration of fresco and mosaic design under the Empire, life on the Nile being an especially popular subject. Here one of the most celebrated examples, believed to date from the reign of Augustus, is the large mosaic from the Sanctuary of Fortuna Primigenia at Praeneste (Palestrina). The yearly flooding of the Nile, on which the fertility of Egypt depended, is shown through its effect on people and animals rather than as an overwhelming natural phenomenon; and the landscape, crammed with spirited detail, serves as scaffolding to small particular scenes, much as it was to do in the Thebaids of Tuscan painters in the fourteenth and fifteenth centuries.

NATURE
AND SYMBOL
The Middle Ages

The Christian religion brought with it a completely new attitude to nature. No longer looked upon as the fount and origin of material delights, or as an arena for the events and actions of human life, nature was for the Christian a manifestation of divine power. It was the mirror and likeness of a spiritual beauty. This spiritual beauty was alone worthy of attention, and should be contemplated, said the philosopher Hugh of Saint Victor in the twelfth century, with the *oculus cordis* rather than the *oculus carnis,* with the soul's rather than the body's eye. The reality behind things mattered more than their physical aspect and was supposed to edify the observer and turn his mind towards the everlasting, immutable perfection of God. Thus there grew up a tendency to make the outward form a symbol, to pare away the external "accidents" of any object and to give it universality and immediately recognizable significance far beyond the factual and physical. Art, in other words, was to create a reality more beautiful than nature, revealing nature's essence more by glories of design and colour than by literal representation. Landscape therefore, in broad sweep or in detail, became a landscape of symbol, far beyond the mere depiction of scene and place, which were not so much described as alluded to. The spectator was addressed not only through his experience, his reading, and his skill in interpretation (this latter especially when, as was often the case, more or less long-established iconographical conventions were used), but also through his imagination. This kind of art thus communicated a higher reality, more significant and intense; a spiritual reality whose symbolism gave rise to a new pictorial language with stylistic elements that came as near as may be to abstraction. This approach to symbolism led so far from the "real" world as to produce the most "unreal" landscapes of Byzantine art.

If you wish to paint mountains properly, take some big stones—rough, not cleaned up—and paint them as they are, putting in the light and shade as reason recommends.

—Cennino Cennini, in Libro dell' arte, *Volume LXXXVIII, at the beginning of the fifteenth century*

Proto-medieval art: Jacob Asking Laban for the Sheep *(detail), miniature illustrating* Genesis 30:30–34, *from the* Vienna Genesis *(fol. IX, 17), beginning of sixth century* A.D. *Miniature, tempera on purple parchment; 35 cm x 25.6 cm. Vienna, Nationalbibliothek.*

27

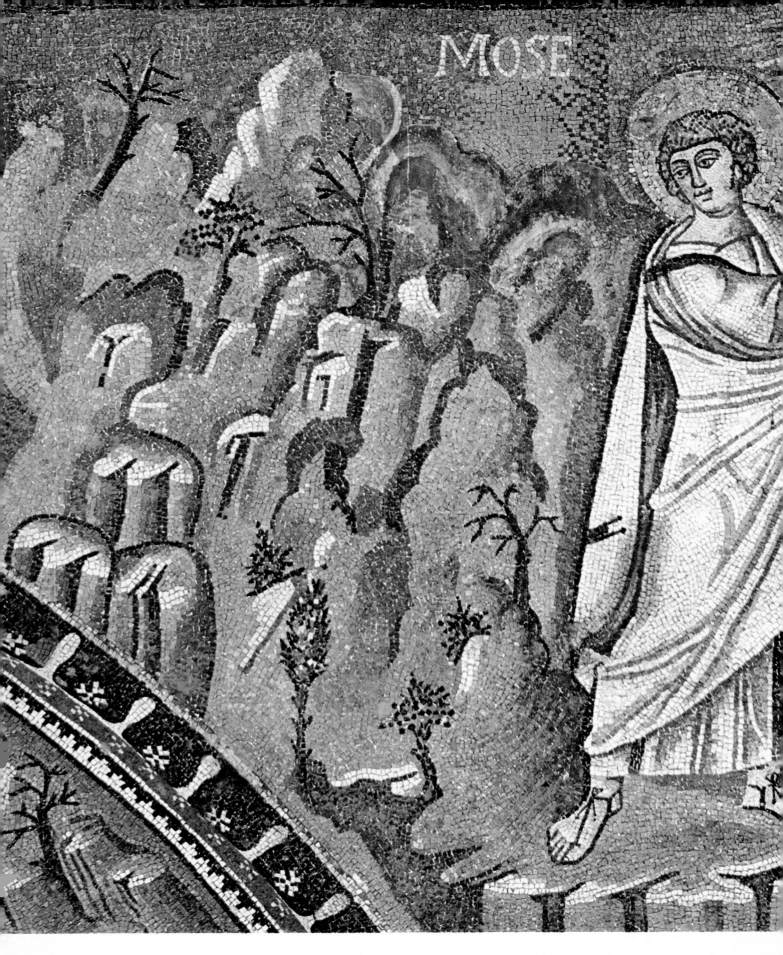

MOSE

28

left: *Byzantine art:* Moses on Mount Sinai *(detail), Byzantine mosaic in choir of San Vitale, Ravenna, 538–547.*

below: Transfiguration with Saint Apollinaris in Prayer *(detail), Byzantine mosaic from apse of Sant' Apollinare in Classe, Ravenna, before 549.*

The Byzantine style was forged in the New Rome of the Eastern Empire, where Hellenistic, or Greco-Roman, currents met and mingled with the visual arts of Asia Minor, Syria, and Egypt. In the reign of Justinian (483–565), who recovered much of the West from the Goths and Vandals, it reached its first and greatest pictorial expression in the Ravenna mosaics.

The movement to abstract symbolism was not, of course, steady and continuous. There were the usual stops and starts. The Greek *Vienna Genesis* in the National Library at Vienna, for instance, is a "purple" codex (i.e., written on purple-stained parchment) illuminated by painters in Antioch, probably in the early sixth century (page 26); yet the landscape details of its miniatures have the fresh Impressionist quality we noticed in the harbour fresco from Stabiae. Even later are the wall paintings of the childhood of Christ in Santa Maria Forisportas at Castelseprio, near Varese in northern Italy. Glimpses of landscape and architecture are much in the Hellenistic style, though they date from the late seventh or early eighth century, and their "Oriental" character may point to an artist from Constantinople, Syria, or Palestine. There is vivid natural observation, for example, in the *An-*

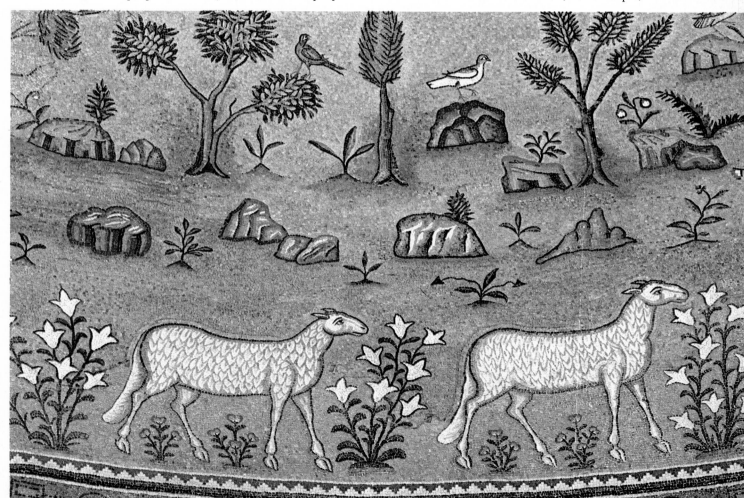

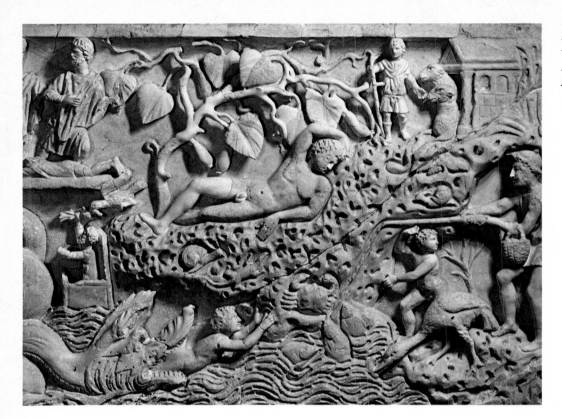

Paleo-Christian art: Sarcophagus with the Story of Jonah *(detail), third century. Marble; 0.66 m x 2.23 m. Rome, Vatican Museums.*

nunciation to the Shepherds in the background of the Nativity episode.

The oldest mosaics in Ravenna, from the first half of the fifth century, are in the tomb of Galla Placidia, and here we find reminiscences of Hellenistic landscape in the *Good Shepherd* lunette. There is still a kind of realism in the variegated yellow rocks, modelled by patches of grey shadow, and in the waving bushes against a deep-blue sky. But the six sheep, though each in a different attitude, are arranged symmetrically, facing inwards to the central figure who dominates the composition with his sheer size and his blazing golden robe. He reaches out to one of them with a mild, grave gesture, imparting a solemn reverence absent from the less formalized scene behind.

The drastic change in landscape art is signalled by another Ravenna mosaic a hundred years later. Among the Bible pictures by local craftsmen that precede the famous panels of Justinian and Theodora with their court in the choir of San Vitale is one of *Moses on Mount Sinai* (page 28). Now the mountain is a brilliant jumble of multi-coloured shapes streaked with darker tones. It lacks depth; it flames and flashes, and the small trees twisting from the blocks of emerald and coral fail to lend even the slightest hint of realism. In this stylization is rooted a mountain convention that holds good throughout the long history of Byzantine art. By the time of the Macedonian emperors of the ninth to eleventh centuries it has become the piled-up, flat-topped rock formation, ascending in steep parallels and gashed with narrow clefts, that we see in another Sinai, painted in the Greek

Bible of Leo the Patrician in the Vatican Library (page 33). Duccio uses it, and even Giotto, the revolutionary genius, puts a jutting, stepped Byzantine mountain in *The Miracle of the Spring* at Assisi, adding a breadth and solidity of his own.

One of the most successful, and most strictly symbolical, of Byzantine landscapes is also at Ravenna, in Sant' Apollinare in Classe. This church, consecrated in 549, has an apsidal mosaic, *The Transfiguration with St. Apollinaris in Prayer* (page 29), with the face of Christ in a huge jewelled cross in a starry sky and three lambs to denote the three Apostles present. Below, in a paradise garden, stands the saint with twelve more lambs for the twelve Apostles. The bright green meadow is subtly contoured in minutely graded colour, and set with flowering shrubs, with rocks, plants, and bushes and, at the top, trees with mop heads of foliage, all highly stylized and set out with a regularity and balance that do more than any realism could do to convey an otherworld harmony. Absorbing that colour and radiance, so straight and light and perfect, they are trees and rocks of heaven, and one can well believe it.

The mosaics of San Marco, Venice, have their few Byzantine landscape notes and one of them offers a wide impressive setting for the simultaneous moments of its story. This is the *Agony in the Garden* (page 32) on the south wall of the western arm of the church, and critical opinions differ as to its period, style, and merits. For some authorities it is authentically Byzantine and a masterpiece; for others, equally knowledgeable–Otto Demus among them–there is nothing Eastern about it. Sergio Bettini goes so far as to cite the

South German "expressionism" of the most important contemporary frescoes of the region from Verona to the Alps; Ferdinando Bologna agrees with Roberto Longhi in condemning it, with other examples in San Marco, as "crude and wearisome" Byzantine mannerism. We are not concerned with this battle of the giants, fortunately, only to know whether, and to what degree, the artist has communicated his feeling for nature. The mosaic may, I think, persuade us that he had gift enough to create out of a set of pictorial conventions and an old, almost outworn, iconography something which is pleasing if not new, and has poetic value.

He was probably a Venetian, and acquainted with Byzantine symbolism. This is at once apparent in the threefold mountain that seems to rise with, and even represent, the prayer of the kneeling Christ, and which recalls the three denials of Peter and the three exhortations to the disciples. The three peaks also help to create a visual unity with their strong horizontal line, and they, and the intervening valleys, suggest an actual landscape—a suggestion at once contradicted by the wholly rhythmic abstraction of a basically repetitive composition. (This repetitive principle constantly recurs in the painting and literature of Byzantium, as witnessed by the rows of martyrs and virgins who line the nave of Sant' Apollinare Nuovo in Ravenna, or the endless hymns of the Orthodox liturgy.) And the artist is hesitant, in a way not easy to define. His three mountains—or, rather, two, for one is partly hidden by the group of sleeping Apostles—are seen from the same angle, they are more or less the same shape, yet their plants and trees are quite different. It is as though a longing to indulge his imagination, and a delight in the variety of nature, persist in conflict with aesthetic ideals that are exclusively intellectual.

Less than a century later, Duccio di Buoninsegna, a painter very much in the Byzantine tradition, treats the same subject more realistically in the Passion scenes originally on the reverse of his *Maestà Altarpiece* (page 38). The triple themes of denial and exhortation are now one; but, having thus renounced the spatial and temporal repetition of the Venetian mosaic, he then portrays the Saviour twice in the same landscape, brilliantly resolving the inconsistency by putting the two complementary but opposed images back to back, with a vertical tree trunk between them. He not only substitutes simultaneous action for the consecutive narrative of the mosaic—which was conceived, so to speak, in cinematic terms—but makes his landscape more concrete, specific, and believable. It is so important that in the scene above, depicting the arrest of Christ, the same landscape is repeated exactly, except that it is seen from a lower perspective, eliminating the section with the sleeping Apostles.

There are many thirteenth-century examples of the freedom of the Tuscan style within the Byzantine idiom, and not only in landscape. The most "easternized" is a composite altarpiece of *Saint John the Baptist* in the Pinacoteca at Siena, whose flavour is positively Arabian. The unknown artist must have been Italian, if not actually Sienese, for the writing on it is in Latin characters; according to the critic Cesare Brandi he was a painter "of the utmost consequence," active between the 1260's and 1280's. Of twelve small border panels, several contain landscape in which the Byzantine linear constructions seem almost to dissolve, reduced to threads of light between areas of dazzling colour. The angel conducts the youthful saint into a sulfurous lava desert with a scaly red surface; the mountains that close in the Jordan valley are red and dark green, like the wings of some enormous butterfly, to the left and right of the slender Christ in the blue, shining river.

The contemporary Guido of Siena is the first of the school known to us by name. In the same gallery is one of his altarpieces, with Jerusalem girdled in red walls beyond a succession of rounded hills in pale tints of rose and green, and gnarled trees, leaves precise against a golden background. Lazarus emerges from a tomb above which grows another extraordinary tree, its bare branches ending in large cuplike flowers of the painter's own invention. As surprising are the plants—trees, bushes, or flowers, it is hard to tell—in the caves and ravines of Monte Gargano in a picture of Saint Michael and six *Histories* by an unknown Florentine of the mid-thirteenth century in the church at Vico l'Abate, near Florence.

below: *Byzantine art:* Agony in the Garden *(detail),* Byzantine mosaic on south wall of western arm of transept, San Marco, Venice, c. 1220; 3.5 m. high.

right: Moses on Mount Sinai *(detail), Byzantine miniature of tenth century (period of the Macedonian emperors), from the Bible of Leo the Patrician. Tempera on Parchment; 37.2 cm x 24.8 cm. Rome, Vatican Library.*

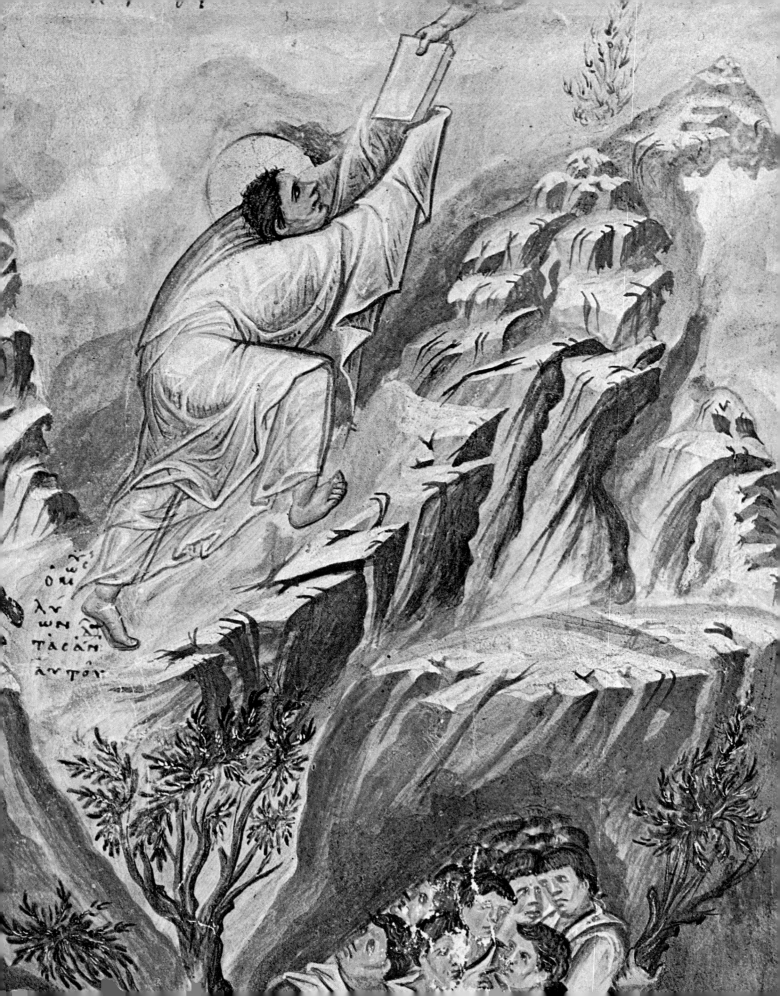

ὡς
ὅτι
λυ
ων
τὰ σαν
αὐτὸν

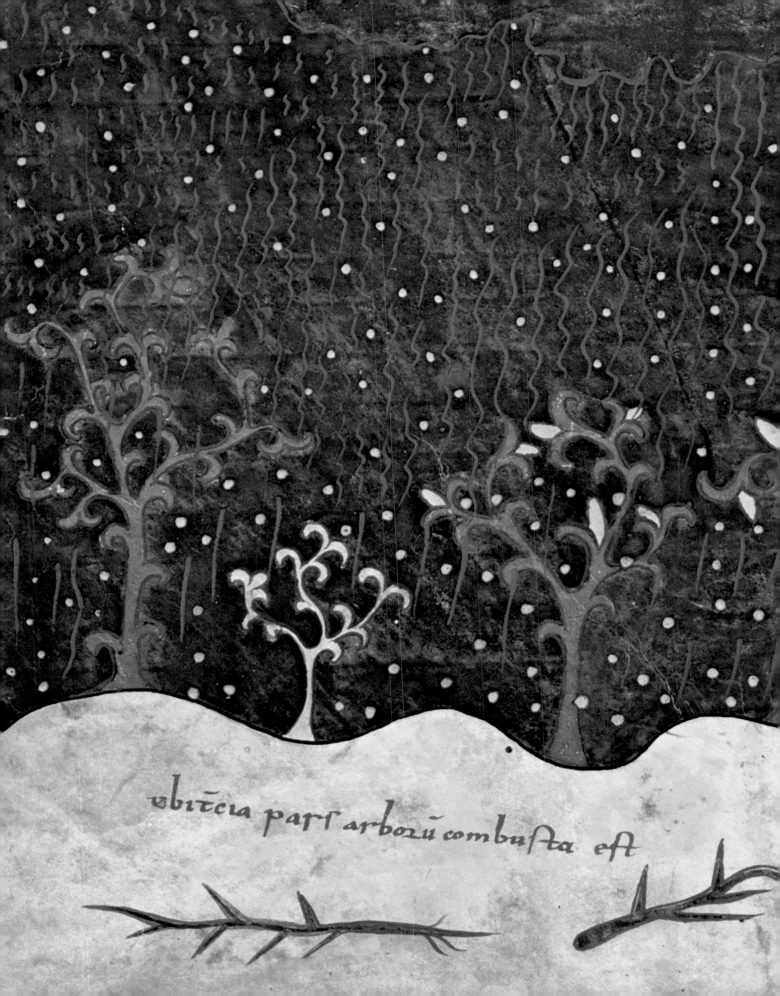

obi̅tcia parſ arboꝛu̅ combuſta eſt

Stephanus Garsia: Rain of Hail, Fire, and Blood upon the Earth *(detail), mid-eleventh century. Miniature; 31.2 cm x 23.5 cm. From* Apocalypse of St.-Sever, *with commentary by Bishop Beatus of Liebana. Paris, Bibliothèque Nationale, MS lat. 8878, fol. 137v.*

The mountain where the Archangel appeared is a rose-coloured mass with a profusion of soft white highlights to suggest the gorges. These soft highlights, becoming more zigzag and calligraphic, are seen in other Florentine and Pisan work: in the San Francesco altarpiece of the Bardi Chapel in Santa Croce, Florence, or the panels of that of Saint Catherine in the Pisa museum. But mountains of this sort, however colourful, are worlds away from reality, and the artists, whoever they were, must, in the writer's opinion, have been utterly indifferent to landscape, as to nature in general. Not even Saint Francis himself could convert them. Florentines, Luccans, and Sienese show him time and again preaching to ranks of birds, attentive on low bushes, in the most appealing episode of his career, but his attitude to nature just did not rub off on them.

The tendency to abstraction in landscape art is not always due to direct Byzantine influence. A fondness for nature details, more often of animals than of landscape, could go hand in hand with a cogent and direct narrative style, and in those Italian centers affected by what is vaguely called neo-Byzantine Hellenism, with its revived classical interest, schools of marked originality and independence evolved—in late thirteenth-century Pisa, for instance, with its Master of San Martino, whose *Madonna* in the museum there is surrounded by enchanting scenes from the lives of Anna and Joachim. But for almost pure abstraction we can turn to an earlier example of Christian art, the wonderful copy, now in the Bibliothèque Nationale, of an illuminated commentary on the Apocalypse, probably by a painter named Stephanus Garsia, at the abbey of St.-Sever-sur-Adour in western France, in the mid-eleventh century (pages 34–35). There are images of earth and the universe, of falling stars and the rain of hail, fire, and blood. Earth is symbolized by an undulating line between zones of very bright, flat colour, and four little trees that Matisse might have drawn there. Here the abstraction stems not from Byzantine, but from Mozarabic culture—that of Christians living in Spain after the Moslem conquest who assimilated and adapted the art of the conquerors. Whether such works, displaying such influence, may properly be

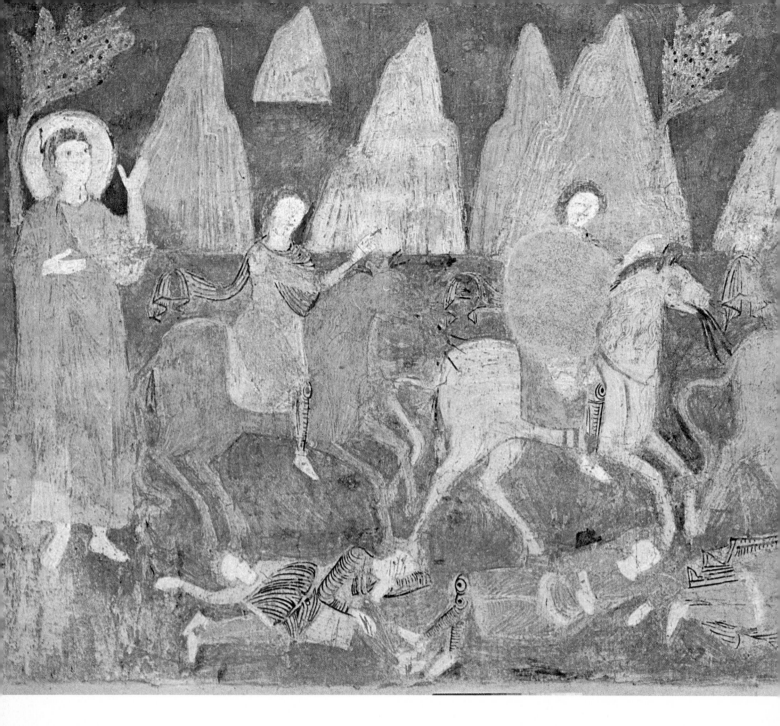

thought of as Romanesque, or even proto-Romanesque, is difficult to decide, since what we understand by "Romanesque" is very different in origin and character.

The term was coined in 1824, partly to distinguish the northwestern civilization of early medieval Europe from the late Byzantine, and even with it the line is not easily drawn. Nevertheless, the northern influence is unmistakable in some of the fresco cycles of the Alto Adige, which are considered the best existing specimens of Romanesque painting. On the chancel arch of the thirteenth-century Church of San Jacopo in the mountain village of Grissiano is a fresco of Abraham and Isaac on their way to the sacrifice, with the Dolomites in the background. The peaks are snow-covered, the sky is blue, and there are clouds, "the first modern clouds," says Ferdinando Bologna. Landscape and landscape details are, however, few and far between in Romanesque art, and not unduly emphasized when they do occur.

By the end of the thirteenth century the Byzantine tradition, the "Greek manner," as Vasari describes it, was fading at last from the Italian scene. The new "Gothic" style, having already appeared in sculpture with Nicola and Giovanni Pisano, had reached painting, too, and Giotto was at work: an innovatory genius who defies the labels of school and period. Incredible psychological insight and comprehension

above: *Romanesque art:* Three Horsemen of the Apocalypse *(detail), fresco, late eleventh to early twelfth century, on south wall of south aisle of the basilica of Sant' Anastasio, Castel Sant' Elia, Nepi.*

right: *Bonaventura Berlinghieri:* Saint Francis Preaching to the Birds *(detail of Portrait of Saint Francis with Six Legends), 1235. Tempera on wood; 1.60m x 1.23m. Pescia, near Lucca, church of San Francesco.*

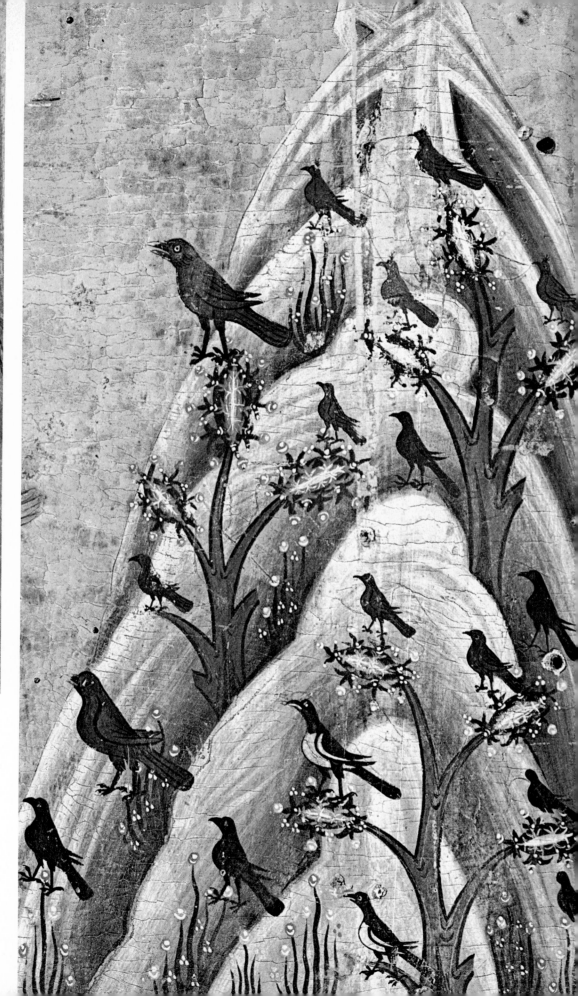

of the human drama are unmatched in him by any corresponding love of nature, yet there seems nothing contradictory in the fact, for we cannot look at his rare landscapes and accuse him of deficient response to the world about him. Their charm and poetry arise from his uncompromisingly truthful vision, and from what might even be called the conventionality of his rendering.

In the following century Cennino Cennini, by his own admission a "lowly member" of the painting profession but versed in every technique of that "mystery," wrote a *Libro dell' Arte,* or craftsman's manual. He had been taught what Giotto taught, he tells us in the preface, adding, truthfully, that he practiced and would pass on those teachings as they were known in Florence in his day. He has this advice for those about to paint mountains: "If you wish to paint mountains properly, take some big stones—rough, not cleaned up—and paint them as they are, putting in the light and shade as reason recommends." Was this Giotto's method? We may doubt it. With his knowledge of Byzantine and Romanesque tradition he is unlikely to have had recourse to a heap of stones when he wanted mountain scenery. Yet "reason"—which, in an artist of his caliber, means inspiration—evidently

ensures that his landscapes are more than simple background or required information. They are always intimately connected with the stories he is telling, infused with their spirit, and their visible counterpart by virtue of a marvellous union of volume with spatial values in extent and depth.

In both interior and exterior settings, Giotto is a great painter of buildings. Their regular geometric shapes have the plasticity, the solidity he bestows on any and every object. He likes things foursquare. Even his landscapes are architecture, and he applies strict laws of construction even when he has few solid-looking components to work on. The chief example of this is the famous fresco in the Upper Church at Assisi, *Saint Francis Preaching to the Birds.* The relation of earth and sky is contrived by nothing more than the contact of two colour areas at a horizon whose slight curve meets the slight, opposite curve of the tree on the right, and the simplicity gives plastic value to the firmly delineated empty space. The movement on the left as the saint bends forward—for his audience is gathered here at his feet, and not on branch or hillside, as in earlier pictures—restates the line of the tree and makes the ground, too, a dynamic part of the composition. The two peaks in *The Miracle of the Spring* deliberately re-

on page 38: *Duccio di Buoninsegna:* Agony in the Garden *(detail), panel from the back of the* Maestà Altarpiece, *1308–11. Tempera on wood; 99.5 cm x 76 cm. Siena, Museo dell' Opera del Duomo.*

on page 39: *Giotto:* The Flight into Egypt *(detail), 1304–06. Fresco; 1.85 m x 2 m. Padua, Scrovegni Chapel.*

on pages 40–41: *Taddeo Gaddi:* Satan Defying God *(detail of* Landscape of Sea and Islands *from frescoes of* The Trials of Job, *middle of fourteenth century. Fresco transferred to three canvases; 9.4 m x 3 m. Pisa, Campo Santo.*

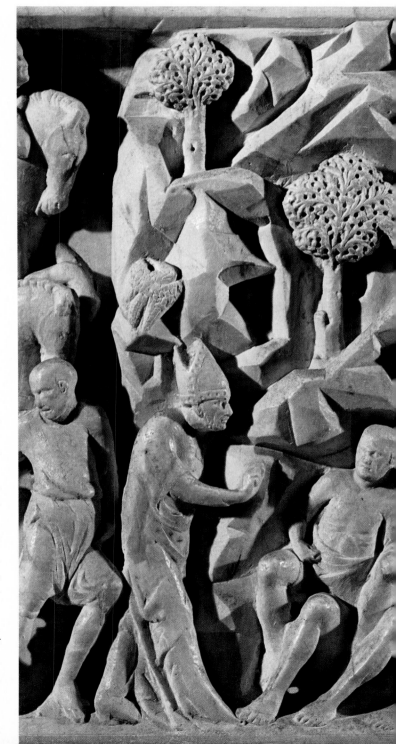

echo the arrangement of the figures, while a segment of sky defines their form and distance and shows how far apart they are.

Giotto's largest landscape is that of *Saint Francis Giving His Cloak to a Poor Nobleman.* Immediately we notice how the hills converge towards the haloed head, which thus becomes the focal point. They have the stepped Byzantine shape, but their stability, and above all the feeling of depth, come from the sharp, "faceted" edges and the angled view, providing a maximum sense of volume, of the buildings in compact groups on their slopes. There are no fields, woods, or roads. A few trees accentuate the loneliness. It is an austere landscape, cut from the hard stone, moulded in its own barren soil.

Harsher, more pared down, and on the whole less realistic are the landscape elements in the frescoes of the Scrovegni (Arena) Chapel at Padua. In the picture *Joachim Returning to His Sheepfold* a wall of rock juts from the mountain as though to receive him, its strong verticals like those of the cloaks and mantles he and his shepherds wear. The same mountain, we see, as is proved by the position of a shed in the foreground, from the same spot, has changed from rectangle to incline in *The Dream of Joachim,* and echoes the angel's swooping flight to where the old man crouches asleep with his head on his knees; for the "supernormal" event, Giotto abandons "normal" representation. Similarly, in the *Lamentation over the Dead Christ,* a naked rocky ledge slants down to the mourners on the left, the hinge of the composition, following the gesture of Saint John as he leans forward, arms flung out behind him. In *The Flight into Egypt* (page 39) the solid, self-contained triangle formed by the mother and child is set against a mountain which repeats and magnifies the shape, and whose more gradual, and lighter-coloured, face runs towards Joseph on the right and draws him into the same pictorial unit.

This fusion of people and surroundings in the Assisi and Padua cycles is also found in the architectural background of the Giotto frescoes of the Bardi and Peruzzi chapels at Santa Croce in Florence, with their quieter and more spacious

right: *Lorenzo Maitani:* Creation of the World *(detail of* Genesis *carvings)*, c. 1330. Stone relief. Orvieto, cathedral facade, first pilaster on the left.

below: *Goro di Gregorio:* Saint Cerbonius Heals Three Wayfarers *(details from the Tomb of Cerbonius)*, 1324. Marble. Massa Marittima, cathedral.

rhythms. *(The Raising of Drusiana* is a particularly good example.) But there is no landscape in them. Even the island in the lunette of *Saint John on Patmos* is mere topographical indication.

The landscape behind the scene of Saint Paul's execution in one wing of the *Stefaneschi Triptych* in the Vatican Pinacoteca is pure and simple background: the gentle valley, its curve marked by trees of varying height, has nothing to do with the action. Interestingly enough, the critic Pietro Toesca attributes this wing not to Giotto but to Taddeo Gaddi, who was his pupil and perhaps his godson. This great and underestimated artist produced, in his *Satan Defying God* in the *Trials of Job* series in the Campo Santo at Pisa, the most breathtaking passage of landscape in all the Giottesque school of Florentine painting (pages 40–41). Beneath the image of God is a lake view, or seascape, with promontories and rocky islands diminishing in the distance. The depth of perspective surpasses anything previously achieved, and a huge white cloud along the horizon increases the dreamy magic of the still, green stretch of water.

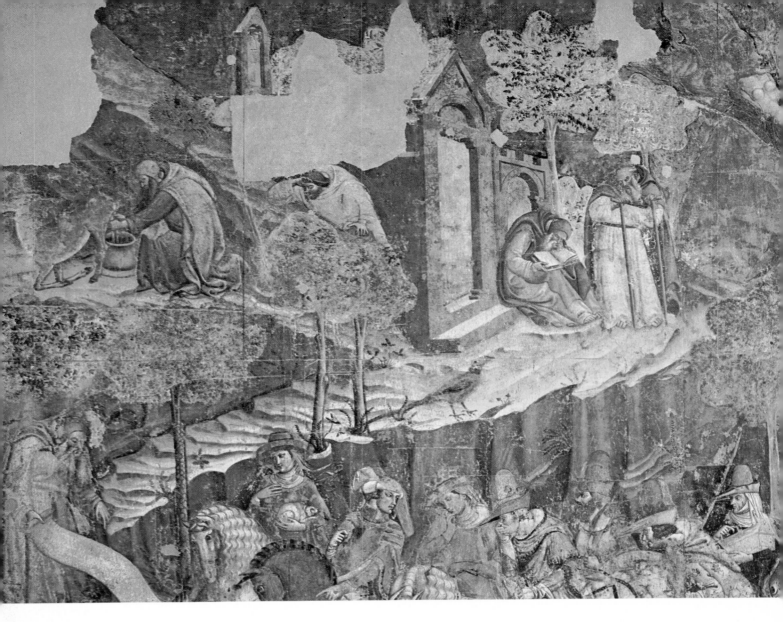

There is a garden, too, in the Campo Santo—or perhaps it is an orchard or orange grove strewn with tufts of flowery grass—where young men and girls sit playing musical instruments and singing under the laden fruit trees. It occupies the lower right-hand section of *The Triumph of Death* (pages 44–45), a fresco painted, according to recent theory, by the Florentine Buffalmacco, perhaps as early as 1336. Though more probably later, it is certainly the first garden picture of modern times. The intention, however, is not to praise the calm pleasures of communing with nature out of doors, but to illustrate the more severe notion of Saint Anselm, who disapproved of gardens because they were such a temptation to enjoy yourself. Death, in the guise of a singularly repulsive hag, is homing in on the oblivious merrymakers, and will cut them down with a scythe.

The rest of the fresco is a procession of the dead and the living with, above them on the left, a handful of hermits engaged in prayer and penitence in a crumbling mountain waste—ideal whereabouts for the exercise of the virtues that get a Christian into heaven. This theme is enlarged in the next fresco, *Legends of the Anchorites,* here inhabiting a landscape riddled with caves and set about with trees and chapel cells. Despite some lively details this is little more than a vast aid to devotion, or *machine à prier,* an entire wall of arduous, rocky pattern, punctuated with improving anecdotes. It is the first of the Thebaids, pictures of hermit life in the Theban desert, and its progeny were numerous in fourteenth- and early fifteenth-century Tuscany; so numerous that we might well put Thebaids in a landscape class of their own, where every ledge and level, every hole and hollow, even every treetop has its tenant. The prize must go to a Thebaid in the Uffizi (pages 48–49), usually thought to be by Gherardo Starnina, but whose almost Renaissance technique, especially in the handling of spatial values, leads Roberto Longhi to suggest the young Fra Angelico and a date around 1420. Indeed, if the perspective falters a little, the sea in the

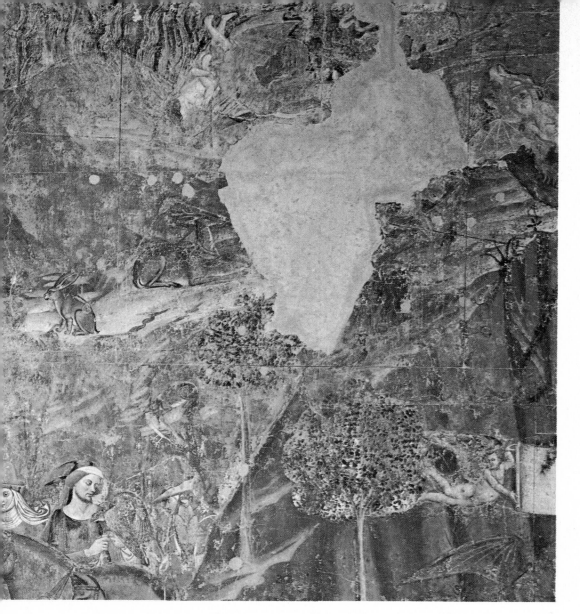

Master of The Triumph of Death:
The Triumph of Death *(detail),*
second quarter of fourteenth
century. Fresco (detached) in
fourteen panels; 5.64 m x 14.97 m.
Pisa, Campo Santo.

foreground, the river, and the plain with kitchen gardens all hang together beautifully; there is an impression of real space, with a final chain of jagged summits to conclude the busy scene.

Duccio and the Sienese are more susceptible to nature than their neighbours from Florence. We have noted that Duccio, while reusing Byzantine motifs, such as the formalized mountains in the small panels painted above, below, and on the reverse of his *Maestà Altarpiece* of 1308–11 (page 38), also links his landscape to his story, as Giotto did. Further, though not always realistically, he can introduce something nearer to lyricism than the other's straightforward narrative or drama. A red sunset glow flares and deepens on the flat-topped crags of his *Flight into Egypt;* a deserted grove in the foreground of *The Entry into Jerusalem* seems to distance the crowds that throng from the city gates, until one could imagine it had deadened their shouting and hosannas; in *Christ Appearing to Mary Magdalene* the two figures are, as it

were, isolated by the rocky enclosure, and the words "Noli me tangere" hang on the air.

Often landscape is for Duccio an instrument for piercing the outer, material aspect of an event, so that nature herself will share its inner meaning. Nowhere, perhaps, is this better seen than in *The Marys at the Sepulchre.* The three women shrink involuntarily from the radiant angel; the hills, falling away into the background on the left, reflect their movement; and that is enough, with the bare, unreal heights that might almost go out of the world and on forever, to make an atmosphere of speechless awe and wonder.

Most of Simone Martini's infrequent landscapes are equally stripped and unreal, though, when commissioned by the Commune of Siena to paint the conquered castles of Arcidosso and Casteldelpiano in the great hall of the Palazzo Pubblico in 1331, he went off, "with a horse and a foot soldier," to inspect the lay of the land before he started; and a miniature of 1340 has nature details that anticipate the Lim-

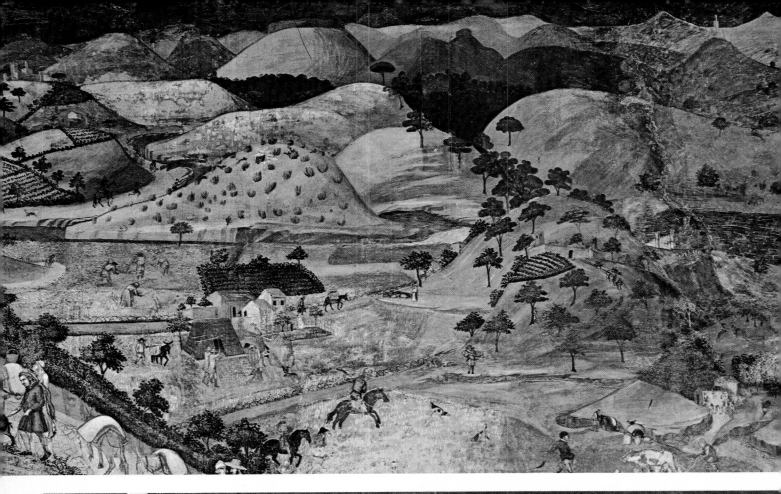

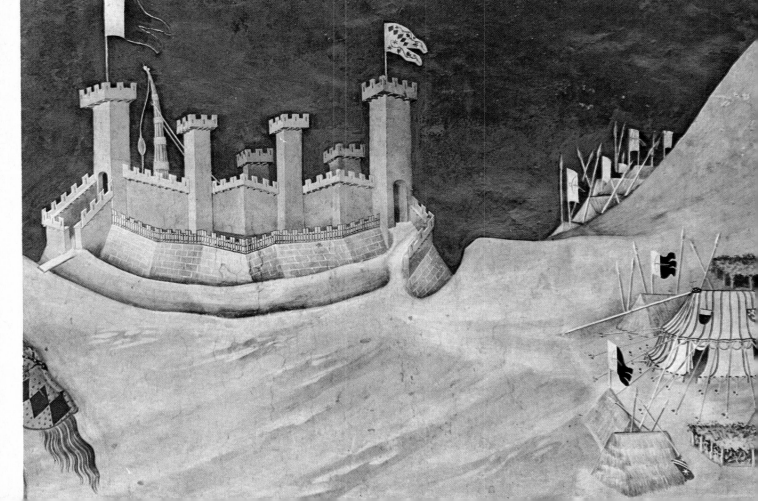

left: *Ambrogio Lorenzetti:*
Allegory of Good Government
(detail), 1337–39. Fresco. Siena,
Palazzo Pubblico.

below left: *Simone Martini:*
Guidoriccio da Fogliano
(detail), 1328. Fresco; 3.40 m x
9.68 m. Siena, Palazzo Pubblico.

below: *Ambrogio Lorenzetti:*
Castle on a Lake *(detail).*
Tempera on wood; 22.5 cm x 33.2
cm. Siena, Pinacoteca Nazionale.

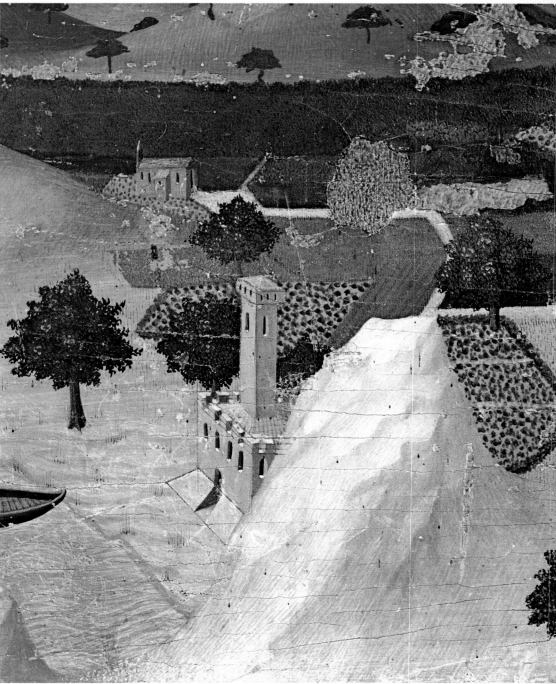

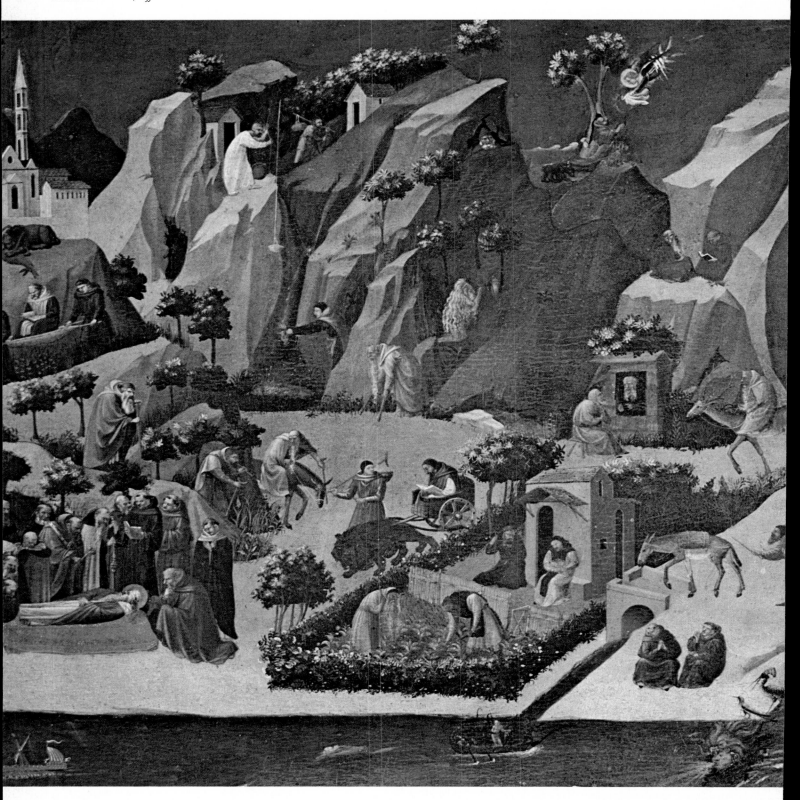

Gherardo Starnina, Thebaid
*(detail), beginning of fifteenth
century. Tempera on wood; 0.75 m
x 2.80 m. Florence, Uffizi.*

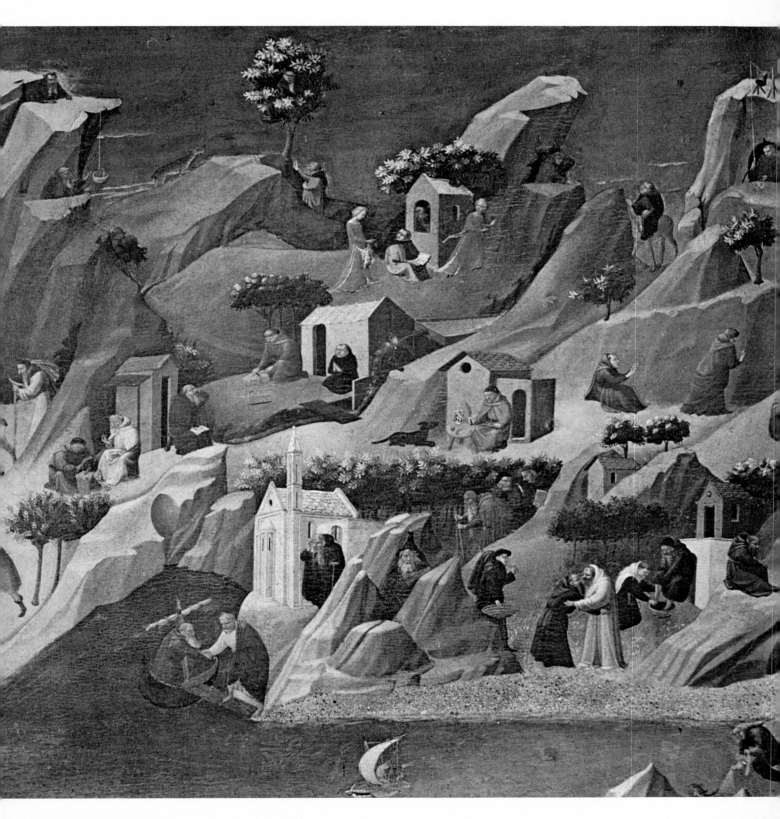

Papal workshop, artist unknown:
Fishing Scene, *c. 1343. Wall*
painting in tempera. Avignon,
Wardrobe Tower of the Papal
Palace.

bourg brothers by nearly a century. This was a frontispiece
for a commentary on Virgil that belonged to Petrarch, and it
breathes the very spirit of the *Eclogues.* Actuality is achieved
by very different means in one of the four miracle pictures for
a votive altar in the Church of San Agostino. The blessed
Agostino Novello (who levitated) comes flying down to res-
cue a fallen horse and rider from the bottom of a ravine
where narrowness and depth are indicated by progressively
darkening shadow. Then there is the gaunt, masculine land-
scape in which Guidoriccio da Fogliano rides on a wall in the
Palazzo Pubblico (pages 46–47) (painted there in 1328), hav-
ing reduced two more rebel castles. The victorious condot-
tiere on the desolate white hillside, stark shapes of castles, his
camp and siege engines, a sky like a pall of velvet—this is the
very spirit of exalted melancholy.

Some ten years later, in the very same palace, the first truly
modern landscape in Western art was frescoed by Ambrogio
Lorenzetti. Symbolizing nothing, illustrating nothing, it is
simply a real view of the country around Siena—in his *Alle-*
gory of Good Government (pages 46–47). A wide sweep of
orchards, fields, and terraces begins at the red tower gate.
Beyond lie the bald chalk hills, typical of that region, with
woods and fertile valleys. Smaller and smaller they roll away,
in spellbound clarity, to a distant horizon. There are castles
dotted about, but huts and farms are businesslike. Peasants
pursue their tasks of plowing and sowing, reaping and win-
nowing grain; huntsmen and wayfarers pass on muddy
tracks. Hard, ordinary life is going on. The blend of fact and
poetry, dream world and working world, marks an epoch in
landscape painting.

By the same artist are two tiny, exquisite panels, of a city
by the sea and of a lakeshore castle, in the Pinacoteca at Siena
(page 47). At one time taken for fragments of a larger com-
position, they are now recognized as the earliest entirely inde-
pendent landscapes known. Perhaps, with others, they were
part of the official filing system. If you wanted documents on
a specific locality under Sienese rule, you turned to the coffer
or chest with the right picture on it. Thus, the city may

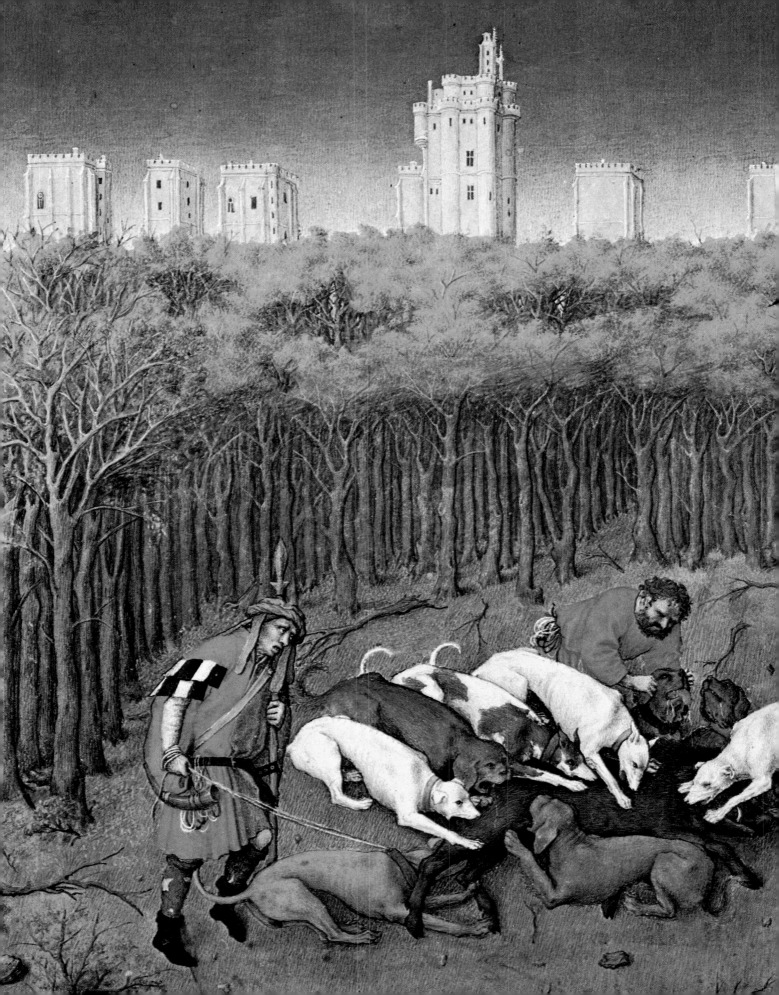

above: Cuer Reads the Scroll at the Enchanted Fountain, *from the* Livre du Cuer d'amours épris, *by René of Anjou, middle of the fifteenth century. Miniature on parchment; 13.2 cm x 16.9 cm. Vienna, Nationalbibliothek, MS 2597, f. 15.*

left: *Pol de Limbourg:* December, Château of Vincennes *(detail), from the* Très Riches Heures *of the Duc de Berry, 1416. Miniature; 22 cm x 13 cm. Chantilly, Musée Condé.*

possibly be Talamone and the castle an outpost somewhere on Lake Trasimeno or Lake Chiusi. A sad, lonely place, wherever it was; the little boat rocking on the green-grey water tells us that.

A Sienese by training though born in Viterbo, Matteo Giovannetti worked in Avignon, perhaps when Simone Martini was there, and may have had a hand in the frescoes executed by artists of the papal workshop around 1343, in the reign of Clement VI (pages 50–51). The pope must have been a sportsman, who wanted his temporal diversions pictured in his private apartments in the Wardrobe Tower, for all kinds of hunting and fishing are shown in a setting of luxuriant woodland that resembles tapestry. There had never been anything quite like this decoration, unless it were Livia's frescoes at Primaporta, and they, of course, were undiscovered at the time.

There were sculptors as well as painters of landscape among the Sienese. The familiar trees and clean, limpid hills appear, elegantly stylized, in the *Genesis* reliefs at Orvieto, on the first pier of the cathedral facade (page 43). These are attributed to Lorenzo Maitani and dated approximately 1320–30. Tino di Camaino, a follower of Giovanni Pisano, also modelled trees with fresh naturalism, and there are landscape details, less acutely observed, but telling, on the stone panels of Bishop Guido Tarlati's monument of 1330, by Agostino di Giovanni in Arezzo Cathedral. The most idiosyncratic sculpted landscapes must be those in two of the

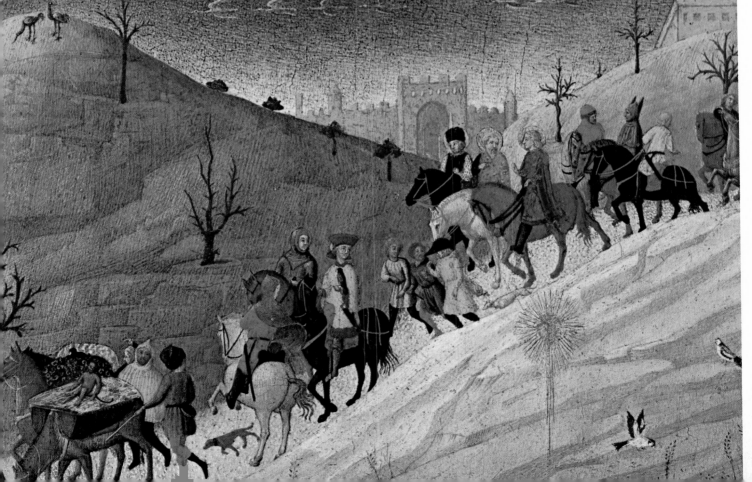

panels on the Tomb of Saint Cerbonius in the cathedral at Massa Marittima (pages 42–43). They were carved in 1324, with prismatic, rather shiny rocks on steep hillsides, birds and squirrels and trees whose compressed foliage is minutely chiselled, like goldsmiths' work. The subject is the saint's journey to Rome, when he alarmed the pope, who had summoned him there for reproof, by the number of miracles he performed on the way.

For the rest, almost all Sienese artists were attracted to landscape, and their landscapes retain the Gothic influence well into the second half of the fifteenth century. There may be an exceptional hint of the Florentine Renaissance in a panel by Stefano di Giovanni—Sassetta, as he is generally known—from a dismembered altarpiece painted in 1423–26 for the Arte della Lana, or Wool Merchants' Guild, and now in the Siena Pinacoteca. The scene is of devils tormenting Saint Anthony, and the mountains and wooded valleys of the background are drawn almost by the rules of linear perspective, against a cloud-flecked "natural" sky. But in his *Adoration of the Magi* in the Metropolitan Museum of Art, New York (page 54), Sassetta is still a Gothic artist. All the grace and sweetness, the *dolcezza* of the "soft Gothic style" are in

its mountain ridges and leafless trees. It dates from the 1430's, when his pupil or associate, the problematical "Master of the Osservanza," was doing exactly the same thing in the same way, in a panel of his *Miracles of Saint Anthony Abbot,* now also in New York, in the Lehman Collection at the Metropolitan (page 55). The landscapes of the *Magi* and of this panel are among the most intensely lyrical of fifteenth-century Sienese art; they rival the enchanting chessboard of fields and the steep pointed rocks in two of Giovanni di Paolo's panels from an altarpiece *Saint John the Baptist,* now in the Art Institute of Chicago (page 62). These were painted in the 1450's and it is interesting to compare them with panels in the museum at Dijon, from an altarpiece by Melchior Broederlam: Franco-Flemish, sixty years earlier at least, and quintessentially Gothic.

But we must question whether the Sienese painters of the fifteenth century really come into the "International Gothic" school, for even their landscapes have too much religious feeling for that charming, decorative style. It may be religion of a popular flavour, though all artists do not display the engaging, bucolic garrulity of a Sano di Pietro, with his apparently endless flow of backyard anecdotes; or it may carry

the sharper, ascetic tang of Lorenzo Monaco, a Camaldolese monk, trained largely in Florence but Sienese born and bred. His backgrounds are rocky and arid, washed in a weird, lunary light. International Gothic, with its microscopic details, its poise and courtly refinement, reflects a different world, other manners, and the taste of other patrons. Masolino da Panicale has some of that softness but must be excluded as a landscape artist, so bleak are the plunging heights in his frescoes of 1435 in the Baptistery at Castiglione di Olona, and, sublime as they are, so arid and uninviting the hills, with their walled towns, in another fresco in Cardinal Branda Castiglione's palace there (page 54). What landscapes to set beside those of International Gothic! Or compare two versions of the same subject, both in the Uffizi: Lorenzo's *Adoration of the Magi* and the magnificent altarpiece painted by Gentile da Fabriano in 1423 for Palla Strozzi, the richest citizen in Florence. Here are no harsh, deserted mountain peaks, as in Lorenzo's picture, but crops and trees in green plots and a smiling countryside. Seen across a wood of pomegranates, all in golden fruit, the kings on horseback go between leafy hedges up a gently winding road to a fairy-tale castle. In the predella below, the *Rest on the Flight into Egypt* is lit not by cold stars but the glory that shines from the child on the stable floor.

Gentile, though born in The Marches, learned his art mainly in the north; that is to say, in Lombardy. From the end of the previous century, Lombardy, with the Veneto, had been the stronghold of the cosmopolitan, International Gothic culture which held out so long against the modernizing Tuscan Renaissance. That culture's love of the minutiae of nature is most marked in the compendiums of herbal and medical lore, such as the *Tacuini sanitatis.* Originating in Lombardy, perhaps at the medical school of Bologna, they circulated widely in Europe, being known in France as *ouvraige de Lombardie.* Their meticulous drawings of medicinal herbs and plants, and even of animals, are amazingly accurate. But, as Roberto Longhi says, International Gothic had a little too much of "the hothouse and the study," and it brought few new developments in landscape painting.

A second large area subject to cosmopolitan influences was mainland Venice from Trent to Verona, because of its transalpine contacts, especially with Bohemia. It was a Bohemian master named Wenceslaus who, around 1400, decorated the Torre Aquila of the castle at Trent with frescoes of the *Months* (page 59). The wide rural landscapes are among the most realistic of their place and period.

The theory that the beauties of nature are our mirror and promise of heaven is expressed in early fifteenth-century pictures of the *hortus conclusus,* the enclosed or paradise garden, which is also a symbol of the virginity of Mary. The most celebrated of these is a small, lovely example, of about 1420, in the Städelsches Kunstinstitut in Frankfurt, probably by Hans Thiefenthal, where Our Lady sits among very distinct and brilliant flowers and plants of many kinds. In the Verona museum is Stefano da Zevio's delicious *Madonna of the Rose Garden,* in which even observation of nature seems less important than the twining linear pattern over the whole surface. Stefano da Zevio, Pisanello, who may have been his pupil, and Gentile da Fabriano are the supreme exponents of International Gothic in Italy. They all drew birds and beasts with superb skill, and studied them like scientists. Pisanello's *Vision of Saint Eustace,* circa 1436–38, in the National Gallery (pages 58–59), with the stags and hounds and other animals in the dark wood, shows the magnificent outcome of this curiosity and exactitude; while a different forest, of pale battlemented towers and marble oratories, fretted spires and

Gothic pinnacles, covers the skyline behind Saint George and the princess in his fresco in Sant' Anastasia at Verona, almost robbing it of spatial depth.

Such imbalance would be inconceivable in the miniatures of the Months in the Duc de Berry's *Très Riches Heures,* last work of the Limbourg brothers and the perfection of Franco-Flemish illumination. The manuscript, in the Musée Condé at Chantilly, was decorated in 1416, with an extraordinarily perceptive understanding of the relation of architecture to landscape. In each miniature the portrait of a known and recognizable building is so placed that we feel its actual distance from the hunting or farming occupations of the foreground. In a clearing of a dense December wood a pack of hounds, derived from a sketchbook of the Lombard Giovannino de' Grassi, tear a boar to pieces, and beyond the treetops shine the towers of the château of Vincennes, where Jean de Berry was born seventy-five years before (pages 52–53). The Sainte Chapelle and the roofs of the Ile de la Cité make a backcloth for the reapers by the Seine, under the deep-blue sky of June. Very ornamental reapers, be it said—ladies and

gentlemen, not the clumsy, more believable rustics of Ambrogio Lorenzetti; but they fit the aristocratic setting, so spacious and airy, like some vast park. And in the February miniature, incidentally, we find one of the first snow scenes, a silent white forecast of all the white snowfalls to come in Western art.

Another "pioneer of naturalistic landscape and aerial perspective," in the words of Erwin Panofsky, is the Master of the Boucicaut Hours, credibly identified with Jacques Coene of Bruges and Milan. The book of hours he illuminated between 1404 and 1415 for the Maréchal Jean de Boucicaut is now in the Musée Jacquemart-André in Paris (pages 6–7). The miniatures contain flowery meadows, brooks, trees, and steep hills, rendered with a delicate, almost calligraphic formalism. There are starry skies and huge bright suns, though the play of light comes nowhere near that in the manuscript of *Cuer d'amours épris,* half a century later (page 53). This run-of-the-mill romance of chivalry by King René of Anjou is medieval in temper and symbolism, but the artist—and the king may have illuminated his own book—belongs unmistak-

above: *Pisanello:* Vision of Saint Eustace *(detail), c. 1436–38. Tempera on wood; 54 cm x 65 cm. Believed to have been painted for the Pellegrini Chapel in the church of Sant' Anastasia, Verona. London, National Gallery.*

right: *Bohemian Master (Wenceslaus?):* Month of July *(detail with reapers), c. 1400. Fresco in series of the* Months, *Trent, Torre del Buonconsiglio.*

Enguerrand Charonton:
Coronation of the Virgin
(detail), 1454. Wood; 1.83 m x
2.20 m. Villeneuve-lès-Avignon,
Hospice.

61

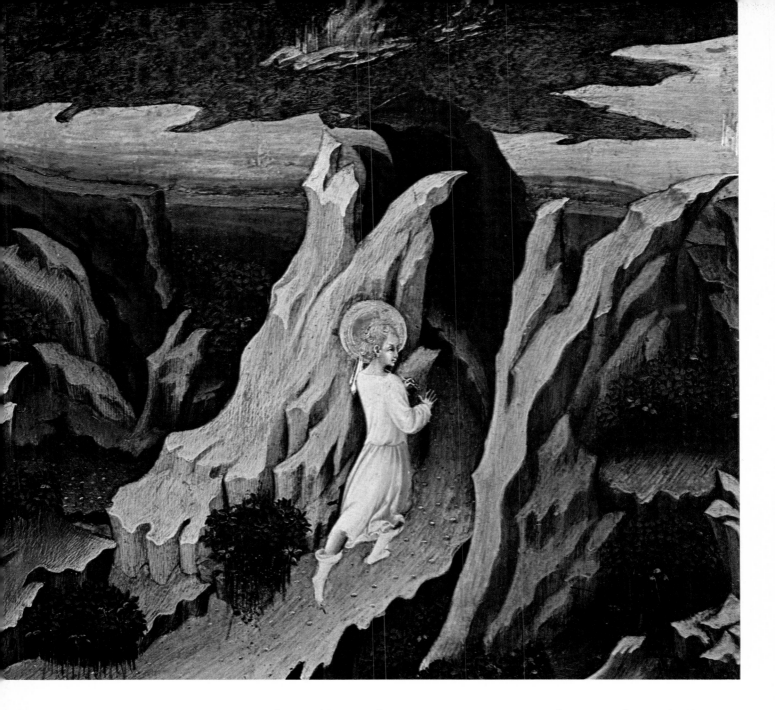

ably to the Renaissance. In his figurative idiom and his use of light and chiaroscuro he recalls Piero della Francesca himself.

It is at Avignon that we catch the last Late Gothic echoes in French landscape painting. Enguerrand Charonton completed his *Coronation of the Virgin* for the Hospice at Villeneuve-lès-Avignon in 1454 (pages 60–61), and in it, between the Queen of Heaven above and the scenes of Hell and Purgatory divided off, like the compartments of a Gothic tympanum, at the bottom of the picture, there unfolds a sea of hills under a lambent Provençal sky. Mont Ste. Victoire stands higher than the rest–Cézanne's mountain four hundred years before Cézanne.

The ultimate and noblest landscapes in this style appear,

however, not in painting but in sculpture, in Lorenzo Ghiberti's ten bronze panels for the east doors of the Baptistery, Dante's *bel San Giovanni,* in Florence (page 63). The Bible stories for these *Gates of Paradise,* which he modelled and cast between 1425 and 1452, have stately architectural backgrounds, or landscapes whose tall trees may separate the different stages of a single episode. The principles of perspective as laid down by Alberti and employed by Brunelleschi and Donatello are much in evidence, and such is Ghiberti's attention to linear values, and so skillfully does he graduate the depth of the relief, that he achieves marvellous effects of recession, with the most distant objects clear and sharp, however lightly indicated. It is Renaissance space but in it are

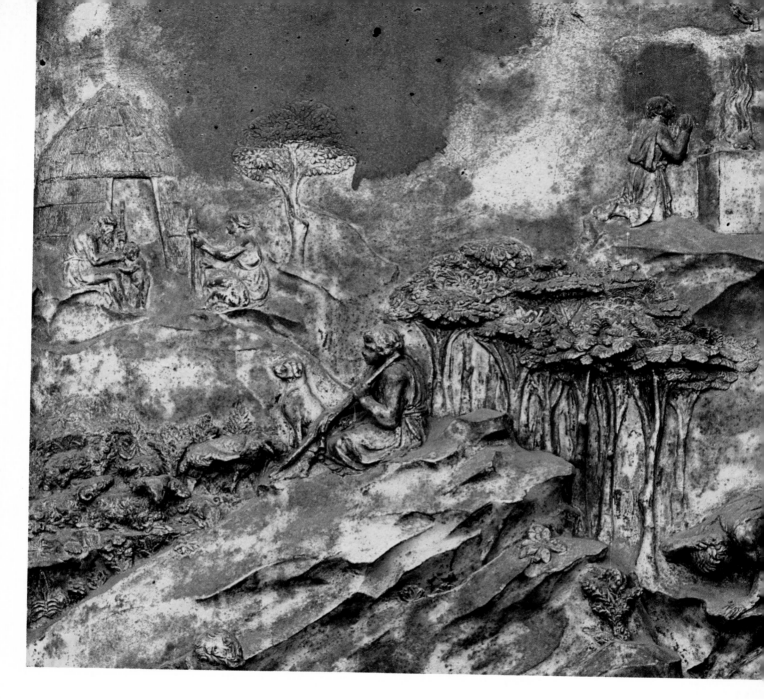

medieval slopes and precipices, and leaves and branches are minute and accurate. The same attentive love has gone into their making as was ever expended on a herbal handbook from Lombardy, or the most luxurious missal for the courtly patrons of International Gothic.

left: *Giovanni di Paolo:* The Young Saint John Going into the Wilderness *(detail), c. 1450–60. Tempera on wood; 68.6 cm x 43.7 cm. Chicago, Art Institute, Mr. and Mrs. Martin A. Ryerson Collection.*

above: *Lorenzo Ghiberti:* Cain and Abel *(detail), panel of the Gates of Paradise, 1425–52. Florence, east door of Baptistery.*

NATURE
ACCORDING
TO REASON
The Renaissance

All the lovingly observed natural detail of the enchanting International Gothic ended, curiously enough, by building up an unreality, a world whose splendour and beauty were those of a fairy tale; and with the coming of new concepts of space this kind of landscape was superseded, in Florence and the Low Countries almost concurrently, in the 1420's. Florence discovered perspective, which organized space; the Netherlands discovered light, which unified it. The leaders and chief exponents of this, one of the most revolutionary departures in the history of art, were Masaccio and the Van Eyck brothers.

In Florence the change was sudden and radical. Masaccio was only twenty-four when he painted his *Tribute Money* fresco in the Brancacci Chapel of the Carmine church in 1425, with a landscape as far as it possibly could be from anything in Late Gothic or, indeed, any other previous style or tradition. His figures are set, as never before, in "defined and habitable space," with every person and object in exact position and proper perspective. Real, recessed space surrounds them, and seems to involve the spectator standing in the chapel. Nature, too, is realistic, with the essential, elementary truth to fact of horizontal ground and vertical mountain. Ground and mountain are alike bare of vegetation, yet so inevitably right that they could be no other than they are. We respond to them immediately, as to something we remember and recognize. There are three groups, all on a narrow ground plane, like a forestage: an oval shape made by the Apostles, with Christ among them pointing to the lake, Saint Peter on the left finding the coin in the fish's mouth, and again on the right, presenting it to the tax gatherer. We are not disturbed that he should appear three times, and the tax gatherer twice, in the same scene, for we are being shown

Mountains, in consequence of the great quantity of atmosphere between your eye and them, will appear blue.

Leonardo da Vinci, Notebooks, *MS. no. 2038, Bibliothèque Nationale, Paris (Irma A. Richter's translation)*

Antonello da Messina: Saint Jerome in His Study *(detail), c. 1474. Oil on wood; 46 cm x 36.5 cm. London, National Gallery.*

Masaccio, The Tribute Money
*(detail), 1425. Fresco; length 5.98
m. Florence, Brancacci Chapel,
church of the Carmine.*

three consecutive moments in the story, told in spatial terms: the expression of Christ's will, the saint's prompt obedience, and the miraculous event. At intervals behind these groups are trees with scanty foliage, one with branches splintered as though by lightning, which act as markers or points of reference for the perspective guidelines of the composition. Such a line descends from the building on the right to where the horizontal boundary of the "forestage" implies a hidden valley lying between it and the mountains farther back. These mountains have been compared by Roberto Longhi to a land newly emerged from, and almost erased by, the Flood; or perhaps they are so far away that we cannot see them properly. They are merely indicated, and their lower slopes melt into the background, so that we take in the whole series of substantial rising contours at a glance. Volume is no longer suggested in the old way, by stepped rocks and chalky cliffs, but by subtly alternated areas of light and shade, with the peaks modelled so accurately that some observers claim to see in them the Pratomagno hills. This very Apennine landscape is in transparent twilight, giving the impression of extent and distance, even of melancholy, behind the more brightly illuminated figures in front. The same melancholy atmosphere is felt in another of the Brancacci frescoes, the *Distribution of Alms,* where Masaccio paints a corner of one of the somber hill towns, foreshortened, with only a white castle on the mountainside beyond.

It was a long time, however, before Florence learned what Masaccio really had to teach, though by 1480 the humanist Cristoforo Landino was praising him as "devoted exclusively to the imitation of truth," *puro sanza ornato,* "pure, and not given to ornament." His leading disciple in the early 1430's was probably Fra Angelico. He understood the new perspective and used its "classically measured" rhythms, derived from Brunelleschi, in strictly constructed interior and exterior architecture and in the spatial recession he suggests so vividly in the background landscapes of his small predella panels. Yet even he still delighted to strew the fields and orchards of his Garden of Eden settings—in the *Annunciation*

pictures at Cortona, in the Prado and at San Marco in Florence, for example—with flowers as detailed as any in a Late Gothic herbal, and employs the iconography of a hundred years before in this broader and better-organized space. His harbour scene with Saint Nicholas of Bari from the Perugia triptych of 1437 (this panel is in the Vatican Gallery) is very like Ambrogio Lorenzetti's version of the same subject, then in the Church of San Procolo at Florence and now in the Uffizi. But Fra Angelico's purpose was to show the divine presence as pure light and absolute beauty in all created things, and even his buildings and mountains have, therefore, a clear and "finished" quality. The mountains occasionally resemble the angular precipices of Lorenzo Monaco, without his strong and somewhat dramatic chiaroscuro; but the colours shine as if washed in the bright air, and their essential light, thus emphasized, becomes for Fra Angelico the expression of God. His landscapes are not those of common earth, though a few may be inspired by real places. One such rare view is the panorama at the left of the *Visitation* panel in the predella of the Cortona *Annunciation:* the winding shores and clear waters of Lake Trasimeno, with the faraway towers and walls of Castiglione del Lago, all in golden light.

Light is perhaps the most important and effectual element in Domenico Veneziano's art, uniting figures and landscape. His earliest known work, the Berlin tondo with the *Adoration of the Magi,* contains a wide and minutely detailed landscape that slopes in perspective from a limpid distance to the row of figures in the foreground who seem, in their sumptuous apparel, to have strayed from the courtly cosmopolitan world of Pisanello; and the first plain morning sunlight in Italian painting falls on the arches and columns framing the Virgin and Child in their niche, Saint Lucy and the attendant saints in his altarpiece for Santa Lucia dei Magnoli, circa 1445-50, now in the Uffizi. Domenico, Venetian born, made Florence his adopted home and profited by his study of Masaccio and Fra Angelico. A predella panel from the same altarpiece, in the National Gallery, Washington (page 69), shows the young Saint John in the wilderness. In an extraordinary

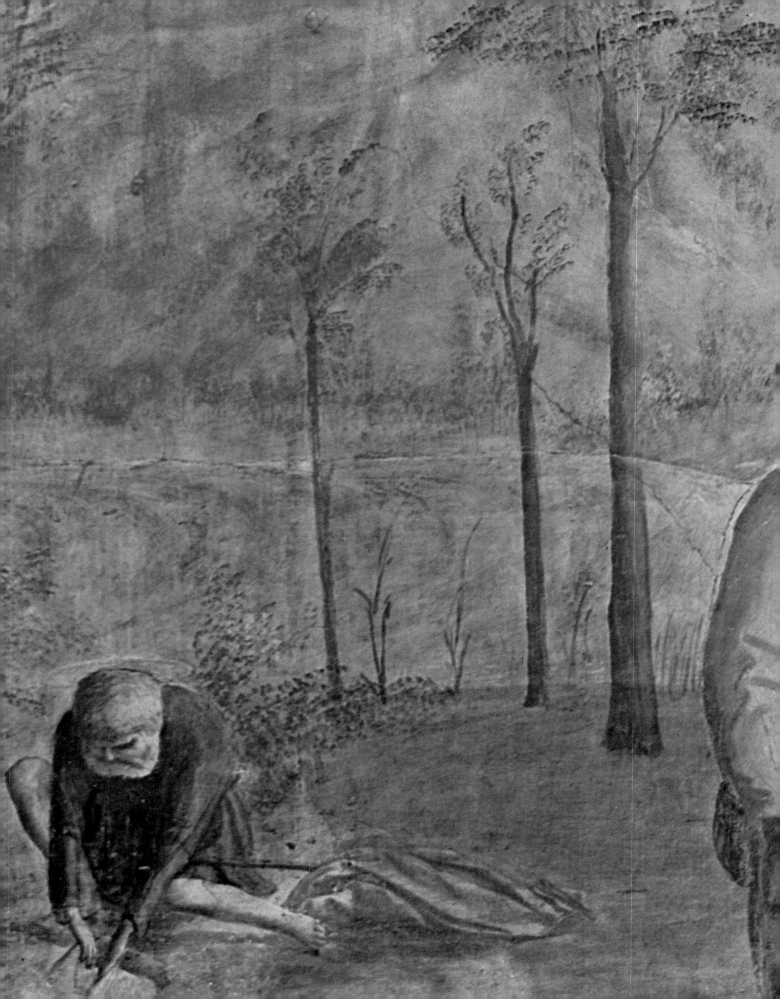

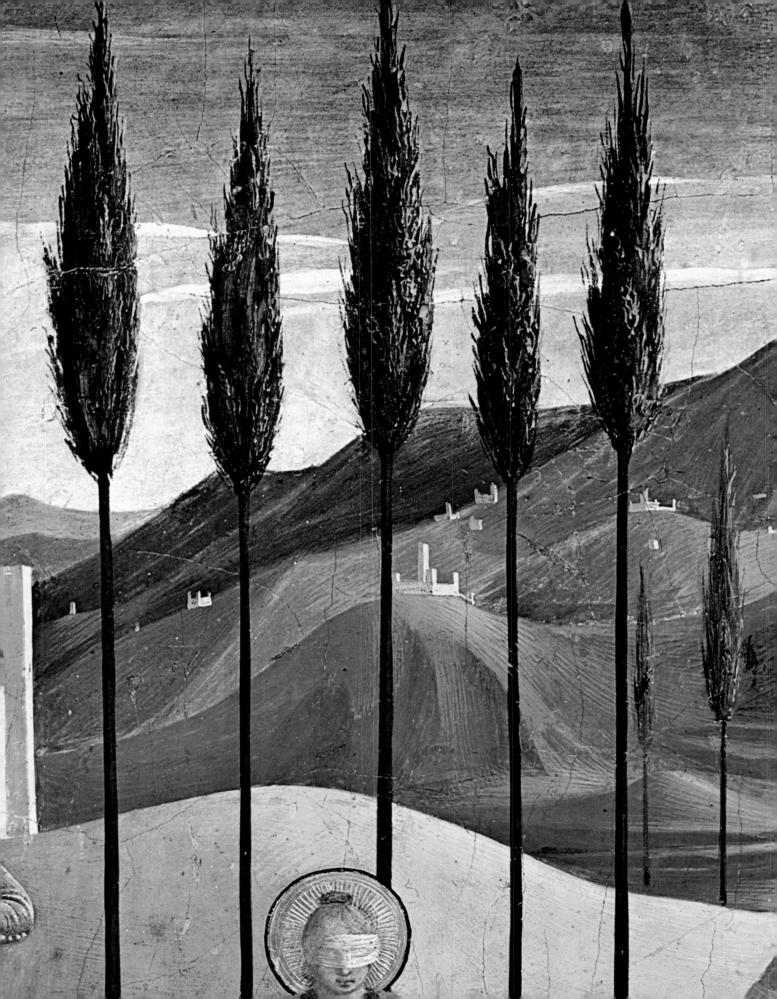

left: *Fra Angelico:* Martyrdom of Saints Cosmas and Damian *(detail), c. 1438–40. Tempera on wood; 36 cm x 46 cm (part of the altarpiece of San Marco). Paris, Louvre.*

right: *Domenico Veneziano:* Saint John in the Wilderness *(detail), 1445–50. Tempera on wood; 28.3 cm x 32.4 cm (part of the altarpiece for Santa Lucia dei Magnoli, now in the Uffizi, Florence). Washington, National Gallery of Art, Samuel H. Kress Collection.*

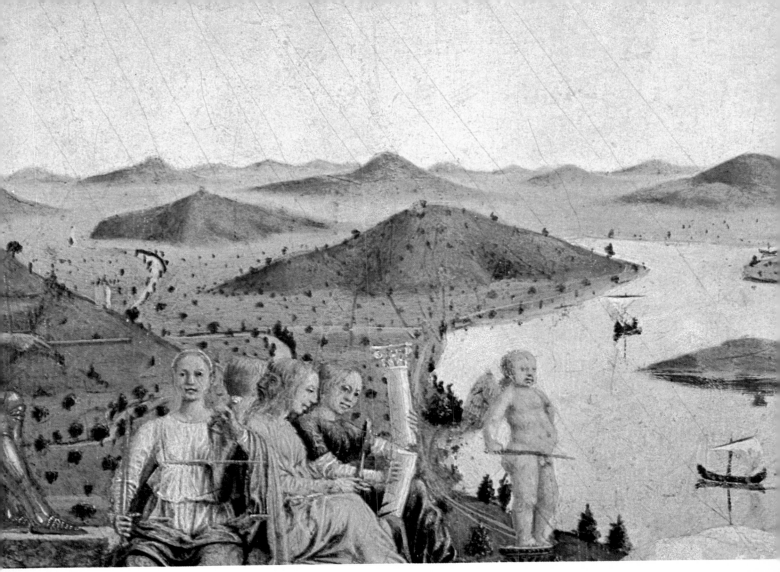

above: *Piero della Francesca:* Allegorical Triumph of Battista Sforza *(detail), painted on the back of her portrait in the diptych* Battista and Federico da Montefeltro, Duke and Duchess of Urbino, *c. 1465. Tempera and oil on wood; 47 cm x 33 cm. Florence, Uffizi (from the ducal palace, Urbino).*

landscape the bare, faceted mountains of Gothic convention are shown in perspective, under a sunset glow that makes the fantastic, inhospitable desert both magical and more real.

The first document to mention Domenico in Florence is dated 1439 and tells us that he has "working with him" on the choir frescoes of Sant' Egidio a youth of little more than twenty named Pietro di Benedetto, from Borgo San Sepolcro: Piero della Francesca. The frescoes have been destroyed, but even without this evidence to connect the two artists, we can see how Piero adopts the daylight in his pictures that was the other's chief innovation, and uses it together with the marvellous spatial effects he based on the laws of geometrical perspective. Nor did Piero neglect the realities of nature. He paints the sun-drenched Arno and Tiber valleys in *The Baptism of Christ* (circa 1450, in the National Gallery), and the *True Cross* frescoes in the choir of San Francesco at Arezzo, of 1452–66. We see the patches of moist fertile land and the parched fields at summer's end, the wooded hills, the trees and solid stone farms reflected in rivers that mirror blue skies and high white clouds; the river in the background of *The*

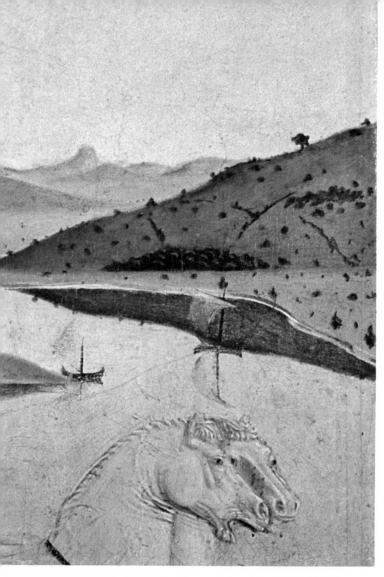

below: *Paolo Uccello:* Saint George and the Dragon *(detail),* 1456–60. *Tempera on wood; 25 cm x 90 cm. Paris, Musée Jacquemart-André.*

Victory of Constantine over Maxentius is navigated placidly by a flotilla of ducks. It is Piero's beloved familiar countryside and this, as Roberto Longhi notes, is how it might have seemed to an anxious peasant hidden in a furrow and knowing its peace in jeopardy on the day of the battle of Anghiari, when pope and Florentines were fighting the Visconti and the Aragonese near Borgo San Sepolcro, fourteen years before.

Twin portraits by Piero of the Duke and Duchess of Urbino are in the Uffizi, each with an allegorical Triumph painted on the reverse (pages 70–71). Behind and below the triumphal cars there stretches landscape vaster and more open than any yet known to art. Beautiful as these panoramas are in their own right, we realize their sheer brand-newness only by including in our view the figures in the chariots which, bathed in the same luminous atmosphere, stand high above the hills and plains, serpentine rivers and roads, with no window, balustrade, or barrier of any kind. They stand so

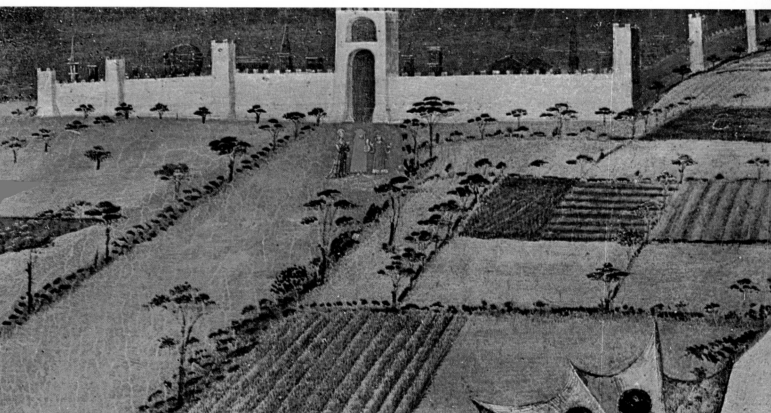

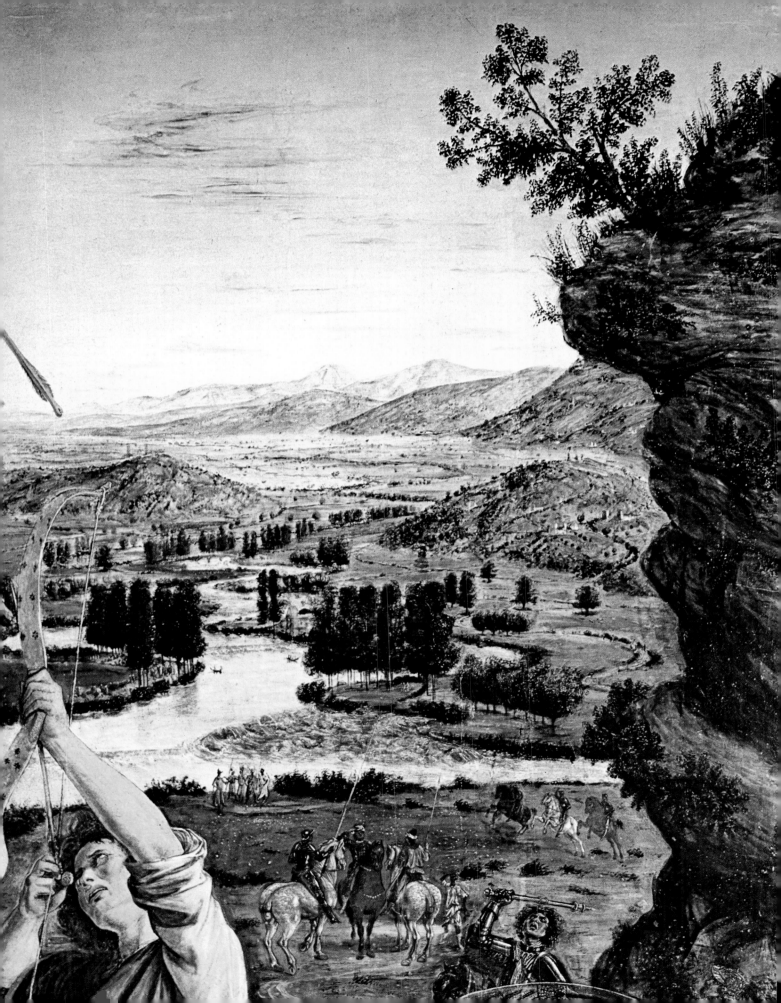

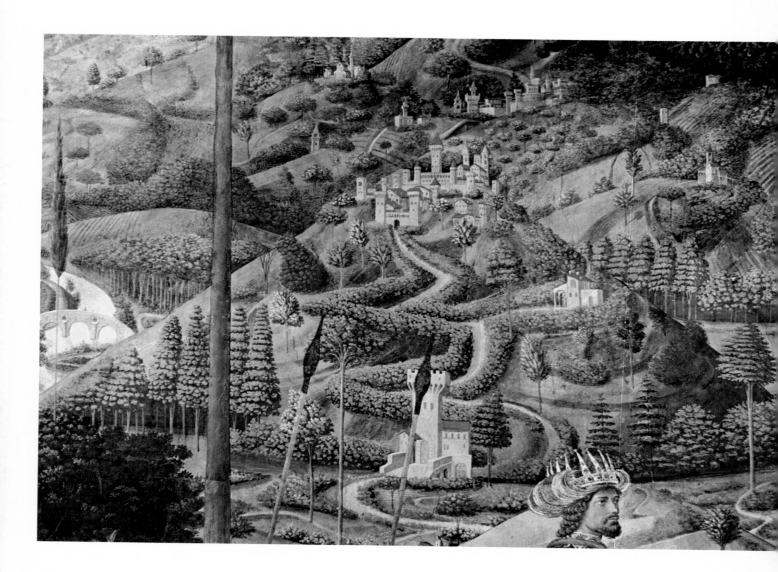

high, and the horizon of shimmering hills is so low and far away, that to look from them to those immense level prospects makes the head reel. It is like looking from a tall tower.

Piero della Francesca wrote a treatise on perspective, which makes him a theorist as well as a practitioner, but for Paolo Uccello, his senior by almost a generation, it was a consuming passion. Morning, noon, and night he studied and experimented with perspective, though with very different results.

With the sort of intellect that attracted him to such studies in the first place and made him, no less than Masaccio, Brunelleschi, or Donatello, a standard-bearer of the *novus ordo* of the Renaissance, Uccello combined a fanciful spirit. He loved the unreal, the fabulous, the Gothic. These diverse strains, which might have led to artistic incoherence, in fact produced painting—landscape included—of splendid originality. Naturalistic landscape he never attempts, disregarding light

and atmosphere to concentrate on pure perspective. Landscape for him is perspective structure, nothing else, with every aspect "regularized" to fit, and all spatial dimension conveyed by essential lines in due perspective. His colour goes on flat, following the strict geometrical planes of the composition, and is often far from natural, so that Vasari chides him for having painted "fields blue and cities red." The fields in *Saint George and the Dragon* at the Musée Jacquemart-André in Paris (pages 70–71) are not, as it happens, blue. They form a huge chessboard divided by thin straight hedges into uniform chocolate-coloured squares, some plowed, retreating in perspective to the white walls of a distant city. They are fields of no particular time or season, a mere mental image of fields, distilling what we should now call a Surrealist or Metaphysical atmosphere. The successful application of perspective has released the artist's fancy and proved to be his actual subject, as Decio Gioseffi points out. As for light, Uccello's landscapes are quite unrealistic. So much so that for a long time no one could decide whether the extraordinary hunting scene in the Ashmolean Museum, Oxford, took place by day or dark, and only when a slip of moon was finally detected, half hidden in the leaves, was the controversy settled and the picture safely entitled *Nocturnal Hunt.*

"A practiced master, very rich in invention, and very productive in the painting of animals, perspectives, landscapes, and ornaments," was Vasari's summing-up of Benozzo Gozzoli. It therefore seems reasonable to expect from Gozzoli the most beautiful landscapes of the fifteenth century, and indeed his perspective unwinds faultlessly, especially in his later frescoes in the Campo Santo at Pisa, with their several "ideal cities." There are cypresses, single or in groups, cultivated hillsides with this crop or that, meandering roads and streams, farms and scattered dwellings, castles in the distance. It is all authentically Tuscan. The only trouble is that there is too much of it, so these pictures seldom rise above the level of reporting, peaceful enough, but basically prosaic. At times, particularly in the extensive landscapes, they are almost map-

making. His masterpiece is the continuous decorative frieze in the private chapel of the Medici Palace in Florence: four walls of *Paradise* and the *Journey of the Magi,* painted in 1459–62 (page 73). His procession of the kings may be seen as a version of Gentile da Fabriano's—a little more up to date, perhaps, a little less aristocratic, and very like a tapestry. As enthusiastic collectors of Flemish hangings and painting, the Medici may well have told their artist to produce something that resembled tapestry as much as possible, and this is the effect of his crowded, lively scene.

A faithful, if not very bold, follower of Domenico Veneziano and Piero della Francesca in matters of perspective is Alessio Baldovinetti. In his 1460 *Nativity* in the cloister of the SS. Annunziata in Florence a luminous plain, dotted with small trees and buildings in a more or less regular pattern, unfolds behind the framing trees overshadowing the tumbledown stable. The background of the pale *Madonna and Child* in the Louvre is a watered valley between high wooded hills. The curving road in the first and the winding river in the second have a new sense of movement that heralds the indented, almost agitated landscapes of Antonio Pollaiuolo. Of these the most important occur in his *Martyrdom of Saint Sebastian,* of 1475, in the National Gallery (page 72), and the *Rape of Deianira* in the art gallery at Yale. In the one, the saint and his executioners are on a hilltop overlooking a wide valley floor with little rows of trees, like screens, at the bends of the river. The river in the *Deianira* picture, rushing around the feet of the centaur with the nymph in his arms, echoes the rushing, headlong movement of the figures, who stand appreciably lower than the distant horizon from which it flows, the light shifting over its long sinuous course.

Botticelli's landscapes mark a turning point. Florentine art of the early fifteenth century had been a serene and penetrating inquiry into the perceptible world, and knowledge of nature had contributed to all its major discoveries. From spatial perspective to the adoption of ordinary daylight as a determining, rather than a descriptive, factor, these find supreme expression in Piero della Francesca. But for Botticelli,

searching so constantly for an ideal beauty full of intellectual meanings (which, towards the end of his life, were tinged with his tormented religious fervour), landscape has a subsidiary, if not in fact symbolical, role. It is related to medieval thought, though medieval considerations of treatment and iconography are lacking. The thicket of orange trees in the *Primavera,* for example, has no depth; it is only a background of vertical lines that throw into relief the linear rhythms linking those lovely, weightless dancers. Aeolus and Boreas in *The Birth of Venus* blow in vain over the green-blue seashell, and scarcely raise a ripple on the formalized small waves, which are mere elegant calligraphy. In the Uffizi *Annunciation* a door is open on a wide river-view, but not even as a source of light has this any connection with Mary and the angel in the room itself. Delicate branches around the figure of Christ in the *Agony in the Garden* in the Capilla de los Reyes of Granada Cathedral are more, it seems, a recondite allusion to the name "Mount of Olives" than an image of the real thing, while the marquetry landscape at Urbino is fantasy pure and simple. This was designed by Botticelli, so critics now believe, in 1476, as part of his work on the duke's *studiolo,* but the attribution of course raises the problem of

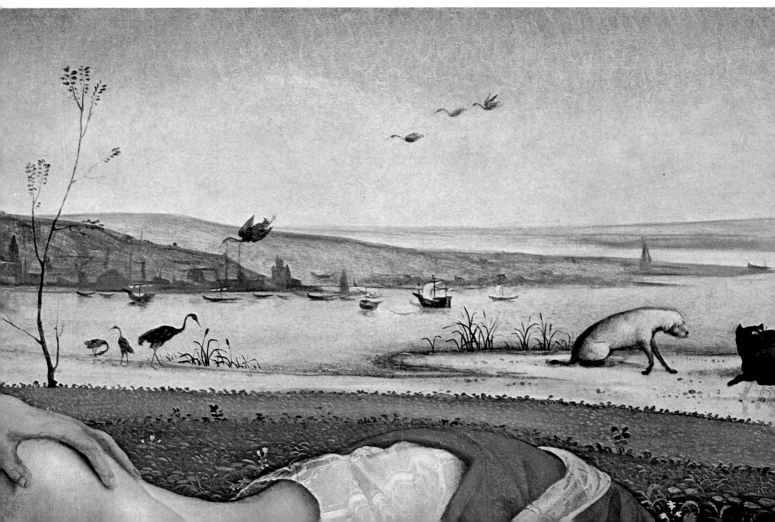

on page 78: *Pietro Perugino:* Galitzine Triptych, *detail of right wing with Saint Mary Magdalene, 1481–85. Canvas, transferred from wood; 95 cm x 30.5 cm. Washington, National Gallery of Art, Andrew W. Mellon Collection.*

on page 79: *Andrea Mantegna:* Landscape with a Castle under Construction *(detail of Huntsmen with Hounds and Horses), 1474. Fresco; length 2.35 m. Mantua, Camera degli sposi (bridal chamber) in ducal palace.*

how much is due to the man who makes a design, and how much to the skill and imagination of the man who carries it out—in this case the architect and engraver Baccio Pontelli.

The Florentine love for Flemish painting, which culminated on the autumn day in 1483 when they installed the Portinari triptych in Sant' Egidio with festival and rejoicing, may be traced in the landscapes of Domenico Ghirlandaio, Filippino Lippi, Piero di Cosimo, and others. On Ghirlandaio the influence is most evident in the minutely detailed background to his *Adoration of the Shepherds,* a fresco of 1485 over the altar of the Sassetti Chapel in Santa Trinità, while more

sober landscape is seen in the famous portrait of Francesco Sassetti and his grandson in the Louvre. Glimpsed through a window, this depends on a contrast of rocks in full light with a vaguely shadowed valley that recalls the young Leonardo. It is interesting to compare it with the landscape through another window, in *Saint Fina's Vision of Saint Gregory,* painted twenty years earlier in the Collegiate church at San Gimignano, for there the clear greens and blues and pearly whites recall Gozzoli.

In Piero di Cosimo, preoccupied with mythology and tales of primitive human society, the Leonardesque "atmosphere"

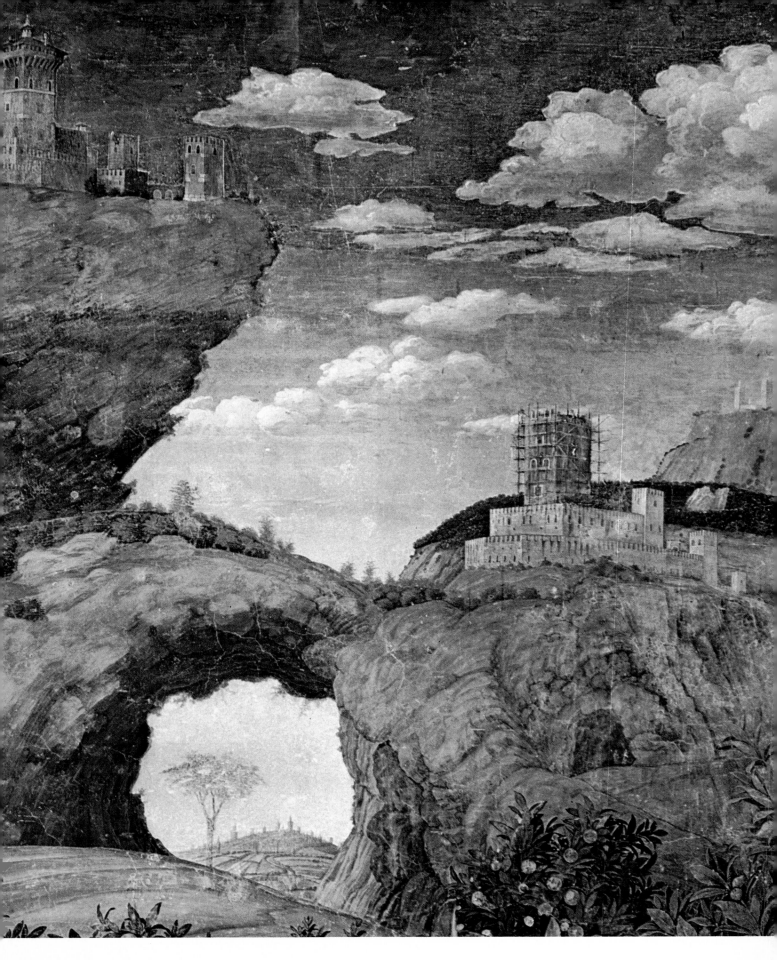

above, right: *Giovanni Bellini:* Madonna of the Meadow *(detail), c. 1505. Oil, transferred from wood to canvas; 67 cm x 86 cm. London, National Gallery.*

on page 81: *Francesco Cossa:* Saint Peter *(detail), c. 1470–73. Tempera on wood; 1.12 m x 0.55 m. Milan, Brera.*

below, right: *Taddeo Crivelli:* The Court of Solomon *(detail), from a leaf of the Bible of Borso d'Este, c. 1450. Miniature. Modena, Biblioteca Estense.*

modifies a meticulous naturalism that he derived from Flanders. The result is a somewhat disquieting poetry that bears an unmistakable signature. We find it in *The Death of Procris* (pages 76–77) in the National Gallery. The girl has been killed, unwittingly, by her husband, and the silent, bewildered grief of the satyr is matched by the desolation of the lakeshore, its farther banks veiled in blue haze. Very different is Lorenzo di Credi. He, too, is a diligent follower of the Flemish style and has echoes of Leonardo, but he is a cold painter. A charming, if mannered, landscape stretches beyond the loggia in his masterpiece, the Uffizi *Annunciation.*

Luca Signorelli, though a native of Cortona, may be counted a Florentine artist. He painted frescoes of the life of Moses in the Sistine Chapel in 1482, assisted to a large extent by the Camaldolese monk Bartolommeo della Gatta, and the settings of the minor incidents, with rocks and woods, are his main excursion into landscape. The intense plasticity of his style is better seen at the Uffizi, in a tondo of the *Madonna and Child* which he presented to Lorenzo the Magnificent. Behind the Virgin's shoulder a grey mountain, bare and craggy, is framed in an archway of reddish rock, making a pattern of massive, fractured, and spiky shapes.

Perugino, too, can paint fantastic rocks of Flemish derivation, like those in the *Magdalene* panel of the *Galitzine Triptych* now in the National Gallery, Washington (page 78). To realize how much he differs from, say, Signorelli, we should remember that this emphatically vertical landscape balances that of the corresponding outer panel, and that the two together flank a wide river valley, opening to a far, luminous horizon, behind the central Crucifixion. Perugino's greatest and most poetical stylistic contribution is the feeling of landscape space; open space between his gentle Umbrian hills that run down to the pale mirror of Lake Trasimeno, enormous skies with silhouettes of slender trees, their leaves too sparse to make a shadow in that transparent air.

A fellow Umbrian was Pinturicchio, whose landscapes are richer and fuller—more buildings, more rocky heights and green hills—and lack the lyrical sweep and amplitude of Pe-

left: *Vittore Carpaccio:* Lament over the Dead Christ *(detail), c. 1510. Oil on canvas; 1.45 m x 1.85 m. West Berlin, Staatliche Museen Preussischer Kulturbesitz.*

right: *Cima da Conegliano:* Saint Peter Enthroned between Saint Nicholas of Bari and Saint Bernard *(detail), c. 1504. Oil on wood; 3.30 m x 2.16 m. Milan, Brera (from the church, destroyed in 1806, of Corpus Domini, Venice).*

rugino. His bright colours and scrupulous detail are those of the miniatures, so that we seem to be looking into some huge illuminated page, decorative and descriptive in almost Late Gothic style, but Renaissance in tone.

Spatial perspective was one of the most important discoveries of the Tuscan Renaissance. It entirely changed the landscape painting of northern Italy, where the courtly International style had flourished, and the change was largely due to Andrea Mantegna. Mantegna had been apprenticed to the Late Gothic artist Francesco Squarcione, but modelled himself on Donatello and the other Tuscans—Paolo Uccello, Andrea del Castagno, Fra Filippo Lippi—then working in Padua and the Veneto. He was also acquainted with Flemish pictures, those of Rogier van der Weyden in particular, for he had visited Ferrara as a young man in 1449, and seen them in the Este collections there; and some of his early work—the *Adoration of the Shepherds* in the Metropolitan Museum, New York, for example—has echoes of Piero della Francesca. His *Saint James Led to Martyrdom,* one of the frescoes in the Ovetari Chapel of the church of the Eremitani in Padua which were destroyed in the last war, had raking fields on a hillside, lined with bushes and hedges. But when we turn to *The Agony in the Garden* in the National Gallery the main feature of that stupendous landscape, among the severest and most intensely felt of the fifteenth century, is naked rock. Rock is layered up into a platform for the kneeling Christ; it soars in dizzy conical peaks, girdled by the walled city below; and the weathered convolutions, hard and crystal clear, foretell the crazy, flinty piles in pictures of the Ferrarese school. Other superb landscapes are those in the Prado *Death of the Virgin,* which includes the lake at Mantua with its bridge in the background, and the frescoes of the *Camera degli sposi* (bridal chamber) in the ducal palace there (page 79). These Mantuan frescoes date from 1474 and are some of the earliest "classical" landscapes known. With his humanist passion for antiquity, Mantegna creates in them a happy blend of natural setting and Roman-inspired buildings and architecture.

The leading artists of Ferrara are Cosimo Tura, Francesco

Jean Fouquet: The Fall of Jericho, *fifteenth century. Miniature from* Antiquities of the Jews, *MS fr. 247, fol. 89. Paris, Bibliothèque Nationale.*

Cossa, and Ercole de' Roberti. This school owes much to the painters employed at the court of the Este dukes, from Pisanello to Rogier van der Weyden and Piero della Francesca, and most of all to Donatello and Mantegna in nearby Padua. With Tura, Donatello's three-dimensional solidity and Mantegna's classicism take on a sort of neo-medieval unreality. His is a landscape of weird escarpments, roads hacked out in spirals and jutting, perilous ledges; sulfurous lightning plays overhead and diamond-shaped pinnacles rear into fiery sunset skies. The same bizarre geology is recognizable beyond the green fields in the allegories of the *Months* in the Palazzo di Schifanoia at Ferrara, where it is combined with vivid realism, as in the group of peasants pruning their vines in March. Though Tura may have planned and actually begun these frescoes, much of the execution is Cossa's, and he, like Piero della Francesca, bathes his pictures in quiet light. In his dismembered *Griffoni Polyptych* this calm light falls on distant scenes, with precise bright rocks and water,

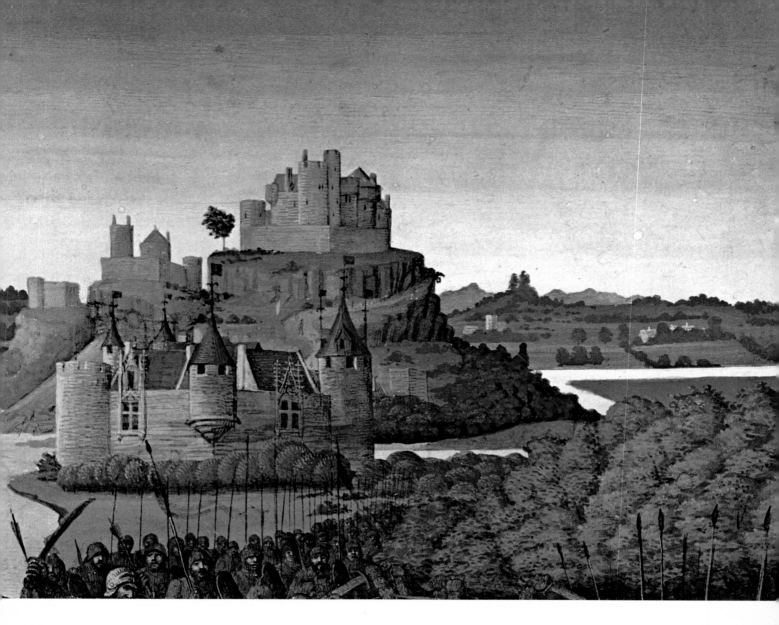

behind the saints, who are huge in proportion to the tiny landscapes. Finally, Ercole de' Roberti adapts the slightly metallic, chill tonality of these two predecessors on warmer, freer lines. The masterpiece of his maturity, painted for the altar of Santa Maria in Porto at Ravenna, is now in the Brera Gallery, Milan; in it we glimpse a wide expanse of lakes and hills beneath the curious raised throne. This mature style of Ercole de' Roberti is the point of contact between Ferrara and the Venetians as exemplified by Antonello da Messina and Giovanni Bellini.

Antonello da Messina grew up and was trained among the artistic crosscurrents of Naples—Provençal, Spanish, and Flemish. Flemish above all: Alfonso of Aragon, King of Sicily and Naples, and the hapless René of Anjou, whom he defeated, both collected pictures from the Netherlands. By 1474–75, when he arrived in Venice, Antonello had also encountered the influence of Piero della Francesca and learned how to apply perspective to the loving detail of these several

schools, as may be seen in *Saint Jerome in His Study* (page 64), now in the National Gallery. The Venetian connoisseur Marcantonio Michiel, writing in 1525, says of this picture, "the landscape is natural, minute and finished, visible through a window on one side and a door on the other"; it "runs away," he adds. The broad landscape of the 1475 *Crucifixion* in the Antwerp museum is flooded with golden sunlight, anticipating—or reflecting: interchange and influence are always thorny problems—Giovanni Bellini.

Bellini, says Kenneth Clark, "was by nature one of the greatest landscape painters of all time"; and so he was. Landscape is of prime importance in many of his works not only as occupying large areas of picture space, but because its perfect accord with the foreground figures or action—sacred or allegorical, Virgin and Child, Transfiguration, Crucifixion, Resurrection, saints in meditation or ecstasy—expresses an unmistakable inner poetry. As much as from his placing and arrangement of architecture and figures, Bellini distils this

left: *Jan van Eyck:* Madonna
with Chancellor Rolin *(detail)*,
c. 1435. *Oil on wood; 66 cm x 62
cm. Paris, Louvre.*

below: *Master of Flémalle
(possibly Robert Campin):* Nativity
*(detail), before 1430. Oil on wood;
0.87 m x 0.73 m. Dijon, Musée des
Beaux-Arts.*

immediate beauty from the truthful observation of nature; from the variations of light as days and seasons change, from flowers, or hillsides green in spring and burned in summer heat, in the morning or at sundown. He observes with incredible accuracy, and his artist's eye is loving. Also, his landscape develops constantly as he accepts new cultural influences or grows more spiritual and inward-looking. He softens the metallic monumentality of his brother-in-law, Mantegna; his grasp is firm on the perspective learned from Tuscany. His incomparable, all-inclusive response to light makes a unity of colour and space, and his colour is as lovely as Giorgione's.

It would be impossible, and is certainly impossible here, to indicate Bellini's "greatest" landscapes. For one thing, they are immensely varied. In some he shows the Veneto as it is, with fields, lagoons, and small towns, hills and distant Alps; in others he gives his fancy rein and makes ideal images of it. Yet they are often alike in the feeling of exaltation they convey. They are penetrated with a sense of measure, a humanist regard for truth and reason; God is omnipresent, and every form and object has a kind of holiness. It is this pervasive holiness that imbues the vision of Bellini with its deep and almost instinctive classicism, which comes from a balance of mind and heart found in no other painter of his century.

Compared with this wonder, even the landscapes of Carpaccio are prose; fascinating and colourful to a degree, but prose. Vittore Carpaccio was a Venetian who loved to paint fabulous Eastern cities, and loved to paint Venice, and whose pictures are thronged with things and people—steady, businesslike people, going about their normal, steady concerns. Lyricism is rare; even when involved in the most outlandish episodes of martyrdom and miracle, they have their feet on the floor. A similar practical attitude is met with in Lazzaro Bastiani, who may have taught Carpaccio, in Benedetto Diana (another of Bastiani's pupils), and in Cima da Conegliano, all of whom as painters, or rather describers, of exquisite landscape are more or less influenced by Bellini. Cima is the best of them, introducing his own personal and idyllic note with scenes that are straight out of the *Georgics.* Carlo Crivelli bears fewer marks of Bellini, perhaps because he left Venice at the age of twenty-seven, in 1457, though the Bellinesque style reached Vincenzo Foppa in Brescia. In the background of his *Saint Sebastian* in the Museo d'Arte Antica at Milan are white houses—"phosphorescent" is Fernanda Wittgens's word for them—and "the dreamy landscape is the true subject of the picture." The most sensitive landscape painter among these Lombard artists was, however, a disciple of Foppa's named Ambrogio Bergognone. There are bewitching glimpses of the countryside, of lakes and tranquil towns and farms as background or adjuncts to his devout Madonnas.

The idea of realistic landscape came more slowly, and by different means, outside Italy than it had done in Tuscany, where Masaccio had appeared like a bolt from the blue, and Piero della Francesca's synthesis of light and perspective spread from master to master. In *The Adoration of the Mystic Lamb (The Ghent Altarpiece)* in St. Bavon at Ghent, the landscape is undeniably medieval, and that supreme piece of Flemish painting, begun by Hubert van Eyck, was completed by his brother Jan after his death in 1426. It breathes the spirit and doctrines of the Middle Ages. In its vision of Paradise—Paradise, what's more, at the gates of a northern city—every object, group, and individual evokes and symbolizes something. Its landscape details, tree, meadow, and flowering bush, are so arranged that, while due care is given to their position in space, they exist not as integral parts of a visual whole, but as "local colour" and support to the different characters and incidents. Because of this we are more attracted to the beauty of separate sections than engaged with the entire composition, though it unrolls before us with unprecedented breadth and amplitude, and this in turn is because the new, refined technique of oil painting makes each tiny thing discernible, with its claim on our attention.

Jan van Eyck is said to have been the first artist who ever mixed his paints with oil, and there seems no aspect of the visible creation that the brothers cannot closely and faithfully

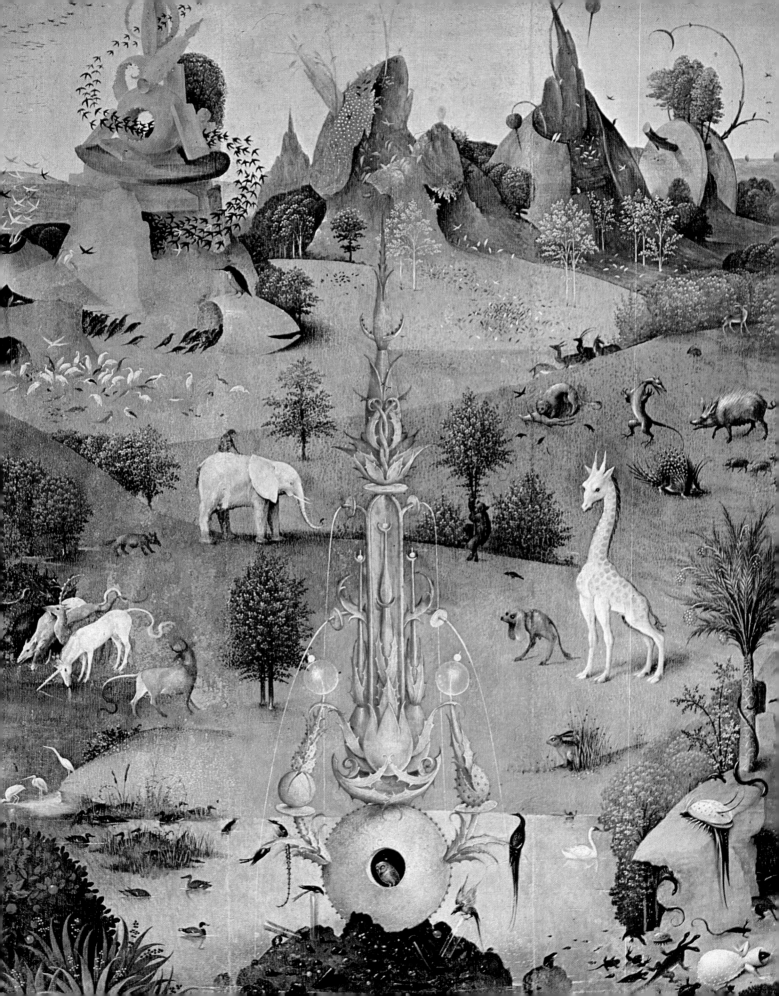

below: *Lukas Moser:* The Voyage of the Saints *(detail of left wing of the Magdalene Triptych),* 1431. *Tempera on wood. Tiefenbronn, parish church.*

right: *Master of The Life of the Virgin:* Conversion of Saint Hubert, *c. 1474–78. Wood; 0.83 m x 1.23 m. London, National Gallery.*

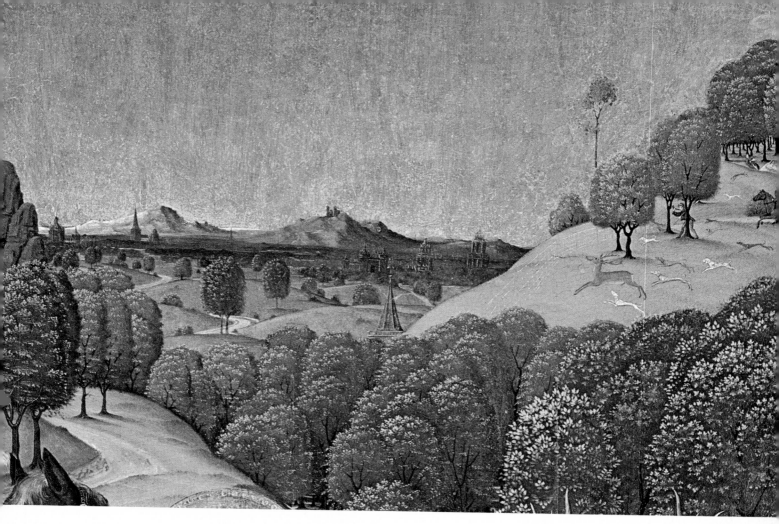

portray. In the realm of nature alone, you know which rocks are hard and which would crumble at a touch; you see the multiple small shadows in the bushes, the thickening darkness under the trees, the brighter green of a clearing. You know the shining leaf would weigh nothing in your hand.

All this is done with colours so intense and pure that the medium might be light, not oil. Light is in the pigments, in the picture; it is the unifying element, and distinguishes this from the clear, microscopic world of International Gothic. It is not, nor ever could be, the light of Domenico Veneziano or Piero della Francesca, much less that of Bellini. It is rather the "artificial" light a mystic might bring into being to reveal the incorruptible beauty of essential truth. This is the secret of the sacred, transcendent quality of the Van Eycks' landscape, even when they are not painting Paradise. In the *Madonna with Chancellor Rolin* in the Louvre (pages 86–87), the same atmosphere breathes over the dream-city spires, seen through the carved marble arches of the loggia, and the view, detailed as any miniature, stretching into the hazy distance.

More down-to-earth, in a way more naturalistic, is the other founder figure of the Flemish tradition, the Master of Flémalle, now usually identified with Robert Campin. Behind the stable in his *Nativity* in the Dijon museum (page 87) there lies a marvellous winter landscape. It is winter without snow. Bare trees, houses, fields, a winding road, a path with peasants huddled in their cloaks—everything is lifelike, humble, and ordinary. The well-defined shadows are very different from the luminosity of the Van Eycks, and the picture is strongly three-dimensional; one can understand how this simple, more immediate approach to nature had a greater impact on European painting than did their aristocratic detachment. The art of Campin announces the Flemish style which Florence, seeing the work of his pupil Rogier van der Weyden and Hugo van der Goes, took to its heart. (It was from Hugo van der Goes that Tommaso Portinari, who had been in charge of the Medici office in Bruges, commissioned his famous altarpiece.)

"Flemish," however, does not necessarily mean "naturalistic," as a glance at the landscapes of Hieronymus Bosch will show. These were painted in the last quarter of the fifteenth century and the early years of the sixteenth, foregrounds and backgrounds alike peopled with monstrous creatures and diminutive men and women, all with complex, and often highly abstruse, symbolical meaning, religious, satirical, or moral. In occasional realistic landscapes he shows a nice awareness of atmosphere and space, with soft colours and the

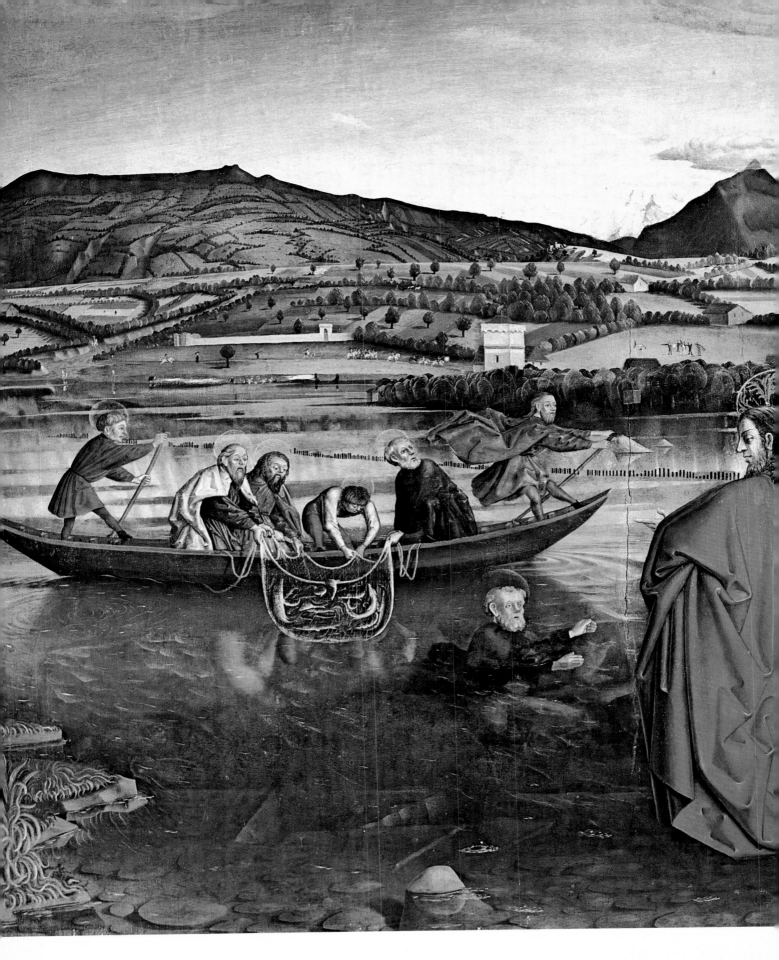

Conrad Witz: The Miraculous Draught of Fishes, *1443. Panel from* Altarpiece of Saint Peter. *Wood; 1.32 m x 1.55 m. Geneva, Musée d'Art et d'Histoire.*

"smoky" effects of *sfumatura* as one receding plane melts into another.

Flemish realism and the measure and balance of Italy are present equally in Jean Fouquet, the greatest miniature painter of fifteenth-century France. He had been in Italy sometime before 1450, and these qualities match one another in his pictures. The landscapes—especially those in manuscripts such as the *Book of Hours of Étienne Chevalier* or the *Antiquities of the Jews* (pages 84–85)—are less crowded with detail than are those of Van der Weyden's pupil Hans Memling and other Flemish artists, though motifs from the medieval repertoire appear side by side with vivid naturalistic touches. Yet all combines in perfect visual unity, to which simple, clear perspective contributes not a little. As Charles Sterling puts it, "It is not in the small corners, but in the landscape as a whole, that he gives the feeling of truth."

In the German lands we find three different conceptions of landscape within a hundred years. First we may take the seascape in the left panel of the *Magdalene Triptych* in the church at Tiefenbronn near Lake Constance (page 90). This triptych is signed by the Swabian Lukas Moser, and dated 1431, but it is hard to decide whether or not the seascape ranks as International Gothic. To some extent it is very Gothic: the high tilted horizon, the line of hills against the sky, the wide sea crisscrossed with calligraphic waves. But there is real space in the composition, with a new air blowing through it. Every object—notice especially the placing of the boats—is more solid and has more volume and reality than anything in the older tradition.

The change from Late Gothic to Renaissance is most clearly marked in the work of Conrad Witz. He knew and understood Flemish landscape, which he interpreted in his own fashion, with three-dimensional forms and logical perspective. His masterpiece, *The Miraculous Draught of Fishes,* executed in 1443 for the bishop of Geneva, is now in the museum of that city (page 92). It shows an inlet of the lake, with a hilly shore that recedes and rises to mountain height through successive planes with changing vegetation, to van-

ish against the distant, snow-covered slopes of Mont Blanc; and as the water varies in depth, so the reflection of the boat in the foreground varies in density. Without going all the way with the critic who recognized the exact spot and told us that Witz had painted there at half past three on a windless summer afternoon, we may safely agree that this is the most accurately rendered real landscape of the fifteenth century.

The landscapes of the great *Isenheim Altarpiece* by Matthias Grünewald, in the Colmar museum, are completely different. They present not realism but the fantasies of an obsessive visionary imagination. Though finished in 1515, and the least medieval of compositions, they are rooted in a passionate religious emotion and a harsh, exalted mystical tension that belong to the Middle Ages. The dark recesses and skeletal branches among which Saint Paul and Saint Anthony the Hermit sit and talk are emphasized by the unreal light on pinnacles of rock; every detail is chosen to evoke the desolation of the deep northern forest and, in the *Temptation of Saint Anthony,* for its nightmare quality. The monsters who do their devil dance around him seem born of forest terrors.

The accepted landscape of the fifteenth century changes with Leonardo da Vinci. Natural and scenic elements in his pictures are not fixed, completed things, for his attention is

caught and his curiosity aroused by states of development and transition. This is first evident, when he is barely twenty-one, in a small ink drawing dated 5 August 1473 (page 94). Here every object is defined in relation to the light we see it by and the place it occupies in a unified space: and this is done by the rapid, vibrant line, now thick, now thin, that never fails in graphic power. The spatial depth, which looks so carefully calculated, is in fact the product of an extraordinary poetical intuition, and it must have been a long, hard way from this view, taken perhaps in his native Val d'Arno, to his otherworld of luminous mist on stony mountains, of the *Mona Lisa* (page 95) or the *Virgin and Child with Saint Anne,* in the Louvre. But Leonardo's blue mysterious shapes are poetry that embodies scientific study. He studied the geology of rocks, and of mountains eroded for thousands of years by wind and water. The vastness of his vision, the airy distances where sky and water join as though at time's beginning, are therefore an image of time as, inexorably, it modifies the appearance of the earth. That, if not their whole meaning, is at least the impression we receive from Leonardo's cosmic landscapes. Their universal breadth has never been matched, and in them science, philosophy, and lyric inspiration bear witness to his all-embracing genius.

Raphael's landscape, in comparison, is closer to fact, although he sees every aspect of nature as a manifestation of the divine, the world as a source of beauty and harmony to be contemplated and enjoyed with all his faculties. With a partly religious motive and a style that gains in realism, he paints its many-sidedness, its intervention in the lives and consciousness of men. Thus from the untroubled skies and clear spaces derived from Perugino he progresses to the Venetian colours of his later works; to the landscape, for example, in the *Madonna di Foligno* of 1515, now in the Vatican (page 97), where a shooting star or thunderbolt refers to the earthly event commemorated, leaving the donor's house unharmed. Mountains and buildings are lit with a bluish glare and the brushstrokes are quick and robust.

The Tuscan Mannerists of the late Renaissance are at first sight reserved, if not diffident, in the face of nature which, even when essential to the subject, seems as though imagined in the studio rather than experienced out of doors. In Pontormo's rustic scene of Pomona and Vertumnus, frescoed in the Medici villa at Poggio a Caiano in 1519–21, it is purely emblematical; in his *Adoration of the Magi* in the Pitti it is an intellectual exercise, apparently after Raphael. Bronzino, great portrait painter that he was, does very little better: his chosen backgrounds are the somber palaces of Grand Ducal Florence, his landscapes few and melancholy, influenced by Pontormo. Domenico Beccafumi in Siena, however, brings a touch of poetry. In one corner of a panel of his altarpiece *Saint Paul Enthroned* (circa 1515, in the Opera del Duomo), a shivering woman is being carried along by a gust of wind. The passage would not be out of place in a picture of the Romantic period and is a kind of realistic nature painting: Beccafumi is "painting the wind." Giovanni Antonio Bazzi of Vercelli–or Sodoma, as he is more generally known–who worked in Siena at the same time, has another interpretation of nature. His landscape backgrounds are full, charming, and descriptive, with Leonardesque echoes from Lombardy and Umbrian traces of Perugino and Pinturicchio.

"The little landscape with the storm and the gypsy and the soldier" is how Marcantonio Michiel noted Giorgione's *The Tempest* (page 2) when he saw it in the Vendramin palace. Though he seems to imply that the tempest and the setting are more important than the human figures, these are, in fact, not so much eclipsed as absorbed by their landscape. They melt into it; whatever the unsolved subject of the picture may be, it is the main character, a landscape based on colour rather than on perspective and the depiction of solid forms. Formal and spatial values are conveyed by the graduation of light in colour and by the fusion, or harmony, of colour areas.

This harmony, or "tone," was Giorgione's chief landscape discovery, to be variously handled by every Venetian painter of the sixteenth century: the uniform golden light that washes over everything in his pictures. But there is besides

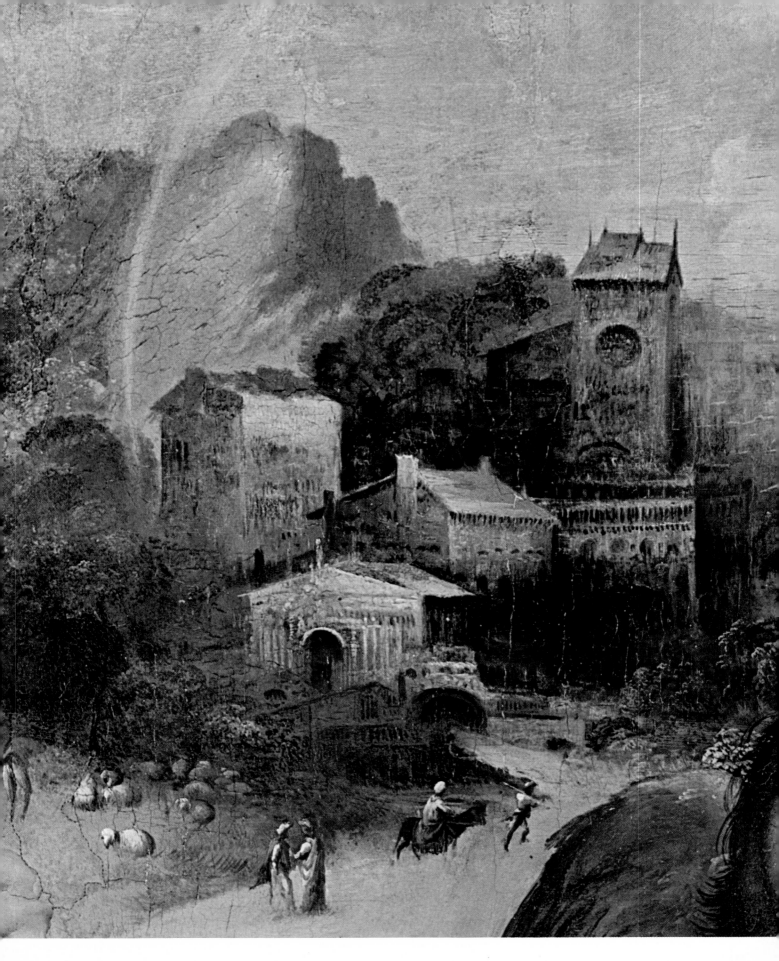

above: *Bronzino:* Noli Me
Tangere *(detail), after 1531. Oil
on wood; 1.75 m x 1.34 m.
Florence, Casa Buonarroti.*

left: *Domenico Beccafumi:* Saint
Paul Enthroned *(detail), c. 1515.
On wood; 2.3 x 1.5 m. Siena,
Museo dell' Opera del Duomo.*

what might be termed an iconographical discovery, for he makes magical use of fantastic or obscurely symbolical features, such as fragments of invented architecture, together with "real" things. The bridge and houses behind the soldier and the gypsy are real, yet though lightning splits the ominous sky the water never stirs, the leaves hardly move on the trees. What we see is less an "ideal" landscape than a dream, an image beckoning us, too, to dream. The door is opened into his spellbound world, and it is so real that he might be showing us actual landscape. Other pictures have the same breathless magic. In *The Three Philosophers* (Kunsthistorisches Museum, Vienna; page 100) he makes the close fifteenth-century detail of ledged rock—one ledge in the fore-

right: *Sodoma:* Adoration of the Magi *(detail), c. 1530. Oil on wood; 3.28 m x 2.03 m. Siena, church of Sant' Agostino.*

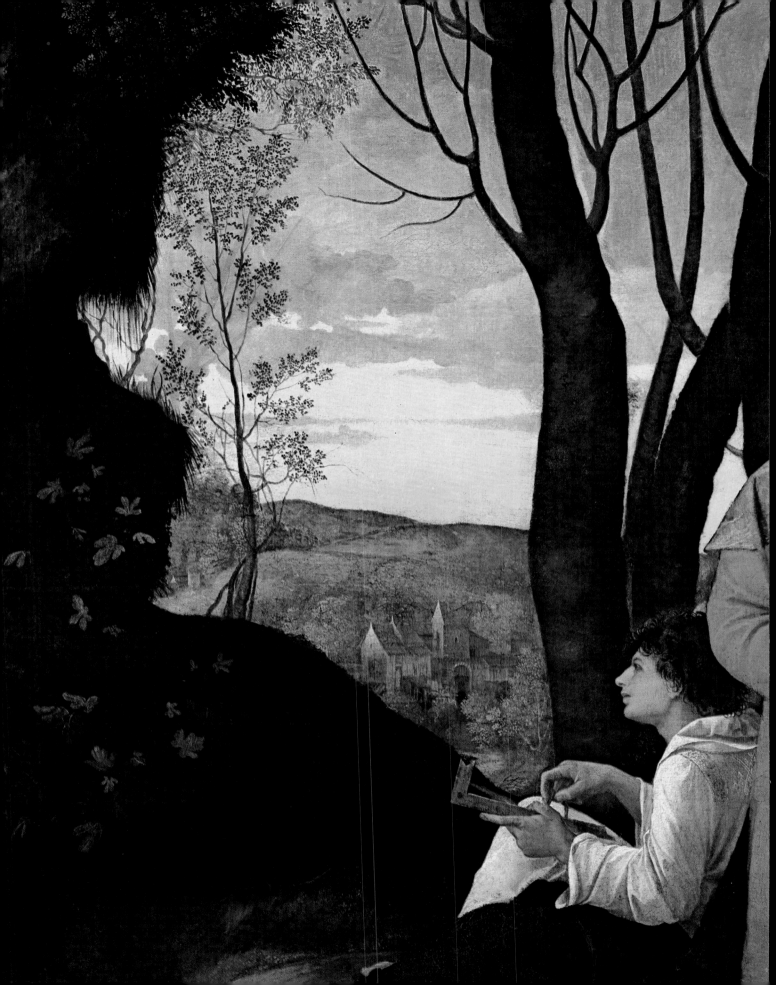

left: *Giorgione:* The Three Philosophers *(detail), 1508–09. Oil on canvas; 1.23 m x 1.44 m. Vienna, Kunsthistorisches Museum.*

above, right: *Titian:* Ruggero and Angelica in a Landscape. *Pen and brown ink; 25 cm x 39.5 cm. Bayonne, Musée Bonnat.*

below, right: *Giulio Campagnola,* Landscape with Two Men in a Wood. *Pen and brown ink; 13.3 cm x 25.7 cm. Paris, Louvre.*

ground lined with pebbles—achieve a miraculous harmony with the shadow of a big grassy mound and trees which lead the eye to a distance of green hills and blue mountains under the faint flush of dawn.

In the engraver Giulio Campagnola the landscapes of Giorgione found a gifted draftsman, who translated their atmospheric values into black and white by means of stippling. He and his pupil Domenico, who took his name, are, however, decidedly more concerned with the minor ups and downs of terrain, and with buildings perched on hilltops, to animate the scene. Under their hands the landscapes become more humanized and in this respect at least resemble Titian's.

The Musée Bonnat at Bayonne has a fine pen-and-ink illustration by Titian of *Ruggero and Angelica in a Landscape,* a subject from Ariosto (page 101). A town on the slopes gives

a sense of depth, and the hill, like the winding valley, the trees and water below, is observed and drawn with the utmost sensitivity. For Lodovico Dolce, writing in 1557, Titian is "nature's equal." The *Dialogo della pittura* speaks of the spontaneity with which he will seize and reproduce reality, especially the most diverse and vivid realities of the perceptible world. And Titian paints nature with such response, with all his heart and senses, that the colours no longer blend, as with Giorgione, into a diffused "atmosphere," but are given their full value, separate, intense, and resonant; the mood of the picture is the sum of their individual contrasts or agreement. The sunsets that illuminate sky and towers in the *Resurrection* in the Church of SS. Nazaro e Celso at Brescia and the *Madonna* in the Ancona Pinacoteca, the tonal variations of trees, meadows, clouds, and water in *Sacred and Pro-*

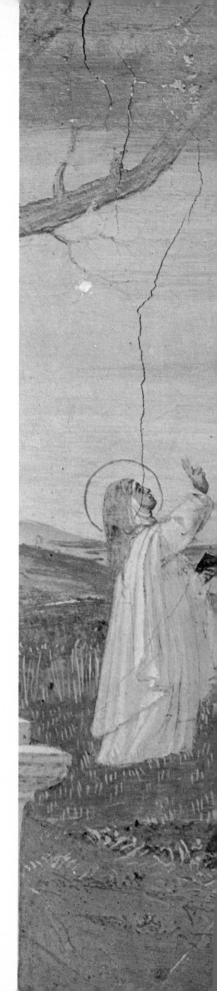

Lorenzo Lotto: Legend of Saint Clare *(detail:* Saint Clare Blessing the Crops), *1524. Fresco. Trescore Balneario, near Bergamo, Suardi Chapel.*

fane Love (circa 1515) in the Borghese Gallery, Rome, are those of a landscape which, instead of washing over the figures as Giorgione's does, grandly complements their proud and dazzling presence.

Lorenzo Lotto's frescoes of Saint Clare, painted in 1524 for the Suardi family chapel in their villa at Trescore Balneario, near Bergamo (pages 102–103), are far from both this chromatic splendour and Giorgione's dreaming poetry. Lotto was influenced by the Lombard naturalism of Foppa, and his landscape passages are direct and charming; they might even be said to have the common touch. Damp green fields, reapers industriously at work, trees with feather heads swaying in the wind make an appropriate and believable background for the miracles of such a practical saint. It is Dosso Dossi, who was not Venetian but Ferrarese, who most successfully combines the poetry of Titian and Giorgione, though his crowded landscapes, thick with trees and set about with architecture, are tinged with romantic fantasy; and their Venetian colouring is heightened, in the words of Giuseppe Mazzariol, by "angry tensions" of atmosphere.

The frescoes in the Villa Barbaro, near Asolo, north of Venice, are inspired by a completely new idea of man's relationship to nature. Illusionist windows and loggias open upon wide, luminous views; since about 1561, when Paolo Veronese painted them, their joyous landscape has invaded the house and the lives of its fortunate inhabitants. The springtime sky usually occupies quite two-thirds of the picture, for Veronese loves huge skies, with billowing or level cloud, above broad peaceful panoramas. Cottages, villa, mills, bridges, and ruins dot the idyllic scenery, all fresh and sparkling in transparent air, and small figures engage in useful, ordinary pursuits. He seems to have employed a quick, "sketchy" style, probably learned from antique frescoes in Rome not long before he executed this amplest of sixteenth-century Venetian landscape schemes. The serenely classical mood suits that lovely Palladian architecture to perfection.

The absolute contrast is Tintoretto. In his pictures there is

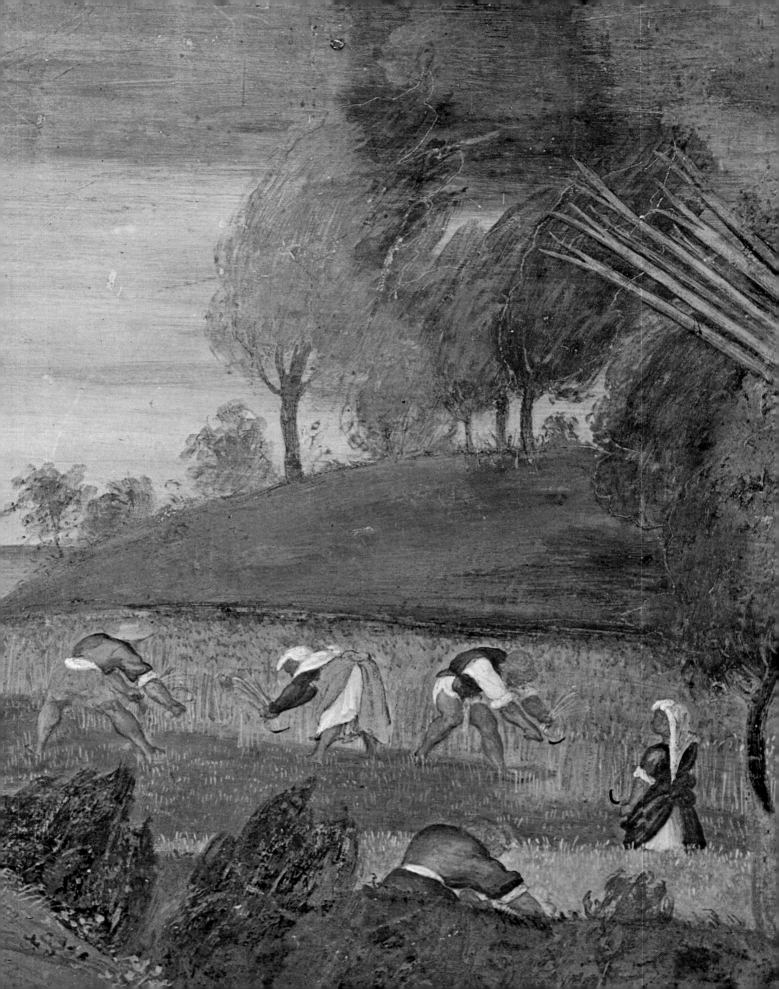

neither serenity nor classicism, but overwhelming Mannerist drama, fire, and darkness, turbulence and spectacle. The three sets of canvases in the Scuola di San Rocco at Venice, painted one set at a time between 1564 and 1587, are the greatest and most consistent ensemble of the kind, and contain his most important landscapes (with the exception of that in *Christ on the Sea of Galilee,* in the National Gallery, Washington, its sky overcast and streaked with light, waves edged with foam as the storm approaches). The San Rocco *Flight into Egypt* is set among tangled undergrowth and arching trees, their highest branches etched against a brilliant moonlit sky. Even more impressive are the two trancelike landscapes in which Saint Mary the Egyptian and Saint Mary Magdalene meditate in solitude. The Magdalene is seen in the dusk, with the last sunset rays striking a huge gnarled tree beside her, but Mary of Egypt sits in the dark (page 108). From some source beyond the picture a thin phosphorescence is cast on trees that might be ghosts in the shape of trees; there is an eerie quivering in the air.

Mannerist landscape, however, has other forms of poetry as well as expressionism and soft Tuscan melancholy. It can be notably elegant, as in the pastorals of Niccolò dell' Abbate, such as the *Orpheus and Eurydice* in the National Gallery. Born in Modena, Niccolò dell' Abbate reflects the influence of Dosso Dossi, Correggio, Parmigianino, and the Flemish painters, but once at least he shows us a country occasion through his own eyes. From 1552 he worked for Henry II at Fontainebleau, where his fresco of *The Winnowers* (page 107) is dominated by an enormous haystack that somehow focuses and intensifies the light of a blazing summer day.

With the *View of Toledo* by Domeniko Theotokopoulos the Greek, in the Metropolitan Musuem, New York (page 109), we come to a picture that lies outside the context of any school or style. El Greco paints as a rule like a more expressionistic and visionary Tintoretto, but this *View* has no peer or parallel, in his time or before or since. A transfiguring imaginative power born, we feel, of inner pain or conflict has heaped the hills of the Tagus gorge into juxtaposed masses, rather than zones, of boldly contrasting colour. The buildings strung along the height are spectral and sinister; the ragged storm cloud surging behind them swells and streams away as if to wrap the whole of Spain in a smoky pall. Yet among this force and frenzy Toledo and its surroundings remain clearly recognizable. No other artist, not even El Greco himself, who produced other remarkable views of the city he had made his home, ever again gave this quality of absolute fantasy to actual landscape. It may be that, at seventy, he was remembering the artistic climate of his native Crete; here, certainly, his art has something of the "unreal" late Byzantine mode.

Albrecht Dürer, with his watercolours of Germany and northern Italy, is the first of the great masters accurately to depict real places on the spot. He does so not to use them as backgrounds for portraits, sacred subjects, or anything else, but to have a record of what he saw and what appealed to him. The landscapes are simply landscapes. Besides Trent and Arco and Innsbruck, his own city of Nuremberg and many more where the scene as a whole interests him more than does any individual building, he includes humbler, unknown localities which he presumably discovered on his travels, and whose beauties are displayed in a vein of such delicate romance, with such an immediate response to nature that we are left marvelling. Dürer was an intellectual prodigy, and it is this deliberate and successful union of northern spirituality with the logic and reason of Italy that makes him one of the most important figures in the art of the Renaissance.

Younger by a few years, Albrecht Altdorfer was another German who painted real landscape. This may be his sole theme, as in the *View of the Danube near Ratisbon,* circa 1525, in the Alte Pinakothek at Munich; or it may outweigh and almost conceal the ostensible subject of a religious picture, as it almost conceals Saint George in a small panel in the same gallery. We really have some difficulty finding him in the thick forest on whose branches we could count the leaves in their Flemish precision and distinctness. Such exaggerated

detail for Altdorfer is a means of immersing, if not losing, himself in nature, and this is a romantic attitude; even, as Roberto Salvini puts it, an excessively romantic attitude. It leads him on to flights of fancy like the cosmic panorama of the Munich *Battle of Issus* (pages 112–113), with lunar mountains, lowering clouds, and blinding light on water. Together with Lucas Cranach, in his youth a painter of fairy-tale land-scapes and later of a series of rousing *Hunts* (page 111), and with Wolf Huber, a founder of the Danube school, which was addicted, as Roberto Longhi said, to forest and full moon, Altdorfer presaged the landscape style of Adam Elsheimer.

Sixteenth-century Flemish landscape begins gloriously with Joachim Patinir and lasts just over a hundred years, to

left: *Tintoretto:* Saint Mary of
Egypt in Meditation, *c. 1585. Oil
on canvas; 4.25 m x 2.11 m.
Venice, Scuola Grande di San
Rocco.*

right: *El Greco:* View of Toledo,
*c. 1595–1600. Oil on canvas; 1.21
m x 1.08 m. New York,
Metropolitan Museum of Art, H.
O. Havemeyer Collection (bequest of
Mrs. H. O. Havemeyer, 1929).*

below: *Lucas Cranach the Elder:* Stag Hunt of the Prince-Elector Frederick the Wise, *1529. Oil on wood; 80 cm x 114 cm. Vienna, Kunsthistorisches Museum.*

the ultra-refinement of Jan Bruegel the Elder. Saints are often very small indeed in Patinir's sacred pictures, the saints a mere pretext for the setting. His landscapes in fact resemble those of his contemporary Bosch, though his space is deeper and more unified, with colour transitions from plane to plane that give the sense of luminous width and distance, and harmonious and poetical atmospheric effects producing the same result.

Pieter Bruegel the Elder, too, owed a debt to Bosch. The influences on Bruegel and the story of his development are complex to a degree, but he is without doubt the greatest Flemish painter of the period, combining Italian *maniera,* "stylishness," with Netherlands realism. His fondness for and skill in painting popular and rural life earned him the title Peasant Bruegel. This has a cheerful ring, though in fact the pictures more often reveal a seriousness born of settled pessimism. He sees humanity as ruled and ensnared by folly, vice, and evil, and sets against these things the purity of nature and the innocence of country occupations. In his later years especially he dwells on the serener vision. The five surviving panels of the *Months,* now distributed among the museums of Vienna, Prague, and New York, date from 1565, not long before his death: northern landscapes, described in their changes of weather and season by a poet who understands them. No one else of that time could evoke as Bruegel does the solemn quiet of miles of white land, with dark shapes of men and hunting dogs against the snow (pages 116–117), or

above: *Albrecht Dürer:* Pond in a Wood, *c. 1495–97. Watercolour and gouache; 26.2 cm x 37.4 cm. London, British Museum.*

following pages: *Albrecht Altdorfer:* The Battle of Issus *(detail), 1529. On limewood; 1.58 m x 1.2 m. Munich, Alte Pinakothek.*

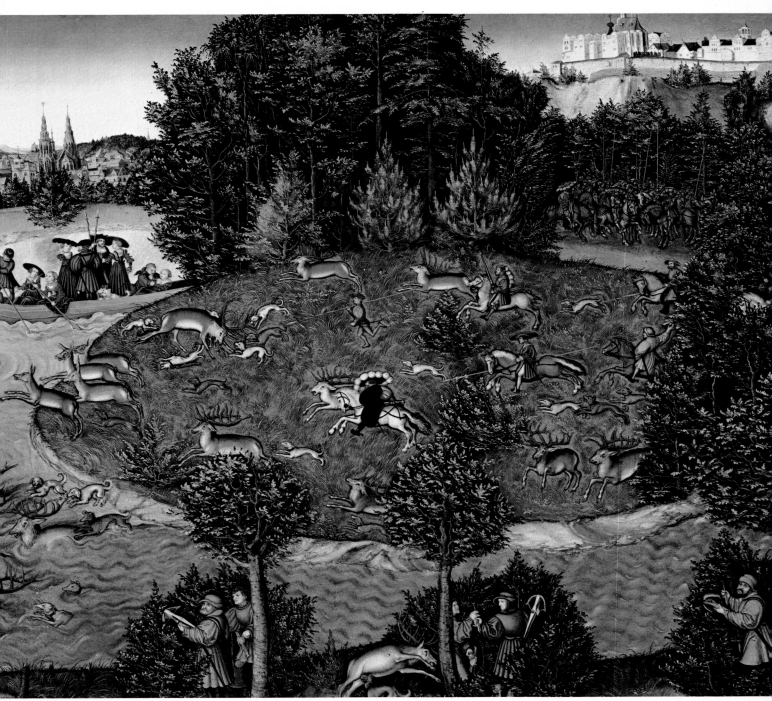

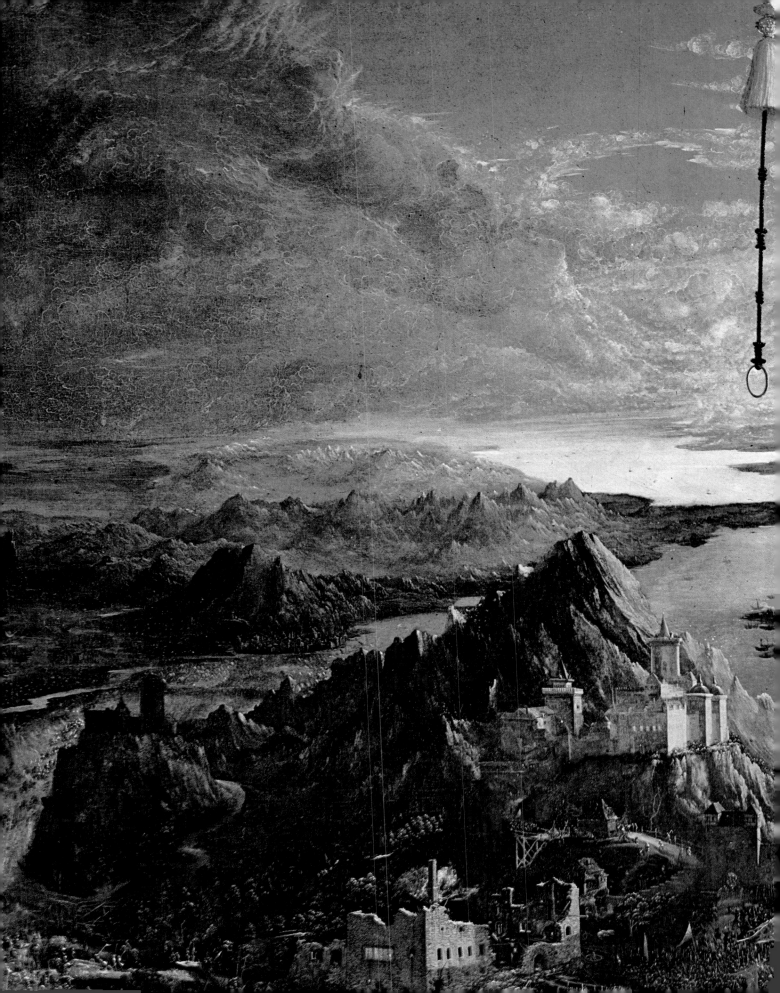

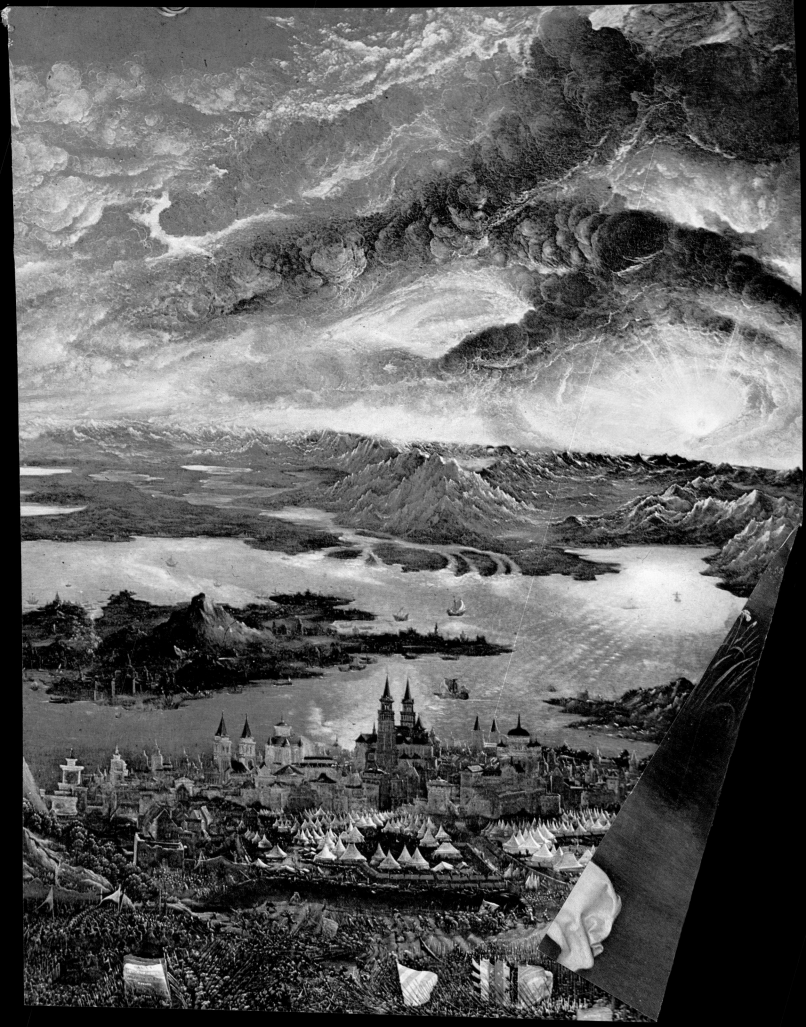

left: *Joachim Patinir:* Baptism of Christ *(detail), c. 1515. Oil on oak panel; 60 cm x 76.5 cm. Vienna, Kunsthistorisches Museum.*

right: *Cornelis Engelbrechtzen:* The Healing of Naaman (detail). *Vienna, Kunsthistorisches Museum.*

following pages: *Pieter Bruegel the Elder:* Hunters in the Snow *(detail), 1565. Oil on wood; 1.17 m x 1.62 m. Vienna, Kunsthistorisches Museum. Believed to be* December *or* January *from a series of the* Months.

the consuming melancholy of a sunless day in summer; he conveys the mirth of the fields at haytime and harvest, the Virgilian peace of the hour when herds come back from pasture.

Pieter Bruegel founded a dynasty of painters active through several generations, into the seventeenth century,

foremost among them being his son Jan the Elder, known as Flower or Velvet Bruegel. Jan's landscapes, frequently a part of thronged and subtle allegories, are more fantastic than his father's. The colours, too, are richer and more sumptuous, for until he died in the 1620's he was the friend and collaborator of Rubens.

right: *Jan Bruegel the Elder:* Sodom and Gomorrah. *Oil on copper; 26 cm x 35.2 cm.*

THE IDEA OF NATURE
The Seventeenth and Eighteenth Centuries

Caravaggio's *Basket of Fruit* in the Galleria Ambrosiana, Milan, may not be the first still life ever painted, but with it he launched a genre that was to prove enduringly popular from the seventeenth century onwards. Though always regarded as having brought new realism to European art, Caravaggio, however, took little interest in landscape. Clearly he must have thought it a distracting element with no place in his revolutionary style, which is an affair of light and volume in monumental synthesis, and great shapes emerging out of shadow. His occasional foreshortened landscapes are youthful work and recall the Lombardo-Venetian influences of his early years. The finest is that in the charming *Rest on the Flight into Egypt* in the Galleria Doria-Pamphili, Rome. There is a hint of Lotto in the contiguous zones of pale green and ocher, while the small, detailed plants along the base line bring to mind what Giovanni Pietro Bellori wrote in 1672 of the "well-imitated fruit and flowers" the artist was "employed to paint" in the Roman studio of the Cavaliere d'Arpino.

For naturalism in seventeenth-century landscape, then, we must look elsewhere, to the provincial centers of Italy. Not that "provincial" in this connection implies backwardness or cultural isolation, as a visit to the gallery at Cento will show. Here, transferred to canvas, are frescoes painted by the young Guercino in Casa Pannini (page 122). They date from 1615, before he left his native town for Venice and then Bologna, where his art was to mature in direct and deeper contact with the Carracci—Lodovico especially—and Guido Reni. In the frescoes, poetical as they are, the Venetian-Ferrarese flavour of Dosso Dossi is transposed into a realistic and even homely key; we see a hunter aiming at a duck, peasants dressing hemp, an old jaded horse out at grass. They are fresh and

That perfect and eternal mind made the first forms, that we call Ideas. Noble painters and sculptors, imitating the first great Creator, also make a mental image of supreme beauty and, with this before them, they improve on nature. This Idea, springing from nature, surpasses its original.

—Giovanni Pietro Bellori, in Vite dei pittori, scultori ed architetti moderni, *1672*

Velázquez: Garden of the Villa Medici: Entrance to the Grotto, *c. 1630. Oil on canvas; 48 cm x 42 cm. Madrid, Prado.*

below: *Guercino:* Landscape with River and Two Boats, *c. 1615.* *Fresco transferred to canvas;* *0.72 m x 1.09 m. Cento, Pinacoteca* *Civica (from the Casa Pannini,* *Cento).*

right: *Tanzio da Varallo:* Saint Benedict in the Thicket of Brambles *(detail). Oil on canvas;* *0.89 m x 1.14 m. Busto Arsizio,* *private collection.*

inventive, and far indeed from the classical shepherds and romantic atmosphere of *Et in Arcadia Ego,* now in the Palazzo Corsini, Rome. Yet this was painted scarcely three years later, and by 1621 he had created the *Aurora* ceiling in the Casino Ludovisi on the Pincio, and a small anteroom full of learned mythological allusions. Cultivated taste was changing, and Guercino's response was anything but sluggish.

Less famous is the Piedmontese Antonio d'Enrico, or Tanzio da Varallo. He is believed to have visited Rome as a young man, but otherwise seems to have lived and worked in a world of his own. The landscape of his *Saint Benedict in the Thicket of Brambles* (page 123; the picture is in a private collection at Busto Arsizio, near Milan) is an essay in dramatic realism. To illustrate a typically northern medieval legend of saintly asceticism, his style, usually a distinctive, not to say showy, version of Caravaggio, turns much harsher. The scene breathes the black penitential spirit of the Counter-Reformation so often found in the Lombard artists (Giovanni Battista Crespi, known as Il Cerano, foremost among them) who were his contemporaries and almost his neighbours.

Caravaggian naturalism did not lack followers in France; and though Caravaggio himself neither had nor could have much effect on landscape painting, it was a follower who

produced the greatest realistic landscapes of the period. Louis Le Nain, though spending nearly all his life in close working partnership with his painter brothers in Paris, was as much of a lone wolf as Tanzio. Pictures like his *Halte du Cavalier* in the Victoria and Albert Museum, or the two canvases of *Peasants in a Landscape* in the Kress Collection at Washington (pages 124–125) and the Wadsworth Atheneum, are memorable not only for the feeling of equality with which he treats such humble folk, for this is customary with him, but for their wide, elegiac landscape. The far views of field and wood and pasture land, scattered with a few small huts, are suffused with the sadness that Corot, too, could capture.

But a new kind of landscape originated in Rome and Bologna in the seventeenth century, closely connected with the aesthetic of classicism and of the ideal promulgated by the Bolognese prelate Cardinal Giovanni Battista Agucchi, secretary of state to Pope Gregory XV, and by Bellori. The latter, art theorist and antiquarian and, incidentally, Queen Christina of Sweden's librarian in Rome, read his celebrated paper entitled "Idea" to the Academy of St. Luke in 1664. He and the cardinal opposed both Late Mannerist formalism and Caravaggesque naturalism and, naturally, the Baroque. Classical landscape was based on a conception of nature as the fount of ideal beauty and of poetry reflecting the emotions and actions of men, and its perfection was reached with Poussin and Claude Lorrain. The century paid more and more attention to landscape, which became an independent and specialized art, as it is to our own day; and this was partly because the old Renaissance brand of inspiration was losing ground. To the Renaissance, inspiration was something that involved every human faculty, combining spirit and senses, faith and reason, fact and fancy. For three hundred years, from Giotto to Tintoretto, from the Van Eycks to Bruegel, it had been the root of, or the necessary condition for, all artistic achievement. The plastic arts had scaled heights, religious and secular, unthought of in previous ages; there seemed nothing they could not express. But now this

Louis Le Nain: Peasants in a Landscape, c. 1640. *Oil on canvas; 46 cm x 57 cm. Washington, National Gallery of Art, Samuel H. Kress Collection.*

Guido Reni: Aurora *(detail),*
1612–14. Fresco; 2.80 m x 7 m.
Rome, Casino Rospigliosi-
Pallavicini.

marvellous unity began to splinter, its components were seen as separate things, and a whole new range of distinct subjects appeared, including still life and genre as well as landscape painting. Artists were thus increasingly aware of the gulf between sacred and profane, and there was a sharpening of the critical sense with which they reviewed the near and distant past. As critics, however, instead of writing instructive handbooks as Cennini did, or probing the theory and rules of perspective to improve their grasp of reality, the artists of the seventeenth century—or at any rate the painters—were apt to set themselves up as litterateurs or history experts. A sonnet sequence by Agostino Carracci, Annibale's elder brother, written under the pseudonym *il buon pittore* (the good painter), is the most noteworthy example of this sort of thing. It is also the most absurd.

But the painters, fortunately, happened to be better painters than theorists, actual or reputed, and the real poetry in the work of the Carracci is there to prove the point. Annibale, Agostino, and their cousin Lodovico had come from Bologna, where their Accademia degli Incamminati ("those who were on the way") was founded in the 1580's. In the decline of Late Mannerism they urged a reconsideration of the great "classical" style handed down from Raphael to Correggio and Titian, not as an anachronistic and servile return to the past, but as an active source of inspiration. It was to arise from true and fervent devotion to the sixteenth-century titans, even at their most tortuously intellectual, and to indicate new horizons, new references, and new poetic values in Nature herself. These things exist in the painting of Annibale above all. He was the youngest of the three, and his are the first "classical landscapes" in Europe. His lovely *Landscape* painted circa 1589–90, now in the National Gallery, Washington (pages 126–127), is already moving in this direction, for the influence of Titian and Veronese is supplemented by the direct observation of nature, whose wildest aspects have, or have been given, an inner harmony of colour, form, and light that transmutes them to pure beauty. The supreme

example comes a few years after this, in about 1604, with *The Flight into Egypt,* a lunette originally in the chapel of the Aldobrandini palace and now in the Galleria Doria-Pamphili. In an atmosphere of vague melancholy the most evocative elements of Campagna scenery are assembled in an impeccable balance of the real and the imaginary—big trees and quiet water, mountains in the distance and a castle above a wooded ravine in the middle of the picture.

Domenico Zampieri, or Domenichino, also uses the Campagna, not only for straightforward landscape, but as the setting for religious subjects, scenes from Tasso's *Gerusalemme liberata,* and from mythology, as in two magnificent *Labours of Hercules* in the Louvre, painted in 1620–22 for Cardinal Ludovisi. He has an elegance and restraint that come of his simple yet lucid admiration for Raphael, together with the neo-Venetian brilliance acquired as a pupil of the Carracci. Domenichino's later work is conceived more definitely in landscape terms, with rocks and trees to frame the composi-

tion and small figures enlarged, as Bellori put it, *heroicamente per l'arte.* Thus was coined the useful phrase "heroic landscape." In heroic landscape high and noble episodes of myth or history were shown with "resonance" and *decoro,* another of Bellori's favourite words. Contemporary critics, such as Roger de Piles in France, would distinguish between heroic and rustic or pastoral landscape, but in fact they differ very little. Francesco Albani, for instance, who was also from Bologna and established in Rome, has classical amorini disporting beneath huge oak groves against impressive mountain backgrounds, and anticipates the Arcadian mode so popular with French and Italians at the end of that century and the beginning of the next.

The fourth Bolognese master among the Romans was Guido Reni. His models, adhered to with uncompromising rigour, were antique sculpture and Raphael, and he paints no landscape unless absolutely necessary. The rosy-purple clouds before Apollo's chariot in his *Aurora* ceiling at the Casino Rospigliosi (pages 128–129) are less real than the divinities. They make no reflection on the still blue sea; the solitary coast with its castled rocks is quite unshadowed by them; and the landscape is so formalized as almost to cease to be a landscape.

Seventeenth-century classicism comes to its zenith with Nicolas Poussin, who, though perhaps the greatest French painter of his time, must be thought of as Italian. He was thirty, and already an admirer of Italian works seen in the French royal collections, when he arrived in Rome in 1624, and he seldom left it, dying there in 1665. Like Raphael before him, he sums up and illuminates the poetic principles of an epoch—always excepting those of Caravaggio (whose influence he deplored). Like all his painting, the numerous landscapes and landscape backgrounds spring from a miraculous union of instinct and reason; of his own penetrating and impassioned way of looking at nature and pruning it of what he does not need; with the warm Venetian colouring

learned from Titian and the clarity of Bellini and Raphael. Having selected and simplified, he rearranges nature almost as severely and mathematically as if he were a fifteenth-century Tuscan laying out perspective. His landscapes are deeply considered. There is literature and history and archaeology in them—as in the two Phocion pictures, the *Funeral* and the *Gathering of the Ashes*—and it is doubtful whether he portrays one real or identifiable place, even as a detail. Yet who, before or since, ever painted the Campagna as he does, secret and enchanted, with its austere outlines and its thousand years of history? Seen through spreading trees and rolling away to his exactly calculated distances, it is most glorious in his *Four Seasons* in the Louvre. These are Poussin's final masterpieces, executed for Cardinal Richelieu between 1660 and 1664. Together they constitute a magnificent poem in praise of nature and epitomize his landscape painting. We catch Virgilian overtones from the *Georgics;* and we are reminded of Milton's *Paradise Lost,* which was to appear in 1668. There are luminous open skies, and leaden skies with lightning and faint sunshine; skies piled with soft white clouds, or veiled in thin mist. Trees and plants, altering through the year, bring the whole earth into his chosen themes: Eden for spring, Ruth and Boaz for summer (pages 132–133), spies bringing grapes from the promised land in autumn, and the winter Flood. All are taken from the Bible, and imbued with profound religious feeling.

Claude Gelée shares with Poussin the mastery of classical landscape in the seventeenth century. Like Poussin, he was a Roman by choice and, even more than he, by education. Coming as a poor boy from his native Lorraine—he is always known as "the Lorrainer," Claude Lorrain—he was a pupil, then assistant, of the landscapist Augustino Tassi, who gave him a liking for the analytical realism of Brill and Elsheimer and others of his friends among the "naturalistic" northerners in Rome. The essence of Claude is nowhere better examined than by Filippo Baldinucci in a collection of artists' biographies published in 1728. He calls him an *Artefice,* and

singles out his "marvellous and never-equalled imitation of all sorts of conditions of nature, such as views of the sun, especially over the sea and on rivers at its rising and setting; and we have things of this kind from his hand which are unimaginable and indescribable." The colour of the sea is always right, and his greatest gift is the ability to vary it "according to his many very excellent observations of the changes of air and light." Certainly he dazzles us by the skill of his effects, and the sun is the chief element in his pictures.

He was a simple soul, with a deep, simple love of nature, poles apart from Poussin, who was so erudite and a prey to so much inner conflict. (The two either never met or pretended each in turn that they were unacquainted.) He was particularly fond of the Roman Campagna, working out of doors to record it in surprisingly modern drawings and watercolours. From these he made set compositions in the studio, frequently on a slightly conventional pattern, used again and again; and he constructed the landscapes by geometry, to idealize them. The Carracci and Domenichino had done the same thing, and it was Poussin's method, too, though Claude alone occasionally left the figures to other people. It was a highly intellectual procedure, the outcome of superb technique and dedicated professionalism, and the wonder is that it not only fails to blunt the feeling for nature, but itself bestows the unmistakable stamp of poetry. Without the noble buildings in accurate perspective, and the towering rocks and trees like the wings and proscenium of an ideal stage; without the rippling, wet, real sea, illimitable pastures and wide skies bronzed by Roman sunsets, these landscapes might still be "heroic," but something of the magic would be lost, and with it the invitation to dream. That invitation reaches us more often from Claude than from Poussin: in the act of painting classical landscape he has made art's earliest romantic communication.

Another great landscapist of French origin in seventeenth-century Rome was Gaspard Dughet. He was Roman born, son of a French pastry cook, and his sister married Poussin,

left: *Claude Lorrain:* View, at Evening, over the Tiber from the Monte Mario, *c. 1640. Watercolour and dark-brown gouache; 18.5 cm x 26.8 cm. London, British Museum.*

who had lodged with the family. Gaspard became his brother-in-law's pupil and was indeed known as Gaspard Poussin; and though this was to injure his critical reputation–in 1688 Félibien, the French architect and historian, referred to his pictures as "crumbs from Poussin's table"–it did no harm with exalted clients such as the king of Spain. His style was in fact a successful blend of that of Poussin with the golden glow of Claude Lorrain, and his huge frescoes and canvases were the first monumental landscapes. A love of sport had led to love of the lonely places where he went after game; not smooth, flat country, but great forest crags and awesome gorges, to which he would add the extra drama of storm-laden skies (pages 136–137). As Francesco Arcangeli remarked, Dughet and his harquebus "must have shattered the peace of the most sacred and least visited beauty spots in Italy." Yet he saw the Campagna as a grave and heroic region, and was particularly fond of Tivoli on its thickly wooded hill, with the waterfalls crashing down the slopes.

In contrast to his colossal works are the tiny paintings of Adam Elsheimer. Somewhat Flemish, in a miniaturelike technique, these seldom measure more than forty centimeters (sixteen inches) across, but the composition is broad and ample. Elsheimer came from Frankfurt and most of his few pictures belong to the last ten years of his life, spent in Rome, where he died in 1610 at the age of thirty-two. This northern realist, with his dash of the romantic, had encountered the classicism of the Carracci in Rome, and had been one of the first to adopt Caravaggio's treatment of light. Yet

right: *Claude Lorrain:* Seascape, *1674. Oil on canvas; 73 cm x 97 cm. Munich, Alte Pinakothek.*

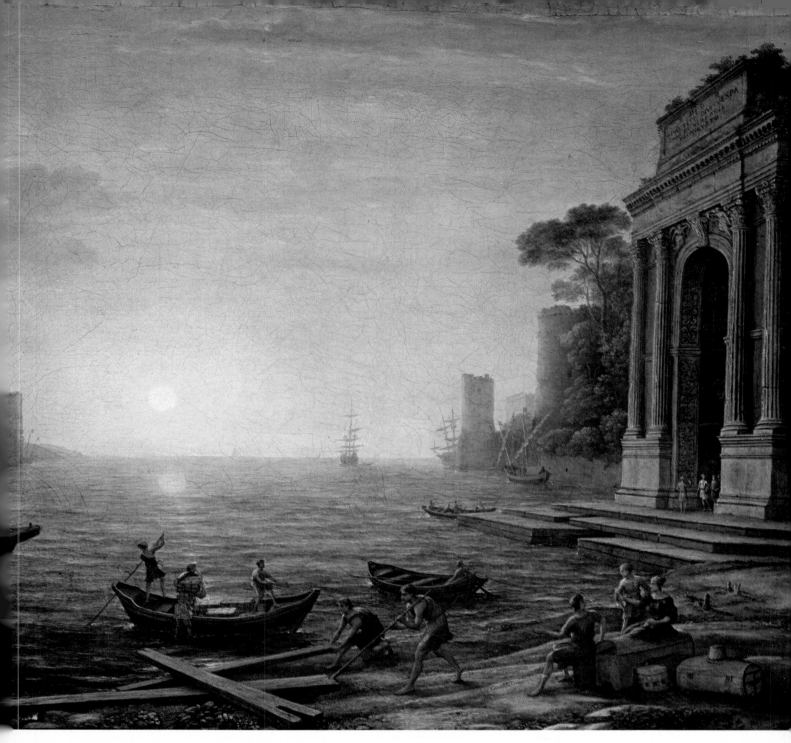

the style he formed is entirely personal, based on strong chiaroscuro; shapes are weirdly illuminated, bonfires blaze in the night. The famous *Flight into Egypt* in the Alte Pinakothek, Munich (page 137), with a moon rising over an inky mass of trees and mirrored in grey water, was itself to influence many of his contemporaries, including the *Caravaggisti* Carlo Saraceni and Domenico Fetti. And not Italians only; it even influenced Rembrandt and Rubens.

Stylistic give-and-take was nothing unusual among the foreign artists, and probably involved Poussin and Claude Lorrain as well as Elsheimer. The senior member of the colony, Paul Brill, born in Antwerp in 1554, was six years older than Annibale Carracci. He had come to Rome in 1582 or so, which meant that he discovered Annibale's poetic classicism in his maturity, and was favoured by the Vatican and in demand as a painter of frescoes, often with landscape, for churches and palaces. His early landscapes are obviously Flemish and Mannerist, though they have the Italianate flavour typical of Antwerp. In Rome they become altogether more spacious, particularly when their subject is the Campagna and its decorative ruins.

Northern artists, indeed, descended in shoals on Rome.

below: *Gaspard Dughet:* The Hurricane, *c. 1645–50. Oil on canvas; 49 cm x 66 cm. Madrid, Prado.*

right: *Adam Elsheimer:* Flight into Egypt, *1609. Oil on copper; 31 cm x 41 cm. Munich, Alte Pinakothek.*

on page 138: *Salvator Rosa:* Grotto with Waterfall. *Oil on canvas; 65 cm x 49 cm. Florence, Galleria Pitti.*

on page 139: *Bartolomé Estéban Murillo:* Landscape. *Oil on canvas; 1.94 m x 1.30 m. Madrid, Prado. Probably a* Flight into Egypt.

They came in ever-increasing numbers from the Netherlands and Germany, attracted by the prestige of the Eternal City and the wealth of her nobles and prelates, for there were more enthusiastic collectors there than anywhere else, and pictures could be sold. Not all the incomers were from the north, however. From 1635 onwards Salvator Rosa joined them, first at intervals, then permanently—a Neapolitan of extravagant personality, all brilliance and high spirits, painter, satirical poet, and ardent controversialist. His painting is not easy to assess, for it reflects his restless tempera-

ment, even his landscape veering from the realistic to the classical. The scenery that most appealed to him was perhaps the rocky, forest sort that appealed to Dughet, untrodden and abrupt, and he would enhance it with strange theatrical rock formations, mountains honeycombed with fearful caves, trees writhing on the cliff tops, and other startling or fantastic features. In the seascapes and harbour scenes of 1640–49, when he was in Florence, ruined towers and temples are invariably silhouetted, as are his lighthouses, against the sunset. These works, clearly influenced by Claude Lorrain, just as

Bautista Mayno was born in 1578, probably near Milan, and there is proof of his presence in Toledo by 1611. Two years afterwards he became a Dominican monk there, and was famous enough to be mentioned by Lope de Vega. A follower of Annibale Carracci, Mayno was also influenced by Caravaggio and by Caravaggio's Pisan disciple, Orazio Gentileschi. Yet one of his best-known pictures, painted for a series to commemorate the victories of the reign of Philip IV, is thoroughly Mannerist. It shows the battle of 1625 in Bahia in Brazil, with ships near the town and others lying in rows off the far shore in the background.

Even for Velázquez, the supreme master, landscape is little more than subsidiary, mere visual exposition in the historical scenes demanded by Philip and his court–the state entry into Pamplona, or *The Surrender of Breda,* another of the victory series. The Prado *View of Saragossa,* of 1647, bears the signature of his uninspired son-in-law Juan Bautista del Mazo, though he himself may have put in the foreground figures. It is the more surprising, then, to find, also in the Prado, studies of two secluded corners of the Villa Medici gardens, *Entrance to the Grotto* (page 120) and *The Pavilion of Ariadne.* Made during his visit to Rome in 1630, they are as untypical of a court painter as of contemporary taste in general, and show an astonishing freedom. The thick stately cypresses must be the first "real" cypresses ever pictured; those of the fifteenth-century Tuscans are trim ciphers beside them. Where almost anyone but Velázquez would have given us a collection of detail, these branches, light and shadow, are rendered in broad synthesized brushstrokes, with touches of impasto. And though it is seldom a good idea to base art criticism on supposed connections with some much later style of fashion, I think we may legitimately see in these small landscapes the *plein air* spirit of Impressionism, and to do so will add to our enjoyment of them.

Like Velázquez, Bartolomé Estéban Murillo painted very few landscapes, but when he does so, they, and his genre passages, are often more attractive than the religious pictures. A presumed *Flight into Egypt* in the Prado (page 139) has a rocky gorge–rather a Dughet or Salvator Rosa gorge–its

clearly anticipate the "picturesque" of the Romantic movement.

More realistic are the landscapes of another Neapolitan, Micco Spadaro, or Domenico Gargiulo. He, too, painted seascapes, but his chosen subjects are historical events dramatically portrayed, in careful settings with remarkably subtle effects of tone and atmosphere.

Spain, with all her great artists, had no important landscape tradition, and in the seventeenth century the best painting of the kind is that of an Italian working in Toledo. Juan

wildness softened by small huts and minor domestic incidents. The peasant cabins, the woman feeding chickens, are the kind of thing Murillo paints with unequalled tenderness and insight.

Among "non-Romanized" Flemish artists, landscape in the early seventeenth century developed in the northern style that began with Patinir a hundred years before and continued with Pieter Bruegel the Elder; Joost de Momper of Antwerp (1564–1635) definitely looks back to them, and may claim to be the leading landscapist of his time. We do not know whether he visited Italy, but he specialized in mountains. His scenes are populated by lively small figures of hunters, peasants, and travellers, as in *The Boar Hunt* in the Rijksmuseum, Amsterdam (pages 140–141), and the *Winter Landscape* of 1644 in the Gemäldegalerie in Dresden, with the fallen horse and the cart turned upside down; or they are full of bridges, houses, straggling villages on narrow spits of land mirrored in lakes or rivers, or with pointed steeples glimpsed among the trees. His distances are very blue, dissolving away from the sharp foregrounds.

But Rubens (1577–1640) was creating a new sort of landscape during the years of Momper's activity. If the now hackneyed term "Baroque" retains any valid meaning, then the landscapes of Rubens are Baroque. Despite differences that mark the stages of his stylistic and intellectual progress, they all have the same flowing brushwork and opulent colour. Vitality erupts from every element and inch of them, transmitted to the spectator in a current of energy and excitement. Nature, calm and splendid or grimly dramatic, is always a spectacle for Rubens. He is fascinated by whatever he paints: a rainbow rising from a thundercloud and melting into the bright sky, or a terrific storm (page 142), or the lovely garden of his Antwerp house in the self-portrait with his young wife Helen Fourment, where the petals of the tulips under the tall trees shine and crackle like little flames. His last, rural and pastoral, subjects have the same scenic quality. The road, or cattle track, that slants across the *Peasants Returning from the Fields* in the Pitti Palace, Florence,

seems to pull the slow flock with it, the cart and the laden women, and the high wind-driven clouds echo its movement overhead.

In Holland, independent of Catholic Flanders since 1588, landscape painting was sufficiently important to rank as a separate branch of art. Hendrik Avercamp (1585–1634) is, indeed, still Flemish. He fills his pictures with people, in the manner of Bruegel; they fish and skate by streams, on levees or frozen rivers in clear winter light, with notes of blue and red (pages 144–145). But in the 1610's and '20's the Flemish tradition gives way to a new, Dutch style with Hercules Seghers of Haarlem (circa 1590–1638). Seghers was a gifted engraver as well as a painter, and his etchings, vivid and realistic, are of strange, mesmeric landscapes and empty lowlands, executed in a fine mesh of lines, the technique he learned from German models. On canvas, too, it is pictorially effective and vigorous; he likes chiaroscuro and monochrome, and golden light against a dull ground. If there can be such a thing as imaginative realism, it exists in these curiously credible conjunctions of Alpine mountains and flat Dutch panoramas. His is a fantastic world, expressing an eccentric and tormented personality, yet with a magical light that evidently appealed to Rembrandt, who owned eight pictures by Seghers.

Working from nature, Rembrandt made drawings and etchings of views around Amsterdam recognizable in their fidelity; it is in his few, and magnificent, landscapes in oils that the supreme genius of the Dutch school rearranges nature drastically. Trees are loftier, or appear to be so, horizons are farther; there are more lowering clouds in the sky, more tempests threaten. All nature, at least in the pictures of the 1630's, seems to emit a mysterious force, as does the fluid "ferment" of the paint itself. The composition is broad and sweeping. Shining distance and foreground darkness are marvellously linked together and every detail is permeated with an inner unrest that, as it were, unifies the whole of creation. This is less marked in the more somber, spreading landscapes after 1640, though we see the same sudden shafts and

tremulous gleams of light, like the halos of his saints and angels.

In Rembrandt's lifetime Jan van Goyen (1596–1656) was discovering that most characteristic beauty of his native country, the breadth of sky over the flat land, the low horizon hardly broken by the slight lift of the dunes. His clouds swim reflected in calm sea or the rivers on whose banks the water-cities stand. There are big churches, towers and pointed belfries, and occasional windmills. It is all vast and open, in cold light under a high northern sky. Even some quite dramatic feature in the foreground, such as the two snapped-off oaks in a landscape of 1641 in the Rijksmuseum at Amsterdam (page 147), serves only to accentuate the peace of the vista beyond.

The most celebrated and versatile of the Dutch landscapists is Jacob van Ruisdael (1628–82), surpassing his uncle Salomon (1600–70), who taught him. (Salomon's work, though more colourful, resembles that of a Van Goyen.) Jacob has no need to select this or that aspect when painting Nature, for he is endowed with the keenest and most truthful understanding of her every aspect. He understands a tumbling waterfall, the hidden marsh in a dark wood, the silver, quiet pond. He studied the structure of trees, from ancient oaks to the frailest bushes beneath them. He knew about open meadows and fields and the sand dunes of the coast, about stormy skies and the haziest soft mist; he paints these things with a lyrical strength, a thoughtful melancholy, so that nothing in his pictures is mere agreeable description. The solitude in them can be frightening; man, when present, is small and weak in the face of nature. The feeling evoked is related to religious awe, and assured the artist's fame, not only among the painters, but with the poets and writers of the Romantic era, from Goethe onwards.

The landscapes of Aert van der Neer of Amsterdam (1603–77) have no such spiritual content. With Ruisdael we could be at any hour of the day or season of the year, in a timeless, unifying light that scarcely changes. But Van der Neer is a

below: *Rembrandt:* The Stone
Bridge, *c. 1638. Oil on wood; 29.5
cm x 42.5 cm. Amsterdam,
Rijksmuseum.*

above, right: *Rembrandt:* The Three Trees, *1643. Etching; 21.1 cm x 28 cm. Dresden, Staatliche Kunstsammlungen.*

below, right: *Jan van Goyen:* Landscape with Two Oak Trees, *1641. Oil on canvas; 0.88 m x 1.10 m. Amsterdam, Rijksmuseum.*

narrative realist—we might almost say a climatic realist—who recounts the ordinary life of town and country as dictated by the weather. For him, as for his fellow townsman Avercamp, a hard frost means that people are skating, sledging, fishing through holes in the ice, and taking brisk walks. He crowds them into the snow beyond the walls or disperses them over the frozen outskirts, diminishing their size as they stray into the white scenery. To this clarity he adds a delicate and near-romantic appreciation of light, with a preference for sunset effects, and for a full moon more than anything. Though he did not actually invent the genre, his moonlit pictures are the most interesting in Dutch art.

Philips de Koninck (1619–88) is a painter who adopts the high viewpoint so well suited to the wide level landscape of Holland, intersected by mazy canals and roads and almost unrelievedly horizontal. Meindert Hobbema (1638–1709), Ruisdael's pupil, tends to concentrate on a few favourite motifs, in or near the foreground, rendered with loving detail. His minute realism takes us into nooks and crannies of the countryside and can attain a true and gentle poetry, as it does in the Amsterdam *Water Mill*. His masterpiece is *Ave-*

nue, Middelharnis, in the National Gallery (pages 152–153), with the double row of soaring poplars running straight down the middle of the picture. For the dense trees and rugged outcrops on which Ruisdael builds his powerful compositions is substituted a vibrant linear pattern of stripped thin trunks against the sky, balanced by field hedges and diked canals.

These three, Van der Neer, Hobbema, and De Koninck, were painters of the highest professional achievement, yet none of them could earn a living entirely by his art. The first was an innkeeper, the second employed as a wine gauger in the Customs Department at Amsterdam, and the third operated a profitable ferry service between that city and Rotterdam: facts that make a sad commentary on the kind of society they worked for.

We come now to the quite exceptional case of a landscape painter who produced only one landscape, and that one more properly a townscape. Jan Vermeer (1632–75) was rediscovered, largely thanks to the efforts of a French lawyer and political journalist named Thoré, after two hundred years' neglect, and since then *View of Delft* has intoxicated artists,

Hercules Seghers: Rocky Landscape. *Oil on canvas; 55 cm x 99 cm. Florence, Uffizi.*

critics, poets, and writers. For Proust it was "the most beautiful picture in the world." Certainly, finding ourselves in the small room in the Mauritshuis at The Hague, we are inclined to agree with him, even as we wonder just what it is that keeps us rooted there. A square yard or thereabouts of painted canvas—and where is the fascination? In Delft, more real than the real thing? For we are invited, or enforced, to explore that surface inch by inch and savour every detail, a thing we cannot do with actual landscape; and this without losing our sense of the whole, such is the wonderful, all-pervading harmony. Or is it the light? In a spellbound, transparent air the old ramparts are mirrored, deep and dark, in tranquil water. Tranquil, but not motionless; the water breathes. Roofs and belfries cast chill shadows to the left. Behind, on the right, the houses and the tower of the New Church are warm and golden in summer evening sun. It is ten past seven by the clock over the Schiedam gate, and the glow is that of the long sunsets of the north. Van Gogh, seeing the *View* from close up, said, "You can hardly believe your eyes, for the colours are nothing like those you saw at a distance." So, is it the colour? The paint seems to be fused and blended, but is in infinite microscopic touches, tiny iridescent pearls, or drops of dew; the black hulk of the barge on the right is dank and moist with them. Or perhaps it is the soundless solitude. A strip of land in the foreground shows the narrow canal to be impassable. We can never get to the place on the other bank, with streets and waterways and gardens lying beyond the walls. In there, somewhere, must be the street that Vermeer also painted, but we should have to find it in the museum at Amsterdam. Here we are left outside, on a shore made to seem more deserted by the six small chattering figures, for not an echo comes to us from the shut-in town. Nothing reaches across save an image of the great fortified gates, faltering on the water. Roberto Longhi is right to call this "the still life of a city."

After the country, the sea was a constant theme of Dutch artists. A distant presence in several of the pictures we have mentioned, it becomes the main subject with those of Jan Porcellis (1584–1632) and Jan van de Cappelle (1624/5–79). In a little canvas by Porcellis at Munich, dated 1620, ships are about to founder in stormy grey water, but Jan van de Cappelle as a rule offers better weather (page 154). With him the water is like silk, holding still reflections, scarcely ruffled near shore or estuary, where fishing boats with long sails anchor at low tide. Willem van de Velde the Elder (1611–93) and his son, also Willem (1633–1707), specialized in naval battles and huge vessels firing broadsides, as in Willem the Younger's *Cannonade* in the Rijksmuseum, Amsterdam. They owed their fortunes to King Charles II, who summoned them to England after the Restoration. They were in the royal service from 1672, and though they naturally left it when Charles's brother James II abdicated, both died at Greenwich, the father in 1693, the son in 1709.

As a land of sailors and explorers, Holland had painters to record her new settlements overseas. Prince Maurice of Nassau, going out to Brazil in 1637, took with him the landscapist Frans Post (1612–80). When he was safely back in Haarlem in 1644, Post turned his sketches from nature

left: *Philips de Koninck:*
Landscape: A View in Holland.
Oil on canvas; 1.33 m x 1.60 m.
London, National Gallery.

below: *Aert van der Neer:* River
Landscape by Moonlight. *Oil on*
canvas; 0.55 m x 1.03 m.
Amsterdam, Rijksmuseum.

right: *Jacob van Ruisdael:* The
Beach at Egmond-aan-Zee. *Oil*
on canvas; 53.7 cm x 66.2 cm.
London, National Gallery.

into finished views which are the earliest exotic landscapes in European art (page 155).

These, then, are a few, perhaps the most important, of the many Dutch artists working in their own country. But as many more were to be found in Italy, congregated in Rome and modelling themselves, in one way or another, on Claude Lorrain. Among them were the studious Herman van Swanevelt, who lived in Rome from 1624 to 1638 and then removed to Paris, where they called him the Hermit of Italy; Jan Both, from whom the stay-at-home Aelbert Cuyp learned the "heroic" Italian style; Nicolaes Berchem, Jan Asselyn, Cornelis Poelenburg, Karel Dujardin, and Jan Hackaert. All these loved and painted the Campagna. Finally there was Jan Frans van Bloemen, nicknamed Orizzonte, because you seemed to see for miles in his pictures. Born in 1662, he settled in Rome in 1688 and never went anywhere else until he died in 1749, at the age of eighty-seven. His hundred or so canvases mark a transition from the manner of Dughet, who had influenced him strongly, to the sort of landscape approved by the newly formed Arcadian Academy, a landscape that was popular, in Rome especially, throughout the eighteenth century.

In France during the reign of Louis XIV an old argument came to a head: which was more important, colour or draw-

ing? Entrenched at the Académie, the partisans of drawing fought under the banner of Poussin. For their opponents, Rubens personified the cause of colour and verisimilitude. The dispute, beginning as part of the epic quarrel of Ancients and Moderns over the niceties of architecture and literature, was extended in pamphlets by Roger de Piles (1635–1709), which brought it before a wider audience than that of academicians' debates. The theories of this staunch Rubenist, progressive critic, and art lover were to have considerable effect on French painting, though he had been dead for five or six years when the final triumph came and the Académie invited Antoine Watteau, at the age of twenty-seven, to submit a *pièce de réception.*

The admission of Watteau in 1717 spelled victory for the colourists. Not, of course, that the greatest painter of the French eighteenth century was a colourist because he read De Piles, but the cultural circumstances are interesting. Watteau (1684–1721) had a rigorously professional training under various masters, the last of whom was Claude Audran, one of the leading decorative artists of the time, third of his name in a famous family of engravers. Audran was *concierge,* or curator, of the Luxembourg Palace, where his pupil could study the pictures commissioned by Queen Marie de' Medici from Rubens. Their influence was decisive, even on his landscape painting, where the references are Venetian, primarily to Titian and Veronese. Affinities and borrowings, however, are transmuted and all but forgotten in his extraordinary ease and delicacy, the interplay of light and shadow, the quivering transparency as one fades into the other. The Goncourts speak of the "beautiful running fluidity" of his brushwork.

He himself advised Nicolas Lancret against wasting time with masters, and told him to "go and draw your landscape somewhere near Paris, then do a figure, and compose a picture from imagination as you choose"; but the second stage of this process obviously meant more to him personally than the first. His own landscape (and here we think chiefly of *The Embarkation for Cythera,* one version of which is in the

above: *Jan van de Cappelle:* Calm
Sea, *c. 1655. Oil on oak wood; 47
cm x 59.5 cm. Cologne, Wallraf-
Richartz Museum.*

left: *Jan Frans van Bloemen
(known as* Orizzonte)*: Storm.
Oil on canvas; 0.75 m x 1 m. Rome,
Galleria Doria-Pamphili.*

right: *Frans Post:* Brazilian
View. *Oil on wood; 53 cm x 69 cm.
Munich, Alte Pinakothek.*

Louvre, another at the Charlottenburg Palace, Berlin, and whose setting Gérard de Nerval believed was inspired by the forest of Senlis) seems indeed to have been put together, superbly, in the studio as an intellectual exercise. It may be allegorical, to suit an allegorical subject, or function as rather grand scenery for a very slight comedy, some *fête galante* presented with all the charm in the world. Graceful feathery trees and other natural contributions combine with classical herms and statues, and—though not everyone agrees with this—the faraway mountains wrapped in luminous mist recall Leonardo and the backgrounds of the *Mona Lisa* and the *Virgin and Child with Saint Anne.*

The landscape tradition of Watteau ends with the delicious idylls of Jean-Honoré Fragonard (1732–1806), whom the Goncourt brothers considered a supreme "virtuoso," spontaneous to the point of improvisation. They did him less than justice. Fragonard had the technique acquired in five years at the French Academy in the Villa Medici in Rome, and on painting expeditions to Venice and Naples, and into

Holland; he is in fact the last "great master" of the French eighteenth century. To him, more even than to Watteau, nature meant a park: acres of well-tended park, with ornamental fountains, parterres and statuary shining in the sun, playground of leisured elegance. It had always been the same. During those five years, when other people were busy with their sketchbooks in the Campagna, his drawings, with a few exceptions, such as the lovely *Waterfalls at Tivoli* in the Louvre, were of parks and gardens. Some of his most splendid pictures are really landscapes—the *Fête at St. Cloud* in the Banque de France (Paris), *Blind Man's Buff* in the National Gallery (Washington), *The Swing* in the Wallace Collection (London), or *The Shady Avenue* in the Metropolitan Museum (New York, page 156). The figures are diminutive, the trees are huge, their tops sun-gilded against skies of softest blue. Fragonard contemplated the world with delight and painted it with a freshness and freedom that are prophetic of Renoir.

A student friend in Rome and companion of his Italian travels was Hubert Robert (1733–1808), whose interest was

not in parks, but in ruins and archaeological remains. Of these there were enough and to spare in the Campagna and are frequently his main subject. But he neither desiccates them into dry-as-dust studies nor drowns them in romantic nostalgia, but sees them in a harmony of past and present, not as dead things. Some of them were, indeed, lived in at that time, and he groups about them *contadini* and wayfarers, men guarding sheep and goats, and women washing clothes, all suitably occupied, and dwarfed by their surroundings. The eighteenth century adored ruins. It hung views of ruins on the wall and built artificial examples to embellish park or garden. Now, through the sense of daily life in his pictures, as well as by their smiling landscape, Hubert Robert gave the ruin cult a touch of domestic warmth and poetry. Nothing of the sort occurs in the erudite and powerful visions of his Venetian friend Giovanni Battista Piranesi (1720-78). Perhaps only another friend, Giovanni Paolo Panini (1691-1765), who came from Piacenza and also worked in Rome, approaches the same style and feeling.

The most direct heir of Claude Lorrain was Claude Joseph Vernet (1714-89), who came to Rome in 1734. His light, and his often remarkable effects of counterlight, resemble Claude's, and like him Vernet favours the Roman Landscape with Ruins. His marine subjects, too, were very fine and picturesque (page 161) and he returned to France to paint an enormous series of seaports for King Louis XIV.

Another Frenchman who lived for years in Rome was Pierre Henri de Valenciennes (1750-1819). His skill in perspective, his serenely classical Italian landscapes, and his un-jaded observation of nature make him a leading figure in what Germain Bazin calls *la ligne d'Italie,* as distinct from, but running parallel to, the *ligne française* that descends from Watteau to Fragonard.

But Rome was not the only cradle of landscape painting. That odd character Alessandro Magnasco (1677-1749) was born in Genoa and trained in Milan in the orbit of Morazzone and Del Cairo, for whose Late Lombard Mannerism

Fortunato Bellonzi chooses the words "sulfurous" and "hallucinatory." There followed an extended stay in Florence, where he saw the pictures of the Bolognese Giuseppe Maria Crespi and engravings by Callot, and knew the Venetians Sebastiano and Marco Ricci. In 1710 he went home to Genoa. There in the previous century Antonio Travi (1608-65), known as Il Sestri after his birthplace, had painted seascapes and pastoral scenes, adorned with sailors and shepherds, with great success; and more recently Carlo Antonio Tavella (1668-1738) was famed for his sensitive rendering of light and distance. Magnasco should not really be included with them, for in his Florentine period he was apt to call in "ruin painters" or "landscapers," who undertook such portions of the work in hand as were their special business. For all that, his masterpiece, the *Patrician Family Scene in a Garden with Panorama* (pages 162-163), at the Palazzo Bianco in Genoa, is a picture with a landscape. The wide view of hills sloping to a huge shallow trough of fields claims more of our attention than the patrician family itself. The picture is one of his last and the short crisp strokes, laid on with a dry brush, that roughen the forms and give dramatic emphasis to his earlier gaping caverns and sinister forest glades–harbours of robbers and witches and hermits–are now gentler, though with no loss of animation. Luigi Lanzi, the learned curator of the Grand Duke's medals and gems in Florence, wrote of Magnasco's "bold touch, joined to a noble conception." A cool, silvery atmosphere unifies the whole.

Among the landscapers employed by Magnasco in Florence, and the best of them, was Marco Ricci (1676-1730). He came from Belluno, north of Venice, nephew of the more famous Sebastiano, and with him the great Venetian landscape tradition begins. The art had been neglected in the Serenissima during the seventeenth century, galvanized only by a visit, in 1687 or thereabouts, from Pieter Mulier the Younger of Haarlem, who, proving very good at storms, was christened Il Tempesta; and there was Luca Carlevaris (1663-1730), painting the sort of views he had admired on a youth-

ful visit to Rome. But Ricci, though appreciating them both, turned to the fantastic landscape of Salvator Rosa and to Titian, whose drawings and themes he studied avidly, the latter in Campagnola's engravings. It would be wrong, however, to think of a sixteenth-century revival in connection with Ricci. Such a thing is precluded by the influence on him of Magnasco's freakish and unsettled style, by his own response to and understanding of light (as noted by Giuseppe Maria Pilo), and by the sort of landscape he paints, often with large foreground trees to assure contrast with his wide blue distances. Though some of his later works are fantasy ruin pieces, Ricci remained faithful to the country around Belluno. The Venetian Antonio Maria Zanetti, writing in 1771, tells us that he went back every year, "to refresh the images which slipped away, he said, when he was living in the city."

He had a determining influence on Giuseppe Zais (1709–84), a native of his own part of the world, and on Francesco Zuccarelli (1702–88), a Florentine, Roman-trained, who later moved to Venice. Zuccarelli paints tender Arcadian landscapes, in tender pastel colours, rococo to a degree, in which nymphs and satyrs and mythological personages inhabit the wooded hills of the Tuscan Maremma or the unalarming heights of the Veneto countryside. He was extremely popular, not least in England, where he worked for nearly twenty years.

But if we take Marco Ricci as the foremost Italian landscape painter, properly speaking, of his day, what is Canaletto? Properly speaking, not a landscape painter at all. Canaletto's art is view painting, a genre widely practiced in the eighteenth century, and the source of many masterpieces.

The obvious difference between landscape and view painting lies in their subject matter. The one looks to country, woodland, or seashore, the other chiefly to the town. The choice is, to some extent, the patron's, his demands conditioned by culture, taste, and even fashion, whose role is never negligible. But the main factor must always be the attitude of the artist himself to reality, and for the landscapist reality is Nature. To her he confides his whole imagination, and through some or other of her changing aspects will express his feelings, or interpret people or events in a particular setting. For the view painter, on the other hand, reality is so much given fact, to be accepted in its entirety and reproduced as faithfully as possible, for what good is a view you can't recognize? To this end he will make use of all the rational aids available, including purely technical devices like the camera obscura. And yet his greatest work is as individual as that of any other artist, with its own transfiguring poetry, since the reality he sets out to represent—or, better, capture—is part of his spiritual and mental environment; it is in tune with the usage, the culture, the civilization that bred him and to which he belongs. Thus both patron and painter were demonstrating, with the view picture, their enlightened eighteenth-century conception of landscape, though the cultural origins of that conception are much older than the Enlightenment itself.

View painting, while known in other countries, was at its best in Italy, and in Italian hands. It is a thoroughly Italian affair, yet it started with a Dutchman, and Dutch artists had paved the way for him. The first realistic and topographical drawings were made of Rome by Maarten van Heemskerck (1498–1574) and Hendrik van Cleef (1524–89), and in the succeeding century by Herman van Swanevelt and Gerard Ter Borch (1617–81), none of whom idealized the City. Their factual records give equal importance to hovel and palace and world-famous ruin. (The perspective backgrounds of Viviano Codazzi, a seventeenth-century artist from Bergamo living in Rome, were less documentation of this kind than settings for history or genre scenes, and as he did not do the figures himself he counts as a *quadraturista,* or painter of illusionist architecture.)

Then, from Amersfoort, came the true father of the urban view. Gaspar van Wittel (1653–1736), twenty when he arrived in Rome, was Gaspare Vanvitelli for the rest of his

right: *Hubert Robert:* The Old Bridge (Ponte Salario), *painted after 1783. Oil on canvas; 0.91 m x 1.21 m. Washington, National Gallery of Art, Samuel H. Kress Collection.*

below: *Claude Joseph Vernet:* Seascape: View of Sorrento. *Oil on canvas; 0.49 m x 1.09 m. Madrid, Prado.*

Alessandro Magnasco: Patrician
Family Scene in a Garden with
Panorama, *painted after 1735. Oil
on canvas; 0.85 m x 1.98 m.
Genoa, Palazzo Bianco.*

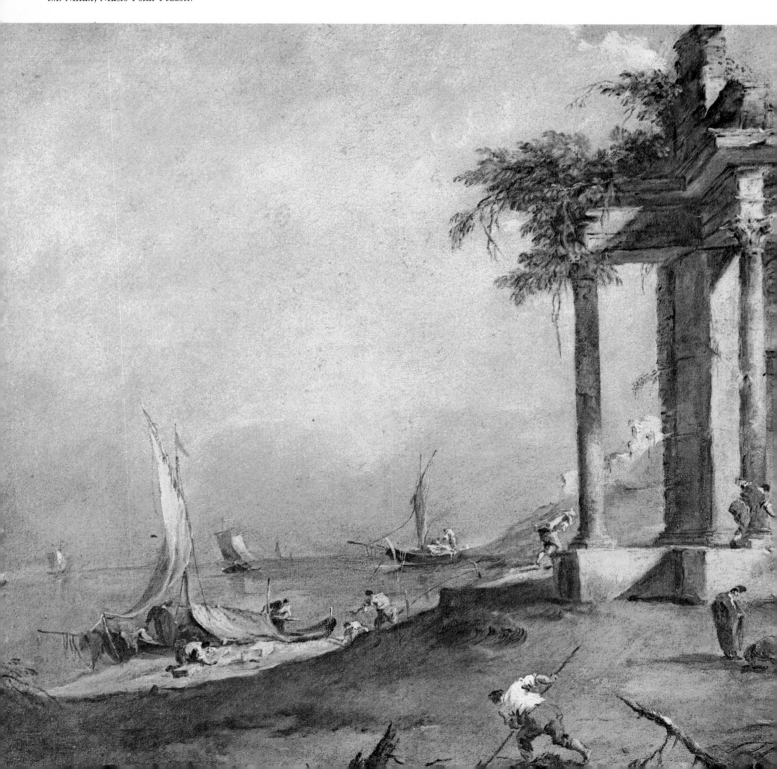

Francesco Guardi: Capriccio:
Fantasy View with Ruins, *c.*
1770–80. On canvas; 60 cm x 75
cm. Milan, Museo Poldi-Pezzoli.

career. Working in Lombardy, at Bologna and Verona, Venice and Naples, as well as Rome, he portrays these places, always from the perfectly chosen spot, with an accuracy that owes much to his exceptionally clear-drawn line.

It was Vanvitelli's example that fired Carlevaris in Venice and, after him, Giovanni Antonio Canal the Younger—Canaletto. Canaletto (1697–1768) may have been a pupil of Carlevaris, but certainly began life as his father's assistant, painting perspective scenery for the stage. After a visit to Rome he abandoned this calling and devoted himself to the scenery of Venice. Now the apparently mathematical perspective is accompanied by an acute awareness of light that adds to the space in his pictures and saves them from mere pho-

above: *Marco Ricci:* The Waterfall. *Oil on canvas; 1.11 m x 1.39 m. Venice, Accademia.*

below: *Giovanni Battista Piranesi,* Waterfall at Tivoli, *from the* Views of Rome, *published 1753–60 (the official date is given as 1751). Engraving; 47 cm x 70 cm. Venice, Giorgio Cini Foundation.*

tographic realism. Distant objects are not dissolved in mist but seen in every detail through an air so clear, and shadows so transparent, that we still know how far away they are. In this clarity colours are stronger, unchanged by shade when not absorbed into the golden glow.

From 1746 to 1756 Canaletto was almost continuously in London. The idea for the journey, and the contacts, came from Joseph Smith, British consul at Venice, who collected his work and arranged his sales to fellow countrymen. English townscapes, English light, were new, but there was no alteration of style. Instead, as the critic Rodolfo Pallucchini says, Canaletto revealed to his new clients a London drenched in lucid southern brightness.

His nephew and pupil Bernardo Bellotto (1720–80) is not far behind him. Some, like Giuliano Briganti, think he enters further into his subject and is more "modern." Instead of Canaletto's vibrant warmth there is a cold crystal light in which shadow is accentuated and architecture chiselled against a faintly hazy sky. With extraordinary penetration he can pick out the hidden details, whether of city or country, and however small, in the Veneto, Piedmont, or Lombardy (page 166), Tuscany and Rome, visited when he was twenty or so. This was view painting that suited the northern towns of Europe very well: the atmosphere and activity of Dresden, Vienna, Monaco, and Warsaw are in his pictures of their great squares lined with princely palaces, their churches and rococo bell towers and huge regimented blocks of multi-windowed houses.

Canaletto and Bellotto, their followers and associates, the most notable of whom is Michele Marieschi (1710–44), paint in one style; Francesco Guardi (1712–93), in quite another. Guardi scarcely ever set foot out of Venice. Influenced by the increasingly free-and-easy late baroque and rococo of Tiepolo, Sebastiano Ricci, and Giovanni Antonio Pellegrini, he had collaborated as a figure painter with his elder brother Giovanni Antonio, and only after this brother's death did he become a *vedutista.* His views are airy and light, with perspective as exact as Canaletto's, and the flickering brushwork

following pages: *Francisco Goya y Lucientes:* The Feast of San Isidro, *1788. Oil on canvas (design for tapestry); 42 cm x 90 cm. Madrid, Prado.*

VEDVTA DELLA CASCATA DI TIVOLI

brings everything in them to life. Rapidly sketched manikins on piazza or quayside, the black gondolas, the buildings, and the sky are all tremblingly alive and touched with fantasy. Light is refracted from water in a shimmer of silver and green. This fresh, glancing execution, sometimes taken for a kind of pre-Impressionism, is in fact the last, best product of a completely eighteenth-century taste and demolishes the distinction between real and fantasy view painting. In his *capricci* he happily plants his fictive arches and ruins by the lagoon, not without some reminiscence of Marco Ricci and Marieschi, just as Canaletto had translated Palladio's basilica

and Palazzo Chiericati from Vicenza to the Grand Canal. Yet many of Guardi's pictures are tinged with melancholy, as if he were mourning for a dreamworld he can never possess. It is to be felt in a grey twilight sometimes over the landlocked water, as in the beautiful, lonely view in the Poldi-Pezzoli Museum at Milan.

In Spain, as we have seen, there was no established landscape tradition, but the Prado has the one great landscape by the greatest painter of her eighteenth century (pages 170–171). *The Feast of San Isidro,* by Francisco Goya (1746–1828), is the very essence of *hispanidad,* the quality of Spanishness,

in costume, style, and setting. It is 15 May, fiesta of Madrid's patron saint, when the people take a country outing to his shrine by the Manzanares. The crowds are on one bank of the river, and on the other, above white, deserted slopes, the city extends against a limitless depth of sky-grey domes and bell towers and walls bleached by the sun. *San Isidro* is actually a tapestry design of 1788; hence, in part, the construction in rising horizontals and the distribution of colour accents. It was never woven, as Charles III died and work on the series was suspended, though Goya went on supplying sketches and cartoons to the royal tapestry manufactory for another eighteen years. By any standards, however, it is a magnificent picture, with a cool, luminous tonality that refers deliberately to Velázquez. For in contemporary Madrid it was the neo-classic and highly cerebral Raphael Mengs who counted, rather than Tiepolo (both had been summoned by Charles III, and Tiepolo died there in 1770); and Goya, at a century's remove, was Velázquez's nearest heir.

From the later 1600's a period of political calm and economic prosperity in England fostered the rise of what Dennis Farr calls an authentic national school; and this included landscape as well as the portraiture that is perhaps its prime

glory in the eighteenth century. Zuccarelli, and of course Canaletto, visited England, as we know, but what was to become the authentic national taste for country-house and country-life pictures was introduced by Dutch artists, some of whom settled permanently. And if many such pictures were ordered because they were the fashion, portraits of the premises rather than works of art, then history was only repeating itself. They were, after all, updated versions of the topographical views of villas and gardens Justus Utens painted for the Medici in sixteenth-century Florence.

A leading exponent of the genre was Jan Greffier of Amsterdam (circa 1645–1718), who was in London from 1666 to 1695, and again for the last thirteen years of his life. Another was the more sensitive George Lambert (1700–65). Lambert breaks away from the topographical approach to emphasize the beauty of country-house surroundings. There are occasional, though never obvious, scenic conventionalities, but he is the first to show genuinely observed English landscape. In his *Hilly Landscape with a Cornfield,* for instance (Tate Gallery, pages 172–173), conventionality plays little or no part; it is unforced and true to nature as is no other picture of its school or period.

As for Gainsborough (1727–88), he became a portraitist of elegant society and Reynolds's chief rival simply because landscape did not pay enough. His subjects are often posed out of doors, like Mr. and Mrs. Andrews, taking the pleasant air of Suffolk in an early masterpiece at the National Gallery, and the close interrelation of figures and landscape is characteristic of his style. At the zenith of his fame and fortune he will put a view in a portrait, not on the client's order but to please himself, and if there are echoes of Ruisdael, Hobbema, and the Dutch masters, the broad imaginative treatment is his own. So imaginative indeed that Reynolds dismissed many of the later landscapes as "pictorial fantasies." But the artist thought them his best work, perhaps rightly, for they have an intense, sometimes dramatic, lyricism.

The Gainsborough tradition of fantastic views continues with George Morland (1763–1804), but the most important of these eighteenth-century landscapists is Richard Wilson (1713–82). To Wilson's seven years in Italy and his study of Dughet and Claude Lorrain is due the spread, if not the actual introduction, of classical landscape in England. He himself adapted the classic manner to the discovery and faithful depiction of English scenery, whose most inspired interpreter he is, from the placid attractions of the tree-bordered Thames at Twickenham, a picture of which is in the National Gallery, to the mighty mountains and cold, clear lakes of his native Wales (page 176).

Among his pupils was William Hodges (1744–97), who imitated, even probably forged, his work. Yet Hodges's own pictures have a place in the history of the commercial expansion of the British Empire and the epic voyages of the century, much as those of Frans Post had illustrated the expansion of Holland. George Lambert and Samuel Scott vis-

ited the East India Settlements as landscape painters in 1732, and forty years later Hodges was Captain Cook's official artist on the second South Seas expedition. His fascinating records of Easter Island statues, Antarctic icebergs, and the unspoiled marvels of Tahiti are a remarkable blend of documentary fact and classical scenic dispositions derived from Wilson.

This was the century in which the Industrial Revolution began to change the face of England, making its early appearance in the mining districts of Derbyshire. Joseph Wright, better known as Wright of Derby, where he was born and spent most of his life (1734–97), can be said to have originated the genre of industrial landscape. He may have been predisposed to it by his keen scientific interest in such things as artificial light, rainbows, and other exceptional phenomena of nature; his Italian memories were of Vesuvius in eruption—which he painted more than once—of coastal beacons and the fireworks of Roman holidays. The celebrated candlelit interiors are matched by open-air scenes showing dark or moonlit valleys with mills and foundries flaring through the night. Industrial landscape and what Arthur Young the agriculturalist called its "sublime horrors" attracted few art collectors but was produced, nevertheless, by William Williams (active in 1758–97; page 176) and by Jacques Philippe de Loutherbourg (1740–1812), who painted weird furnace flames in the Severn Gorge; and there is a certain eighteenth-century panache in the pictures of William Havell (1782–1857), though he worked in the first half of the nineteenth.

Finally there are the watercolourists, with their wonderfully soft effects of tone and light in landscape. The greatest of them, John Robert Cozens (1752–97) made studies of the country around Rome described by Lord Clark as "nostalgic visions which distil all that we have read or dreamt of Italy from the time of Virgil to that of Shelley and Keats." The Water Colour Society, later the Royal Society of Painters in Water Colours, was founded in 1804, just seven years after his death.

Thomas Gainsborough, Landscape with a Bridge, *painted after 1774. Oil on canvas; 1.13 m x 1.33 m. Washington, National Gallery of Art, Andrew W. Mellon Collection.*

NATURE AND PHILOSOPHY
The East

Among the great civilizations of Asia whose artistic heritage has come down to us, those of India were the least responsive to landscape. Some landscape elements are found in the relief carvings of stupas, those emblematic shrines meant originally to house holy relics, raised from the second century onwards with hemispherical domes to signify the universe, surmounted by one- or two-tiered stone umbrellas that symbolize the different heavens, and enclosed in stone railings several stages high and topped with coping. Their landscape elements are, however, quite unrealistic and present only because they are necessary to the legend and iconography of the Buddha. The tree under which his mother, Maya, gave birth to him was necessary, and he is himself occasionally depicted as a tree; a relief in the Indian Museum, Calcutta (page 180), shows Erapata-Naga kneeling to adore him in this guise. The carving comes from the stupa at Bharhut in central India, built in the second century B.C. under the Sunga Dynasty. The tree—or, rather, trees, for there are several small accompanying specimens, as if to indicate a larger forest setting—is strongly stylized, the top almost a sphere, but flattened, with branches springing from dense leaves and flowers. The lines are firm, unbroken; nothing about it in any way suggests the Hellenism that came to India with Alexander the Great.

Nor is there more than a minimum of conventionalized nature detail in the magical wall paintings of the cave temples at Ajanta, Ellora, and Elephanta, which date from the golden age of the fourth to eighth centuries A.D. and are the largest body of Indian art in existence. This must be for purely religious reasons, however, since landscape seems to have played a larger part in secular paintings, now all unfortunately lost. It is only in nonreligious art, and particularly in

When Yü-k'o painted bamboos he was conscious only of the bamboos and not of himself as a man. Not only was he unconscious of his human form, but sick at heart he left his own body, and this was transformed into bamboos of inexhaustible freshness and purity.

Su Shih, on "My Regretted Friend Wên Yü-k'o" (or Wên T'ung) (translated by Osvald Sirén in The Chinese on the Art of Painting)

Indian Mogul art: Lovers in a Landscape, *c. 1760–70. Miniature; 41 cm x 27 cm. New Delhi, National Museum.*

miniatures of the Moslem era—sixteenth to nineteenth centuries—that real naturalistic landscape backgrounds appear in scenes of court and daily life. An enchanting Mogul miniature of the eighteenth century from the National Museum, New Delhi, shows two lovers in a flowery garden surrounded by a rocky ledge, with a wide prospect of lakes and wooded promontories beyond (page 178). In the later 1700's, miniatures in the style of the hill state of Kangra, picturing the loves of Krishna and Radha in green forest groves, load every tree and leaf with a symbolic value that argues a pre-romantic attitude toward the harmony of man with nature. Examples of such Kangra painting are found at Heidelberg University and in the Victoria and Albert Museum.

Symbolism of this kind exists even in what the West would call genre painting. In pictures of the various hill schools of similar date (where Indian ladies appear "at a rendezvous," "on a swing," or "scolding the cat that stole the parrot"), symbolism is in the delicate natural detail. Four

girls swim, clinging to straw-filled pitchers, in a Garhwal miniature of about 1750 in the collection of Mr. Ram Gopal. Here the lotus flowers on the water are the purity of the soul that rises above the world's pollution, which is represented by the mud at the bottom of the pool. Western influence accounts for some effect of spatial depth in these pictures, but basically they are pure decoration, as is obvious from the repetition of flowers and other nature motifs, and the generally stylized design.

In Persian art there is almost no landscape except in miniature painting. The schools that grew up, mainly in Shiraz, Tabriz, and Herat, were devoted to book illustration. They illustrated chivalric poems, bestiaries, and collections of fables, and their art attained its greatest splendour under the patronage of Baysunghar Mirza (late fourteenth to early fifteenth century), a prince of the house of Tamerlane and a passionate and openhanded art lover and bibliophile. Its two masterpieces are the epic *Shah Namah,* or *Book of Kings* (page

183), and the *Book of Kalila and Dimna,* a collection of animal fables about two jackals. The *Kings* manuscript may be dated to 1429–30, the jackals and their adventures to 1410–20. Both were produced by the school of Herat, include miniatures attributed to Amir Khalil, and are in the Gulistan Library at Teheran. In both, the landscapes have a Chinese feeling, with wide spaces often framed in trees or rocks – trees and rocks of the utmost elegance, placed with exquisite rightness in relation to the lively and expressive animals. Miniatures were painted in this style almost to the end of the sixteenth century, when Jesuit priests came to Persia and the various local schools were influenced, however slightly, by the Flemish engravings they brought with them, and these schools even began to use Christian motifs.

Of quite another sort are the landscapes, if they can be called that, in Turkish miniatures. The miniature painting of Turkey is often, and wrongly, regarded as a variant of that of Persia, but Persian influence was neither continuous nor very considerable. There were flourishing centers of the art at Baghdad and Damascus from the end of the thirteenth century, but landscape is rare before, and indeed during, the sixteenth. This is because Turkish manuscripts, unlike the Persian, which were usually literary, were often in praise of militant Ottoman princes. The manuscript with the most landscape is, indeed, the *Menazil Namah,* or *Road Book* (page 182), describing the routes and marches of the army of Suleiman the Magnificent on his first expedition into Persia. It was written by Matrakdij, a famous historian and geographer, and each of its 107 large miniatures is the panoramic view of some specific place or town. Houses, trees, bridges, and other features are, however, all drawn to a few unvarying models, their rigid patterns only slightly animated by winding roads and blue rivers where the warships ride. But among these coldly objective pieces of topography – the Turks, it may be remembered, were wonderful map-makers – are others in which the artist, while preserving the same sober style, has introduced land and sea creatures, moving vigorously against landscapes whose wry "perspective" recalls that of the tomb paintings of ancient Egypt.

The landscape painting of China has no parallel in that of any other civilization, for nowhere else has the art been practiced on so vast a scale of time and territory, or produced so many schools, styles, and masters. From what was the beginning of the Christian era in the West it was cultivated, often deliberately fostered, in connection with Taoism; even its underlying aesthetic values were based on the philosophy and doctrine that was accepted almost throughout China. Taoism (from *tao,* the road, and, by extension, guide and universal principle) emerged between the sixth and third centuries B.C. Its central concept, according to Hellmuth Wiehelm, was that of harmonious union between man and the universe, and this was achieved by immersing oneself in nature. Accordingly, sages, mystics, and painters retired to the mountain solitudes where the Taoist temples were often built, and passed months, sometimes years, far removed from practical care, in contemplation of the landscape. In this they were unlike the followers of Confucius, who were busy about the world's work, but they were trying to understand the essence of their surroundings in those aspects that best reflected the universal principle they sought. A landscape picture was an assembly of such components, made by the artist working rapidly, from memory – a process calling for the greatest technical skill and depending on individual inspiration. The first of the six "conditions of good painting" propounded by Hsieh Ho refers to "spirit resonance," which seems actually to mean inspiration.

Hsieh Ho lived in Nanking at the end of the fifth century. He was the forerunner of many Chinese critics to concern themselves with landscape painting, though artist-authors before him had emphasized its spiritual function. Ku K'ai-chih (345–405) wrote an essay, "On Painting the Cloud Terrace Mountain," which was where an early Taoist disciple named Chao Sheng had been sent to gather the fruit of immortality from an inaccessible tree. The landscape painter, in Ku K'ai-chih's opinion, should seek to convey the magical and religious side of his art, and is advised to follow the mystical path to liberation and independence of spirit. The contemporary Tsung Ping, in his "Preface on Landscape Painting,"

left: *Chinese art of Turfan, Central Asia:* Lake in the Mountains, *ninth to twelfth centuries. Fragment of wall painting. West Berlin, Staatliche Museen Preussischer Kulturbesitz, Museum für indische Kunst.*

below, left: *Chinese Art, Ma Yüan:* Mountain Path in Spring, *1190–1230, Sung Dynasty. Ink and colours on silk. Taipei, Formosa, National Palace and Central Museum Collections.*

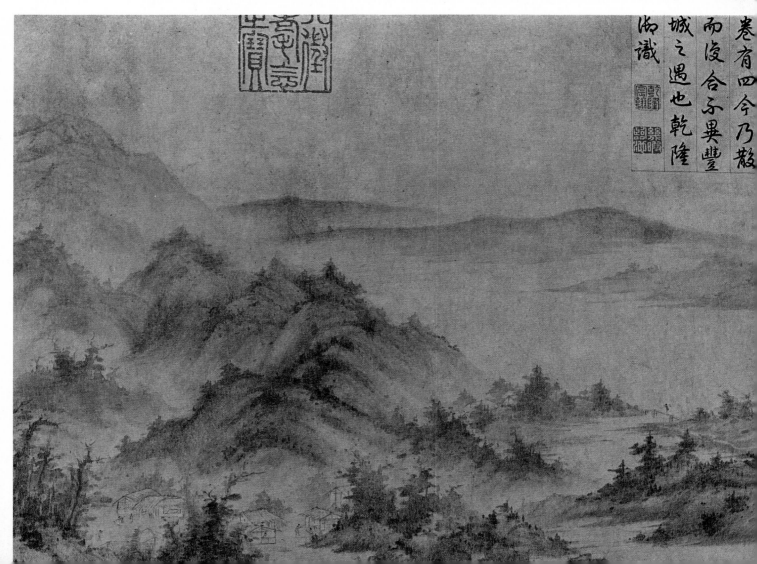

卷有四今乃散
而復合不異豐
城之遇也乾隆
御識

on page 185, above: *Chinese art,
attributed to Tung Yüan:* Clear
Weather in the Valley, *twelfth to
thirteenth century, Sung Dynasty.
Makemono (horizontal scroll), ink
on paper; 0.37 m x 1.50 m. Boston,
Museum of Fine Arts.*

on page 185, below: *Chinese art,
attributed to Li Lung-mien:*
Imaginary Journey in the Hsiao-
Hsiang Region, *late eleventh to
early twelfth century, Sung
Dynasty. Makemono (horizontal
scroll), ink on paper; 0.30 m x 4.03
m. Tokyo, National Museum.*

left: *Chinese art, Liang K'ai:*
Landscape with Snow, *early
thirteenth century (Southern Sung
Dynasty). Kakemono (vertical
scroll), ink and colours on silk;
1.11 m x 0.50 m. Tokyo, National
Museum.*

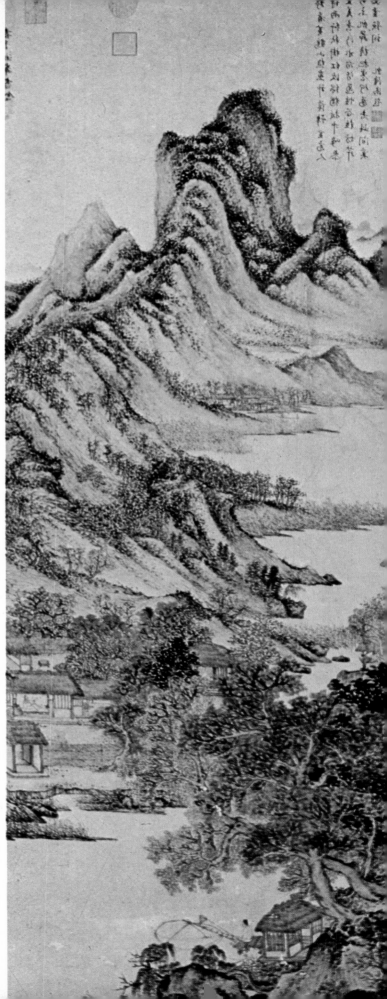

right: Chinese art, Wang Mêng:
Cabins Near the Hills in
Autumn, *second half of fourteenth
century (Yüan Dynasty).
Kakemono (vertical scroll), ink and
colour on paper; 88 cm x 19.5 cm.
Taipei, Formosa, National Palace
and Central Museum Collections.*

*on page 188: Chinese art, Chu
Tuan:* Landscape with Snow,
*first half of sixteenth century
(Ming Dynasty). Kakemono
(vertical scroll), ink and colours on
silk; 1.72 m x 1.09 m. Tokyo,
National Museum.*

states that Tao alone can put one in touch with nature.
Similar ideas are found in many later authors, notably the
painter-poet Wang Wei (699-759). It will be seen therefore
that Chinese landscapes, though they may have detailed titles
mentioning place, season, or time of day, and conditions of
cloud or rain or wind, and though they strike us as incredibly
realistic, are always, in fact, "ideal" landscapes, in which every
element serves some symbolic purpose. The fundamental pur-
pose of landscape painting–called in Chinese *shan shui,*
"mountains and water"–is the union of the opposites *yin* and
yang, activity and repose, complementary aspects of the crea-
tive energies contained within the Tao, which is the eternal
state of becoming of the universe. In the "mountains and
water," waterfalls and ravines stand for the wild forces of
nature, clouds for the mutability and brevity of things. Pines
are among the trees most frequently shown, their straight
trunks representing the victory of the wise or virtuous man
over ill fortune and mishap, typified by the wind. The reg-
ularly jointed, flexible bamboo is the enduring quality of
friendship and the symbol of ideals such as that of the gentle-
man, or *chü-jen,* who bends before the blows of fate and so
recovers from them. The flowering thorn means the coming
of spring. For us it is a new language and, unused to these
complex and delicate emblems, we find it difficult to fathom
the full significance of Chinese landscape painting; looking at
it with Western eyes we are likely to make arbitrary judg-
ments. Yet the pictures fascinate us by the poetry they distil
no less than by the formal and technical beauties–elegant
drawing, bright or vaporous colours, subtle chiaroscuro–that
were valued in their own time by critics who saw them so
differently. If we remember the value those critics placed on
handwriting, however, we shall begin to understand their
attitudes and standards, and why style and technique mat-
tered so much.

Handwriting or, rather, calligraphy is, on the face of it, the
simplest and least creative of manual skills, but in China

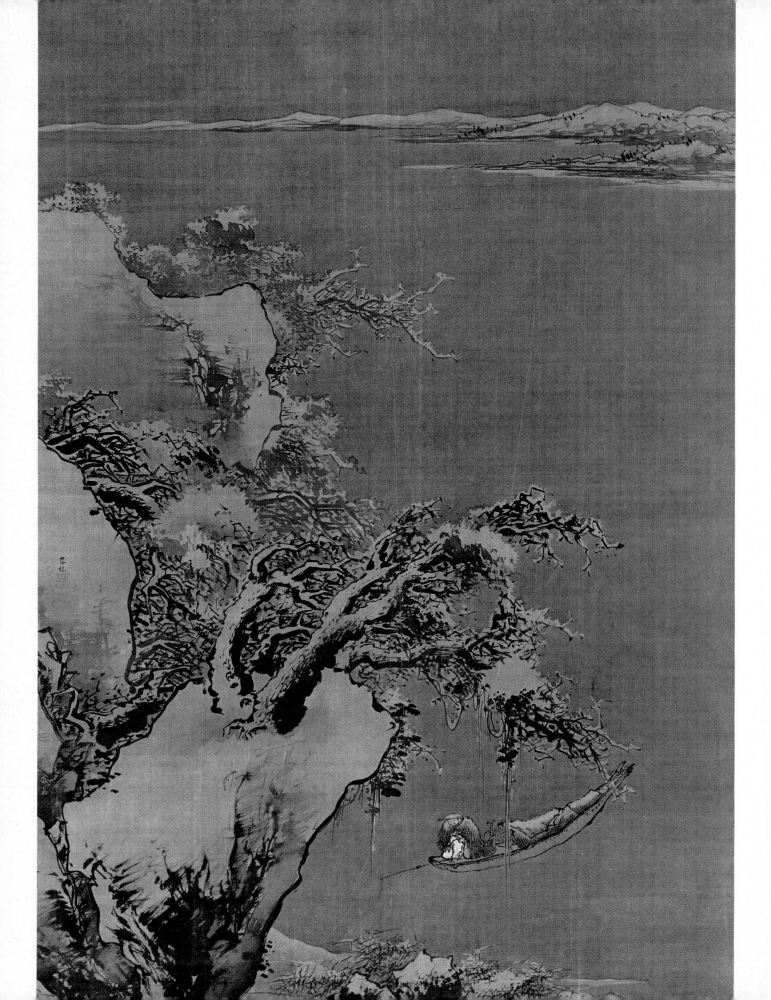

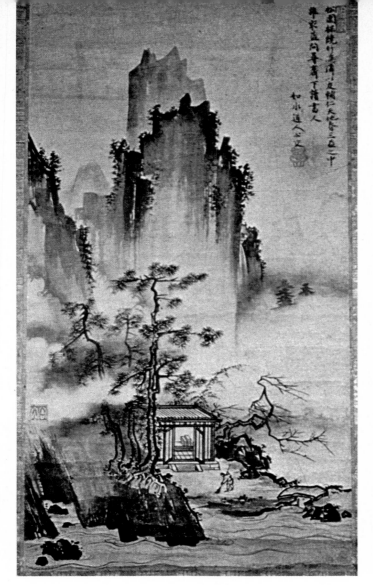

above, left: *Japanese art, Shūbun:*
Pavilion of the Three Sages,
1418 (Muromachi period). India
ink and colours on paper. Tokyo,
Seikado Foundation.

above, right: *Japanese art, Sesshū:*
Landscape, *1495 (Muromachi*
period). Kakemono (vertical scroll),
ink in hatsubo-ku *("splashed*
ink") style; 1.47 m x 0.32 m.
Tokyo, National Museum.

below, right: *Japanese art, Sesson:*
Storm on the Coast, *early*
sixteenth century (Muromachi
period). India ink and colours on
paper; 22.4 cm x 31.4 cm. Kyoto,
Nomura Collection.

great poets were also great calligraphers. A poem was prized not only as poetry, but as an actual piece of writing: for how, and with what art, the thought had been transmitted in signs or ideograms. When this is realized it is easy to see how important, and not merely aesthetically so, the endless, ultra-refined methods of painting were. There was *chien-pi,* or short brushstroke; *p'o mo,* or broken ink; *kan pi,* or dry brush; there was the use of the fingertips with or instead of the brush to obtain the most precise gradation of light and shade. From the tenth century onwards there was also monochrome. This was especially suitable for landscape since colour, however slight, was a distraction, weakening the spiritual concentration required to consider and paint it properly.

Here we can do no more than name a few of the masters of this immense, magnificent pictorial tradition. They were all great individualists. Some of them were monks, some of them *wen-jen,* "literary painters," or cultivated amateurs. They might form family studios, as did Li Ssh-hsün and his son Li Chao-tao, perhaps the most remarkable landscapists of the T'ang period, who worked from about 650 to 730; or they might belong to properly constituted academies, the oldest of

which, the Hua yüan, was set up for the court painters under the Five Dynasties in the tenth century. The number of copies made from the masters over many hundreds of years shows how highly they were regarded, and when fragile originals, on silk or paper, have perished the copies are especially valuable. Wall painting, though more solid, was little used except in tombs. One of the oldest and most beautiful fragments left is in the West Berlin Museum and comes from the base of a stupa at Bazaklik in the sands of the Turfan depression (page 184). Its dating is uncertain, suggestions varying from the ninth to the twelfth centuries, nor is the style purely Chinese: until 1000 this area of Chinese Turkestan was known as Serindia, the great crossroads of Asia, where her civilizations met and mingled. In the painting a dragon swims in a lake among mountains. He is completely Chinese, the mountains are not; they have reminded one critic, Werner Speiser, of the earliest landscape conventions of Mesopotamia. This fragment, with its bright, fairy-story colours, remains part of the enigma of ancient Chinese painting and its links with India.

In the T'ang era of 618–907 figure painting was predomi-

nant, and was introduced even into landscape. Pure, unpeopled landscape assumes importance only under the Five Dynasties (907-959). This and the Sung period that followed saw the supreme masters, whose influence was to endure for centuries. Li Ch'eng is first to use the twisted trees that are a main element in some later pictures, but the most famous of these artists is Tung Yüan, who lived in the second half of the tenth century and worked at the court of Nanking. The styles he employed were various, sometimes with colours, sometimes the monochrome said to have been originated by Wang Wei, the poet-artist, and which had spread with Ch'an (or Zen) Buddhism. He is thought to have painted landscapes, now known through ancient copies, such as the monochrome watercolour *Taoist Temple in the Mountains* in the National Palace and Central Museum Collections, Formosa. This is a balanced and satisfying composition of wooded foreground, clouds in the valley, and mountains behind, though there is some sacrifice of depth in the stylization of the steep, rhythmically soaring ridges. His *Clear Weather in the Valley* (page 185) conveys depth, however, with the greatest economy of means—no more than subtle atmospheric gradations in a wide, airy space. This hand scroll, a twelfth- or thirteenth-century Sung copy, is in the Museum of Fine Arts, Boston, which also has another Tung Yüan landscape, *Clear Weather in the Mountains,* whose Sung copyist has faithfully reproduced the pointed ink dots of the master's "Impressionist" touch. Two silk hanging scrolls of *Stags in the Forest* may be originals. They are painted in light colours, and trees and animals are flat shapes with no empty space between them, as though in tapestry.

From 959 to 1279 China was united under the Sung. She had no desire for foreign conquest, and the peaceful revival of old local traditions led to a magnificent flowering in every branch of culture, from philosophy to poetry and painting. One of the foremost masters of the first, Northern Sung period was Li Lung-mien (circa 1040-1106), who is also known as Li Kung-lin. His style is that of *pai-maiao,* outline or "plain" drawing, and to him is attributed the stupendous

Imaginary Journey in the Hsiao-Hsiang Region (page 185) in the National Museum, Tokyo. He painted it at the request of a Zen monk who had long and vainly wished to see that part of China and the great Yangtze River, which is shown in the picture winding among distant mountains.

Another master of the Sung was Ma Yüan, active between 1190 and 1224, and known from his fondness for asymmetrical design as "One-Corner Ma." He would place some large tree, mountain, or other important element in the corner of a composition and leave the rest empty, or occupied at the most with a few sparse, light brushstrokes, thus giving an illusion of infinite space. It is a method that corresponds to the dictum of Confucius that no one was worth teaching who, if shown one of four angles, failed to discover the other three for himself, and is used in paintings like *Mountain Path in Spring* (page 184) in the National Palace at Formosa, and *Man Looking at the Moon.* Silent snowy landscapes, with the uniform soft whiteness smothering every shape, were particularly favourable for meditation, and favourite subjects with Sung painters. A beautiful thirteenth-century example by Liang K'ai is in the National Museum at Tokyo (page 186): a kakemono, or vertical wall scroll, on silk, with a small tree, twisted and leafless, in the foreground, and two travellers on horseback to suggest, by the contrast of their tiny figures with the huge, snow-covered overhanging mountain range, the melancholy and desolation of the scene. When Liang K'ai was already famous, he left the court academy of painting, retired to a Ch'an monastery, and there produced his finest work. Almost his contemporary was another Ch'an monk, Mu-ch'i, to whom is attributed an ink scroll, also in the Tokyo museum, *A Fishing Village by Twilight.* Here, too, the spreading, misty panorama is silent, the shoreline beyond the water imprecise in the dusk. A boat in the foreground is the merest shadow; there are drifts of cloud or fog in the mountains. Mu-ch'i is one of the greatest of Chinese painters and his "unacademic" style had considerable influence in Japan.

The arts suffered no untoward effect when in 1270 the

empire fell to invading Mongols and a ruling house descended from Genghis Khan, who had been a barbarian soldier of fortune from the north. Instead, China civilized the Yüan Dynasty, and in their time four great painters flourished: Huang Kung-wan, Ni Tsan, Wang Mêng, and Wu Chên. Little of Huang Kung-wan's work survives, but we have several very simple silvery landscapes by Ni Tsan, who lived from 1301 to 1374, part of the time on a houseboat, and expressed in art his detachment from life and love of solitude. Wu Chên (1280–1354) was celebrated for the depiction of bamboo, which is often the main feature of his quiet landscape studies. Wang Mêng (circa 1308–85) had by contrast a turbulent career, was accused on a political charge of which he seems to have been innocent, and died in prison. His landscapes appeal to Western eyes by their robust unity. *Cabins near the Hills in Autumn* (page 187), in the National Palace and Central Museum Collections, Formosa, is constructed, for instance, on a continuous, noble curve that rises from the leafy trees beside a river or lake in the foreground, to follow the steep mountain ridge above.

A victorious general chased the Yüan rulers back into the deserts of Mongolia in 1367 and became the first Ming emperor. During the Ming period, which lasted until 1662, the many influences and local schools of painting that arose, mostly in the south, were in direct contrast with the academic tradition. Academic art was, of course, devoted not so much to the reappraisal as to the actual imitation of the great artists of the past, those of the Sung especially. This attitude, which in the West would be unacceptable or lead to sterile anachronism, is historically valid in the East as casting light on the fine intellectual creative processes of the old, pre-Mongol masters. Li Tsai was an academic painter, active in the mid-fifteenth century, whose landscapes are full of borrowings from two hundred years before, but used in such a way as to acquire a new accent, almost that of "scholarly poetry." Scholarly poetry was among the aims of an art whose highest accomplishments were theoretical and unspontaneous, one in which the painter was apt to merge with the man of letters. The imitative tendency, moreover, constantly recurs in Chinese painting, if only as an expression of national piety: a kind of humanistic impulse, drawing new energy from the contemplation and perpetuation of ancient glories. It should not surprise us, therefore, to find a sixteenth-century court painter like Chu Tuan taking as his master and model Ma Yüan, his predecessor by three hundred years. The "one corner" appears again in the fine kakemono, painted on silk and now in the Tokyo museum (page 188). There, in a familiar lower corner, are the trees and snow-covered rocks, stretching away to the vast, vacant water. Scarcely perceptible in the distance, the slopes of a line of hills are mantled in white.

The Ming was in due course overcome by another foreign dynasty, the Ch'ing. Manchus from the north, they held the throne from 1662 to 1911 and, according to pattern, assimilated Ming culture. A degree of naturalism had appeared already in some of the Ming artists, Li Tsai among them, but, although more naturalistic, painting still looked to the past. The best period of Ch'ing landscape comes in the seventeenth century with masters such as Kung-hsien of the Nanking school, who was active between 1625 and 1698, and wrote a treatise on the subject. He even inaugurated a measure of interest in Western painting, though this was limited to the study of perspective in landscape, and his own techniques remain faithful to Chinese precept and practice; as also did those of Wang Hui (1632–1717), whose marvellous classical landscapes have nevertheless a new warmth and intimacy. But the eighteenth century was to see an Italian Jesuit, like a portent of things to come, win fame and fortune as a painter at the court of the painter emperor Ch'ien-lung. Father Giuseppe Castiglione (1688–1766), taking the Chinese name of Ling Shih-ning, worked in an eclectic, not to say hybrid, style that typifies, and is the most remarkable example of, the ever-increasing encroachment from the West that would rob the great pictorial tradition of its purity.

The history of landscape painting in Japan is one of intervals of Chinese influence alternating with others when the

Japanese art: The Uji Bridge, *late sixteenth to early seventeenth century (Momoyama to Edo periods). Six-panel folding screen, painted in gold and colours; 1.54 m x 3.17 m. Tokyo, National Museum.*

native style, or *yamato-e* (which means, literally, Japanese painting), prevails. This developed, slowly enough, in what is known as the Nara era, Nara being the capital city from 645 to 794. It starts with the introduction of very slight and highly stylized nature motifs in both religious and non-religious art, and the first true *yamato-e* landscapes date from the Kamakura period (1185–1336). They reveal an austere, even mystical spirituality such as is found in the sober *Nachi Waterfall,* an early fourteenth-century kakemono in the Nezu Museum, Tokyo. This is a masterpiece of its style, and as in all landscapes of that time its true subject is sacred, for the waterfall represents the Shinto temple of Kumano and its deity. Chinese influence reappears with the numerous, and often very beautiful, ink landscapes in the style known as *suiboku,* in the Muromachi period (1336–1573). Muromachi painting begins early in the fifteenth century with Shūbun Tensho, a Zen monk of the Shokoku-ji in Kyoto, and its asymmetrical composition recalls that of the Sung and of Ma Yüan in China. Sesshū Toyo (1420–1506), Shūbun's pupil, was a priest in the same monastery, and visited China in 1468 to study her old masters. He is himself considered one of the greatest and most versatile Japanese painters of any epoch. A magnificent landscape of 1495, now in the Tokyo museum (page 189), is carried out in the "splashed ink" technique, or *hatsubo-ku.* The construction and the carefully thought-out but apparently spontaneous execution seem to anticipate as-

pects of modern *tachisme,* down to the severe monochrome employed. Mountains, bushes, a boat, a building are barely suggested; they emerge from the harmony of brushwork and chiaroscuro: vigorous dabs and thick brushstrokes, very dark and incisive, and subtle shading that fades to clear, ethereal distance. This picture evokes, rather than describes, a landscape that stimulates the imagination and touches the innermost being, thus fulfilling the highest spiritual purposes of Zen. Another painter, Sōami, who lived from 1472 to 1525, was not a priest but an archivist, in charge of the art collections at the court of the Ashikaga shoguns (the generalissimos of the Muromachi period), where he also acted as tea master. He wrote the first critical essay on Japanese art, in 1511, and his landscape has the lightness and freedom and the remote, wide backgrounds of that of the Sung.

Towards the end of this period, however, the pure ink technique derived from China merges with the *yamato-e* colour painting that had never entirely disappeared. Lively lake and sea pictures by Sesson Shukei (1504–post-89) are executed in ink and light colours on paper, and often show boats and shipping in great variety (page 189). In the new appreciation of colour the lead was taken by the Kanō school, which had originated in the monasteries, and reached its height with the Tosa clan in the Edo period (1615–1868). The Tokyo National Museum has a landscape attributed to Tosa Mitsuyoshi, most illustrious of the family, painted on

above: *Japanese art, Ogata Kōrin:*
The Bay of Matsushima, *early*
eighteenth century (Edo period).
Six-panel folding screen, painted in
ink and colours; 1.55 m x 3.78 m.
Boston, Museum of Fine Arts,
Fenollosa-Weld Collection.

right: *Japanese art, Sakai Hōitsu:*
Summer Rain, *early nineteenth*
century (Edo period). Detail of
two-panel folding screen of painted
paper; 1.66 m x 1.83 m. Tokyo,
National Museum.

the panels of a folding screen in the second half of the six-teenth century (page 190). Winding, brilliant lines of green and brown on a golden background magically suggest the riverbanks and trees, and a quarter-moon in the golden sky is all that tells us it is night. With this artist we enter the short Momoyama era (named after a palace near Kyoto), which, though lasting only from 1573 to 1615, is artistically impor-tant for two reasons: it marks the beginning of a progressive withdrawal from the Chinese monochrome convention, and the emergence of painting, hitherto largely the affair of monks, from the temples and monasteries. From now on, more and more artists are found in the outside world. Kanō Eitoku (1543–90) and Hasegawa Tōhaku (1539–1610) still work in monochrome, but the former, with his brilliant, flickering, thin black brushstrokes (though he also used colour), is entirely un-Chinese, as may be seen in *Chao-fu and the Ox,* National Museum, Tokyo; and Hasegawa Tōhaku, a follower of Sesshū Toyo, develops the latter's chiaroscuro with the lively freshness we see in his *Pine Tree* (page 193), where the varying breadth of the brushstrokes gives a won-derful impression of branches vanishing in the mist.

Between the Momoyama and Edo periods–Edo, later to become Tokyo, was the capital from 1615–there was much painting of views on the Uji River near Kyoto, with its bridges, mills, and locks (pages 194–195). These views are in a new landscape mode that has nothing to do with the Chi-nese tradition. Instead of touches of ink and shading, there is elegant outline, sinuous and subtle, clear against the golden ground. It is this exquisite decorative art that was to be so much appreciated in the West; a rarefied and beautifully linear style, in many ways the opposite of the older, and never abandoned, Kanō school, and one to which Japanese artists adhered, through all other schools and variations, right up to the end of the Edo regime in 1868.

It culminates with Nonomura Sōtatsu and his followers, the greatest of whom, Ogata Kōrin (1658–1716), had been trained in the school of Kanō. His masterpiece is a wonderful six-fold screen, now in the Museum of Fine Arts, Boston, decorated with a view of the bay of Matsushima (pages 196–197). The waves, beating around the craggy green islands, are

the finest possible, almost abstract, lines, yet so brilliantly drawn that we both see and feel that stormy water. Ogata Kōrin was himself the founder of the Rimpa school, whose subjects–plants and flowers–were painted, as in the West, directly from nature, in minute detail, though the decorative character of the composition as a whole is never lost. Most distinguished of the Rimpa artists was Sakai Hōitsu (1761–1828), who painted charming silver-ground screens (page 197).

The last great names are those of Katsushika Hokusai (1760–1849) and Andō Hiroshige (1797–1858). Both are view painters in the modern sense of the term; their pictures are innocent of symbolic or religious undertones, meant only to show the beauties of known, identifiable places. The fame of Hokusai, whose fancy on occasion borders on the bizarre, rests chiefly on his series *Thirty-Six Views of Mount Fuji*. This appeared in 1831–33, having been preceded by the *Hundred Views* in 1817, and displays the conical white peak from every conceivable and inconceivable standpoint. Once, surprisingly, it is framed in a cresting wave (page 199). The whole series, at times not far from Mannerism, demonstrates the inex-haustible imaginative powers of its creator.

Hiroshige sticks much closer to reality. Even his effects of atmosphere are more balanced and more narrowly observant, as we see in his *Fifty-Four Stages on the Tōkaidō*–the wide, tree-lined coast road running from the shogun's capital to the emperor's at Kyoto. All these views, and various sets by the same artists, were issued as woodcuts in the *ukiyo-e* style ("the floating world"). Since the seventeenth century this had pictured the trivial and transient incidents of life in black-and-white or coloured prints employing the *kara oshi* technique, in which the areas of blank paper are vital to the composition. These were the prints which, together with those of Utamaro (1753–1806), made such an impact on the French Impressionists and other European painters when ex-hibited in Paris in 1867 and 1889; and the three masters–Hokusai, Hiroshige, and Utamaro with his portraits of allur-ing Japanese courtesans–became, as they remain, very popu-lar. They were precursors of the modern integration of Western and Oriental art.

REALITY AND IMAGINATION
The Nineteenth Century

Neoclassical painters, it is generally held, had no time for landscape, or were at best indifferent to the beauties of nature. Jean Dominique Ingres (1780-1867), making his one considerable landscape in the big lunette of the *Golden Age* fresco at the château of Dampierre in about 1848, groaned over it as "Iron Age làbour"; and it proves to be little more than a bushy hedge, without depth, behind some splendid nudes. Three small tondi of 1807 come, therefore, as a surprise. Only six inches or so across, they are captivating glimpses of parks in Rome, done from nature when he was a young man. The prettiest of them, now in the Musée des Arts Décoratifs, Paris (page 203), shows Raphael's house–pulled down, alas, in 1848–basking in sunshine among the pines of the Villa Borghese: as full of light, as logically composed, as a Corot of twenty years later. All three are equally fresh and charming, and Ingres never did anything else of the kind.

The adjective romantic was already in use in England at the end of the seventeenth century with the meaning "resembling of romance." It was during the eighteenth century that it came to denote the opposite of classical, and in time, as applied to the plastic arts, of neoclassical; in the nineteenth century it was to acquire a variety of meanings. It is in England therefore, where William Blake and the naturalized Swiss Heinrich Füssli, or Henry Fuseli, anticipated the whole Romantic movement, that we begin our survey of romantic landscape.

There is of course no hard and fast dividing line, in chronology or even style, between classical and romantic landscape painting. Richard Wilson's "grand manner" already has a vein of romance in it; John Martin (1789-1854) and James Ward (1769-1859) bring us to the real thing, with a strong

Caspar David Friedrich: The White Cliffs of Rügen, *c. 1818. Oil on canvas; 90 cm x 70 cm. Winterthur, Reinhart Foundation.*

flavour of the sublime. The sublime was an emotional appeal, part of the ethical and aesthetic furniture of the Pre-Romantic and Romantic eras. It stood for feeling as opposed to cold reason. Instead of the detached contemplation of beauty and its ensuing calm delights, the sublime afforded transports of the soul, amazements, long thoughts aroused by boundless prospect and grandiose spectacle—at times savage and "horrid" as well as grandiose—and by the unleashed powers of nature. This attitude, rather than taste, had guided Ward in the choice of his most famous subject, Gordale Scar in Yorkshire. It cost him untold effort in drawings and oil and watercolour sketches; he exaggerated the height and incline of the great limestone ravine, and dramatically exaggerated its light and shade; and produced a final version that measures over ten feet by twelve. (Which was nothing for him; one of his pictures is a good thirty-six feet wide.)

This sublime Gordale Scar inspires fear and wonder, as do the mountain peaks of John Martin. For his subject matter he turns constantly to literary sources and the darker medieval legends, and his miniature humans are all but invisible amid the cataclysm and turmoil of cosmic events. Another anti-Academy man was the Irishman Francis Danby (1793–1861), whose landscape is unarguably romantic, somber and shadowed, or aflame with sunset light. He may borrow his construction from Claude Lorrain, but Walter Scott and Ossian set the scenery.

Joseph Mallord William Turner (1775–1851) had the deepest reverence for Claude, who with Poussin had an early and fundamental influence on his work; so much so, indeed, that his *Festival at Mâcon,* exhibited at the Royal Academy in 1803 and now in the Graves Art Gallery, Sheffield, can be read as a perfect classical landscape. Yet he had experienced the Swiss Alps in their sublimity the year before, recording his journey in direct and simple watercolours and in the famous *Devil's Bridge, Pass of St. Gothard* (now in the Birmingham, England, Art Gallery), with an inky chasm that makes one's head go round; and he would subsequently devote himself to the close and penetrating study of the En-

glish scene. But in 1819, past his fortieth birthday, he travelled to Rome and Venice (visited again in 1835 and 1840), and it was the first sight of Italy that was partly responsible for a marked change of style. In this new and definitive phase solid shapes dematerialize in atmosphere; they are transmuted into wraiths of light shot through with blazing colour; perspective distance is invaded by, and yields to, a vision of space that is nothing but colour, from the fire-opal blaze to vaporous, transparent wisps of tone. Earth, sky, and sea are fused in a sort of primeval chaos, with whirling eddies of light and shadow, as in *The Morning After the Deluge,* at the Tate Gallery (pages 8–9); or curtained in rain; or veiled in drifting clouds, as in the *Storm at Sea,* in the same collection. Many of these pictures symbolize the eternal struggle of Light and Darkness, conceived by the Romantics as no less spiritual than cosmic; but they are at the same time so freely executed, with such immediacy in their *plein air* effects of luminous atmosphere in long, clear distances, that we may consider them as among the most significant precursors of Impressionism.

Nothing could be further from the Turner of the late landscapes than the band of artists known as the Norwich school. Instead of showing us what a place looks like, Turner will often present the purely lyrical evocation of storm or dawn or sunset—the essence of some special moment or condition which moves us and seems to involve and change the universe. For them, all Norwich men by birth or residence, the main purpose is to paint East Anglia, its coast and landscape, exactly as they saw it. Stylistically apart from them, however, is John Sell Cotman (1782–1842), though he also came from Norwich, and opened a drawing academy there in 1806. Even in watercolour there is neatness and vigour in his crisply organized composition and flat colour areas.

So we come to John Constable (1776–1837), greatest of the English landscape painters. His entire art rests on fidelity to Nature: real, observed Nature, which he loved down to her humblest, least spectacular or obviously inspiring aspects, for they, too, he thought, attested God's presence and spoke

directly to the heart. Not that Constable reproduces mere banal "truth." Wordsworth's notion of the purpose of poetry was his of painting—that it should, in appropriate and expressive terms, transfigure familiar things. (This has been pointed out by Mario Praz.) So much is proved by the hard work he puts into his landscapes, trying above all to identify and depict what his letters more than once refer to as "the chiaroscuro of nature." This for him was not only the basic principle and unifying element of the composition but, in Lord Clark's words, "the keynote of feeling in which the scene was painted." His landscape, with its echoes of the Dutch masters, Ruisdael especially, thus takes on a new spiritual dimension. The starting point was always a first quick impression of what he actually saw on a certain day and at a certain hour, in certain weather; occasionally he notes such data on the drawing. From this he will make large oil sketches which, though more elaborate, retain the freshness of the original jotting and are now usually preferred to the finished work, where accuracy is not always innocent of pedantry. Most of Constable's landscapes are flooded with light from the broad sky and evince a close and loving communion with nature. The paint is rich and fluid; light and shade gain emphasis from the pure colours thickly laid on, often with a palette knife. Pictures by him caused a sensation among French painters when shown at the Paris Salon of 1824.

That Salon was also a triumph for Richard Parkes Boning-

ton (1802–28). Despite his tragically short career, Bonington is surpassed only by Constable and Turner as a landscape painter in the transition period between Romanticism and Realism. Constable never went abroad, for his vocation, he said, sprang from love of his native Suffolk: "Those scenes made me a painter, and I am grateful." But Bonington left home at seventeen (his father had had to emigrate to Calais) to study in Paris, and travelled widely in France and the Netherlands. Later he visited Italy, and Venice still kindled his imagination in his last three years of life, in England. He and Constable were firm friends, but though there are resemblances in their work, his is the more varied subject matter. This becomes most evident in his coastal studies with their huge transparent skies, and in the concentrated composition that has affinities with the landscape of Corot.

In France the course of politics had a strong, if indirect, influence on landscape painting of the Romantic era, for when the July Revolution of 1830 was followed by the reactionary regime of Louis Philippe several radically minded artists took themselves off to the village of Barbizon near the forest of Fontainebleau, to seek consolation and inspiration in the country. The most talented, though not the first to make the move from the capital, was Théodore Rousseau (1812–67). His early training had been among neoclassical pupils of Jacques Louis David, but the study of Dutch seventeenth-century and English landscape art—of Constable in particular—led him to paint from nature in the environs of

right: *John Martin:* The Bard, *before 1817. Oil on canvas; 2.13 m x 1.55 m. Newcastle-upon-Tyne, Laing Art Gallery.*

below: *Francis Danby:* The Enchanted Castle, *painted before 1841. Oil on canvas; 0.84 m x 1.17 m. London, Victoria and Albert Museum.*

Paris. The forest was a tangle of branches that seemed to pulsate with a mysterious life-force; there were sudden shafts of light through dark leaves overhead, great trees by lonely heaths and ponds. Rousseau lingered over every detail of his trees, attempting, as critics have noted, to reveal their "psychology," and endowing them with a melancholy, elegiac air that is, in fact, romantic.

Other Barbizon artists were Constant Troyon (1810–65)

and Narciso Virgilio Diaz de la Peña (1808–76), who was of Spanish extraction, from Bordeaux. He painted the bushes and undergrowth in dabs of unmixed, brilliant colour. These two and Rousseau made an almost religious cult of nature. In retreat from the artifice of urban life, they equated it with lofty moral values. Jean François Millet (1814–75), for his part, saw the country not as an Arcadian or literary background but as a working place. With grave and subtle in-

Joseph Mallord William Turner:
Petworth Park; Tillington
Church in the Distance, *1829.*
Oil on canvas; 0.63 m x 1.39 m.
London, Tate Gallery.

above: *John Constable:* Wivenhoe Park, Essex, 1816. *On canvas, 0.56 m x 1.01 m. Washington, National Gallery of Art, Widener Collection.*

right: *John Sell Cotman,* Greta Bridge, 1805. *Crayon and watercolour; 24.2 cm x 33 cm. London, British Museum.*

sight he glorifies the hard, common toil of shepherd and cultivator, for he came of similar stock—"a peasant and nothing but a peasant," as he liked to proclaim. The breadth and graphic economy of his rural landscapes match the substantial figures without which the pictures themselves would be unthinkable. There is something almost sacred about Millet's peasants in their steadfast poses, their monumentality, their palpability.

After the revolution of 1848 Millet lived more or less permanently at Barbizon and in his last years, on the example of his friend Rousseau, turned increasingly to pure landscape in oils or pastel, always with this same touch of sacredness. He used pastels with superb skill, and the gentle melancholy, the light and colour of his *Spring,* for example, done in oils some time between 1868 and 1873, suggest the world of Symbolism (pages 226–227).

Another frequenter of Barbizon was Charles Daubigny (1817–78), of the simple, uncluttered landscapes, who from 1852 was to be the intimate friend of Corot. Jean Baptiste Camille Corot (1796–1875) is the acknowledged giant among the landscapists of nineteenth-century France. He had

above: *Richard Parkes Bonington:*
Mountain Landscape. *Oils; 26.6
cm x 34.2 cm. London, Tate
Gallery.*

known the forest of Fontainebleau before the colony existed
and by 1830 was a mature artist, whose professional and
ethical standards were an inspiration to the school of Bar-
bizon: "school," of course, in the most general sense, for it
had no set theory or program. He was in his twenties when
he started painting and, despite lessons from two academic
landscapists, Achille Etna Michallon and Victor Bertin, the
latter a follower of David, always said he had no masters.
This denial was not due to pride—he was the mildest and
most generous of men—but to humility. Incapable of absorb-
ing much from other people and conscious of the fact, he put
his trust in his own methods, suggested by his own vision—
candid, naïve, offspring of a serene dedication to nature.
(Baudelaire in his review of the 1845 Salon spoke of his
naïveté and Corot, agreeing, often called himself *naïf.*) He
was an instinctive painter. Argument, theories, programs
were not his line at all. His entire personality and way of life
centered on the contemplation of beauty, which he saw
everywhere in nature, in human beings and in landscape. He
worked purposefully, with unbelievable discipline, in and at
his own idiom, and never seemed to stop. (The initial, and

incomplete, Corot catalogue ran to some 2,500 paintings.) An early biographer, Roger Miles, gives a moving account of him on his deathbed when, gasping with fever, "fingers curved around imaginary brushes," he kept repeating, "See how beautiful! I never saw such beautiful landscape!" And we are reminded of Donatello, dying at eighty-three, still "modelling" clay in trembling, half-paralyzed hands.

Italy had been a revelation to Corot. It was there he discovered his beautiful landscapes and how to paint them: feeling, he said, must be the only guide. To him Italy meant not galleries of Old Masters, but dazzling landscape— *l'éclatante nature*—and Mediterranean light. To the rapturous

years between November 1825 and September 1828, when he was visiting Rome, Naples, and Venice, belong his first fully realized masterpieces, *The Colosseum* and *The Bridge at Narni*, in the Louvre. He went again in 1834, more in love than ever with the scenery, to Rome and Venice, the Lakes and Tuscany, where he painted magnificent landscapes near Volterra; and again in 1843. With each journey he awoke to more, discerned more.

But it is not easy to sum up what is so wonderful, and so new, about Corot. The spontaneity, the instinctive rightness are also deeply considered. A sense of order and construction links his art to that of Poussin and Claude Lorrain, yet he

Jean Baptiste Camille Corot:
Cornfield in the Morvan, *1842.*
Oil on canvas; 75 cm x 38 cm.
Lyons, Musée des Beaux-Arts.

venerated them, it is said, without enthusiasm and they seem to have no visible influence on him. "Better to be nothing than the echo of others," he wrote. And, addressing hypothetical pupils (whom in practice he refused to accept), "In nature, look for form to start with; then work out values and relationships of tone, then paint your picture." His landscapes show us what he meant. They are solid, and solidly painted in dense masses of colour permeated with light which, though keyed to his low tones and opaque shadows, is not diffused in the atmosphere. The shadows are opaque because the veil of transparency would make the shapes less solid, and he unhesitatingly flouts the fundamental rule against the mixture of white with dark colours when using oils.

The newness of his method is most evident in the landscapes this timid yet impassioned man painted as an emotional outlet and let hardly anyone see. Less "finished" than his Salon pictures of nymphs and swains in solemnly classical settings, they have led to the belief that Corot was a sort of Jekyll and Hyde. But he would feel no artistic contradiction, indulge in no opportunism or pandering to academic taste. He had too scrupulous a professional conscience for such things, and there is in these pictures too much regard for the poetical and almost transfigurative power of memory. Mem-

ory, the recollection of things and places seen and loved, grows steadily more important to him, and several of his famous later works are specific "souvenirs": the 1869 *Souvenir of Mortefontaine,* the *Souvenir of Castelgandolfo.* He is recreating reality in the studio, with a slight added mournfulness that may in turn produce imaginative essays like *The Gust of Wind,* no less true in style and inspiration than are the views and landscapes taken straight from nature. It is the private meaning in Corot's pictures that makes them romantic and distinguishes them, above all, from those of the Impressionists, who are immersed in the actual physical appearance of nature.

In Italy the great manifestation of the Romantic movement was, of course, romantic opera. Its achievements in painting, compared with those of France and England, are relatively modest and more or less confined to Lombardy and Piedmont, the only Italian artists to gain any reputation in Europe at large being Giovanni Carnovali, known as Il Piccio, and Antonio Fontanesi.

Carnovali (1804–73) studied Luini and Correggio in his youth, and hints of their voluptuous grace and charm are found in his fine mythological sketches, while Mia Cinotti notes in his highly individual landscape style "a curious mingling of sixteenth- and seventeenth-century fantasy with a foretaste of Lombard naturalism." He employs a free technique, obtaining effects of dense and luminous colour with dots and clots of paint and the juxtaposition of pure tones. Paint is scraped onto the canvas, or flicked in rainbow touches that make the shadows vibrant and fill the spaces with delicate mist. He was an exquisite nature poet, loathed the squabbling of artistic coteries, and preferred a solitary life in the country. (And as an old man he was drowned when swimming, unaccompanied, in the River Po.) Carnovali both broke with the neoclassical academic art of the day and revived the Lombard school of view painting, where the chief figure before him had been Giovanni Migliara. The lyrical chiaroscuro of Migliara influenced Tranquillo Cremona and had much to do with the institution of the Bohemian or Scapigliati group—realism and art-for-art's-sake—in Milan.

Antonio Fontanesi (1818–82) was a cultured cosmopolitan, a convinced admirer of Corot and the painters of Barbizon, of Constant Troyon and Auguste Ravier in particular. He travelled a great deal, was professor of landscape art in Turin, and taught for two years in Tokyo. He also lived for

some time in Florence, where the theories of the Macchiaioli, or "patch painters," failed to change his innate romanticism. Serious and introspective, he found in nature an "unease and uncertainty," in Marziano Bernardi's phrase, to match his own. His pictures are simple, the nature elements in them few. Trees form big side wings, or stand alone in the fore-

ground against the light; his backgrounds are shining, or enveloped in distant cloud or falling dusk. All conventional enough, but imbued with a sense of melancholy, the romantic yearning for the infinite, beyond human reach or sharing. This feeling is personal to Fontanesi, but his fluid style, his light that seems almost to consume the canvas, would influ-

left: *Giovanni Carnovali (known as Il Piccio):* Alpine Foothills, Morning, *1862–63. Oil on canvas; 0.83 m x 1.22 m. Brescia, private collection.*

below: *Antonio Fontanesi:* Morning, *c. 1856–58. Oil on cardboard; 20 cm x 31 cm. Turin, Galleria Civica d'Arte Moderna.*

216

ence men such as Vittorio Avondo and the sensitive Enrico Reycend among the succeeding generations of Piedmontese landscape artists.

At the other end of the peninsula there is some romanticism in the work of Giacinto Gigante (1806–76), one of the talented circle gathered about an excellent Dutch landscapist named Anton Pitloo, who had come to Naples in 1815. Its members formed the nucleus of what the reigning academics, in scorn, christened the school of Posillipo, but if the Posillipans, as was implied, tended to make too much of local folklore, they at least represented the liveliest current of southern Italian art. In 1828 a Turner exhibition in Rome stimulated Gigante to unrestrained romance. His images, says Raffaello Causa, came "from books, from dreamy ecstatic myths of enchanted isles and foreign lands, of thickets haunted by nymphs and satyrs, their presence betrayed by hidden signs, small quiverings of light, suddenly fractured brushstrokes." Deservedly popular in Naples, he was also the leading watercolourist in Italy. As such he paints his most vivid and charming landscapes, with forms built up with thin washes of colour, light and even.

In northern countries the romantic view of nature varied enormously. Painters were either sternly realistic, as was the Austrian Ferdinand Waldmüller in his Alpine pictures, or they tried each to heighten the characteristic beauties of his native country. When Julius Schnorr von Carolsfeld (1794–1872) portrays the German Alps, for instance, it is with fantastic effects of red light on the snow. He spent some time in Rome, where, although a Protestant, he was one of the Nazarenes, a group of Catholic German artists among whom was the Austrian Joseph Anton Koch (1768–1839). Koch had been to Switzerland and now sought to apply the classical severity of Poussin to his mountain scenes, so that he may perhaps, despite their strong romantic flavour, be regarded as the last painter of heroic landscape.

Patriotically inspired Romantics in Scandinavia included the Danish Christen Købke (1810–48), the Swede Simon Marcus Larsson (1825–64), famed for his pictures of the North Sea, and the Norwegian Johann Christian Dahl (1788–1857). Dahl, who is the most important of the three, studied the Dutch masters and became a friend of Caspar David Friedrich after settling in Dresden in 1818. He shows Nature at her most spectacular, if not terrifying; a *Study of Clouds* in the gallery at Goteborg is an example of his glittering, vast, tempestuous skies.

Friedrich (1774–1840), undoubtedly the greatest exponent in northern Europe of the romantic conception of landscape—and not of landscape alone—was a genius. His painting ranks with the poetry of Heinrich von Kleist, Novalis, and Goethe, all of whom were his friends and fervent admirers. He observed and conveyed the sublime in nature with unmatched depth and understanding, and with detail so clear that one looked at it, thought Von Kleist, "as if one's eyelids had been cut away." Yet in his pictures everything carries a sense of immanent mystery, of the bewilderment of man confronted with the huge Creation. It seems right that the few figures, standing on mountain peaks or precipices, on deserted beaches, dunes, or rocks, gazing at the sea, brooding, questioning, should never have their faces to us. In fact these figures represent, or are, Friedrich himself, and nothing he beholds lacks symbolical or religious meaning. A limitless landscape is dominated by the Cross, the towers and pinnacles of a Gothic cathedral thrust between forest and sky. His rocks are salvation by faith, his clouds the errors of humanity or the untellable future. Blasted oaks stand for death. A crescent moon over the sea is the birth of Christ, a rainbow God's reconciliation. Even the apparently uncomplicated *White Cliffs of Rügen* (page 200), probably a reminiscence of his honeymoon there in 1818, is wholly allegorical. He lived and worked in spiritually elevated circles where symbols and allusions were readily grasped and appreciated; where a patron could order an altar picture from the sketch of a slender cross among fir trees on an Alpine hillock. In one way his art might be seen as continuing from medieval saint and mystic, restating the message of redemption enshrined in sculpture, fresco, and cathedral. Many painters of the Romantic period

and after worshipped nature. Friedrich was a nature worshipper who lived his religion, though the complex ideas behind his work neither obscure the passionate sincerity that urges him nor impair the formal values of his painting. In his feeling for infinite space, for light and colour, he is a great creative artist.

With the Swiss Arnold Böcklin (1827–1901) religion is less in evidence than mythology and literary allusion. Educated in Germany, Böcklin visited Rome in 1850, from which date his so-called Mediterranean landscapes are a melee of nymphs and satyrs, sirens and centaurs, personifications of the seasons, the forces of nature and the ages of man. He came late to the German Romantic movement and contributes little to our subject, for these are canvases of an academic professionalism strangely at odds with the perhaps genuine anxieties and inner anguish that fed his aspiring imagination. But a mediocre painter will occasionally come up with a masterpiece, and Böcklin produced *The Island of the Dead* (pages 220–221), and made several versions from 1880 on. The mesmeric power of this picture, and its originality, lie in the meticulous handling that makes an unreal and forbidding place real and compelling.

Meanwhile a new continent had entered art as well as history. There had been American-born painters since the end of the eighteenth century, and European painters had settled there (in North America, that is; the colonial art of South America, exclusive of landscape, demands separate treatment), but America was without a true and important landscape tradition in the early days. However, in 1836 Ralph Waldo Emerson published his lectures on nature, preaching that God, man, and nature are romantically one – the doctrine of Transcendentalism – and this only a year or so after Thomas Cole (1801–48) came back from a trip to Europe, brimming over with the discovery of Poussin, Lorrain, and Turner. Together with the English-born Thomas Doughty (1793–1856), who had studied Dutch art of the seventeenth century, Cole founded the Hudson River school, which would comprise the best talents of New York and New

above: *Simon Marcus Larsson:* Sogne Fjord, 1861. *Stockholm, National Museum.*

right: *Arnold Böcklin:* The Island of the Dead, *version painted after 1880. Oil on wood; 0.80 m x 1.5 m. Leipzig, Museum der bildenden Künste.*

right: *Johan August Strindberg:*
Stormy Sea. *Oil on canvas,*
mounted on cardboard; 31 cm x
19.2 cm. Stockholm, National
Museum.

following pages: *Albert*
Bierstadt: Morning in the Sierra
Nevada. *1.42 m x 2.18 m. Tulsa,*
Oklahoma, Thomas Gilcrease
Institute of American History and
Art.

England—all of them, as it happened, landscapists. Apart from their Emersonian attitude to nature, these painters were primarily inspired by love of the land they lived in, untouched, magnificent, beautiful: one of Doughty's finest works is actually entitled *In Nature's Wonderland.* They travelled ever more widely about America, over the north and west. Albert Bierstadt (1830–1902), whose German parents had come to Massachusetts a few months after his birth, reached the lonely lakes and the grandeur of the Rockies and the Sierra Nevada (pages 222–223), and Frederick Edwin

Gustave Courbet: Roe Deer in a Forest, *1866.* Oil on canvas; *1.74 m x 2.09 m. Paris, Louvre.*

Church (1826–1900) made views of Niagara Falls. There is enormous space in these pictures, and something approaching alarm before the untamable violence of nature. They are thus symbols of what John Wilmerding calls the "savage iconography" of America.

We return to France and the case of Courbet (1819–77). His political and social ideas do not concern us here, though he sincerely believed in and actively upheld them, spelling them out in *The Stone Breakers, Funeral at Ornans,* and *Women Winnowing Corn.* These are, literally, revolutionary pictures, narrowly saved from being mere socialist sermons because they are only masterpieces. It is his landscape which proves how irrelevant to great painting are the neat labels and declarations of intent that artists, as well as critics, are so fond of.

Gustave Courbet grew up in the Late Romantic heyday and, self-educated by dint of hard application and the copying of Old Masters—the Flemings, Rembrandt, Velázquez—is rightly hailed as the father of realism. But the odd thing is that he, who is supposed to have said to Corot once, as they worked at some vista side by side, "I am not strong like you, Monsieur Corot: I have to paint what I see," should then have painted what we see in *The Studio,* of 1855. This enormous canvas bore the subtitle "A real allegory, the interior of my studio, which determined a phase of my life that lasted seven years." There they are assembled, the writers and artists who shared in "communal action" on behalf of realism. And there he is himself, observed by a model—naked Truth, of course—busy on a landscape. Not out of doors, but in.

The fact is that the development of Courbet's art, straightforward enough in his figurative work (after 1848–50, at any rate), is less so in the landscapes he painted all his life, and about which there is a slight ambiguity. Not because some were done in the open air—probably those of the country around Ornans and the Loue valley, where he was born, and of the Normandy coast—and others in the studio. The ambiguity lies in a half-romantic attitude to nature. In the late work especially this is evident in the careful arrangement, the viewpoint chosen to emphasize the beauty of the scene, and

right: *Jean François Millet:*
Spring, *1868–73. Oil on canvas;*
0.86 m x 1.11 m. Paris, Louvre.

on page 228: *Johann Barthold*
Jongkind: The Inn, *1869. Paris,*
Petit Palais.

on page 229: *Édouard Manet:*
The Swallows (The Artist's
Wife and Mother), *1873. Oil on*
canvas; 65 cm x 81 cm. Zurich,
Emil G. Bührle Foundation.

most evident in the feelings conveyed: the exact emotion of someone who watches a storm at sea or ventures among wild deer in a forest. These are pictures to refute the reproach of his friend and supporter Baudelaire, who said he sacrificed imagination, "the queen of faculties," for the sake of realism. Courbet, being an artist, had imagination. He no more disdained the aid of photography than the eighteenth-century *vedutisti* did that of the camera obscura, but his imagination surmounts pedestrian reality and finds a pictorial language to express, in sheer intensity of painting, what Giorgio Castelfranco calls "a well-defined mental image." Light and pigment fuse together. The brushwork sparks with energy, seeming to conjure up things he knows by heart with dazzling, almost sensuous tangibility – hard rock, rough bark, the swirl and ruffle of skirts, a girl's delicate flesh. The bridge from naturalism to Impressionism is most easily, perhaps unknowingly, crossed in Courbet's marvellous landscapes.

They represent only one branch of his art, however, for he also painted figures, still life, and portraits, whereas the Impressionists found in landscape their ideal art form. It offered perfect scope for what they wanted to do, and how they wanted to do it, and their very name originated with a landscape.

There was no Impressionist school or prescribed plan of action. There was a band of friends sharing a great love of nature, which they understood, or rather saw, as colour and light. In 1874 they held their first show in an empty studio lent by the Parisian photographer Nadar, and the public was appalled. It was appalled at the freedom and immediacy of execution, appalled at what it took for flagrant neglect of proper "subjects" by Monet, Pissarro, Sisley, Cézanne, Renoir, and others regularly refused admission to the official Salon, and greeted the whole thing with ridicule and outcry. Among the pictures was Monet's *Impression: Sunrise,* and Leroy, the critic of the paper *Charivari,* sneeringly referred to the show as "an exhibition of impressionists." In complete incomprehension, he named the most glorious episode of nineteenth-century painting.

226

It was not a movement that just happened and we shall not pause to unravel the complicated story. Its main link with the second generation at Barbizon was Daubigny, who knew Corot and Courbet and influenced Monet, but the true forerunners are Johann Barthold Jongkind (1819–91) and Eugène Boudin (1824–98). Jongkind, a Dutchman, went to live at Le Havre in 1846. Most of his landscapes are in water-colour, with a light touch and transparent atmosphere. Boudin, too, painted on the Channel coast, luminous pictures with huge skies that earned him the epithet *roi des ciels* from Baudelaire; and it was he who taught Monet to work in the open air.

The great productive span of Impressionism was short, from about 1866–67 to 1880, and the three leaders were Claude Monet (1840–1926), Camille Pissarro (1830–1903), and Alfred Sisley (1839–99). Others, such as Édouard Manet (1832–83) and Pierre Auguste Renoir (1841–1919), though less authentically Impressionist, shared the same aims and impulse and may even have been better painters. But all the Impressionists were terrific characters and each of these had an unmistakable style and manner. Also, they loved the places where they chose to live and work. With confiding simplicity, utterly unaffected, they plunged heart and soul into "their" villages, small towns, or regions, so that now one is apt to think of the place before the painter. They picked nowhere particularly grand, famous, or unusual, no recognized beauty spots. They went where anybody might go for a quiet interval away from city streets, on a modest middle-class summer holiday or a Sunday outing. They introduce a new kind of landscape and make of it superb art, not by using it as a vehicle for ideas but because of how they see and paint it. Light and colour form a single harmony, indepen-

dent of subject, setting, or viewpoint, and we as spectators, needing none of these aids, are involved at once. Out of pure, inclusive love they create new poetry and happiness, and make us part of it, by looking at the real world.

"Monet is only an eye, but what an eye!" said Cézanne, paraphrasing what Ingres said of Courbet. Impressionists saw colour as it was, permeating shadows, killing black and neutral tones, dissolving every outline, and their technique for painting what they saw was absolutely fresh. The humblest thing, snatched in the flow and throb of light, is transformed into a fragment of universal life. Trouville, Ste. Adresse, and Honfleur in Normandy, Bougival, Argenteuil, La Grenouillère, Louveciennes, Vétheuil (where Monet's first wife died in tragic poverty), and Le Port-Marly on the Seine, Pontoise—unpretentious, ordinary places with no history to speak of, we know principally because of them. Moreover, they stay

with us, Pontoise, Argenteuil, and the rest. To hear them mentioned is enough, passport to a land of lost contentment that is ours, is everyone's, before it belongs to art experts and critics. This, surely, is the secret and the glory of the Impressionist painters.

Their landscapes were not always rural. A city could inspire the same lyricism as did country, river, and seashore. They painted Paris, her bridges and boulevards, with the plane trees and the people. They painted in Holland and Venice, and in London fog; they painted Gothic cathedrals, huge facades, architecture and ornament blurred in flecks of luminous colour. Monet, the preeminent Impressionist, was as happy perched in the smoky hangar of the Gare St. Lazare, watching steam from the engines blowing away in early morning light, as by the Bacino in Venice or the banks of the Seine. Water fascinated and bewitched him and the series

above, left: *Camille Pissarro:*
L'Hermitage, Pontoise, *1873.*
Oil on canvas; 55 cm x 65 cm.
Basel, Kunstmuseum.

below: *Alfred Sisley:* Flood at Le
Port-Marly, 1876. *Oil on canvas;*
60 cm x 81 cm. Paris, Louvre.

above, right: *Pierre Auguste*
Renoir: The Rising Path, *c. 1874.*
Oil on canvas; 0.6 m x 0.74 m.
Paris, Louvre.

of colossal *Water Lily* studies of his last years—the largest of them covers the walls of a special room at the Orangerie in Paris—mark the zenith of Impressionist colour which is here almost like music, akin to the piano and orchestral scores of Debussy (pages 232-233).

The loveliest townscapes are by Pissarro, eldest of the great trio, and loveliest among them those he painted from high windows in Paris or Rouen. During ten years in what was then the small village of Pontoise he had, however, found much simpler subjects in the Vexin countryside. Mindful of Corot, who, contrary to his custom, had given him lessons, he treated them with a constructive clarity that has something of the vibrating light of Monet and something of Cézanne's solidity.

Other masters influenced Alfred Sisley, who was born in Paris, where his English parents had an export business. As a young man, supposedly occupied at the London office, he spent much of his time looking at pictures—Gainsborough, Constable, Turner. The memory of English landscapes is in

his sober style and the subdued colours that suit the winter daylight, the muddy lanes, the snow and floodwater of his chosen motifs. He painted *The Flood at Le Port-Marly* (page 230) in several versions, some of them his most expressive and poetic work.

Unlike Sisley, who was a landscape artist pure and simple, Manet did little unfigured landscape. Exceptionally, there are the fresh, lively oils and watercolours of a summer holiday at Berk-sur-mer in 1873. Instead of the dark colours he had admired in Goya and the Spanish school, he puts light into the tones and builds up shapes in broad flat areas. Concision in art, he said, was "necessary and elegant."

When we consider Renoir's *Luncheon of the Boating Party,* of 1881, we look at a masterpiece of nineteenth-century art. It is also a landscape masterpiece containing hardly any scenery, by a painter who declared that he wrestled with his figures "until they are one with the landscape of their background." Through reedlike bushes there is a glimpse of sparkling river, young men and girls talk around a table; a breeze

stirs the edge of an awning above them and brings light and happiness from the tiny landscape flooding over everything. Clothes, and flowered hats, and bottles and glasses on a clean white cloth are part of the delight in nature that we sense so often in Renoir.

Many of his pure landscapes date from the years between 1869 and 1874, when he and Monet would work together by the Seine, and Impressionism was young. A favourite motif was that of field paths in tall grass (page 231), or with female figures, canvases that convey an intoxicated sinking into green springtime or golden summer. The multiple tones are rendered with almost feathery brushstrokes that seem to tremble with the joy of painting, which for Renoir was the

joy of life. It stayed with him into his old age at Cagnes-sur-Mer when he was crippled with arthritis; brushes fixed to his fingers, he went on painting splendid Titianesque nudes and the hills baking in Mediterranean sun.

Impressionism spread beyond France to other European countries, and to America. It is easily forgotten, perhaps, that James Abbott McNeill Whistler (1834–1903) is an American, for he had a Paris studio as a boy in his twenties. His first homage had been to Courbet and realism, but then he frequented the Café Guerbois in the Avenue de Clichy where the Impressionists gathered and might have been one of them had he not, during his long residence in England, adopted a decorative style, mannered and "aesthetic" and not

too far removed from Art Nouveau. When he rejected Courbet and realism (his reasons are set out in a letter to Fantin-Latour in 1867) he used the new technique for landscapes. The most celebrated and beautiful of these, the very Impressionist-sounding *Nocturne in Blue and Gold: Old Battersea Bridge,* was done in 1870–72 and is in the Tate Gallery (page 236). But he has not the direct Impressionist way of seeing. A suggestion of sentiment and exquisite, yearning melancholy lies like a veil between him and reality.

Mary Cassatt, though born in Pittsburgh, was educated and lived in France; she cannot be counted as an American Impressionist, nor were her landscapes numerous. On the other hand, Homer Dodge Martin (1836–97) qualifies as the oldest American Impressionist there was; a Hudson River artist, who went to Paris at the age of forty, he came under the influence of Barbizon and knew Whistler quite well. From then his landscapes were Impressionist, though there is some romantic feeling in his pictures, and occasionally they have romantic titles, like *The Harp of the Winds* for a tranquil French river scene of 1895, now in the Metropolitan Museum, New York (page 238).

More faithful to Impressionism in spirit than in style was Theodore Robinson (1852–96), for whom Monet was "the prophet of the new vision," and who stayed with him at his house in Giverny. The naturalism of Corot and Barbizon was introduced to America by George Inness (1825–94), and ap-

plied in his work to the passionate, and at times dramatic, study of weather and atmosphere. One of his finest pictures is the 1878 *Coming Storm* in the Albright-Knox Art Gallery, Buffalo (pages 238–239). But the greatest American artist of the century, Winslow Homer (1836–1910), was hardly touched by Impressionism. For him, nature is the enemy. He paints the open sea in forcefully realistic images of man's struggle with the elements (pages 238–239).

The first art exhibition after the unification of Italy was held in Florence in 1861. Twelve months later, twelve years ahead of Leroy of the *Charivari* and if anything less perceptive, a newspaper critic pronounced the realist group shown there to be *macchiaioli,* from their *macchie,* or patches, of colour. The name soon ousted the previous term, *effettisti,* and was welcomed by one of the best painters in the style, Telemaco Signorini, who wrote in its defense even before the discriminating Diego Martelli had analyzed its aims and methods. The movement was mainly Florentine, with a Guerbois in the Caffè Michelangelo, near the unholy ground of the academy of painting. Not that those who argued and debated at the Michelangelo from 1850 until it closed in 1861 were exclusively Tuscan, for all sorts and conditions of artists joined. But wherever they came from, whatever their cultural background, they were united against official art, dogmatic and historical art, formal academic art, and in favour of truth to the smallest workaday details of life and

landscape. As the sculptor and painter Adriano Cecioni said, "From the point of view of art, everything is beautiful." "Impressions from reality" were to be rendered in patches or spots of colour, light or dark, each endowed with its proper tonal value in relation to the whole. Recalling and fixing what he saw in juxtaposed patches of unmixed colour, the artist should "take nature by surprise." The result, Cecioni insisted, was not a sketch but a finished picture in which form and outline had played little or no part.

Though Gigante and the Posillipo school were their chief precursors in Italy, the Macchiaioli derived their attitude to nature from the romantic upheaval in France and the realism of Barbizon and Corot. French pictures were to be seen in Florence among the Demidoff family collections at the Villa San Donato, while several of the painters made the journey to Paris—Signorini, Serafino de Tivoli, the Roman Nino Costa, and the Veronese Vicenzo Cabianca. Their work thus escaped the provincialism that was to affect their followers almost into our own day, and took its place in the current of nineteenth-century art independently of the later Impressionist movement, from which it was quite separate.

Practically all the Macchiaioli were gifted landscapists and enthusiastic open-air painters. They loved the gardens and orchards of Piagentina, outside Florence, and what was known as the school of Piagentina consisted of Silvestro Lega, a native of Romagna, Odoardo Borrani, a Pisan, the

left: *Giovanni Fattori:* Southwest Wind, *painted after 1880. Oil on wood; 28.4 cm x 68 cm. Florence, Galleria d'Arte Moderna.*

below: *Telemaco Signorini:* From the Sanctuary of Riomaggiore, *c. 1890. Oil on canvas; 0.66 m x 1.12 m. Rome, United States Embassy (formerly in the Marzotto Collection, Valdagno).*

Neapolitan Giuseppe Abbati, and Raffaello Sernesi and Signorini, both Florentines. Other favoured localities were the mountains of Pistoia, the rocky Cinque Terre coast near Spezia, Tuscany, Liguria, the eastern coast near Ancona, even the lonely malarial fens of the Maremma. Giovanni Fattori (1825–1908), who came from Leghorn, as did Serafino de Tivoli, especially liked the Maremma. Round about 1860 Nino Costa persuaded him to stop covering yards of canvas with historical and military scenes, and he was to be the most vigorous and inventive of the *macchia* group.

The critic and travel writer Raffaele Calzini spoke of the Maremma as "a low deserted marshland with wild horses," a place "scoured by winged winds and fevers, traversed by migrant flocks and heavy clouds," where southwesterly gales tore through the tops of a few starved trees on the shore. Fattori paints this inhospitable region as it was, with no concessions to the anecdotal or the picturesque, as though he disdains it, in landscapes full of sturdy melancholy. These can be small–he would paint them inside cigar-box lids–but never cramped. Trenchant, low-keyed, compact, they have, in some mysterious way, a classical balance that has been attributed, wrongly, to early Renaissance influence. As the years went by he made them more dramatic, and elemental conflicts of nature seem to express what Dario Durbé calls the silent suffering of a republican whose political ideals were betrayed by the course of events. This is the feeling in his *Southwest Wind,* painted after 1880 and now in the Galleria d'Arte Moderna, Florence (page 234).

Telemaco Signorini (1835–1901) produced serener, luminous pictures. A man of keen wit and inquiring mind, he travelled to all corners of his own country, as well as to England and Scotland, and in France, where he met Manet and Degas. He was the first to try the patch technique, after a stay in Spezia in 1858, and several times revisited that breathtaking coast. Now and again he emphasized its vast panorama with a vertical stroke not often used in landscape (page 235).

Two of the greatest landscape artists among the Macchiaioli were Giuseppe Abbati (1836–68) and Raffaello Sernesi (1838–66), who, perhaps more than the rest, imposed compositional pattern on their patched, pure colours. (Sernesi died of wounds received fighting against the Austrians, as many of the painters did, for Italian unity and independence.) Finally there is the simple and delicate realism of Silvestro Lega (1826–95). He was a pupil of the academic Luigi Mussini, advocate of a return to the purity of medieval art, and his earlier pictures on these lines are notable. But gradually he learned *macchia* principles and became, like Bor-rani, one of their most subtle and accomplished interpreters, not least in landscape.

In France Impressionism declined between 1880 and 1886. This happened not so much because artists had had enough, or too much, of it, as that some of them were seeking a scientific and rational solution to the problem of light, which the old Impressionists had worked out empirically, if brilliantly. Art and science had never been closer, unless it were in the Renaissance dawn, when the relationship had been rather different. Then it led to the discovery of perspective. Now laboratory analysis of the spectrum gave rise to a new technique, known as *pointillisme* in France and *divisionismo* in Italy, by which the individual colours of the spectrum were applied in separate dots or points. Impressionists were already familiar with experiments begun by the French chemist Eugène Chevreul and the American physicist Ogden Rood, but the first to paint in the new scientific way was Georges Seurat (1859–91). At the last Impressionist exhibition, in 1886, he showed what is considered the pointillist manifesto, *Sunday Afternoon at the Island of La Grande Jatte.* Vibrant light is diffused all over the canvas. It is, as Longhi finds the works of Piero della Francesca, "a conjunction of painting and mathematics." The spatial relation of the landscape elements to the static figures has been calculated by geometry and the picture constructed accordingly. Seurat prepared for and followed it with innumerable studies, colour sketches, and pure landscapes (pages 240–241). These have a sincere and penetrating approach to nature, never choked by the unfailing geometrical regularity of every object and natural feature.

Seurat's most devoted disciple was Paul Signac (1863–1935). With the critic Félix Fénéon he championed pointillist theories, and was the recognized leader of the Neo-Impressionists after Seurat's premature death. (The system was pointillist, its practitioners Neo-Impressionists.) Signac's view of reality was more lyrical and less restricted than his master's. From the minute intricacies of Pointillism he moves, in landscape, towards a broader mosaic of ever brighter colours, like those of the Expressionists, and more

below: *Homer Dodge Martin:*
The Harp of the Winds, *1895.*
Oil on canvas; 0.73 m x 1.03 m.
New York, Metropolitan Museum
of Art.

bottom: *Thomas Eakins:* Max
Schmitt in a Single Scull, *1871.*
Oil on canvas; 0.82 m x 1.16 m.
New York, Metropolitan Museum
of Art, Alfred N. Punnett
Foundation.

right: *George Inness:* The
Coming Storm, *1878. Oil on*
canvas; 66 cm x 99 cm. Buffalo,
Albright-Knox Art Gallery.

below, right: *Winslow Homer:*
The Gulf Stream, *1899. Oil on*
canvas; 0.71 m x 1.25 m. New
York, Metropolitan Museum of
Art, Wolf Fund.

rhythmic intervals. Working at the same time, Henri Edmond Cross (1856–1910) seems to give a foretaste of the high-keyed colouring that would be characteristic of the Fauves.

Neo-Impressionism met with a warm, if considered, welcome in Belgium. Théo van Rysselberghe (1862–1926) saw it as a kind of antidote to Impressionism, which already showed signs of relapsing into academic art. Colours, such as violet, in his later landscapes are unreal, indeed vaguely romantic; certainly less bold and varied than those employed, then and a little earlier, by the Dutch painter Jan Toorop (1858–1928) in his Neo-Impressionist phase.

In Italy, on the other hand, colouring as applied to nature was, like that of Symbolism, mystical. The leading Divisionist was Giovanni Segantini (1858–99), freely as he interpreted the style, and his ambition was "to combine Nature in her

ideal state with the spiritual images found in man's soul." He had an urge to fall on his knees before mountains "as before so many altars under the open sky," and religious emotion is very marked in his pictures of the shining solitudes of the Upper Engadine. For the most part, however, the web of symbolic and literary allusion need not interfere with our enjoyment of the actual painting. Such is not invariably the case with Gaetano Previati (1852–1920), who can fall to the level of mere illustration, though his brand of the technique is individual, with loose, gossamer brushwork. Giuseppe Pellizza da Volpedo (1868–1907) is known best, unfortunately, for his social messages. These messages are the fruit of experience and human concern, but he is better with landscape. Yet here, too, he does not always resist the meaningful title;

every picture is rather apt to tell a story.

Ferdinand Hodler (1853–1918) was a prolific artist, of Swiss birth, to whom literary and symbolic content was evidently meat and drink, though his later canvases have neither the intellectual load nor the somewhat rhetorical adornment of the big figure-compositions, and his later landscapes are much simplified. Broad, mainly horizontal bands of emphatic colour give solemnity and repose to his lake and mountain scenery.

Naturalism and Impressionism were by now accepted facts of art. The reaction came with Symbolism, whose object was to make a synthesis between the world of appearance and the painter's personal and private "idea." Within the larger movement the determining role in landscape was that of the

above, left: *Giovanni Segantini:*
Death, *from the* Triptych of
Nature, *1896–99. Oil on canvas;
1.88 m x 3.17 m. St. Moritz,
Musée Segantini.*

below, left: *Giuseppe Pellizza da
Volpedo:* The Mirror of Life
(Follow My Leader), *1895–98.
Oil on canvas; 1.32 m x 2.91 m.
Turin, Galleria Civica d'Arte
Moderna.*

above, right: *Ferdinand Hodler:*
Lake Geneva, *1905. Oil on
canvas; 0.82 m x 1.04 m. Basel,
Kunstmuseum.*

Pont-Aven school, a group working in or near Pont-Aven in Brittany from 1885 to 1894 and revolving about Paul Gauguin (1848–1903). Gauguin's landscape is highly subjective, the embodiment of inner feeling, of a dream he had that alters nature. Using a technique learned from another member of the group, Émile Bernard, he shows natural features as large blocks of flat colour, often with dark outlines, like pieces of leaded stained glass or sections of cloisonné enamel. The colour areas are, as it were, cut out and fitted together into shapes whose contour is an unbroken, decorative curve. Gauguin was a man who lived by dreams. "Dream in the presence of nature" was his advice to a painter friend. Dreams and the desire for escape had turned the bank employee into a sailor, and made an artist of the stockbroker. Dreams took him, after much travel, to his death on a lonely Pacific island.

Vincent van Gogh (1853–90) was a yet more tragic figure, who suffered attacks of madness and killed himself before he was forty. It was less the artistic temperament that tortured him than an overwhelmingly generous heart and abnormal sensitivity to the burdens and sorrows of others, and to their social conditions. The landscapes and stupendous portraits of

his last years contain both the torment and the generosity. Trees, especially the great swelling cypresses of Provence that were his theme in 1889, become like human beings, fevered with an excitement that beats in the swirling, jabbing paint. They soar into the deep-blue sky like flames, and eddies of cloud, white or leaden-dark, contrast with glowing fields of ripe wheat. There is a tumult of fractured brushstrokes, one after another, trailing from thick whorls of colour. And the colours of these last weeks of his life at Auvers-sur-Oise have nothing in common with the more Impressionist palette he had used in Provence. In landscapes such as the *Wheat Field with Crows* in the Van Gogh Museum at Amsterdam, with its

paths of unbelievable blood-red, the tumult is raised to paroxysm. They are pictures that transcend reality, seeing nature as a drama, of his own mind as well as of the world.

"Refaire Poussin sur nature!" Cézanne's declared aim meant not that he considered an anachronistic revival of antiquity, but that he wished to impose upon Impressionist light-colour the order and limpid, strict construction of Poussin's classical landscape—for it was mainly landscape that would be redone. Paul Cézanne (1839–1906) in fact never repudiated Impressionism, his insight into which he owed chiefly to his revered friend Pissarro; and Pissarro of all the Impressionists paid most attention to constructive synthesis in open-air

Paul Cézanne: Lake Annecy, *1896. Oil on canvas; 64 cm x 81.3 cm. London, Courtauld Institute Galleries.*

Vincent van Gogh: Cypresses, *1889. Oil on canvas; 93.3 cm x 74 cm. New York, Metropolitan Museum of Art, Rogers Fund.*

painting. They loved the fleeting moment, Nature changing as they watched her. Cézanne wished to catch that moment in a more objective way. Eliminating anything weak or impermanent, he would make it "solid and durable as the art of the museums." Anguished often, untiring always, he arrived at a new concept of landscape painting.

Working in the country around Aix-en-Provence, where Mont Ste. Victoire is almost an emblem of the plastic values he was searching for, he exposes the structure of his landscape by the articulation of successive planes. Objects derive volume, and space is suggested, by colour modulation. His colours are pure and vibrant, and his space is luminous. His method was a truly original discovery, and if it did not, as is often said, anticipate Cubism, it was fundamental not only to landscape but to the general development of art in the nineteenth century.

We conclude with Henri Rousseau (1844–1910), who is quite out of the mainstream and known as Le Douanier, since he worked in the Paris customs. The Douanier Rousseau painted exotic tropical landscapes which he made up out of his own head with exemplary perseverance–some might say downright obstinacy–in his studio, for he had never been anywhere near the tropics. Yet these are the pictures that pose the vexed question, Is he or is he not a genuine *naïf?* Doubtless he was entirely detached from the whole contemporary situation, and probably never understood it much anyway; technical limitations are painfully obvious in his feeble portraits and figure compositions. But here he knew what he was doing. He taught himself a great deal by copying Old Masters in the galleries and museums, and those impressive scenes of primordial nature, with their jungle dignity and riotous vegetation, reveal amazing powers of imagination and conscious painterly style. He is in no sense an early Grandma Moses. He is a great painter in his own right.

LANDSCAPE AS FORM
The Twentieth Century

In the mazy currents of twentieth-century art, where few of the groups, tendencies, movements, and directions are "schools" in the recognized sense of the word, there are as many different interpretations of landscape as of everything else. Between them, or some of them, there is, however, the faint common denominator of the painter's purpose. Increasingly bent on affirming his own personality, he transforms or transfigures Nature, either to express the emotion she has aroused in him, or to apply to her a new style, worked out by intellect alone. The most artistically successful of these styles, Cubism, was short-lived; it was Expressionism that would dominate much of European painting and produce a number of often diverse offshoots. By contrast it is strange that our violent century should open with a group whose one wish was, apparently, to illustrate the joy of living.

Our tragic century. Not over yet, and already the entire Western world thinks in terms of before the war, between the wars, after the war; divisions that would have meant less in the art chronology of former times, when the scars left on art by war and revolution were never quite so deep. And here, in its very first years, are the Fauves. They did not last long, but they did try to communicate happiness, whether of hope, dream, or reality. *Luxe, calme et volupté:* in 1904 or thereabouts Matisse borrowed the line from Baudelaire for one of his early pictures, and not long afterwards called another, larger canvas *Joy of life.*

After using Impressionist technique and the Pointillism of Signac, Henri Matisse (1869–1954) soon found his individual style and became exclusively a colourist. His colour is pure, brilliant, chosen always with regard to tonal values and atmospheric modulation, and conveys a sense of the whole

We want the destruction of traditional landscape inherited from the painters of the past, for, from the Impressionists up to the present day, another sort of landscape has been in existence.

Umberto Boccioni, "Against Landscape and the Old Aesthetic," in Pittura scultura futuriste, *1914*

Georges Braque: Houses at L'Estaque, *1908. Oil on canvas; 73 cm x 59.5 cm. Bern, Kunstmuseum, Herman and Margrit Rupf Foundation.*

Pablo Picasso: Factory at Horta de Ebro, 1909. *Oil on canvas; 53 cm x 60 cm. Leningrad, Hermitage.*

visible world bursting with exhilaration and vitality. He is the leading spirit of the Fauves, or "wild beasts." (The name, an allusion to the violence of their colouring, was bestowed by another witty critic, this time at the famous Autumn Salon of 1905 in Paris.) With colour learned from Gauguin and Van Gogh, and the enamelled, incisive line of Oriental ceramics, about which he knew a good deal, he creates forms with a minimum of drawing, for outline thickens into colour when it exists at all. With these shadowless, two-dimensional forms he annihilates depth, and does the same thing in landscape by up-ending perspective and simplifying each element to the utmost. The result is a composition in which every magical piece seems to lie directly on the surface, in a harmony of often quite unrealistic colours. Because of its light and colour, Matisse preferred the Mediterranean to any other landscape. He passed the winters of 1911–12 and 1912–13 in Morocco, and much of his long, hardworking life on the Côte d'Azur.

Raoul Dufy (1877–1953) had also exhibited with the Fauves in 1905. His landscapes take us straight into the Belle Époque, the first before-the-war: flag-bedecked streets on Bastille Day, smooth emerald racecourses, parasols blooming on promenade and beach, and sails on the water. The colours sing, the line is an elegant arabesque of quick, light strokes. Almost as irresistible is Albert Marquet (1875–1947). His serene town and seaside views have plenty of room in them; we look down from his high vantage points onto people and carriages in dots of pure, dark colour. André Derain (1880–1954), too, had his Fauve period before adopting a more classical style; and Maurice de Vlaminck (1876–1958) painted landscape in the brightest, most brutal colours, though his later pictures are more structural and show the influence of Cézanne. Fauvism has been called, not without reason, a Mediterranean variant of Expressionism. This, as usually understood, was more a concept than a movement, much less a school; a subjective attitude, by a typically northern existentialist agony of spirit. Most early twentieth-century art is Expressionist insofar as it reacts from Impressionism to im-

254

pose upon external reality an inner reality, psychic and subjective. The standard-bearer of this personal, agonized Expressionism is the Norwegian Edvard Munch (1863–1944). He had briefly admired the Impressionists on a visit to Paris, but by the 1890's, the high noon of Symbolism, Munch was painting severe, pared-down landscapes in thick, gloomy colours—cheerless fjords, the indented shores deserted, the still water studded with flat islands, imprinted with all the signs of perturbation and private nightmare. Sometimes the moon is shining and not a ripple stirring. The clouds may look like streaks of blood, as they do in *The Scream,* of 1893 (page 264); or they are creatures of undefined menace, hanging in weird black shapes.

Expressionism culminated with the German group Die Brücke just when in Paris Cubism was changing absolutely the perspective-illusionist view of space that had held good, one way or another, ever since the Renaissance. In Cubist painting an object is dismantled, independently of how the spectator sees it in space, and the different aspects are shown simultaneously as a series of flat geometrical planes, or facets, which, intersected and fitted together, make a synthesis of the object. This was the most novel, radical, and immediate conception ever to appear in Western art and was applied to a huge variety of things, the human figure included, and to landscape, in which the perception of space is essential. In 1908 Georges Braque (1882–1963), working at L'Estaque, near Marseilles, where Renoir and Cézanne had painted, treated space as volume (page 250) in landscapes that definitely mark the end of his two-year dalliance with the Fauves. Cubist principles seem to be fully developed at once as, with cube houses, cylindrical trees, and continuous interlocking mountain ranges, he converts nature into a new reality, simply with plastic forms.

What L'Estaque was to him, the barren hills and poverty-stricken village of Horta in Tarragona were to Picasso, painting there the following summer (pages 252–253). The two had founded the Cubist movement in 1907, and now Pablo Picasso (1881–1973) was experimenting further, analyzing the human model and the components of his still-life studies. The Spanish countryside is an early, and most effective, theme of Cubist landscape, where the sky itself is sectionalized and given equal importance, as form, with the houses and mountains.

Divisionism, meanwhile, was running its course in Italy, led, in the 1900's, by the Turin-born Giacomo Balla (1871–1958), though he and his circle stuck to it less strictly than did the French Pointillists, or even Segantini and Pellizza da Volpedo in Rome. Before turning to Futurism, Umberto Boccioni (1882–1916) was directly influenced by Balla. But on 14 March 1907, Boccioni was writing, "I want to paint what is new, what springs from our industrial age," and among his subjects for the next two years were town outskirts and modern suburbs, seen, usually from a height, in panoramic views. Often a straight road runs across the picture, and the brilliance of grass and fields in the foreground fades into the smoke and fumes of factory chimneys on the skyline (pages 258–259).

A friend of Boccioni's and, like him, to some extent a disciple of Balla, was Gino Severini (1883–1966). Born in Cortona, he moved from Rome to Paris in 1906, there to learn more of Pointillism and to paint tree-filled, tree-lined squares and boulevards, luminous with green spring foliage, or brown and golden-yellow in the autumn.

The next step after Pointillism was Futurism with its synthesized colour and movement, the most important trend in Italian art before the 1914 War. Balla, Boccioni, Severini, and Carlo Carrà all signed the famous Manifesto of 11 February 1910, a month before the Technical Manifesto of Futurist Painting and a year after Filippo Tommaso Marinetti published his initial manifesto in the *Figaro* on 20 February 1909. It was a movement which produced no landscape, however, since the rejection of nature was an article of Futurist faith. With a few exceptions (non-Italian, such as the Russians Mikhail Larionov and Natalia Gontcharova, whose Rayonism attempted to express mathematical concepts of time-space; or later in date, such as the minor Thirties company of

right: *Maurice de Vlaminck:* The
Valley of Le Port-Marly, *1905.*
Oil on canvas. Paris, B. Y. Fize
collection.

below: *Raoul Dufy:* Provincial
Landscape with the
Amphitheatre at Mont Mayor
(detail). Oil on wood; 21 cm x 58.5
cm. Private collection.

on page 257:
Vasily Kandinsky: The Blue
Rider, *1903. Oil on canvas; 52 cm*
x 54.5 cm. Zurich, Bührle
Collection.

on page 258: *Umberto Boccioni:*
Morning, *1909. Oil on canvas; 55*
cm x 60 cm. Milan, private
collection.

Aëropainters), Futurists concerned with settings of any sort confined themselves to the modern urban scene. Boccioni's *The City Rises,* of 1910, is perhaps the chief example of their exaltation of its turmoil and dynamism.

A painter who gives at most a nod in the direction of Futurist technique is the Venetian Leonardo Dudreville (1885–1975), a member of the *Nuove tendenze* group in Milan. His 1912 series, *The Seasons* (page 259), seems to admit and examine the "dialogue with external reality," as the critic Guido Ballo calls it, and to see this as a problem of light in relation to the Divisionist separation of colours. But

soon enough the likeness to reality becomes very vague in truly Futurist works. Things are altered practically out of recognition, as in Boccioni's three *States of Mind,* analyzing the emotions felt when a train leaves. In these pictures, versions of which he made in 1911 and 1912, objects are elevated to the status of symbol or memory, and fragments of them emerge, now and again, in contexts where forms respond only to dynamic pressures; and with the geometrical, repetitive character of Balla's *Iridescent Interpenetrations* of 1912–14, realism is left behind.

Abstract art, in one manifestation or another, ruled su-

on page 259, above: *Gino Severini:* Spring in Montmartre, 1908. *Oil on canvas; 73 cm x 60 cm. Milan, E. Bianchi collection.*

on page 259, below: *Leonardo Dudreville:* Spring, 1914. *Oil on canvas; 1.55 m x 1.65 m. Novara, Museo Civico.*

left: *Vasily Kandinsky:* Impression V (The Park), *1911. Oil on canvas; 1.05 m x 1.57 m. Paris, Mme. Nina Kandinsky collection.*

below: *Paul Klee:* Terraced Garden, 1920. *Oil on cardboard; 28 cm x 39 cm. Basel, Kunstmuseum.*

right: *Piet Mondrian:* Tree, 1912. *Oil on canvas; 93.9 cm x 69.8 cm. Pittsburgh, Museum of Art, Carnegie Institute.*

below: *Franz Marc:* Roe Deer in the Wood, *1913–14. Oil on canvas; 1.1 m x 1 m. Karlsruhe, Staatliche Kunsthalle.*

right: *August Macke:* The Storm, *1911. Oil on canvas; 0.84 m x 1.12 m. Saarbrücken, Saarlandmuseum.*

preme after the Second World War but its founders, Vasily Kandinsky (1866–1944) and Piet Mondrian (1872–1944), trod more slowly than the Italians, and by more considered stages. Kandinsky, the Russian, moved towards it gradually in his 1900's landscape. *The Blue Rider* (page 257), painted in 1903, eight years before he and Franz Marc (1880–1916) instituted the group in Munich that was known after it, has fields, trees, and sky which, though charged with symbolic meaning, are still basically realistic, with the bright, thickly encrusted colours found in late Impressionism. Then, between 1907 and 1911 or so, Kandinsky spends his summers at Murnau in Upper Bavaria, painting the Alps in the Fauve style he absorbed but never practiced much; explosive colour goes on in broad ground areas and strongly contrasted streaks in which forms expand and outline is lost. By the time he reaches the splendid *Improvisations* of 1911 and 1912, their great patches of mostly pale colour slashed here and there by long, irrelevant black brushstrokes, no connection with real-

ity is left save in an occasional title: *Impression V (The Park)* for instance.

Piet Mondrian was a Dutchman. Whereas Kandinsky arrived at nonobjectivity through free and intensely poetic imaginings that expressed, as he himself put it, "an inner need," Mondrian's transit from naturalism to symbolism to abstraction was very different. By a logical progress that perhaps has something to so with analytical Cubism, he simplifies his images into pure, one-plane geometry, quite without volume. They are constructed on the fundamental vertical-horizontal equilibrium which, according to the Dutch philosopher M. H. J. Schoenmaekers, affirms the principle of mathematical regularity underlying the unstable and capricious appearances of nature. Schoenmaekers's "plastic mathematics" are operative in the tree theme of 1909–12 (page 261), where the treetop is stripped, from picture to picture, to skeleton web of branches with no knot or asymmetry remaining, an interwoven pattern of darting lines. The

above: *Oskar Kokoschka:* Tre Croci Pass in the Dolomites, *c. 1913. Oil on canvas; 0.82 m x 1.19 m. Hamburg, private collection.*

Edvard Munch: The Scream *(detail), 1893. Oil, casein, and pastel; 91 cm x 74 cm. Oslo, Nasjonalgalleriet.*

on page 266: *Carlo Carrà:* Seascape at Moneglia, *1921. Oil on canvas; 38 cm x 43 cm. Milan, private collection.*

on page 267: *Mario Sironi:* Mountains, *1930. Oil on wood; 50 cm x 65 cm. Milan, private collection.*

below: *Ernst Ludwig Kirchner:* Cemetery in the Wood, *1933. Coloured woodcut; 35 cm x 50 cm. Bremen, Budezies Collection.*

slight, almost monochrome shading that adds minimum variation to the background is used also in, for example, *Pier and Ocean,* of 1915, last of a series inspired by Damburg on the Walcheren coast. Here an oval area on an unrelieved grey ground is filled with a pattern of short lines crossing vertically and horizontally and thickening towards the top of the canvas. Abstraction in landscape could hardly go further.

Paul Klee (1879–1940) alternates and sometimes mingles the figurative and nonfigurative, though there is neither indecision nor want of coherence or consistency in his large output. He is an artist apart, who taught and wrote and probed deeply into the techniques he developed, and who defies pigeonholing with any of the modern movements. Even the Blaue Reiter group to which he belonged, and Kandinsky, who was a friend of his, did little more than extend his already vast cultural perceptions. Far more important and

decisive was a visit to Tunis in 1914, where he, whose work had been mainly graphic, discovered colour and painted some memorable landscapes. Still, no rules can be made about Klee landscape, for a picture by him, whatever the subject, is always an investigation, something new in itself. His inexhaustible imagination responds to nature with the enthralled, untarnished sensitivity of a child, yet the superb technique is never out of control, the sure stylistic sense never wavers. Perhaps no painter has established so immediate and direct a link between the innermost secret impulses of the human spirit and the processes of figurative art. We may see in this century greater artists, greater pioneers; Klee is our poet.

He was working in Germany when Expressionism was at its height. The powerhouse, Die Brücke–"the bridge"–had been formed in Dresden in 1905 by Ernst Ludwig Kirchner (1880–1938), its most typical member and theoretician; Karl

Schmidt-Rottluff (1884–1976); Erich Heckel (1883–1970); and others. The intention was to attract to themselves as to a bridge the "revolutionary and fermenting elements" of the day. Emil Nolde (1867–1956) was a recruit of 1906, though somewhat senior to the rest (pages 10–11).

Their work as a whole, even after the original group dissolved in Berlin in 1913 and despite the diversity of style, suggests that ideological fury at the shortcomings of the Kaiser's Germany had spilled over upon their attitude to nature; inverted perspectives and the jarring proximity of strident colours in their landscapes convey, however, more of open melodrama than hidden conflict. Indeed, they do not seem to have liked Nature very much. Their bold distortions scarcely make her beautiful and can verge on the repellent, though this fact does not, of course, justify the later Nazi

condemnation of their work as degenerate. Often bitter, it was at least sincere.

The other main group in Germany before the First World War was Der Blaue Reiter, founded, as we have seen, at Munich in 1911 by Franz Marc and Kandinsky. Though similarly Expressionist, it did not actually and fully succeed the Brücke, for its aim was less what Mario de Micheli calls "release of the instincts on canvas" than a presentation of the "spiritual essence of reality." This is the purpose of Kandinsky's inward-looking experiments, and is what we find in the painting of Marc. For him animals, horses especially, are a recurring motif, interpreted as a sort of lifeline to nature, while intersecting colour planes, clustered light, and dynamic contours, recurved or intertwined, lend enchantment to his pictures.

Oskar Kokoschka (1886–1980) is the last great voice of German Expressionism. He was more of a guest than a member at the Blaue Reiter shows, and painted delicious landscapes in his long and productive career. Violent colour and thick texture grew clearer and finer until at last we have the scintillating, mercurial light of some of his Venetian studies.

There were few Expressionists in Italy. An exception, though he developed independently of German influence, was Lorenzo Viani (1882–1936) with his dramatic interpretations of the Puglia countryside and of the desolate coast near Viareggio, its vagabonds, beggars, and fisherfolk. Almost all the leading Italian painters between the two wars were, however, Futurists at one time or another, with more or less enthusiasm and orthodoxy, and some of them belonged to the Metaphysical school, the only Italian movement to attain

a European reputation in the 1910's and into the next decade. Liveliest and most prolific exponent of the various styles in the first thirty years of the century was Carlo Carrà, whose cogently argued books offered commentary on his own progress. He reached a turning point in 1921 with a sequence of stupendous landscapes—*The Pine by the Sea, Seascape at Moneglia* (page 266), *St. Anne's Mill*—in which he reduced objects of nature to their essentials as volume and as constructive elements. In this he was following in the footsteps of Giotto and the early Renaissance masters, but he and the artists and critics of the group centered on the review *Valori plastici* were by no means retrograde. What they sought was a new classicism that would accommodate the latest needs, spiritual and artistic, from the "magic" or "sharp-focus" realism of Magritte to the Metaphysical "paint-

Arturo Tosi: Autumn
Landscape, *1924. Oil on canvas;*
68 cm x 87 cm. Rome, Galleria
Nazionale d'Arte Moderna.

Ennio Morlotti: The Adda at Imbersago *(detail), 1955. Oil on canvas; 68 cm x 75 cm. Monza, private collection.*

ing of essential forms." With Carrà's work between 1920 and 1937, in which the German scholar Wilhelm Worringer recognized "the ultimate elective affinity between the laws of the spirit and the laws of nature," landscape asserts itself once more as a protagonist in history. To a lesser degree—lesser only because he painted things more often than places—so does that of Giorgio Morandi (1890–1964). Casually thought of in connection with Metaphysical still lifes of bottles and bowls and jugs, Morandi also painted the hills surrounding Bologna, where he lived. They are seen in much simplified, strictly balanced arrangements, generally front-on, with planes of pure colour-light appearing side by side. The light, steady as Corot's, has been, as it were, tested against reality, put through a filter of memory, and as a result Morandi's landscape exists beyond time rather than in the here-and-now of the Impressionists and Macchiaioli. The critic Cesare Brandi notes in it a quality of "duration" exactly matching that of the still lifes, which are perhaps the finest and most intellectual of the century.

right: *Giorgio Morandi:*
Landscape, *1925. Oil on canvas;
52 cm x 49 cm. Milan, private
collection.*

below: *Ardengo Soffici:* The Road
through Carmignano, *1911. Oil
on cardboard; 31 cm x 23 cm.
Florence, private collection.*

Constant Permeke: Seascape, c. *1934. Oil on canvas; 65.5 cm x 90 cm. Rome, private collection.*

At the other end of the scale from these simple, intimate, and quiet landscapes is the overwhelming scenery of Mario Sironi (1885–1961). His earlier pictures show the sad outskirts of cities, with squalid blocks of housing hemmed in among industrial buildings, gasometers, black chimneys, iron girders. Then he becomes aware, as Agnoldomenico Pica says, of the "inexpressible beauty of rock" and the awe-inspiring mountains (page 267). His mountains rear up, structure laid bare in harsh, emphatically articulated planes, areas of shadow standing out against others where the thick impasto looks like solid light. Nature has no smile, no welcome, in these lonely and monumental visions. There is a feeling of menace and we seem to catch a sensitive modern statement of the old romantic theme of man's dismay before the indifference of the Creation.

In about 1920 Italian Futurism was followed by what was called the return to order, to nature and tradition (the same kind of thing happened in France as Cubism waned), and Ardengo Soffici (1879–1964), once a leading light among the Futurists, acquired considerable reputation both as painter and writer. He had lived in Paris, and articles by him in the Italian avant-garde reviews *La Voce* and *Lacerba* did much to spread a knowledge of French art since the Impressionists. For him the return to order meant a return to Tuscany, where he painted his native countryside and the country people with perceptive affection. Soffici is saved from the trivial anecdote and the "picturesque" of the later Macchiaioli by an acute response to contemporary problems, by exalted moral purpose, and by style. He had learned breadth and control from the Renaissance masters and from the soundest and most durable tendencies in modern French art. He paid especial heed to Cézanne, and his sober landscapes are firmly constructed, their colours serene and luminous. Their very accuracy shows a notably clear intelligence at work.

Not unlike Soffici in his Tuscan sturdiness was Ottone Rosai (1895–1957). He, too, had been a part of the Futurist extravaganza, but his later landscapes, painted round about Florence, are simple and concise, with a subdued and unmis-

takable melancholy. Objects are plain volume, trees a solid mass, receiving prominence not from any Cubist-derived methods, but a vigorous chiaroscuro in the tradition of Masaccio.

Italy between the wars saw the development of much markedly regional painting and this, in retrospect, seems to

have been in reaction against the circumstances of fascism. A fair number of artists, Soffici and Rosai among them, supported the regime in all good faith. Many, on the other hand, did no such thing, while those who did had artistic, never political, motives, and their art, as was to be expected, found its immediate outlet in landscape. Thus the pronouncedly Tuscan character of Rosai and Soffici is echoed by the equally strong Lombard strain in the work of Arturo Tosi (1871–1956). There is something of Cézanne in his lucid studies of the Brianza, of Lago d'Iseo in the Brescian Alps and Zoagli near Rapallo, but Tosi never forgot his beginnings with the "Bohemians" in Milan, or the example of Daniele Ranzoni,

himself a follower of Carnovali. Pio Semeghini (1878–1964) painted lagoon views that completely capture Venice with a freedom, lightness, and transparency recalling not only Monet but Bonnard and the French Post-Impressionists. Landscapes of Apulia and Calabria by Vincenzo Ciardo (1894–1976)—a painter fallen too quickly into obscurity—are rendered in tiny dots of pure colour reminiscent of Divisionist stippling. To these we may add what was known as the school of the Via Cavour—out-and-out Romans such as

Mafai and Scipione who developed, in their own cool colours, the Expressionism wafted to them through the *école de Paris* of Chagall and Soutine. And there are many other instances to prove that even in the fascist decades Italian painting never lost touch with Europe as a whole and that its regionalism was in no way parochial.

An appreciable Expressionist group in Belgium was headed by Constant Permeke (1886–1952). For their spare construction and thick paint, his landscapes have been com-

pared to those of Mario Sironi and often have huge level horizons and lowering skies shot through with livid light against the dark. An Expressionist element is also found in the landscape of Georges Rouault (1871–1958), who uses the incandescent Fauve colours with enormous dramatic effect. This he augments by heavy enclosing lines, even around the blood-red globe of the sun which appears in many of his pictures. Rouault was deeply and sincerely devout and much of his landscape is biblical or Christian in tone. The fifty-seven aquatints and etchings of the *Miserere* and *War* sequence, his most overtly religious work, are among the masterpieces of modern graphic art.

After Expressionism, the longest-lived, most vital and productive current of our time has been Surrealism with all its branches. Frequently as Surrealist pictures contain landscape, however, there is no way of defining what Surrealist landscape is in the pictorial terms we have so far relied on. To depict its fantasies, to liberate the forces of the unconscious

left: *Salvador Dali:* Atavistic
Vestiges after the Rain, *1934.
Oil on canvas; 64 cm x 54 cm.
Rome, private collection.*

right: *René Magritte:* The Castle
of the Pyrénées, 1959. *Oil on
canvas; 2 m x 1.40 m. New York,
Harry Torczyner collection.*

© 1980 by A.D.A.G.P., Paris

mind and show the disquieting images of dream, Surrealism will, or may, employ every known technique of visual art, from the unrestrained and almost literally unformal to the driest of academic pedantry. It seems, indeed, that the more objective and realistic the painting, the more readily can the spectator enter the hallucinatory Surrealist world. The objects and space there are perhaps strange, irrational, abnormal—in short, unbelievable; but when they are painted in a style that carries conviction, so that our normal senses recognize them at once, the sheer contrast between the strangeness and the recognizability generates belief. We accept that, in another dimension, they exist.

The movement was founded in 1924 and at its zenith two of the outstanding and most imaginative Surrealists were René Magritte (1898–1967) and Salvador Dali (born 1904).

Wide distances, scattered with landscape motifs, in their pictures have this believable quality, this somehow real feeling. But the *peintures sauvages* of Joan Miró (born 1893) are violent pastels divorced from anything real; André Masson (born 1896) derives a great deal from Cubism; and Max Ernst (1891–1976) makes startling and marvellous transitions from one style and technique to another, not excluding the automatic process of *frottage*. He is a remarkably inventive creator of form.

When we come to artists of the post-1945 years it is difficult, for our present study, to summarize their response to nature, so diverse, and in some cases so utterly unforeseeable, have been the modes of expression adopted. Perhaps, though, these modes, or the best of them at any rate, should be regarded as arising not from lack of discipline, but from

tension, from inner restlessness and an often tormented search for new directions; and we should respect them for this reason, whatever the artistic value of the results.

In Italy the Corrente, a group in Milan who combined their art with politics, had painted landscape among other experimental work in 1938–40. Pictures of orange groves by the Sicilian Renato Guttuso are in vivid Expressionist colours with incisive controlling draftsmanship, while for Bruno Cassinari (born, like Guttuso, in 1912) colour is an intensely constructive element. Another of the Corrente artists, Renato Birolli (1905–59), produced memorable, free interpretations of the Cinque Terre coast; and Ennio Morlotti (born 1910) in particular paints Lombard landscapes in rich impasto, heavy with the presence of earth, its flowers and fruit, as though he has immersed himself in nature.

This impulse for contact with Nature was explored also by Graham Sutherland (1903–80); he was fascinated by her every aspect, however unfamiliar, and by the mysterious laws that govern her perpetual change and renewal. Even the childlike "informal" styles which have influenced modern directions may include landscape. It occurs, for instance, in pictures by Jean Dubuffet (born 1901).

Apart from what is traditionally understood as painting– roughly defined as colour brushed onto a flat surface–there are works incorporating materials not usually associated with art. The Futurists were the first to cut up bits of paper and affix them, as calculated components, to the canvas. The practice continues, through the collages of Kurt Schwitters (1887–1948), to the "combine painting" of the American Robert Rauschenberg (born 1925). Rauschenberg's large compositions may include the most prosaic objects, even flotsam and refuse, put there to evoke an image of daily life and the filth of consumer civilization (if that is the word). But though these virulent, ironical, and often disagreeable productions may be genuine comments on the existential unease and vulgarity of our mass society, they do not, perhaps, enter

the realm of landscape. A stricter, more inventive and imaginative artist is Alberto Burri, who was born in 1915 and lives in his native Umbria. From metal, sacking, and pieces of charred wood he creates a "reality that imitates painting"— the phrase of the critic Giulio Carlo Argan—and has thus reversed the age-old relation of reality and art. To some of his works he gives such titles as *Green Umbria* or *Franciscan Landscape,* and those commonplace sacks, patched and bursting, do in a new way epitomize the country of Saint Francis, of the Lady Poverty, and the painful, haunting *laude* of Jacopone da Todi.

And so we arrive at earthwork, land art, or ecological art, a final, and disconcerting, effort towards the union of nature and man. This takes the form of direct intervention in the environment. Not in order to beautify, cultivate, or do anything useful with it; the sole purpose is expression, though what is expressed, and for what reason, is seldom if ever mentioned. We can, therefore, contain our curiosity as to

why, exactly, Robert Smithson (1938–73) constructed an immense spiral of rock, mud, and sand, visible from the air only, in the Great Salt Lake in Utah (page 280); why Michael Heizer (born in 1944) dug great ditches in the Nevada desert; why Dennis Oppenheim (born in 1938) should mark mountains, like cattle for slaughter, with his macroscopic signs; why Christo (the Bulgarian Christo Jaracheff, born in 1935) went to Australia and swathed the reefs in plastic wrapping (page 280).

Air and sea are polluted. Much of earth's surface is corseted in concrete. Artists like this are all we need to complete the desecration, appearing with their grim testimony to what we are pleased to call progress and civilization. Or they may well be heralding disasters to come, for how is Nature to survive when even artists turn against her?

Some Brief Biographies

A short biographical list of landscape painters whose pictures are here reproduced, or who are mentioned in the text, and of artists in whose work landscape plays a major role

Abbati, Giuseppe

Italian painter (Naples, 1836–Florence, 1868). Son of an artist who specialized in romantic interiors, he lived as a young man in Venice, where he studied at the Academy and in 1856 met Signorini and Vito d'Ancona. Took part in Garibaldi's campaign of 1860, then settled in Florence, where he was friendly with the critic Diego Martelli and became a leading figure in the Macchiaioli group. He first experimented with the technique of *macchie*–patches or spots–paying particular attention to the white tones, in an attempt to revive romantic genre painting, but soon concentrated exclusively on landscape, painting in the open air with others of the Piagentina school (Lega, Borrani, Sernesi, Signorini). A meeting with Fattori at Castiglioncello in 1867 led to a close alliance with him in the search for a simplified pictorial structure, based on essential volumes.

Altdorfer, Albrecht

German painter and engraver (Ratisbon, c. 1480–1538). Save for a stay in Venice in 1535, he rarely left his native city, where he was municipal architect, though we have no record of his work in that capacity. His first drawings and engravings date from 1506; they reveal the influence of Dürer and of the painters of the Italian Renaissance, who would be known to him through prints. From these beginnings he evolved a highly original, composite pictorial vision, which gradually changed the relation of figures to background. The natural landscape became the main theme of the picture, though he still strives for a monumental quality borrowed largely from Cranach the Elder. Altdorfer's position as the greatest painter of what is called the Danube school of landscape is assured by such works as *The Satyr Family* (1507, Staatliche Museen in Dahlem, Berlin), the two cycles for the convent of St. Florian, near Linz, of 1511–18 and 1520–25 (the polyptych of the *Passion* is still in the convent, the *Legend of Saint Florian* series now distributed among various private collections, the Uffizi, and the Nuremberg and Prague museums), and above all by the *Landscape with a Footbridge* (National Gallery), the 1510 *Saint George in the Forest,* and *The Battle of Issus* (both in the Alte Pinakothek in Munich).

Fra Angelico *(Guido di Piero, later the Dominican friar Giovanni da Fiesole)*

Italian painter and illuminator (Vicchio di Mugello, 1386/1400–Rome, 1455). Little is known of his training, and his first documented work, of 1417, owes as much to the Late Gothic tradition of Lorenzo Monaco as to the stylistic innovations of Masaccio, which he probably learned from studying Giotto. Pictures in this early style include the Prado *Annunciation* and *The Last Judgement* in the San Marco Museum, Florence. His mature style, first displayed in the altarpiece for the *Arte dei Linaioli,* or Linen Guild (1433, also in San Marco), combines the new humanistic awareness of man and the world around him with the old didactic symbolism of religious art. He had joined the Dominican order at Fiesole sometime before 1423 and painted numerous polyptychs and altarpieces for the churches and convents of Florence and neighbouring towns. From 1438 to 1445 he planned the frescoes in the Dominican convent of San Marco, executing them with the help of assistants. From 1445 until his death he worked a great deal in Rome for Eugene IV and Nicholas V. The frescoes in the Cappella Niccolina in the Vatican date from 1448.

Antonello da Messina

Italian painter (Messina, c. 1430-1479). Probably apprenticed before 1456 to the Neapolitan painter Colantonio. Though he may have travelled in Flanders, he could easily have seen Spanish and Franco-Flemish works of art in the south, which was then under Angevin rule, or in Sicily, under the Aragonese. From the northern schools Antonello derived his fundamental concern with the relation of colour and light--made more complex by the possibilities opened up by the new oil technique--and for details of setting, especially those of landscape, and for psychological truth in portraiture. He worked in Messina, but visited central and northern Italy, learning the Renaissance treatment of space from artists such as Piero della Francesca. His stay in Venice and acquaintance with Giovanni Bellini in 1474-76 had important results not only for his own style, but for northern Italian painting generally. (See his 1475 *Crucifixion* in the Musée des Beaux-Arts, Antwerp.)

Avercamp, Hendrik

Dutch painter (Amsterdam, 1585–Kampen, 1634). A follower of Pieter Bruegel the Elder, he was among the earliest painters of winter views, usually of landscape under snow or village scenes, with fishing and skating. His palette is silvery, with tones of brilliant red.

Beccafumi, Domenico *(Domenico di Giacomo di Pace)*

Italian painter (Valdibiena, near Siena, c. 1486–Siena, 1551). The classicism of Mariotto Albertinelli and Fra Bartolomeo, Leonardo's style and the "northern" eccentricities of Piero di Cosimo are all early influences, encountered on a probable visit to Florence in the 1500's. In Siena he was taught by Sodoma. According to Vasari, he was in Rome from about 1510 to 1512, at a time when he would see Michelangelo's first frescoes and meet his fellow townsmen Peruzzi and Raphael; and he was there again in 1519. His earliest remaining, and already mature, works are frescoes in the chapel of the Madonna del Manto in the Ospedale di Santa Maria della Scala in Siena (1512), and a *Saint Catherine Receiving the Stigmata* (c. 1513–15) in the gallery there. They show that, like his younger Florentine contemporaries Pontormo and Rosso, he was from the very first a Mannerist. A series of pictures for Pisa Cathedral date from 1537 to 1541, but from 1519 onwards he worked almost entirely in Siena. Between that year and 1551 he produced biblical designs for the inlaid marble pavements of the cathedral, gospel-story frescoes in the apse, and eight bronze angels for the choir. His allegorical ceiling frescoes in the Sala del Consistorio of the Palazzo Pubblico were painted in 1529–35.

Bellini, Giovanni *(Giambellino)*

Italian painter (Venice, 1426/1433-1516). Son of Jacopo Bel-

lini, in whose studio he and his brother Gentile were trained. By 1459 he had a studio of his own and had formed an individual style quite different from those of his father and brother. His knowledge of perspective and drawing equalled that of his brother-in-law Mantegna (polyptych of *Saint Vincent Ferrer,* c. 1464–68, in SS. Giovanni e Paolo, Venice, and *The Coronation of the Virgin,* of 1471–74, in the museum at Pesaro). Urged on by Antonello da Messina, who was in Venice in 1474–76, he studied the problems of spatial depth, finding their solution in the relation of colour and light by which he gave monumentality to his figures. (See the *Job* altarpiece of 1487 in the Accademia, and the triptych in the Frari church, of 1488). This monumental quality also arose from the soft but precise line of his drawing, and the smooth insertion of figures into or in front of landscape, as in his *Madonna and Child* pictures and *The Transfiguration* of c. 1487 in the Museo di Capodimonte, Naples. In the *Sacred Allegory* (1490–1500) at the Uffizi, landscape assumes the dominant role, and as an old man Giambellino still studied colour and form, could still learn from, as well as teach, "disciples" such as Lorenzo Lotto, Giorgione, Sebastiano del Piombo, and Titian. To this last period belong the 1505 *Madonna* in San Zaccaria, Venice, the *Madonna of the Meadow,* c. 1505, in the National Gallery, the *Pietà,* of the same date, in the Accademia, and *The Feast of the Gods,* 1509–14, in the National Gallery, Washington.

Bellotto, Bernardo

Italian painter and engraver (Venice, 1720–Warsaw, 1780). Nephew and pupil of Canaletto, he worked from 1742 in Rome, Lombardy, and Turin, and in 1748 went to Dresden as court painter to Frederick Augustus II. During the Seven Years' War he moved between Munich and Vienna, then entered the service of Stanislaus Poniatowsky, King of Poland, and settled in Warsaw in 1767. The influence of Canaletto, obvious in his early townscapes, gives way to a different and freer construction based on diagonals, to less restricted colouring and a vivid use of anecdote.

Benozzo Gozzoli (*Benozzo di Lese*)

Italian painter (Florence, 1420–Pistoia, 1497). First heard of working with Ghiberti on the *Doors of Paradise* at the Baptistery and demanding a three-year contract, Gozzoli must have been trained at San Marco about 1440, and Fra Angelico, with whom he collaborated on the Vatican frescoes in 1447–49, was always the most important influence in his painting. Though his most successful achievement, the *Journey of the Magi* (1459–62), is in the chapel of the Medici Palace in Florence, he was much in demand as a fresco painter in the towns of central Italy. Being of an eclectic turn, he could present the technical advances of Fra Angelico, Masaccio, Paolo Uccello, and Piero della Francesca in a smooth and comprehensible, if superficial, style that was still Late Gothic, with a dash of Flemish in it. Frescoes on the life of Saint Augustine are in the Church of Sant' Agostino at San Gimignano. A cycle of Old and New Testament scenes in the Campo Santo, Pisa, painted between 1467 and 1484, was badly damaged in the war.

Bernard, Emile

French painter and art critic (Lille, 1868–Paris, 1941). For a short time, as a youth, he attended the studio of the academic painter Fernand Cormon, together with Toulouse-Lautrec, but his development owed most to the stay at Pont-Aven in Brittany, in 1886. Here he worked out the theory of symbolic form known as cloisonnism, in which colours are applied in separate, flat compartments, as in old enamels. When Gauguin came back from the West Indies in 1888, acknowledged leader of the new school of painting, Bernard returned to Paris to write and work energetically on his behalf, and on that of Van Gogh and Cézanne.

Bierstadt, Albert

American painter of German origin (Solingen, Westphalia, 1830–Irvington, New York, 1902). Educated in New Bedford, Massachusetts, where the family had moved some months after his birth, he went to Europe in 1853 and attended the Düsseldorf Academy, then a mecca for German landscape painters. Before returning to the United States four years later, he made painting trips to the Rhine, Switzerland, and Rome, sketching landscape from nature, as he did subsequently in the White Mountains of New Hampshire. As a war artist with the Northern armies during the Civil War he painted sober, realistic scenes of military life, and his pictures of the wild, unspoiled beauty of the Rockies and the Sierra Nevada were popular in America until the 1880's. He and Frederick Edwin Church were mainstays of the Hudson River school.

Bloemen, Jan Frans van (*Orizzonte*)

Flemish painter and engraver (Antwerp, 1661–Rome, 1749). Apprenticed to Antoine Goubau in Antwerp, his training was Italian-inspired, and in 1681 he joined his brother Pieter, already established as a portrait and genre painter in Rome. Jan Frans, however, concentrated on landscape, earning his nickname for the beautiful effects of distance he produced. He was a prolific artist, and his pictures, reminiscent of the idealized compositions of Claude Lorrain and Gaspard Dughet, appealed to the new taste for Arcadian landscape in intellectual circles, and were much sought after by aristocratic collectors, Roman and foreign.

Boccioni, Umberto

Italian painter, sculptor, and writer (Reggio Calabria, 1882–Sorte, near Verona, 1916). His boyhood was passed in various towns of Italy, and in 1901 he went to Rome and there had his first art lessons, attending the studio of the Futurist Giacomo Balla, together with Severini. He visited Paris and St. Petersburg in 1906, and on his return entered the Academy at Venice, settling in Milan a year later. From 1908 to 1910, under the influence of the Divisionist painters there, he produced, for the most part, portraits, interiors, and his first townscapes, the latter already full of violence and dynamism. In 1910, with the rest of the group, he signed the Futurist manifestos, and began a series of pictures which unite the new Dynamism with a modified Divisionist technique. *The City Rises* (1910), in the New York Museum of Modern Art, is one of these. In his last years he was in close touch with cultural developments in Paris and made fresh experiments in search of a synthesis of Futurism and the spatial theories of Cézanne and the Cubists. See his *Portrait of Ferruccio Busoni* (1916) in the Galleria d'Arte Moderna in Rome.

Böcklin, Arnold

Swiss painter (Basel, 1827–San Domenico di Fiesole, 1901). He trained at the Düsseldorf Academy with Johann Wilhelm Schirmer, then studied in Brussels, Antwerp, Paris, and Rome, after which he was appointed a professor at the Academy in Weimar in 1860. On his return to Rome in 1862 to improve his knowledge of classical and Renaissance art, he was attracted instead to the landscapes of Poussin and Dughet. He worked in Basel, Munich, and, from 1874 until his death, in Fiesole, painting mainly official frescoes and mythological and allegorical pictures. The latter illustrate northern folktales and legends and seem to anticipate Symbolism with their mysterious, uneasy settings.

Bonington, Richard Parkes

English painter, watercolourist, and lithographer (Arnold, near Nottingham, 1802–London, 1828). His family moved to France in 1817, where his first teacher, in Calais, was a follower of Thomas Girtin. Afterwards he studied in Paris with Antoine Jean Gros. From 1823 to 1826 he travelled and studied in northern France, the Low Countries, London–which he and Delacroix visited together in 1825–and Italy, taking in Venice, Bologna, Pisa, and Florence. The pictures and lithographs he made from drawings and townscapes of these years have great freedom of colour and composition, combining realism with a romantic feeling for nature. The same is true of his watercolours and small oil paintings of literary medieval subjects.

Bosch, Hieronymus (*Hieronymus van Aeken*)

Flemish painter ('s Hertogenbosch, 1450/60–1516). He probably began in the family studio workshop, and the first documentary evidence of his activity as a painter comes in 1480–81. He never left his native city, though his clients included Philip the Handsome, regent of the Netherlands (for whom he painted a lost *Last Judgement* in 1504), and Henry of Nassau, a later regent, who commissioned the triptych *The Garden of Earthly Delights,* now in the Prado. It is difficult to establish the chronology of his work, but his subjects, taken from mystical texts of the Middle Ages, from astrology, alchemy, from esoteric books and from the Bible, emerge as so many moralities directed against the corruption of the times, in tune with the atmosphere of spiritual and religious crisis that preceded the Reformation. Though fully aware of fifteenth-century discoveries in the painting of space and volume, he turns to the iconography of popular medieval belief and includes monsters, animal and human, in his inexhaustibly inventive interpretations. An interest in landscape is evident, not only in the great triptychs–*The Garden of Earthly Delights, The Hay Wagon,* and *The Epiphany,* all in the Prado, and *The Temptation of Saint Anthony* in the Museu Nacional de Arte Antiga in Lisbon–but in religious pictures such as *Saint Christopher* in the Boymans-van Beuningen Museum, Rotterdam, *Saint John on Patmos* in the Beaux-Arts, Ghent, and the Prado *Saint Anthony.*

Botticelli, Sandro (*Alessandro Filipepi*)

Italian painter (Florence, 1445–1510). He was employed in Filippo Lippi's *bottega* in 1463, and working with Andrea Verrocchio in 1467, when he first came into contact with the Medici. By 1470 he had a studio workshop of his own. In Florence the wealthy and noble classes were abandoning the civic ideals of early humanism and, in the wake of the Medici, adopting those of a luxurious court culture based on neo-Platonism; Botticelli, for whom drawing meant the creation of perfect beauty, and who partly revived the "image-making" of late Gothic he had learned from Flemish painting, more than satisfied their tastes and needs. As well as his portraits and his beautiful Madonnas, he produced the myths and allegories–the *Primavera* of c. 1478 and *The Birth of Venus,* c. 1485, both in the Uffizi–that appealed to an intellectual audience. In 1481–82 he was in Rome, painting the *Moses* frescoes for the Sistine Chapel, but in the days of Savonarola's ascendancy and the expulsion of the Medici he shared in the profound spiritual and political ferment that marked the end of the Renaissance in Florence. His disquiet is reflected in his pictures in which the northern, Gothic feeling is very strong, such as *The Mystic Nativity,* of 1501, in the National Gallery.

Boudin, Eugène

French painter (Honfleur, 1824–Deauville, 1898). Originally a printer, stationer, and weekend artist, he was encouraged by Millet to concentrate on landscape, and did so from 1845 onwards. His delicate gift, which from early on was dedicated to catching outdoor impressions, found its most suitable material at Le Havre, where he painted the sea and the beach. He was Monet's master and a friend of Courbet and Jongkind, whom he met in 1859 and 1862 respectively. In 1874 he exhibited at the first Impressionist show.

Braque, Georges

French painter (Argenteuil, 1882–Paris, 1963). After studying in Paris he showed his first work with the Fauves at the Salon des Indépendants of 1906. He and Picasso met in the following year and, as a result of the Cézanne commemorative exhibition, began to study the breakdown of space and the logical arrangement of natural data on canvas. These experiments led to the earliest examples of pure Cubism in 1910. After the First World War, Braque developed a style which, though derived from Cubism, presents its elegantly stylized images in a harmonious series of superimposed planes.

Brill, Paul

Flemish painter (Antwerp, 1554–Rome, 1626). He began by decorating harpsichords in Antwerp, but went to Rome in 1582 and stayed there for the rest of his life, being elected to the Academy of St. Luke in 1582. His earliest works are Flemish in style, recalling Pieter Bruegel the Elder and Gillis van Coninxloo, but in his maturity, though influenced by Adam Elsheimer, he tends towards a synthesis of northern form and Roman classicism. He painted many religious and mythological landscapes, such as the *Creation of the Animals* in the Galleria Doria-Pamphili, and frescoes for other palaces and churches in Rome. These include landscapes in the courtyard of the Lateran (1589), and the landscape in the *Martyrdom of Saint Clement,* in the Sala del Consistorio at the Vatican (c. 1602).

Bruegel, Jan, the Elder (*Velvet or Flower Bruegel*)

Flemish painter (Brussels, 1568–Antwerp, 1625). Second son of Pieter Bruegel the Elder. He was taught by Pieter Goetkint and completed his studies in Italy, staying in Rome from 1593 to 1594 and meeting Cardinal Federico Borromeo, one of

the first Italian collectors to appreciate genre pictures, in Milan in 1596. The following year he settled in Antwerp, and was later appointed to the court in Brussels of the Archduke Albrecht and Archduchess Isabella. He was a prolific and highly accomplished painter of flowers and animals, as evidenced by his *Garden of Eden* in the National Gallery; of religious subjects, such as his *Virgin with a Garland* series; and of allegories such as *The Five Senses* in the Prado. He frequently helped artists—Frans Francken, for example, and Rubens—with landscape backgrounds.

Bruegel, Pieter, the Elder (*Peasant Bruegel*)

Flemish painter and draftsman (Breda? 1525/30–Brussels, 1569). Probably a pupil of Pieter Coecke van Aelst, the miniaturist, in Antwerp. He was admitted to the local guild of painters in 1551. Two years later he travelled to France and Italy, and perhaps to Sicily; in Rome he may have provided landscape backgrounds for some of Giulio Clovio's miniatures. On his return he worked at first in Antwerp, where he had many friends in intellectual circles, then went to Amsterdam in 1562, and, finally, to Brussels the following year. In Antwerp in the early days he had provided landscape designs and Bosch-like drawings on religious and moral themes for the engraver Hieronymus Cock, themes which also occur in later pictures such as the *River Landscape with the Parable of the Sower,* of 1557, now in the Timken Art Gallery, San Diego, and in *Netherlandish Proverbs,* of 1559, in the Staatliche Museen, Berlin. While he took the greatest care with the realism of his scenes of ordinary life, as even his drawings show, Bruegel conceived his paintings as allegories

directed against vice and corruption, and the audience he aimed at was an intellectual one. The apparently spontaneous style in fact combines elements culled from the Flemish tradition with Italian doctrines of perspective, and the whole Mannerist mixture is achieved with dazzling technical skill. (See the *Months* cycle of 1565, now distributed among the museums of Vienna, Prague, and New York, *The Magpie on the Gallows* in the Landesmuseum, Darmstadt, *The Parable of the Blind,* of 1568, in the Museo di Capodimonte, Naples, and *The Birdnester* in the Kunsthistorisches Museum, Vienna.) Pictures such as his *Battle in the Bay of Naples* in the Galleria Doria-Pamphili in Rome and *Tempest at Sea* in the Kunsthistorisches Museum, Vienna, remind us that he was also one of the first marine painters.

Campagnola, Domenico

Italian painter and engraver (Padua, 1500–Venice, 1581). Of northern origin, he was adopted by Giulio Campagnola, who taught him the art of engraving. He completed his training under Titian in Venice and worked mostly in Padua, applying to Titianesque themes the Mannerist techniques learned from artists such as Pordenone, Romanino, and Salviati, then active in the Veneto. (See The *Miracle of the Drowned Child* in the Scuola del Santo, Padua.) The dots and hatching used to express pictorial values in his engravings after Titian tend to destroy outline, so that the forms are blurred.

Campagnola, Giulio

Italian painter and engraver (Padua, 1482–1515 or later). Trained in Padua and Ferrara, where he lived from 1498 to 1499. His earliest engravings,

such as *The Astrologer* of 1509, are inspired by Dürer and Mantegna. He worked in Venice, probably collaborating with Giorgione, whose tonality he conveyed in engraving by a kind of Pointillism that softened the outlines and reproduced the shading. Examples are the *Reclining Nude* and the *Young Shepherd.*

Canaletto (*Giovanni Antonio Canal*)

Italian painter and engraver (Venice, 1697–1768). Began as pupil and assistant to his father, a designer and painter of opera scenery, and went to Rome in 1719. Seeing the views and landscapes of the artists, Italian and foreign, who lived there, he promptly abandoned the theatre and theatrical effects for an exact, naturalistic portrayal of reality. Back in Venice he began his enormous output of views—pictures and engravings of the town which were not only sold to local collectors and Grand Tourists, but also sent directly to England by dealers and merchants. From 1746 to 1756, save for two short visits home, Canaletto was himself in England, working in London and elsewhere, painting townscapes and country seats or reproducing his Venetian views. Though his clients seemed always to want their favourite spots recorded, and these were always the best-known ones, like the Piazza and the Grand Canal, and though he used a camera obscura as an aid to accuracy, Canaletto keeps a genuine and lively interest in the little figures he puts in. He also has a wholly pictorial feeling for subtle colour variations in architecture and for the light effects of cloud and water.

Cappelle, Jan van de

Dutch painter (Amsterdam, c. 1624/25–1679). Owner of a

prosperous dyeing business, with the income from which he was able to form a notable collection of the Flemish and Dutch masters, and particularly of marine paintings. He also had five hundred drawings by Rembrandt, who was a friend of his. He was himself primarily a marine artist, specializing in calm seascapes, preferably under early evening or morning light. Simple composition and the use of silvery greys mark his early work, recalling that of Simon de Vlieger, but his palette brightens after 1650, and there is more movement and surprise in the structure of his pictures, light reflections on cloud and water receiving special attention.

Carpaccio, Vittore

Italian painter (Venice, 1460/65–1526). We have few definite facts on his early training, but may assume the influence of the Bellini brothers; he certainly shared Gentile's interest in chronicle painting. His attention to architectural detail suggests Piero della Francesca and the court of Urbino, and here the link would be Antonello da Messina. His iconographical sources, on the other hand, are clearly in contemporary wood engravings and illuminated manuscripts. He stands somewhat apart from the great stylistic innovators of the Venetian school—Giovanni Bellini, Giorgione, and Titian—painting mostly series for the *scuole*, or fraternities, of Venice, such as that at San Giorgio degli Schiavoni—the Dalmatian merchants—with Saint George, Saint Tryphonius, and Saint Jerome, or the *Legend of Saint Ursula,* of 1490–95, now in the Accademia. His sacred subjects—for example, the *Lamentation over the Dead Christ,* of c. 1510, now in the Staatliche Museen, Berlin—are often taken from northern books of devotion, such as *The Golden*

Legend. In all these pictures he was able to introduce the sea and the lagoon and the ships on which depended the rich trade and political dominance of his beloved city.

Carrà, Carlo

Italian painter (Quargnento, near Turin, 1881–Milan, 1966). Trained as a designer, then studied at the Brera Academy, Milan. He signed the Futurist manifesto of 1910, but in Paris, over the next four years, became interested in Cubism. With De Chirico, whom he met in 1916, he originated Metaphysical painting. From 1919 onwards, however, he reacted against avant-garde experiments and returned to traditional "plastic values" and the great Italian masters—Giotto, Masaccio, Paolo Uccello, and Piero della Francesca—whom he saw through eyes accustomed to Cézanne and the Cubists. In this back-to-order phase, landscape, and especially Tuscan landscape, was his favourite subject. His style softened under Post-Impressionist influence after 1926, and grew more mannered after the Second World War, as though he were intent on rediscovering the Lombard origins of romantic realism.

Carracci, Annibale

Italian painter and engraver (Bologna, 1560–1609). He began in the Mannerist climate of Bologna, like his brother Agostino and their cousin Lodovico, and all three collaborated on the *Jason* frescoes in the Palazzo Fava. His earliest altarpieces and genre pictures (e.g., *The Bean Eater,* c. 1585, in the Colonna Gallery in Rome), however, show the more realistic tendencies that had already reached Bologna and are found in the work of Bartolomeo Passarotti. These tendencies were reinforced less by his presumed visit to Tuscany than by a stay in Lombardy in or around 1584, when he learned more of the naturalistic Lombard style as practiced by Vicenzo Campi of Cremona and the Flemish genre painters established in the region. Equally important in its effect on his palette and composition was his study of Correggio and Frederico Barocci, supplemented by a trip to Venice to look at Tintoretto and Veronese. The outcome of all this was that Annibale, and Agostino and Lodovico with him, adopted the classical idiom, which comprised the developments of the sixteenth century and could fulfil the demands of post-Reformation religious art while appealing to aristocratic patrons who flattered themselves on their intellectual tastes. In 1595 Cardinal Odoardo Farnese invited him to Rome, where the Correggio influence came to its full flowering in the mythological frescoes for the great gallery of the Palazzo Farnese, executed in approximately 1597–1602, and in the Aldobrandini lunettes at Palazzo Doria, which show religious episodes framed—indeed, embowered—in ideal landscapes.

Cézanne, Paul

French painter and draftsman (Aix-en-Provence, 1839–1906). Having studied for the law at Aix, he enrolled at the school of design there, and at the Académie Suisse in Paris in 1861. During the next four years he saw much of the Impressionists but hated Parisian life and regularly went back to Aix. His artistic development was neither quick nor easy and in 1873 he was still doing figure scenes and portraits in the romantic style, using dark colours. He then passed on to Impressionist landscapes and views, unappreciated even by his painter friends, and after his lack of success at the Impressionist exhibition of 1877 he broke away to conduct his own researches by himself. He now painted still lifes, portraits, and landscape to show that solid reality is constructed of essential forms and all that matters is volume defined by areas of colour. After moving about between L'Estaque, Pontoise, Fontainebleau, and Giverny, he settled more or less permanently in Aix, evolving a modern classical style in his paintings of Mont Ste. Victoire, his still lifes with apples, and his landscape pictures with groups of bathers.

Christo (*Christo Jaracheff*)

Bulgarian artist (Gabrovo, 1935). Educated in Sofia and Vienna, he went to Paris in 1958 and indulged in neo-Dada experiments—*empaquetages,* or the art of wrapping things in parcels to reveal their essential meaning. Next he joined the New Realists in 1962, and has since continued his investigations into the nature of reality, in the course of which, following a planned program, he has packaged various civic monuments in large sheets of plastic tied with rope, fenced off tracts of countryside, including a stretch of the Australian coast in 1969, and strung a large red plastic curtain over the Grand Hogback at Rifle, Colorado, in 1971. This artistic intervention will, he says, either "ennoble" reality by making everybody take notice, or turn it into something we can all share and enjoy—an art object—while a protest is also registered against the ecological pollution spread by modern society.

Church, Frederick Edwin

American painter (Hartford, Connecticut, 1828–New York, 1900). After art lessons in Hartford he was from 1844 to 1846 a pupil of Thomas Cole at Mountain House in the Catskills, and moved to New York in 1848. His landscapes combine realistic observation with the naïve grandeur of the Hudson River school, to which he belonged. He painted out of doors in Vermont, New Haven, and at Niagara Falls, and travelled to South America, Jamaica, Paris, London, Rome, and the Middle East. He returned to the Catskills to paint in 1869, and paid frequent visits to Mexico during his last years.

Chu Tuan

Chinese painter (active 1500–1525). Born in the province of Chekiang, he worked for the first twenty years of the century at the court of the Ming emperors. Though a disciple of the Chê school, his landscape was more monumental, in the tradition of Ma Yüan and the Northern Sung in the thirteenth century. He painted in ink and pale watercolour, the brushstrokes being usually broken and incisive in the foreground, and the backgrounds softly shaded with fine dots.

Cima da Conegliano (*Giambattista Cima*)

Italian painter (Conegliano, c. 1459–Venice, c. 1517). His first known works reveal affinities with Bartolomeo Montagna, but there are no accounts of his training as an artist. He is mentioned in a document of 1492 as being in Venice, and had probably lived there for some years by then. There was some early leaning towards Alvise Vivarini, but by 1493 the rhythm of his pictures, and the elegant formal dignity of the figures, are clearly derived from Giovanni Bellini and Antonello da Messina. The sensitive handling of landscape is, however, all his own, learned

in the hills and fields of the Veneto.

Cole, Thomas

American painter of Lancashire birth (Bolton-le-Moors, 1801–New York, 1848). His parents emigrated to Philadelphia when he was eighteen. In 1820 he began as an amateur portrait painter, then studied at the Pennsylvania Academy of Fine Arts. Turning to landscape, he took the Hudson River as his subject and, with Bierstadt and Church, was a founder and leading member of the Hudson River school. He went to Europe in 1829, and three years spent among London, Paris, Florence, Rome, and Naples opened his eyes to actual "civilized" landscape and to the ideal landscape of Lorrain and Poussin.

Constable, John

English painter, watercolourist, and draftsman (East Bergholt, Suffolk, 1776–London, 1837). Began drawing as an untrained amateur and because of family opposition could attend classes at the Royal Academy for only one year, in 1779. The next two years were marked by growing interest in Dutch and English landscape painting as represented by the two Van Ruisdaels, Gainsborough, and Wilson. He went to Holland in 1803 and the Lake District in 1806, but otherwise lived in London, with short annual holidays in Suffolk or, from 1811, to Salisbury or the south coast, to sketch in the open air. From his earliest post-student days his landscapes were true to nature: *Malvern Hall,* of 1809, in the Tate Gallery is an example. His technique became increasingly fluid, far removed from neoclassical "polish," and a marvellous

instrument for catching a subject in its different aspects as shifting light or atmosphere affected form and colouring. (See his studies of Flatford Mill and Salisbury Cathedral.) Constable's "scientific" approach to landscape emerges most clearly in his drawings and watercolours, and at its most individual and vivid in his sketches of sky and clouds.

Corot, Jean Baptiste Camille

French painter, draftsman, and engraver (Paris, 1796–Ville-d'Avray, 1875). Working in the family business, he could not devote himself to painting until 1822, when he took lessons from Achille Michallon and Victor Bertin, who directed his attention towards classic landscape. Between 1825 and 1828 he visited Rome, Naples, and Ischia, studying the Roman Campagna and scenery with classical ruins. The following year he worked with the Barbizon painters in the forest of Fontainebleau, and travelled about France. He was again in Italy in 1834, seeing Genoa, Venice, and Tuscany, went to Rome in 1843, and during his last twenty years made journeys to Holland, Switzerland, and England. His "classical" landscapes with nymphs and mythological figures were so popular that he produced them for the rest of his life, but he preferred the true landscapes he was already painting on the first Roman visit, and it is these that matter in the development of nineteenth-century art. In them he is feeling towards an ever more simplified treatment of form, with expanses of soft-toned colour, alive with the vibrations of light. His figures, too, are studied and treated in the same way–peasants of the Campagna, painted like Renaissance portraits.

Cossa, Francesco

Italian painter (Ferrara, c. 1436–Bologna, 1478). He is thought to have been trained in Padua, where he would know the work of Donatello and Mantegna, but was also greatly influenced by Piero della Francesca, who painted frescoes, now lost, in Ferrara in 1449. Rogier van der Weyden, who visited the town in 1449, may have introduced him to Flemish art. In 1469–70 he worked with Cosimo Tura, who probably planned the cycle on allegorical and mythological frescoes for Duke Borso d'Este in the Palazzo di Schifanoia at Ferrara. The *March* and *April* pictures are his, he collaborated on *May,* and perhaps on *July* and *August,* differing from Tura and the younger Ercole de' Roberti by his more serene and classical manipulation of space, somewhat in the style of Piero della Francesca. Dissatisfied with what the duke paid him, Cossa left for Bologna, where his work, again in collaboration with Ercole de' Roberti, included the *Griffoni Polyptych* of c. 1472, for San Petronio, the parts of which are now dispersed in museums in Italy and abroad. His frescoes for the Garganelli Chapel in San Pietro, begun in 1477, were destroyed at the end of the following century.

Costa, Nino (Giovanni)

Italian painter and writer (Rome, 1826–Marina di Pisa, 1893). First studied painting with Vincenzo Camuccini in 1845, and subsequently at the Academy. In 1849, on the fall of Mazzini's short-lived Roman Republic, he moved into the country and lived for ten years between Albano and La Sabina. There he began to paint open-air landscape in a style that owed much to his love for the great Renaissance masters, especially Leonardo and Luini, whose

works he had admired in Milan. His "archaism," with its clear-cut colouring, influenced the emerging Macchiaioli group, whose discussions he joined at the Caffè Michelangelo when he went to Florence. He travelled often to Paris (the first visit may have been as early as 1860), to London and Florence. In 1885 he founded the *In Arte Libertas* movement in Rome to combat the materialistic "art" that was popular there at the time.

Cotman, John Sell

English painter, watercolourist, and draftsman (Norwich, 1782–London, 1842). He went to London in 1798 and attended life classes together with other young landscape painters such as Girtin, Turner, and De Wint. He lived in London, Norwich, and Yarmouth, but almost every year made long journeys in search of subjects all over the country. In 1834 he became professor of drawing at King's College, London. It was in watercolour rather than in oils that he developed his free, direct technique of landscape painting, using broad masses of synthesized colour.

Courbet, Gustave

French painter (Ornans, 1819–La Tour du Peilz, Vaud, 1877). Coming to Paris in 1840, he neglected his law studies for art classes at the ateliers of Père Suisse and Père Lapin, and learned a great deal by copying in the Louvre, where he preferred the Flemish, Dutch, and Venetian schools. He first submitted portraits and self-portraits to the Salon in 1844. His 1847 entries were refused, however, and in that year he visited Amsterdam, mainly to study Rembrandt. After the revolution of 1848, with the approval of Baudelaire and influenced by the

socialism of his friend Proudhon, he began painting in a realistic, anticlassical, antiromantic style. Their technique and monumental composition were derived from the past, but the ordinary, everyday subjects were meant to appeal to the ordinary, everyday public. (See *Funeral at Ornans,* of 1849, in the Louvre, and *Young Girls on the Banks of the Seine,* 1859, at the Petit Palais.) In the last ten years of his life he applied these ideas to landscape painting—seascapes, forest and hunting scenes—deliberately rejecting received notions of spatial organization and pretty subject matter. He supported the Commune in 1870 and served on the Federal Commission of Artists in 1871. When order was restored, Courbet was tried and imprisoned for "complicity in the destruction of the Vendôme Column." Threatened with sequestration of his property, he afterwards took refuge in Switzerland, where he remained until his death.

Cozens, John Robert

English painter, watercolourist, and draftsman (London, 1752–99). He and his father, Alexander, who was born in Russia about 1715 and died in London in 1786, were the founders of the English school of watercolour. Both worked with and for William Beckford, a key figure in the Romantic movement, who took lessons from Alexander. John Robert began to draw landscape as a child and his landscape painting *Hannibal Crossing the Alps* was shown at the Royal Academy in 1776, soon after his return from the first of two journeys to Switzerland and Italy. The skill in atmospheric effects and the expressive directness of vision learned on his travels make him the true precursor of Girtin and Turner—both of whom copied his watercolours—and even of the Impressionists.

Cranach, Lucas, the Elder

German painter and engraver (Kronach, 1472–Weimar, 1553). Trained in his father's studio, and from 1498 worked in various German cities. From Vienna, where he was in touch with humanist circles at the university, the elector of Saxony, Frederick the Wise, summoned him to Wittenberg in 1503. Wittenberg was a center of the reformed religion as well as of Renaissance currents from Italy, and he became intimate with Luther and Melancthon. His flourishing studio carried out commissions for the Emperor Charles V, Cardinal Albrecht of Brandenburg, and Duke Albrecht of Prussia, and produced altarpieces, portraits, mannered and erotic nudes, nonreligious pictures, and hunting scenes. He had a large repertory of given subjects and employed a number of assistants. Cranach at his best is a magnificent draftsman. The incisive line gives unity to the traditional German themes, which he endowed with the spirit of the Renaissance and set in deep, spreading landscapes, a blend of fantasy and accurate natural detail.

Dahl, Johann Christian

Norwegian painter (Bergen, 1788–Dresden, 1857). Studied at the Copenhagen Academy, but in 1818 went to Dresden, where he encountered German romanticism and the influence of Caspar David Friedrich. His landscape style, however, remained distinct from that of the Romantics, for the light and atmosphere he admired in pictures of the Dutch school inclined him to naturalistic landscape, of which he was a pioneer. Many of his studies of sky, clouds, and countryside remind us of Constable, though there is no evidence that he ever knew the English painter's work. Dahl is Norway's greatest landscape painter.

Danby, Francis

Irish painter (Wexford, 1793–Exmouth, 1861). After studying landscape painting in Dublin, he went to London in 1813, where he saw pictures by Turner which influenced him deeply. He lived in Bristol until 1830, making one journey to Norway, but for the next ten years moved among France, Germany, Switzerland, and Italy. In London again from 1840 to 1847, he then settled in Devonshire, where he combined the activities of artist and boatbuilder. As a young man he was a successful painter of Turneresque seascapes, but his later pictures have the full romantic load of allegory and hidden meaning, with fantasy landscapes like those of Claude Lorrain.

Daubigny, Charles

French painter and engraver (Paris, 1817–78). First taught by his father, who was also a landscape painter. He spent a year in Italy in 1836 and, like many young artists, worked as a book illustrator, but turned to landscape as well. When working at Fontainebleau and in the Morvan in 1832, he met Corot, a meeting which, together with his discovery of Constable during a visit to England, confirmed him in his taste for the art. He was one of the most sensitive of the second wave of Barbizon painters, and his attention to the effects of light and atmosphere would influence the Impressionists.

Diaz de la Peña, Narciso Virgilio

French painter of Spanish origin (Bordeaux, 1808–Menton, 1876). As a boy he decorated porcelain in a china factory, but at the same time studied masters such as Correggio, Watteau, Boucher, and Delacroix, and developed a neo-rococo style. This changed when he met Théodore Rousseau in 1837 and joined the Barbizon painters at Fontainebleau, though he never possessed Rousseau's quality or inner strength, and was earthier than Daubigny. He paints crisply, with a rich, dark palette, and is apt to introduce nymphs into his forest scenes.

Domenichino (*Domenico Zampieri*)

Italian painter (Bologna, 1581–Naples, 1641). Trained in Bologna by the Carracci at their Accademia degli Incamminati, and went to Rome in 1601 to work with Annibale Carracci on the frescoes at Palazzo Farnese, where the lunette of *The Girl with the Unicorn* is said to be his. Under the patronage of the learned cardinal Giovanni Battista Agucchi, Domenichino gained a huge reputation in Rome for altarpieces, frescoes (such as his *Scenes from the Life of Saint Cecilia* in San Luigi dei Francesi), and mythological subjects such as *Diana and the Hunters,* now in the Borghese Gallery. These latter have a flavour of Raphael, but works in which landscape plays a large part—the Louvre *Landscapes with the Legends of Hercules,* for example—are clearly derived from Annibale Carracci.

Domenico Veneziano

Italian painter (Venice, c. 1405–Florence, 1461). Nothing is known of his early years, but he was almost certainly trained in the International Gothic culture of the Veneto, perhaps at Padua, and influenced by Gentile da Fabriano, Pisanello, and Masolino. He dates a letter from Pe-

rugia in 1438 and is heard of in Florence twelve months later, though he must by then have been familiar with the Florentine painters Masaccio, Fra Angelico, and Filippo Lippi, and the changes they had introduced. While he may have been in Rome as a young man, acting as assistant first to Gentile and then to Masolino, probably in 1426–30, and is unlikely to have lost touch with his friends in Venice as he grew older, some critics believe that he had an important role in Florence in the 1430's and '40's. Piero della Francesca was his pupil, through whom, they think, his studies of light in relation to spatial perspective were to influence fifteenth-century painting in central and northern Italy.

Dosso Dossi *(Giovanni Luteri)*

Italian painter (? c. 1489–Ferrara, 1542). His warm, fantastic colour, recalling Giorgione or the early Titian, suggests a Venetian training. We know that he worked in Mantua in 1512, painted frescoes in the Villa Imperiale at Pesaro about 1530, and in the Castello del Buonconsiglio at Trento in 1531–32. Mostly, however, he worked for Alfonso d'Este at Ferrara, painting altarpieces and mythological pictures such as the *Circe* in the Borghese Gallery, Rome, or the *Argonauts* in the National Gallery, Washington. Though he remains very much a colourist, the influence of Giulio Romano, Pordenone, and the first Mannerists is evident after his stay in Rome in 1519–20.

Dubuffet, Jean

French painter, sculptor, engraver, and composer (Le Havre, 1901). After some art lessons in Paris in 1918 he went into business, and it was not until 1942 that he devoted himself to paint-

ing. His early pictures show the influence of Klee, but after 1945, under that of Jean Fautrier, he turned to what he calls *art brut,* crude art. On coarse grounds of plaster, sand, or clay he traced lines and shapes suggestive of the prehistoric or the primitive, of graffiti or the scrawls of children and the mentally unbalanced. The *Paysages grotesques* of 1949 were the result of visits to the Sahara Desert in the previous two years. They were followed by the *Sols et terrains* series of 1951, and the *Tables paysagées,* in which nature themes are marked directly into the composition, like plants and animals in weird geological strata. Since 1955 Dubuffet has also experimented with collages and assemblages of the most varied materials, ranging from coloured paper to butterflies' wings. His lithographs, the *Phénomènes* of 1959–62, are entirely inspired by nature.

Dudreville, Leonardo

Italian painter (Venice, 1885–Ghiffa, 1975). Studied with Cesare Talloni at the Brera Academy in Milan, and from 1906 to 1912 belonged to the Divisionist group, adopting a symbolic style of painting, not unlike that of Segantini in his last period. He met Severini in Paris in 1912 and two years later, together with the critic Ugo Nebbia, the architect Antonio Sant'Elia, and the painter Carlo Erba, took the path of Futurism and founded the *Nuove tendenze* group (which boasted few other members). In 1922, however, he was one of the founders of a more traditionally minded group, the Novecento.

Dufy, Raoul

French painter, decorative and scenic artist (Le Havre, 1877–Forcalquiers, 1953). Studied at the Academy of Le Havre, and went to the Beaux-Arts in Paris in 1901. In 1905, having met

Matisse, he joined the Fauves, and about five years after that dallied briefly with Cubism. The personal style he evolved after the First World War owed something to Impressionism and some of its colour to the Fauves. His favourite subjects were landscapes, seascapes, and views, with scenes of daily life executed in a decorative fashion, often in fantastic colours, with figures delicately sketched. Pictures of this kind led to a great deal of decorative work: murals for the Palace of Electricity at the Paris Exhibition of 1937 and for the monkey house at the Jardin des Plantes in 1938, textile and tapestry designs, even pottery and book illustration.

Dughet, Gaspard

Italian painter of French origin (Rome, 1615–75). His first teacher was his brother-in-law, Poussin, in whose house he lived from 1631 to 1635. But he was interested in and learned from all the landscape painters then in Rome, from Claude Lorrain to Salvator Rosa, and was certainly acquainted with contemporary Dutch and Flemish art. During the 1630's he visited Perugia, Naples, and Florence, sketching in the open air, and became himself the most famous landscape artist in Rome with his frescoes of 1640–44 for the Carmelite church of San Martino ai Monti. The papal aristocracy employed him, and he painted a number of easel pictures for Italian and foreign collectors, including the grand duke of Tuscany and the king of Spain. He was fond of scenes of storm and tempest and of idealized landscape, constructed with remarkable freedom of perspective and foreshortening.

Dürer, Albrecht

German painter, draftsman, engraver, and writer on art (Nur-

emberg, 1471–1528). He began his training with his father, a master goldsmith, and was apprenticed in 1486 to the town's leading painter, Michael Wolgemut. From 1490 to 1494 he travelled around Germany and Switzerland as a journeyman, then for another twelve months to Venice, Padua, and Mantua. Here the works of Giovanni Bellini and Andrea Mantegna introduced him to the Italian Renaissance. During this time and in the following years he painted watercolours of the Trentino and of Nuremberg and its surroundings that are among the first pure landscapes known, and similar views of Kalkreuth followed in about 1511. He opened a studio on his return, where work was done not only for local patrons but for Frederick the Wise of Saxony and the Emperor Maximilian I. He was in Venice again from 1505 to 1507, and made a triumphal progress through the Low Countries in 1520–21. In Dürer the German tradition is subordinated to the new learning of Renaissance Italy. Drawing and brilliant colour are of the first importance, and his figures are real people, set in space suggested by real perspective. This is true both of his portraits, such as that of *Hans Tucher,* painted in 1499 and now in the Schlossmuseum, Weimar, and his religious pictures–the Uffizi *Adoration of the Magi,* of 1504, for instance, or *The Martyrdom of the Ten Thousand,* of 1508, in the Vienna Kunsthistorisches Museum. He was also a masterly engraver and a pioneer of wood engraving, the full potential value of which had not been previously explored. (See the *Apocalypse* series of 1498, the *Great Passion* series of 1499–1510, and that on *The Life of the Virgin,* of 1505–10.)

Eakins, Thomas

American painter (Philadelphia,

1844–1916). After studying in his native city, he went to Paris in 1866 and had lessons from the academic painters Gérôme and Bonnat, though he preferred the style of Manet. Three years later he visited Spain, and seventeenth-century Spanish art, that of Velázquez in particular, was to be a prime influence on him. Returning to America in 1872, he painted intensely realistic portraits, landscapes, and scenes of bourgeois life, working from nature and experimental photographs as a means of analyzing the dynamics of bodies in motion. He was the leading realist painter in the country, and an influential teacher.

Elsheimer, Adam

German painter and engraver (Frankfurt am Main, 1578–Rome, 1610). Frankfurt was an important art center, receptive to developments in landscape painting by reason of the presence there of several of the Dutch Mannerists. After an apprenticeship with Philipp Uffenbach and a brief stay in Munich—one of the capitals of international Mannerism—Elsheimer went to Venice, where he was chiefly impressed by Tintoretto and Jacopo Bassano. Documents show that he was in Rome by 1600. There he remained until his death ten years later; ten fruitful years in which he knew, influenced, and was influenced by Paul Brill and the Roman landscapists such as Agostino Tassi, and added to his own northern art the classicism of Annibale Carracci and the luminous values of Caravaggio. His small paintings, many of them on copper, are of sacred and mythological subjects in landscape settings, with a pronouncedly Mannerist liking for the contrasts of light in night scenes.

Eyck, Jan van

Flemish painter (probably Maastricht, c. 1390–Bruges, 1441).

Of his early years nothing is known, though some critics believe that he painted several miniatures from the now-destroyed *Turin Hours* (Museo Civico, Turin). These must have been executed about 1420, and their style is already in advance of the Late Gothic convention used elsewhere in the manuscript, perhaps by his brother Hubert. There is evidence that Jan was at The Hague in 1422–24, and in 1425 he was appointed court painter to Philip the Good, Duke of Burgundy, and settled at Lille. In 1427–28, at Tournai, he met Robert Campin and Rogier van der Weyden, and in 1430 made his final move to Bruges, seat of the ducal court in Flanders. He painted in oils, a technique employed since the fourteenth century, but by adding oil-mixed paints to tempera was able to obtain rich and wonderful effects of light and colour. His vision of man as being at one with nature is almost that of the Renaissance, and with it he combines the meticulous portrayal of reality learned from the Franco-Flemish illuminators. The great polyptych, *The Adoration of the Mystic Lamb (The Ghent Altarpiece)* in St. Bavon, Ghent, begun by Hubert in 1425 and finished by Jan in 1432, marks the beginning of this entirely new kind of painting. Other works include religious subjects and a series of superb portraits, among them *Giovanni Arnolfini and His Bride,* of 1434, in the National Gallery.

Fattori, Giovanni

Italian painter and engraver (Leghorn, 1825–Florence, 1908). After studying at Leghorn, he attended the Academy in Florence from 1846 to 1848. Though he drew from nature and met his contemporaries at the famous Caffè Michelangelo, Fattori painted in the style of academic romanticism—see, for instance, his *Mary Stuart at the*

Crookstone Camp, of 1858–59, in the Galleria d'Arte Moderna at Florence—until 1859, when he met Nino Costa. *The Italian Camp after the Battle of Magenta* (1861–62, in the same gallery) is a work of conscientious and methodical realism, based on historical research and the study of landscape and animals, and full of sincere and fervent patriotism. The Risorgimento inspired him to several such pictures. At the same time, however, he adopted the *macchia* technique of spots or patches of colour, using it in portraiture and landscape, though in freer fashion than was usual, since for him the colour mattered more than anything. Until 1867 he lived in Leghorn, where his renewed friendship with Nino Costa naturally encouraged him in this way of working. He visited Paris in 1875, and was less inclined to the Impressionists than to Corot and the Barbizon school, though Corot was never a strong influence. A productive draftsman and watercolourist, Fattori also took to engraving in 1875, producing admirable landscapes of the Maremma marshes, where he liked to paint.

Fontanesi, Antonio

Italian painter and etcher (Reggio Emilia, 1818–Turin, 1882). Trained in Reggio Emilia and went to live in Turin in 1847. A volunteer soldier in the rising against the Austrians of 1848–49, he spent the following years in exile at Geneva, where he first saw the work of Alexandre Calame and the Swiss Romantic school of landscape painters. Journeys abroad further extended his knowledge of foreign landscape artists—of Corot and the Barbizon painters on a visit to Paris in 1855, of Constable and Turner in London ten years later. From 1869 onwards he occupied the chair of landscape painting at the Albertina Acad-

emy of Fine Arts in Turin, with an interval in Tokyo as head of an art school in 1876–78. His work, always romantic and, towards the end of his life, pre-Symbolist in character, includes landscape in oils and etching.

Fouquet, Jean

French painter and illuminator (Tours, c. 1420–1477/81). Probably trained as a miniaturist in the Franco-Flemish tradition of the court of the Duc de Berry, Fouquet was acquainted with the art of early fifteenth-century Italy and applied Renaissance treatment of space and volume in his own painting. He was himself in Italy from 1444 to 1447, certainly in Rome, where Fra Angelico was then working, and perhaps in Florence, where Domenico Veneziano and the young Piero della Francesca could have been important influences. Returning to France, he entered the service of King Charles VII in Paris, and everything of his that has come down to us dates from the second half of the century. His few easel pictures include the Louvre portrait of the king and the *Melun Diptych,* one of whose panels is now in the Antwerp Museum and the other in Berlin. Of the illuminated manuscripts, the *Antiquities of the Jews* and the *Grandes Chroniques de France* were done between 1470 and about 1476 and are both in the Bibliothèque Nationale in Paris; the *Hours of Étienne Chevalier,* in the Musée Condé at Chantilly, is from 1450 to about 1455.

Fragonard, Jean-Honoré

French painter, draftsman, and book illustrator (Grasse, 1732–Paris, 1806). His family moved north to Paris in 1738 and for a time he took lessons from Chardin, Boucher, and Van Loo. Having won the Prix de Rome, he was at the French Academy

there from 1756 to 1761, studying Italian decorative art of the sixteenth and seventeenth centuries and spending much time in the company of compatriots such as Greuze and Hubert Robert. It was here he painted his first landscapes, including *The Gardens of the Villa d'Este, Tivoli* (now in the Wallace Collection), and landscape drawings from nature which were later engraved by his friend Abbé de Saint-Non. He was a great connoisseur of all things Italian, as of Dutch landscape and genre painting, and possessed of outstanding technical ability. His rococo *scènes galantes* were famous—and *The Swing*, of 1767, also in the Wallace Collection, is perhaps most famous of all—but he had the happy art of mingling and cross-fertilizing widely diverse styles—portraiture, landscape, history painting, genre painting, legend. In later life he even did book illustrations, for example his *Fables* of La Fontaine.

Friedrich, Caspar David

German painter, watercolourist, draftsman, and engraver (Greifswald, Pomerania, 1774–Dresden, 1840). Trained as a young man in his native city, then under Swedish rule, and, from 1794 to 1798, at the Copenhagen Academy. From there he went to Dresden and frequented the circle of romantic intellectuals, in which literature was represented by Goethe, Tieck, Novalis, and Kleist, and art by Runge, Dahl, Kersting, and Cornelius. His drawing never lost its minute, neoclassical precision, but he painted full-blown romantic landscape. The colours are heightened, the appeal is emotional, and there is symbol and significance in everything that could be made to bear some philosophical or Christian meaning and so oppose the "paganism" of the freethinkers.

Gainsborough, Thomas

English painter and draftsman (Sudbury, 1727–London, 1788). Began by painting in the Suffolk countryside, and from 1740 to 1748 was pupil and assistant to the engraver Hubert Gravelot in London. Here he gained a knowledge of contemporary French painting, and was also influenced by the work of Jacob van Ruisdael and the Dutch landscapists. In the next few years he practiced mainly as a portrait painter in Sudbury, but, as in *Mr. and Mrs. Robert Andrews* (1750, now in the National Gallery), liked to show his sitters in an open-air setting and thoroughly in tune with their surroundings. In Bath, from 1759 to 1774, he continued with portraits—the famous *Blue Boy* in the Huntingdon Library and Art Gallery at San Marino, California, belongs to c. 1770–but also painted landscape, which he loved, frequently borrowing passages from Rubens. (An example is *The Harvest Wagon* of c. 1767, in the Barber Institute, Birmingham.) In his later years he studied landscape even more, preferring it to the conventional "pastoral" style. (See *The Market Cart*, 1786–87, in the Tate Gallery.) Gainsborough lived in London from 1774 until his death, and was a founder member of the Royal Academy.

Gauguin, Paul

French painter, sculptor, engraver, and potter (Paris, 1848–Hiva Oa, Marquesas Islands, 1903). A prosperous Parisian stockbroker, he began as a Sunday painter, first showing his work with the Impressionists in 1880. Three years later he abandoned his business for full-time painting and evolved away from Impressionism. The style he arrived at, after much experiment, was antirealist, based on strong, simple outlines and flat contrasting colours, and he chose symbolic subject matter. His inspiration came from medieval stained glass, popular French and primitive art, and from the similar experiments of Van Gogh, Cézanne, and the Symbolists. His endless search for an unspoiled, "natural" society took him to Brittany, then to Arles, and, in 1891, to Tahiti. This first visit lasted for two years, and he went back there when he left France permanently in 1895, moving, before he died, to the more remote Marquesas Islands.

Gentile da Fabriano

Italian painter (Fabriano, c. 1370–Rome, 1427). Nothing is known of his youth, though it seems certain that he was trained in his birthplace and worked in Lombardy, in various Sienese towns, perhaps at Orvieto and in the Veneto. Documents show that he was in Venice itself from 1408 to 1414, painting portraits and historical frescoes in the ducal palace–a *Storm at Sea* is mentioned–but none of these, unfortunately, remains. His art, so perfectly suited to the elegant narrative style of International Gothic, found admirers not only in Venice but also in Brescia, where he worked in 1414–19 for Pandolfo Malatesta. In 1422 he went to Florence in the retinue of Pope Martin V, worked in 1425–26 in Siena, then, at the pope's invitation, in Rome, where he died before finishing a fresco cycle in St. John Lateran.

Ghiberti, Lorenzo

Italian sculptor and commentator on art (Florence, 1378–1455). Possessed of enormous technical skill, gained as an apprentice to his goldsmith stepfather, he was learned enough to appreciate both the discoveries in classical art being made in late thirteenth-century Florence and the older Gothic tradition, whether Tuscan or French. He also studied in Rome in 1416 and in Venice in 1424–25. His masterpieces are the two sets of bronze panels for the Baptistery doors in Florence, for the north door between 1401 and 1423, and for the eastern *Gates of Paradise* in 1425–52. They mark the stylistic transition from Late Gothic to Renaissance. Ghiberti worked, in addition, for the cathedral and for the church of Orsanmichele, and a number of terra-cotta Madonnas were made in his studio. He seems to have been a painter and an architect as well, though there is documentary evidence only of his having designed stained-glass windows. His three books of *Commentarii* were begun in 1447 and left unfinished at his death. Book II is the first history we have of Italian art, from Giotto to his own time, which contains more serious criticism than biographical gossip.

Gigante, Giacinto

Italian painter, watercolourist, draftsman, and etcher (Naples, 1806–76). He came from a large family of painters, and specialized in Neapolitan views and popular genre scenes for the tourists. He was a pupil first of the German topographical artist Hüber, then of Anton Pitloo, a romantic view painter and central figure of a group known as the Posillipo school. From topography, Gigante turned to painting Naples, the Bay, and the islands, of which he produced an abundance of oils, watercolours, etchings, and lithographs, with occasional genre scenes. His technique was all charm and rapidity, catching essentials with a few strokes of brilliant colour. He was familiar with the anticlassical Neapolitan landscape school of the seventeenth and eighteenth centuries, and his knowledge of the classical tradition was doubtless acquired on visits to Rome from

1826 onwards. (Though Paris, where he stayed in 1869, apparently left no traces.) He was an enormously successful artist, with his fellow townsmen and with their visitors, and worked for the Bourbon sovereigns. After the unification of Italy he was also patronized by the House of Savoy.

Giorgione (*Giorgio* or *Zorzi da Castelfranco*)

Italian painter (Castelfranco Veneto, 1477/78–Venice, 1510). Trained in Venice, if not as a pupil of Giovanni Bellini, then certainly in his immediate circle. He knew the work of Antonello da Messina and Carpaccio, and may actually have known Leonardo, who was in Venice in 1500. We have few biographical facts about him, the chronology of his pictures is doubtful, and critical argument continues as to their enigmatic meaning and even the attributions. *The Madonna Enthroned between Saints Francis and Liberale,* in the cathedral at Castelfranco, is, however, from his early period, and the allegorical pictures, such as *The Three Philosophers* in the Kunsthistorisches Museum at Vienna, the *Sleeping Venus* in the Gemäldegalerie, Dresden, and the Louvre *Concert Champêtre* were painted for Venetian noblemen in the last years of his life. Giorgione revolutionized Renaissance art and led the way to the Venetian style of the sixteenth century. He painted, so Vasari says, "living forms and other representations" straight onto canvas, without preparatory drawing, and his art was one not of contrasted light and shade, but of softly blended colour that harmonizes the components of a picture into a luminous whole.

Giovanni di Paolo

Italian painter (Siena, c. 1400–

82). He probably learned from Taddeo di Bartolo and other artists at work in the cathedral sacristy, but must also have seen pictures by Gentile da Fabriano, who was in Siena in 1426. Giovanni never adopted Renaissance innovations from Florence but remained faithful to fourteenth-century Sienese ways. The modelling of his figures, the taste for childlike narrative, the beautifully observed animals, flowers, and fruit, and more especially his faraway fairy-tale backgrounds are all inherited from Late Gothic tradition. His first works date from 1426, but his masterpieces are the polyptychs of 1445 and later, among them that of *Saint Nicholas of Bari* (1453) and the *Last Supper,* both in the Pinacoteca at Siena.

Gogh, Vincent van

Dutch painter (Groot Zundert, 1853–Auvers-sur-Oise, 1890). Starting at sixteen, he worked in the Goupil galleries in The Hague, London, and Paris, but after a religious crisis in 1879 spent two and a half years as a lay preacher in Belgium, among the mining communities of the Borinage region. To this period belong his earliest drawings and paintings, depicting the lives of the poor in a manner recalling Millet, Courbet, and Daumier. In 1886 he went to Paris, became friendly with Gauguin, Toulouse-Lautrec, and Seurat, and completely changed his subject matter. Now he painted portraits, street scenes, and landscapes, adopting the style and lighter colours of the Impressionists, and drawing with the almost flowerlike delicacy he found in Japanese prints. From 1888 to 1889 he had a house in Arles, where Gauguin joined him for a time, and there he completed almost two hundred pictures—landscapes, views, portraits, and flower pieces—in a style of his own derived in part from Impressionism, but whose

colouring owed something to the Dutch tradition and to Delacroix. Naturalistic nineteenth-century notions of the relationship of the artist to reality were left behind. He used only clear, contrasted, dazzlingly brilliant colours laid on in thick strokes with brush or palette knife, and his aims resembled those of the Symbolists. (See the *Sunflower* pictures, and those of the bridge at Arles.) Suffering from hallucinations and mental stress, he was admitted to an asylum, where he continued to paint cypress trees and starry skies and cornfields, the thick, swirling brushwork growing more and more forceful, the colour contrasts starker and more simplified.

Goya y Lucientes, Francisco

Spanish painter and etcher (Fuendetodos, 1746–Bordeaux, 1828). He was apprenticed to a painter in Saragossa, near to his birthplace, then went to Madrid, completing his artistic education by the study of Velázquez, Raphael Mengs, and Gian Battista Tiepolo (the latter two then working for the court), and a visit to Italy in 1770–71. With a commission from the royal tapestry manufactory, he settled in the capital, and between 1775 and 1791–92 produced the designs, now in the Prado, on themes of peasant and popular life, based in part on French *scènes galantes.* His portraits—lucidity tempered with elegance—of the Spanish nobility won him the post of first painter to King Charles IV. Yet it was now that his style changed, and he discarded the pictorial conventions of the epoch to experiment with the freest of dramatic forms, foreshadowing the Romantic movement and castigating superstition and corruption. The set of etchings known as *Los Caprichos,* the *Caprices,* of 1799, are

of this period. But though he had friends and sympathies among the francophiles and freethinkers, he was sickened by the French invasion and occupation. We see what his feelings were in the etchings of the *Disasters of War* series (1808–09), and in the two paintings of the executions of Spanish patriots after the rising in Madrid on 2 and 3 May 1808. (These date from 1814 and are in the Prado.) When the Restoration came he was, however, politically suspect, and he retired first to his house near Madrid, whose walls he painted with the famous *Black Goyas*—also in the Prado—of 1820–23, and then, in 1824, to Bordeaux, where he died four years later.

Goyen, Jan van

Dutch painter (Leiden, 1596–The Hague, 1656). He had various undistinguished teachers, but in 1615 became a pupil of the landscape painter Esaias van de Velde, and after two years his partner. He visited France and England, returning to The Hague in 1634. His early style resembles that of Van de Velde, naturalistic and descriptive, but by the 1620's he had begun to paint very simple, almost monochromatic landscapes, in tones of brown and sepia. He specialized in marine and river studies in increasingly pale colours, and his brushwork became translucent, delicately shadowed, and fluid. In his last years he modelled his light effects on those of Aelbert Cuyp, who was his own pupil.

Greco, El (*Domeniko Theotokopulos*)

Spanish painter of Cretan origin (Candia, 1541–Toledo, 1614). His early works in Crete, where he is known to have lived until 1566, were conventional Byzantine religious pictures. By 1568, however, he had already been for some time in Venice, where Tin-

toretto and the more "Northern" painters such as the Bassani seem to have had a stronger influence than Titian, whose studio he frequented. (See the altarpiece in the Galleria Estense at Modena, and the view of Sinai on the back.) In 1570 he went for three years or so to Rome, meeting the Late Mannerist painters and studying the century's earlier masters; and there may have been a second visit to Venice before he left for Spain in about 1577. He settled in Toledo, a cultured, lively, cosmopolitan, passionately religious town, where he developed to the full his nonrealistic, anticlassical style. This, despite its debt to Venice and Rome and its brilliant eccentricities of form and colour, touched the heights of mysticism in religious works such as the pictures, begun in 1603, for the Hospital de la Caridid at Illescas, or the 1608–16 *Annunciation* in the Santa Cruz Museum, Toledo. The mystical quality is recognizable, too, in one of his rare essays in pure landscape, the *View of Toledo* in the Metropolitan Museum, New York; and his portraits – the serried faces in *The Burial of Count Orgaz* (1586–88) in Santo Tomé, Toledo, for example – catch the very soul and essence of his sitters.

Guardi, Francesco

Italian painter (Venice, 1712–93). Trained in the studio of his brother Giovanni Antonio, a painter of altarpieces, but he also learned from the works of Sebastiano Ricci, Alessandro Magnasco, and of his brother-in-law Gian Battista Tiepolo. From Tiepolo he took his light touch and the flickering, luminous tonality that gave a soft outline, quite unlike the strict and rigid vistas of Canaletto. Except for a few religious pictures, Guardi paints mostly *capricci* and fantasy views which include beautiful

landscape passages. His actual views of Venice show not only the great sights but small streets and side canals and the islands of the lagoon, as well as sparkling social events and state occasions.

Hasegawa Tōhaku

Japanese painter (Nanao, 1539– Edo, 1610). After his early training, he entered the Buddhist monastery of Koryu-ji at Kyoto, where his artistic education was completed. His early work was influenced by Sesshū, but later on he had followers of his own, the school of Hasegawa, who took their themes – landscapes and scenes with flowers, plants, and animals – from Chinese art, developing its monochrome-ink technique by keying it to shaded tones of grey, giving the effect of chiaroscuro. Hasegawa decorated a house for the shogun Toyotomi Hideyoshi in Kyoto with screens and wall painting, and afterwards worked for Ieyasu Tokugawa, the shogun who replaced him, at Edo (now Tokyo).

Hiroshige, Andō (Utagawa Hiroshige)

Japanese painter and engraver (Edo, 1797–1858). Son of a samurai, he attended the school of the artist Kuniyoshi Utagawa, and began as a book illustrator. Like Hokusai, he was soon designing woodcuts with scenes of daily life and views of famous buildings and beauty spots in Japan. These he drew from nature, carefully showing any interesting features and indicating changes of weather or season. (Examples are the *Fifty-four Stages on the Tōkaidō*, of 1831, and the *Famous Views of Kyoto*, of 1834.) His work is characterized by an attention to perspective that reflects the current Japanese interest in Western art, and a subtle and lyrical use of colour

and the witty observation of small, ordinary incident. A successful and prolific artist, Hiroshige in his latter years adopted a vertical, instead of a flowing, line and often relapses into mere straining after effect.

Hobbema, Meindert

Dutch painter (Amsterdam, 1638–1709). From 1655 to 1657 he was taught by Jacob van Ruisdael at Haarlem, though he seems to have done much else with his life besides being a painter. His landscapes include views of the Dutch countryside with woods, windmills, and open prospects. Pale skies are strongly contrasted with dark-toned trees, and he has subtle effects of light among shadows and on water.

Hodges, William

English painter (London, 1744–97). Pupil of and later collaborator with and imitator of Richard Wilson. He may have travelled in Switzerland and Germany before, in 1772, he sailed with Captain Cook as his official artist on the second Pacific voyage. His pictures are detailed and accurate records, composed on classical lines, of New Zealand and the South Seas, and were reproduced when he returned home to London. Visits to India in 1778–84 and to Russia in 1790 were to provide him with new exotic subject matter.

Hodler, Ferdinand

Swiss painter (Bern, 1853–Geneva, 1918). He was trained first at Thun, then at the School of Fine Arts in Geneva. He was especially interested in Corot and the French landscapists, and in 1878 made a painting trip to Spain. In Geneva he associated with the Symbolists and produced allegorical pictures of literary inspiration, with a curling,

curving line, simplifed shapes and flat washes of exotic colour. After 1910 his favourite art form was landscape, stylized and highly decorative.

Hokusai, Katsushika

Japanese painter, engraver, designer, and illustrator (Edo, 1760–1849). His training as painter and wood engraver was influenced by various schools, among them those of Kano, Tosa, and Korin, and until 1797 he changed his style more than once and signed his works by different names. As Hokusai, "Star of the North," he settled to his most characteristic work, with paintings, drawings, wood engravings and book illustrations in the *ukiyo-e* style, the "painting of the floating world," producing lively portraits, landscapes, and genre scenes. He took additional details from Chinese art of the Ming and Ch'ing periods, from the more realist of the Japanese masters and from Western, particularly from Dutch, painting. He also travelled the country, constantly and observantly, in search of material. His landscape is either a background to the real-life scenes, as in the wood engravings of the Tōkaidō highway from Edo to Kyoto; or shown for its own sake, as in the 1831–33 views of Mount Fuji, and others dealing with the beauties of Japan. Hokusai also liked painting flowers, plants and animals, and grotesque and erotic subjects. He wrote two treatises on the arts of painting and book illustration, and himself illustrated some five hundred books. When he died he left behind him over three thousand drawings and sketches from nature.

Homer, Winslow

American painter, draftsman, and engraver (Boston, 1836–Prouts Neck, Maine, 1910).

Studied lithography and began as a free-lance book illustrator in 1857. His records of the Civil War, when he was *Harper's* correspondent, include photographs, engravings, and a series of realistic paintings. A visit to France in 1866–67 aroused his admiration for modern developments in art and he began to paint "ordinary" scenes in the manner of Manet and the early Impressionists. In England in 1881 he saw the landscapes of Constable and Turner, and evolved a loose, free style in imitation, with particular success in watercolour. He settled in Maine in 1883, and most of his pictures thereafter were of the sea and fishermen.

Huber, Wolf

German painter and engraver (Feldkirch, Voralberg, c. 1490–Passau, 1553). Trained in the circle of Michael Pacher, but was chiefly influenced by Dürer's woodcuts and the pictures of Cranach the Elder. He lived at Passau and was one of the most important artists of the Danube school, and his religious scenes, of a simple, popular kind, are set in deep, dramatic landscapes, inspired by the mountains where he was born.

Ingres, Jean Dominique

French painter and draftsman (Montauban, 1780–Paris, 1867). He first took lessons at the Toulouse Academy, then in 1797, with David in Paris. He won the Prix de Rome and was there from 1806 to 1820, with a further four years in Florence. From 1834 to 1841 he was back at the Villa Medici, this time as director of the French Academy. The neoclassical flavour of his early training gave him the taste for precise and perfect drawing and he drew figures of ideal beauty, in rhythmical, curving line. Unlike Delacroix and the

Romantics, he sought his inspiration in the past, from Raphael and Michelangelo, the Italians both "primitive" and Mannerist, and from archaic Greece, and used these models with the greatest skill and virtuosity. To the historical and mythological subjects, the nudes and Oriental scenes that commanded the interest of wealth and fashion in Paris, he added landscape. In the early Roman years he adopts a Roman convention of using exterior settings for his portraits; and his treatment of light in three small tondi with Roman views (painted about 1807 and now divided between the Musée Ingres at Montauban and the Musée des Arts Décoratifs in Paris) seems to anticipate Corot.

Inness, George

American painter and engraver (Newburgh, New York, 1825–Bridge of Allan, Scotland, 1894). Self-taught, he worked for a firm of map engravers before becoming a landscape painter. His travels in France and Italy–where he visited Rome and Florence–began in 1837, and he was especially interested in Corot, Millet, and the Barbizon school among the landscape painters of Europe. Inness was one of the foremost American practitioners of romantic realism, and the style of his last years, with its light touch, had become very like Impressionism.

Jongkind, Johann Barthold

Dutch painter and watercolourist (Lattrop, near Rotterdam, 1819–Côte-S.-André, 1891). After studying at The Hague he went to Paris in 1846 as the pupil of Eugène Isabey. From the first he devoted himself to landscape painting, combining the influence of the Dutch seventeenth century with the realism of Barbizon. A stay at Honfleur

between 1863 and 1865 led to his fondness for painting the sea and the northern French coast, and he is a forerunner of Impressionism in his handling of light and atmosphere.

Kandinsky, Vasily (*Kandinskij, Vasilij*)

Russian painter and art theorist (Moscow, 1866–Neuilly-sur-Seine, 1944). In 1896 he abandoned a law practice in Moscow and went to study painting in Munich. After some preliminary dabbling with the Jugendstil, or Art Nouveau, he evolved a completely Expressionist style, based on the juxtaposition of flat, vibrant colours, and between 1908 and 1909 painted a series of landscapes and townscapes at Murnau in Bavaria, and another of North African scenes remembered from a Tunisian holiday in 1904. His *Composition No. 1* (in the collection of Mme. Nina Kandinsky, Neuilly), of 1910, is generally regarded as the first truly abstract watercolour, but in 1911 he was one of the founders of the Blaue Reiter, a group so called after one of his own paintings, now in the Bührle Collection, Zurich. He returned to Russia in 1914 and taught there until 1922, and then taught for ten years at the Weimar-Dessau Bauhaus in Germany. When this was suppressed by the Nazis in 1933 he went to live at Neuilly. In the Bauhaus years his painting was entirely abstract; for painting had remained for him a form of pure personal expression, like music, and he was preoccupied, as in the earlier period, with the balance of colour, line, and shape.

Kirchner, Ernst Ludwig

German painter and engraver (Aschaffenburg, Bavaria, 1880–Frauenkirch, near Davos, 1938). From 1900 to 1902 he was an architecture student in Dresden,

but chose instead a career in wood engraving, expressing popular German themes with Expressionist sensitivity. In 1905 he was a founder of the group known as Die Brücke–"the bridge"–and moved to Berlin with other members in 1911. His health was poor and he spent much time in Switzerland from 1917 onwards, settling there, at Frauenkirch, when the Nazis came to power. His pictures are mostly of urban life, street scenes and portraits, with distorted shapes and dark, discordant colour.

Klee, Paul

Swiss painter and draftsman (Münchenbuchsee, near Bern, 1879–Muralto, Locarno, 1940). Studied art in Munich from 1898 to 1901 and after visiting Italy and France took part in the last period of Jugendstil. In 1910–11, however, he turned to Expressionism after a meeting with Kandinsky and the foundation of the Blaue Reiter group. His early work was all in drawing and engraving, and it was not until he went to Tunisia in 1914 that he "discovered" colour, natural, luminous, exotic, and intense, as it is seen in his watercolours of Tunisian views and landscapes. He then began to paint, and proved a prolific artist. He taught at the Bauhaus from 1921 to 1931, and at the Düsseldorf Academy after that, but in 1934, when the Nazis had taken over, returned to Switzerland for the rest of his life. He made imaginative experiments in every kind of graphic and pictorial technique and arrived at an inimitable personal style, somewhere between the figurative and the abstract. Observed natural data are shown, always in a key of fantasy, in balanced, exact compositions with rich and beautiful colour harmonies and often ironic titles. Fishes, animals, plants, flowers, imaginary

people and landscapes appear side by side with ciphers and abstract forms of every kind.

Köbke, Christen

Danish painter (Copenhagen, 1810–48). Köbke is the most remarkable landscape painter Denmark has produced, and the early decades of the nineteenth century, which saw the dawn of realism, are known there as the Köbke period. He was trained by Christoffer Wilhelm Eckersberg; and from the Dutch landscape school of the seventeenth century took his feeling for transparent light and his preference for tones of grey and grey-lilac. His slightly melancholy vision recalls that of Friedrich, though he is nearer to Corot in his free handling of landscape.

Koch, Joseph Anton

Austrian painter, watercolourist, and draftsman (Obergibeln, Tyrol, 1768–Rome, 1839). First apprenticed to a sculptor, then trained from 1785 to 1791 in Stuttgart, where David was the reigning influence. From there he went to Strasbourg and in 1792 to Basel—which expelled him for his revolutionary notions—and to various places in the Bernese Oberland, where he began to draw mountains from nature. A journey to Italy in 1794 took him as far as Naples, and he settled the following year in Rome. There he studied classical landscape and sixteenth-century painting, and was soon a leading member of the foreign colony. He was especially friendly with the Danish painter Asmus Jacob Carstens and Bertel Thorwaldsen the sculptor, and the German Nazarenes, with whom in 1825–28 he collaborated on frescoes for the Sala di Dante at the Villa Massimo near St. John Lateran. Koch painted historical and literary pictures, but in landscape his favourite subjects were Alpine views—he is the first great interpreter of Alpine scenery—and the countryside around Olevano Romano, beyond Palestrina. Already in the first decade of the nineteenth century he was a recognizable Romantic, combining a neo-Renaissance eclecticism with the minute regard for detail that typified romantic art in Germany.

Kokoschka, Oskar

Austrian painter, scene designer, writer, and playwright (Pöchlarn, 1886–Montreux, 1980). Studied at the School of Arts and Crafts in Vienna and in the 1900's painted his first pictures—visionary still lifes in the Jugendstil—wrote plays which he designed and produced himself and which are the prime examples of Expressionist theatre, and, in Switzerland in 1909, began a series of vehemently dynamic Expressionist landscapes. He went to live in Germany, worked there with the Blaue Reiter group and from 1920 to 1924 taught at the Dresden Academy. His travels in Europe and North Africa led him to paint landscape in a more Impressionist style, though his shapes and colours never lost their quality of fantasy and drama. After 1931 he worked in Vienna, Prague, and London, and in Italy from 1948 to 1949, settling in Switzerland in 1953.

Koninck, Philips de

Dutch painter (Amsterdam, 1619–88). A pupil of his brother Jacob, though the great influence on him was that of Rembrandt. He painted portraits, religious pictures, and genre scenes, but chiefly landscape from 1650 onwards. He developed the panoramic landscape, adopting the high viewpoint and dramatic treatment. Low horizons emphasize his storm-laden skies, struck through with gleams of sunshine.

Lambert, George

English painter (Kent, 1700–London, 1765). After an apprenticeship with John Wootton, a follower of Claude who taught him to appreciate the French landscape school, he worked as a scene painter at the theatres in Lincoln's Inn Fields and Covent Garden. His composition is conventional enough, but he shows farming and country pursuits, and great country houses, with great accuracy. In a remarkable collaboration he, Samuel Scott, and Hogarth produced a series of marine pictures for which he supplied the scenic backgrounds, Scott the ships, and Hogarth the figures.

Larsson, Simon Marcus

Swedish painter (Örsätter, 1825–London, 1864). After studying in Stockholm and Germany, he went in 1852 to Dresden, then the main center of German landscape painting. Three years later he went to Paris for twelve months, and travelled to Finland in 1860 and Russia in 1861. From Russia he moved to London, and there remained for the rest of his life. He was a technically accomplished artist, fond of striking effects, and his sea and landscapes abound in storms and tempests in the romantic taste.

Lega, Silvestro

Italian painter (Modigliana, near Forlì, 1826–Florence, 1895). His early work was influenced by the Purist painter Luigi Mussini, whose pupil he was, but his artist friends at the Caffè Michelangelo showed him the potentialities of realism, and he adopted the style in 1857. About 1860 he was painting military subjects with much attention to the effects of light, and from 1861 he frequented the company of Odoardo Borrani, Raffaello Sernesi, and Giuseppe Abbati, the *Macchiaioli* painters who worked at Piagentina, near Florence, and began to use their technique of painting in spots or patches of colour. The years from 1873 to 1878 were unhappy. There were family misfortunes; he suffered from eye trouble and ceased to paint. When he began again it was in the naturalist style of the Tuscan Impressionists, themselves influenced by developments in Europe as a whole.

Le Nain, Louis

French painter (Laon, 1593–Paris, 1648). With his brothers Antoine and Mathieu he was trained at Laon and may have visited Rome sometime before 1630, when he could have seen the work of Caravaggio and mingled with the foreign artists there, especially the painters of the popular *bambocciata,* or small genre pictures of low life that sold to dealers and middle-class buyers. There is documentary evidence that all three brothers were in Paris in 1630, owners of an atelier that produced a steady stream of religious and mythological canvases signed merely Le Nain—a fact that makes it very difficult to know which of them is responsible for what. However, it is generally agreed that Antoine painted the small genre pictures in the Dutch and Spanish taste, Mathieu the portraits, and Louis the large genre subjects. These show cottage interiors, or peasants at their labours, and though they certainly depict the prevailing misery of rural France, there is no overt protest in them; they are rather moral lessons for an educated public, presented in a well-mannered way. Louis and Antoine Le Nain were founder members of the Académie Royale de Peinture et de Sculpture in 1648, the year in which both died.

Leonardo da Vinci

Italian painter, sculptor, architect, scientist, and writer (Vinci, near Florence, 1452–Amboise, 1519). In 1469 he went to work in Andrea Verrocchio's studio in Florence, and had a hand in at least one of his master's pictures: an angel and part of the landscape background in the Uffizi *Baptism of Christ* are his. As an independent artist in the 1470's he paints devotional pictures and portraits, such as the Uffizi *Annunciation* of 1472/75, and the portrait of Ginevra Benci (1474) in the National Gallery of Art, Washington, related to the great linear phase of Florentine art exemplified in the work of Ghirlandaio, Botticelli, or Filippino Lippi; but a new, pyramidal concept of space composition appears with the *Adoration of the Magi,* of 1481–82, now in the Uffizi. In 1482 he entered the service of Ludovico il Moro at Milan, for whom he designed buildings and engineering projects and built machinery and settings for feasts and festivals at court. *The Virgin of the Rocks,* of 1483–86, in the Louvre and the *Last Supper* fresco at Santa Maria delle Grazie belong to the years in Milan, as do investigations in every field of knowledge. After the French invasion of 1499, Leonardo went to Mantua and Venice, and accompanied Cesare Borgia on his campaigns in central Italy as topographer and military engineer. On his return to Florence he painted the *Virgin and Child with Saint Anne and Saint John* and the *Mona Lisa,* both in the Louvre–the most "Leonardesque" of all his pictures in their summing-up of his attitude to art as the culmination and expression of man's intellectual knowledge of the world about him, and of his study of the interrelations of light and colour. Louis XII of France made him court painter and engineer at Milan in 1507– 13, and for three years after that he lived, in considerable grandeur, in a Rome dominated, artistically, by the circle that surrounded Raphael. When Francis I succeeded to the French throne and invited him to France, Leonardo accepted the invitation and went to live in the château of Cloux, near Amboise. His interests in these last years were astronomy and the cataclysmic forces of nature–see the *Deluge* drawings in the royal collection at Windsor Castle.

Liang K'ai *(Po Liang, Liang Feng-tzu)*

Chinese painter (died sometime after 1246). Of noble birth, he was court painter to the last emperors of the Southern Sung, and a professor of drawing, who retired at the end of his life to the monastery of Liu-t'ung. He painted first as an accomplished academic, but was to develop an individual style, treating Buddhist, Taoist, and Confucian themes in landscape settings freely inspired both by the monumental art of the Northern Sung, and the more lyrical, asymmetrical manner of the Southern Sung. Working in accordance with the famous classical canons laid down in the sixth century, which urged freedom of expression and technical experiment, Liang K'ai painted Ch'an, or Zen, themes with simplified monochrome landscapes based on graphic dots and short, fractured brushstrokes.

Li Lung-mien *(Li Kung-lin, Li Po-shih)*

Chinese painter (Anhwei Province, c. 1040–Lung-mien, 1106). Son of an antiquarian and bibliophile, he received a scholarly education before embarking on an administrative career. He became famous in the intellectual society of the provincial capital K'ai-feng, pursuing scientific, philosophical, and literary interests. He worked in ink and monochrome wash on paper, at first copying pictures by the old masters, of which he had a large collection, and painting horses with deliberate archaism. In time he arrived at a style of his own, in harmony with the rules for "learned painters" which rejected naturalism, balanced composition, and traditional techniques in favour of subjective expression and "raw" experimental execution based on the broken, essential line. He took his themes from history and from Buddhist, Taoist, and Confucian belief. In 1100 he retired to his house in the mountains of Lung-mien, and the misty river scenes, executed in the "dotted" technique, belong probably to his last years. The pictures we have are perhaps early copies rather than originals.

Limbourg, Pol de

Franco-Flemish miniature painter (Nijmegen, after 1385– probably Paris, 1416). All three brothers, Pol, Hermant, and Jehannequin (or Hennequin), worked closely together, settling in Paris around about 1400, when Pol was probably apprenticed to a goldsmith. In 1412 he and Jehannequin were commissioned by Philip the Bold, Duke of Burgundy, one of whose court painters was their uncle Jean Malouel, to decorate a Bible, which has not survived. At Philip's death in 1404 the Limbourg brothers seem to have an atelier in Paris. Certainly they were in contact with artists from the regions of the Rhine and Meuse and borrowed freely from their decorative conventions. Various books and detached leaves are attributed to them, but the only undoubted works are the two great *Hours* for the Duc de Berry, brother of Philip the Bold. The painting of the *Belles Heures,* now in The Cloisters, New York, is usually thought to be by Pol alone, though he may have employed assistants; and when the three brothers died, possibly of the plague, in February 1416, they left the *Très Riches Heures,* now in the Musée Condé at Chantilly, to be completed some seventy years later by Jean Colombe. In these manuscripts culminate two centuries of careful, loving nature observation, of attention to every unusual detail or embellishment, on the part of the miniaturists of the school of Paris. The discernible echoes of Lombard and Paduan Late Gothic art are, however, more likely to have their source in Jean de Berry's library than in a possible journey made by Pol to Italy.

Lorenzetti, Ambrogio

Italian painter (Siena, first heard of 1319–48). His elder brother Pietro was born about 1280, but Ambrogio is first mentioned as working in Val di Pesa in 1319, and he seems to have lived in Florence until 1321. He may then have gone back to Siena, but was again in Florence in 1327, when he was enrolled in the guild of Medici e Speziali– doctors and druggists, who included painters in their membership–and stayed there until 1332 at least. He thus had first-hand knowledge of Giotto and of his most important followers, and could pass on their realism and spatial technique to the painting of his native Siena, which was then passing from the tradition of Duccio to the graceful, elaborate International Gothic of Simone Martini. Ambrogio demonstrates the new style not only in his many Virgin and Child pictures and composite altarpieces, but in secular works as well. His great fresco the *Allegory of Good and Bad Government in Town and Country,*

painted in the Sala dei Nove of the Palazzo Pubblico in 1337-39, is a huge political allegory, meant to drive a lesson home. His previous experiments with landscape, in his panels for the church of San Procolo in Florence, illustrating the miracles of Saint Nicholas of Bari, and the *City by the Sea* and *Castle on a Lake,* later in date and now in the Siena Pinacoteca, are here extended and bear marvellous fruit. He is known to have been in Siena from 1335 to 1347, and, like his brother, probably died in the plague of 1348.

Lorrain, Claude (Claude Gelée)

French painter (Champagne, 1600–Rome, 1682). He arrived in Rome in 1613, and from 1619 to 1621 worked in Naples with Goffredo Wals, a Flemish assistant of the landscape painter Agostino Tassi and, returning to Rome, in the studio of Tassi himself. Save for a two-year collaboration with Claude Deruet on the lost frescoes for the Carmelite church in Nancy (1625-27), he never moved again, living among a foreign colony that included Poussin, the crippled Pieter Van Laer (the original *bamboccista* painter of genre scenes), and the Flemish sculptor Duquesnoy. His one subject, with variations, such as harbour and river scenes, was ideal landscape, with figures taken from classical literature. His habit was to draw in the open air, and between 1629 and 1635 Joachim von Sandrart accompanied his sketching expeditions. The material thus gathered was worked up in the studio and incorporated into the magical landscapes. These are distinctly theatrical in composition, with foregrounds like proscenium arches and "wings" of trees or classical architecture opening onto far distances. Atmosphere and illumination are truthful

and exact, yet the colour, too, is that of the stage, graded from dark foreground to palest background tones, with an unnatural cool or golden light suffusing everything.

Lotto, Lorenzo

Italian painter (Venice, c. 1480–Loreto, 1556). In the 1550's his early studies were divided between Venice and Treviso, and among those who influenced him were Giovanni Bellini, Antonello da Messina, and Dürer. He is not a classical painter, and a markedly northern, and often deliberately archaic, colouring and iconography seem, in his portraits, to foretell something of Mannerist disquiet, and set him apart from the mainstream of Venetian painting as that develops from Giorgione to Titian. In 1506 he went to work in The Marches, producing rather harsh anecdotal pictures, frequently of low life, that have touches of Raphael, whom he met during a short visit to Rome. *The Transfiguration* in the Pinacoteca at Recanati was done in about 1513, when he settled in Bergamo to paint portraits, altarpieces, and frescoes with a strong landscape element, for patrons among the local nobility. The frescoes of Saints Barbara, Catherine, and Clare in the chapel of the Villa Suardi at Trescore nearby date from 1524, and from a year later those of the life of the Virgin in the church of San Michele al Pozzo Bianco in Bergamo itself, where he also provided designs for marquetry work in the presbytery and choir stalls of Santa Maria Maggiore between 1524 and 1532. By the 1530's he was back in the Veneto and The Marches, becoming a lay brother at the holy house of Loreto in 1554.

Macke, August

German painter (Meschede,

Westphalia, 1887–Perthes-les-Hurlus, Marne, 1914). Studied in Krefeld, Berlin, and Düsseldorf. After travelling and studying abroad in various parts of Europe, he joined the Expressionist Blaue Reiter group in 1911, experimenting with colour and a progressive simplification of form, like that of the Fauves, Matisse and Seurat. The results are at their most remarkable in his landscapes and scenes of ordinary daily life.

Maestro dell'Osservanza:

see Sassetta

Magnasco, Alessandro

Italian painter (Genoa, 1667-1749). His father, who was a painter, sent him to Milan around 1678, where he stayed until 1703, influenced by Late Mannerist religious painting and by Sebastiano Ricci. From 1703 or so until 1710 he was at Florence in the service of the Medici grand duke Cosimo III, where he encountered the work of Giuseppe Maria Crespi and of Jacques Callot, and took as his subjects satire and low-life scenes, with soldiers, brigands, gypsies, mountebanks, and suchlike colourful characters. From Florence he returned to Milan and the north, adding monks and monasteries to his repertoire. He adopted an almost monochrome palette of brown tones, with occasional streaks of gold, and enlivened his pictures with small gesticulating figures, often in dramatic or threatening landscapes. Settling in Genoa in 1735, he obliged local patrons, who preferred paler colours and a cooler light, with religious episodes in landscape settings, and records of aristocratic life.

Manet, Édouard

French painter (Paris, 1832-83). After attempting to qualify as a

naval cadet to comply with his family's wishes, he obtained their permission to be an artist instead. His father's choice of teacher was the academic Thomas Couture, but Manet's artistic education came from copying in the Louvre–the work of Titian and Velázquez especially–and from travel abroad. He visited Italy in 1853 and 1856, Holland, Germany, and Austria also in 1856, and Spain in 1865. His early pictures were of scenes from daily life–partly at the suggestion of his friend Baudelaire–and already he was rejecting traditional pictorial vision. There is no shading to suggest modelling and depth; instead he uses pure colour and clear-cut forms, divided only by firm lines and the contrasts of the colours themselves. (See *Le Déjeuner sur l'herbe,* 1863, in the Musée de l'Impressionnisme, Paris.) His pictures, regularly refused by the official Salon, caused such scandal that he ceased to exhibit with the Impressionists, though he remained an inspiration to them and his river scenes of the 1870's were painted according to their theories, with a lighter palette and softer outlines than before. Later, perhaps as a result of his friendship with Zola, his style grew more realistic and he painted bars and café scenes in Paris. Semiparalyzed in his last twelve months, he produced only still-life and flower pieces.

Mantegna, Andrea

Italian painter and engraver (Padua, 1431–Mantua, 1506). In 1441 he entered the studio of the Gothic-Renaissance painter Francesco Squarcione in Padua, but learned more from the Tuscan artists working in the town–Donatello, Filippo Lippi, and Paolo Uccello, and from Piero della Francesca's frescoes at Ferrara and Andrea del Castagno's in Venice. In Venice, too,

he was on close terms with the Bellini family, and in 1454 married Nicolosia, Jacopo Bellini's daughter. In his work, Mantegna employed all the new humanist discoveries in scientific perspective, achieving bold and often complex effects by means of drawing and the direction of light. He showed man as intimately linked to his surroundings, and was one of the main channels by which Renaissance ideas reached northern Italy. After some years in Padua, during which, c. 1448-56, he painted frescoes of Saint James and Saint Christopher in the Ovetari Chapel of the Augustinian church of the Eremitani (little remains of them since the war), and the altarpiece of the church of San Zeno at Verona in 1456-59, he went to Mantua. For the rest of his life he was court painter to the Gonzaga family, though he visited Florence in 1466 and 1467, and Rome in 1488-90. For the great marquesses he painted frescoes in the palace at Mantua, completing those in the *Camera degli sposi* in 1474, and the allegories in the *studiolo* of the Marchioness Isabella d'Este in 1497. These latter are now in the Louvre, together with the *Madonna of Victory,* painted to celebrate Francesco Gonzaga's defeat of the French at Fornovo in 1496. The *Triumphs of Caesar,* another Mantuan work, is now at Hampton Court.

Marc, Franz

German painter (Munich, 1880–Verdun, 1916). Abandoning his philosophical and theological studies, he went to the Munich Academy in 1900 and began to paint landscape and portraits in traditional style. From 1905 onwards, animals became his favourite subject—goats, horses, bulls, and exotic beasts in luxuriant imaginary settings. Influenced by Gauguin,

he had a Symbolist phase, but in 1910 his association with August Macke, Kandinsky, and the Blaue Reiter group led him to concentrate on colour and lyrical expression. In Paris and Munich in 1912 he encountered and adopted the "orphic" style of the Futurists, whose spatial organization he breaks up into harmonious geometrical shapes, touched with blending, brilliant colours.

Marquet, Albert

French painter (Bordeaux, 1875–Paris, 1947). He went to live in Paris in 1890 and there met Matisse at the École des Arts Décoratifs. They met again in Gustave Moreau's studio seven years later, and with him and the rest of the Fauves Marquet took part in the first battles to establish painting as a violent, nonnarrative expression of pure colour. He worked with Dufy in Normandy in 1906, and with Matisse in Morocco in 1913. Gradually he moved away from the vision of the Fauves and began to paint in a quieter, simpler style, more delicately harmonious, and displayed a marked liking for wide river and harbour scenes.

Martin, Homer Dodge

American painter (Albany, 1836–St. Paul, Minnesota, 1897). Self-taught, he painted landscape out of doors, in the realistic style of the Hudson River school. In 1876 he went for ten years to Paris and elsewhere in France, where he had the opportunity to see Impressionist painting and he came under Whistler's influence. On his return he was one of the first to spread the new gospel of painting from nature, though his own landscape remained traditional.

Martin, John

English painter and engraver

(Haydon Bridge, Northumberland, 1789–Douglas, Isle of Man, 1854). Worked for a coach painter in Newcastle, and then with the Piedmontese Bonifacio Musso, who was settled there and who introduced him to engravings of pictures by Claude Lorrain and Salvator Rosa. In 1806 he was studying at the Academy schools in London. He painted many romantic landscapes with high-flown literary themes. His aim was the Sublime, and they illustrated human impotence in face of various natural cataclysms. Engravings of similar subjects brought him popularity in France and America as well as in England.

Masaccio *(Tommaso di Giovanni Cassai)*

Italian painter (San Giovanni Valdarno, 1401–Rome, 1428). He was enrolled as a master painter in Florence in 1422, the year of his first datable work, the triptych for San Giovenale at Cascia, now at the Soprintendenza ai Beni Artistici e Storici at Florence. We do not know who taught him, but he applied the Renaissance rules of perspective with a freedom and mastery that went straight back to Giotto, the fountainhead of the Florentine tradition who so marvellously expressed the humanist union between man and the world he lives in; and this fact argues close links with Brunelleschi and Donatello. Early sources, Vasari among them, tell us that Masaccio was in Rome for the Jubilee of 1423, and between the end of 1424 and the spring of 1425 he took over works begun in Florence by Masolino, who had gone to Hungary with the condottiere Pippo Spano and who wanted to ensure the completion of his outstanding commissions. Masaccio finished a *Virgin and Child with Saint Anne* now in the Uffizi, and did parts of the first scenes of the

fresco cycle in the Brancacci Chapel at Santa Maria del Carmine (the buildings in *The Raising of Tabitha* are his), continuing to work on them until his departure for Rome. Meanwhile, still engaged on these Brancacci frescoes, he also painted a triptych for the church of the Carmine at Pisa (parts of this are to be found in museums in Italy and elsewhere) and the great fresco of the *Trinity* in Santa Maria Novella in Florence. These were both done after 1425. In 1428 Masolino summoned him to Rome, but he died suddenly within a few months—of poison, it was rumoured.

Masolino da Panicale *(Tommaso di Cristoforo Fini)*

Italian painter (Panicale, near Lake Trasimene, c. 1383–c. 1440). Probably—or so Vasari says—he was apprenticed to Starnina and later acted as assistant to Ghiberti; and while remaining faithful to his Late Gothic beginnings, he was not untouched by the naturalism of the early Florentine Renaissance. In 1425 he went to Hungary in the service of the condottiere Pippo Spano, though he stayed for only two years, and entrusted his unfinished work in Florence–a *Virgin and Child with Saint Anne* now in the Uffizi, and the frescoes for the Brancacci Chapel in the Carmine–to Masaccio, the most promising young artist in the city. It was Masaccio who led him to put more emphasis on geometrical space and Renaissance classical ornament, without ever changing his courtly style. There are landscapes and townscapes in his pictures, as may be seen in the Carmine frescoes and those in the castle and church at Castiglione di Olona, but scientific perspective is merely an instrument by which he can increase their magic and remoteness.

Master of the Boucicaut Hours (*Jacques Coene?*)

Flemish miniaturist and illuminator (Bruges, late fourteenth to early fifteenth century). The artist who, sometime before 1417, illuminated a book of hours, now in the Musée Jacquemart-André, Paris, for the Maréchal de Boucicaut, and other books for Philip the Bold of Burgundy (an *Hours* in collaboration with Jacques de Hesdin, in the Bibliothèque Royale, Brussels, and the *Grandes Heures* in the Bibliothèque Nationale, Paris), and for the Visconti (whose *Offiziolo* is in the Biblioteca Reale at Turin), is by many critics identified with the Flemish painter Jacques Coene. Coene is heard of in Paris in 1398, when he would have known the Milanese illuminator Giovanni Alcherio, and the following year in Milan, where he furnished the cathedral authorities with a complete decorative scheme. In Paris once more, he worked with Hainsselin de Haguenot and Ymbert Stanier on a Bible for Philip the Bold, completed after 1404. His work is in the true tradition of the school of Paris, and also bears traces of the Lombard, Tuscan, Flemish, and Burgundian styles.

Matisse, Henri

French painter and sculptor (Le Cateau Cambrésis, 1869–Nice, 1954). Studied at various schools in Paris, including the École des Arts Décoratifs, and from 1895 to 1899 took lessons from Gustave Moreau at the Beaux-Arts. He also studied the Impressionists, met Pissarro, and came to use colour for its own sake, rather than to give outline or description (see his *Notre Dame in the Late Afternoon* in the Albright-Knox Art Gallery, Buffalo). In the 1900's his extension of the Neo-Impressionist experiments of Van Gogh and, in par-

ticular, of Gauguin, gave rise to the Fauve movement, whose almost exclusive use of primary colours–yellow, red, blue–was already prophetic of Expressionism. Matisse himself was to develop a highly decorative style, reminiscent of Ingres and Delacroix in its arabesque line and subtle, vivid tones. As well as painting (see his *Odalisque* portraits of the 1920's), he became a sculptor, engraver, and stage designer, made tapestry cartoons, and in 1948–51 executed murals for the chapel of the Dominican nuns at Vence.

Ma Yüan (*Ch'in-shan*)

Chinese painter (Ho-chung, Shansi; active c. 1190–1230). The Ma family had been painters to the Southern Sung emperors for five generations, and Ma Yüan was among the great innovators of his time. When young he adhered to the classical canons, as is seen by the central composition of his monumental landscapes, but later, with Hsia Kuei, he founded the school known after them as Ma-Hsia. This was to have enormous influence on Chinese and Japanese landscape painting. Working on paper or silk in pale watercolours and thick brown ink, applied in dots and broken brushstrokes, Ma Yüan based his landscapes on bold foreshortening and the contrast of painted areas with those left blank. They thus lose none of their decorative value but, as an essential factor in the composition, add to the importance of the figures, whose activities usually illustrate some philosophical theme or concept.

Micco Spadaro (*Domenico Gargiulo*)

Italian painter (Naples, 1612–75). A painter of elegant altarpieces and portraits, Spadaro was also famous for his landscapes, views, and documentary scenes.

As a young man he worked with Codazzi (he put the figures in the big architectural pictures), and was always attracted by the *bambocciati* and their lively genre style, although he developed a personal, poetical touch with landscape, proving particularly successful in conveying effects of atmosphere.

Millet, Jean François

French painter and draftsman (Gruchy, near Gréville, 1814–Barbizon, 1875). Born of peasant stock, he had his first art lessons in Cherbourg, then, in 1837, with Paul Delaroche in Paris, under whose influence he produced portraits and romantic mythological pictures. But he shared the revolutionary ideas that were to bring down the July Monarchy in 1848, and in 1847, on meeting the painters of Barbizon–where he settled two years later–he abandoned romantic mythology and the academic style to paint peasant working life in terms of realism and social and humanitarian purpose. (See *The Gleaners,* of 1857, in the Louvre.) Inspired by Théodore Rousseau, he began to concentrate on landscape in 1863, and his work, especially in pastel, is Impressionist in character.

Momper, Joost de

Flemish painter (Antwerp, 1564–1635). Trained by his father, Bartholomeus, and recorded as a member of the painters' guild of Antwerp in 1581. He may have visited Italy in the following year, and if so could have met his compatriot Lodewyk Toeput, who lived in the Veneto region. His landscapes, often enlivened by peasant scenes, are derived from Bruegel and extend the Mannerist taste for the bizarre and the fantastic. Frequently, in fact, the small figures were added by Jan

Bruegel, son of Pieter; and Momper himself, who was no figure painter, often contributed landscape backgrounds to the pictures of, among others, Frans Francken and the younger Teniers.

Mondrian, Piet (*Pieter Cornelius Mondriaan*)

Dutch painter and art theorist (Amersfoort, 1872–New York, 1944). Studied and taught in Amsterdam, and in 1904 produced a series of Post-Impressionist and Symbolist landscapes, much influenced by Van Gogh and the Divisionist Jan Toorop. Moved to Paris in 1911, where acquaintance with the Cubists stimulated his interest in abstraction, which he reached through a progressive stylization of nature themes, a process that may be observed in his series *Trees*. On the outbreak of war he returned to Holland and in 1917, with Theo van Doesburg, founded the magazine *De Stijl*, which had a decisive role in the development of abstract art. These were the years of the first of the paintings we think of as typical Mondrians, based on rigid geometrical division of the surface, subdivided with equal rigour into squares and rectangles, all in black, white, and the three primary colours, yellow, blue, and red. He explored every possible relationship and combination of these basic forms and colours, ringing endless changes, and in the last four years of his life, in New York, eliminated black to obtain yet more luminous and dynamic effects.

Monet, Claude

French painter (Paris, 1840–Giverny, 1926). As a young man in Le Havre, self-taught, he used to draw caricatures, but Boudin, with whom he became friendly, persuaded him to paint landscape from nature. He went to

Paris in 1859, where he preferred the Académie Suisse to the official Academy, frequented the society of Courbet and his circle, and studied the work of Delacroix, Corot, and Daubigny. Following a brief interlude back at Le Havre, he attended Gleyre's studio in Paris, making the acquaintance of Renoir, Sisley, and Bazille and continuing his open-air painting at Barbizon and Honfleur. His treatment of figures remained realistic, like that of Courbet, until his *Women in the Garden,* of 1876, with its reminiscences of Manet—a canvas now in the Musée de l'Impressionnisme, Paris. His earliest Impressionist pictures were those of 1869, when he worked with Renoir at Bougival (for example, *La Grenouillière,* in the Metropolitan Museum, New York), but during the Franco-Prussian War he went to Holland and England with Pissarro; and these travels—England producing its customary revelation of Constable and Turner—proved a great new stimulus to his art. Pictures painted in 1870–80 at Argenteuil, Vétheuil, and elsewhere in the Paris region include those which formed the essential core of the first Impressionist exhibition in 1874. After a stay on the Riviera and at Bordighera in 1883–84 his palette became more brilliant, and in the years at Giverny, from 1883 until his death, he went far beyond Impressionism. Volume and form were gradually abandoned for a free interpenetration of light and dazzling colour. Moving from abstraction to Fauvism, from Expressionism to nonformal painting, he anticipates the twentieth-century avant-garde. (See his series on Rouen Cathedral of 1892–94, the views of Venice of 1908–09, and the *Water Lilies* of 1906–26.)

Morandi, Giorgio

Italian painter and etcher (Bologna, 1890–1964). From 1907 to 1913 studied at the Academy of Fine Arts in Bologna, where he was later to be a professor. In 1914–15 he evolved an individual style that took account of developments in contemporary European painting, of Cézanne in particular, and experimented in landscape with construction based on a balance of essential forms. For two years after the war he was associated with the Metaphysical school, but moved away from Italian movements, although, like the Novecento group, he was deeply aware of the severe plastic values of Giotto, Masaccio, Piero della Francesca, and other early fifteenth-century masters. With the exception of a few self-portraits made between 1920 and 1925, he painted only landscape and still-life pictures, the latter usually including glasses, carafes, bottles, and similar objects. With these restricted forms and his favourite tones of brown and grey, he experimented ceaselessly. The drawings and etchings, begun about 1911, are on these same themes.

Morlotti, Ennio

Italian painter (Lecco, 1910). After early training at the Florence Academy he began painting Lombard landscapes in 1937, much influenced by Cézanne and the Expressionists. In 1939 he went to live in Milan, where he attended courses at the Brera Academy and joined the Corrente group. He painted landscape at Brianza and Gropparello near Piacenza during the war and in 1947 was a founder member of the New Art Front (Fronte Nuovo delle Arti), which gave place to the Group of Eight (Gruppo degli Otto) in 1952. Since the war he has evolved, by way of a post-Picasso period, a highly individual style, painting trees and plants and flowers in contrasted, flaring

colours, usually applied with a palette knife.

Moser, Lukas

German painter (active in Sweden, first half of the fifteenth century). He may be identified with the Meister Lukas who is heard of as designing stained glass for the Basser Chapel in the cathedral at Ulm between 1409 and 1434. The only work that is undoubtedly his is the 1431 triptych of the *Madonna* in the church at Tiefenbronn—Late Gothic in character, but with a spatial unity that argues familiarity with Flemish art, especially that of Robert Campin.

Murillo, Bartolomé Estéban

Spanish painter (Seville, 1617–82). Trained in the realistic Spanish style of Zurbarán, Ribera, and Velázquez, of which Seville was the main center, he adopted the baroque manner towards the middle of the century, with a brilliant palette derived chiefly from Venetian pictures he had seen. He was much in demand for religious works, full of the slightly sentimental mysticism of the time, but was also a naturalistic portrait painter, and the lively realism of his homely genre scenes, often with outdoor settings, outweighs their conventionality.

Neer, Aert van der

Dutch painter (Amsterdam, 1603–77). Studied with the Camphuysen brothers at Gorinchem, and towards 1630 went to live in Amsterdam, where he painted in a desultory way, combining art with innkeeping. He specialized in winter views in the manner of Avercamp, and in moonlit river and sea scenes executed in grey and silvery tones. He would paint the same subject at different times of day to catch the varying effects of light.

Niccolò dell' Abbate

Italian painter (Modena, c. 1509–Fontainebleau? 1571). First worked in Modena, where he was painting in 1537, and its neighbourhood. The subjects of his pictures and frescoes are for the most part literary and mythological (see the frescoes for the castle of Scandiano, now in the Galleria Estense, Modena), and his elegant Mannerism is derived from many sources, including Correggio, Parmigianino, and Dosso Dossi, and from Ferrarese and Flemish painting. He went to Bologna in 1548, and his frescoes in several of the palaces there are strongly reminiscent of Parmigianino and the Raphaelesque style then much in vogue in that city. (Examples are the cycle of scenes from Ariosto from Palazzo Torfanni, now in the Pinacoteca, and those in Palazzo Poggi.) He also painted glowing detached landscapes, treating them, it seems, as a separate branch of art. Henry II of France, on the advice of Primaticcio, summoned him to Fontainebleau, where he arrived at the beginning of 1552 and stayed until his death. In close collaboration with Primaticcio he executed a series of decorative frescoes in the château—mostly lost and known only through contemporary engravings—and a group of pictures on mythological subjects, among them *The Abduction of Proserpine* in the Louvre.

Nolde, Emil

German painter and engraver (Nolde, 1867–Seebüll, 1956). Began painting in 1897 after studying decorative arts and furniture design. Two years later he went to Paris, attended the Académie Julian, and admired the work of Van Gogh and Gauguin as well as that of masters such as Rembrandt, Goya, and Daumier. His pictures from 1901 to 1904 are almost all of flowers or

flower gardens, but his meeting with the Brücke and Blaue Reiter groups turned him to landscape of a completely Expressionist kind, with the accent on the symbolic value of colour. In 1913 he made a voyage to the South Seas, after which his pictures contained exotic elements that increased their decorative quality and sense of primitive nature, while he also began to paint wildly misshapen human figures.

Ogata Kōrin (Ogata Koretomi)

Japanese painter (Kyoto, 1658–1716). Son of a wealthy textile merchant, he studied painting at Edo (modern Tokyo), with various masters, being especially influenced by Sōtatsu, who had revived the traditional style with much emphasis on unusual compositional schemes. Kōrin accentuated the decorative side of his style, using notched and sinuous lines which do not, however, detract from the realism of his portraits, genre and literary scenes, land- and seascapes. The school he founded and which was named after him enjoyed an enthusiastic middle-class public until the beginning of the nineteenth century. He painted folding screens and lacquer objects, designed textiles, and, with his brother Ogata Kenzan, even painted pottery.

Paolo Uccello (Paolo di Dono)

Italian painter (Florence, c. 1397–1475). He was probably trained in the circle of Gherardo Starnina and is first heard of in 1407, assisting Ghiberti with the panels for the north door of the Baptistery at Florence. He set up as an independent painter in 1415 and seven years later was working as a mosaicist at San Marco in Venice, where he may have stayed until 1430. His idio-syncratic style is perhaps due to his absence from Florence in these particular years, so vital for the new art and learning. When Renaissance ideas were developing there he was surrounded by a still-living tradition of Late Gothic. Instead of using Brunelleschi's laws of perspective, he applies and extends those of the Middle Ages, and chooses his colours to suit the fairy-tale atmosphere of subjects that are often those one would expect to find in Gothic courtly painting. Many of his small pictures were executed for private patrons, but he was also employed on major works for the main churches in Florence: his fresco portrait of the English condottiere captain John Hawkwood–Giovanni Acuto–is in the cathedral, and there are frescoes of the Creation and the Flood in the eastern bays of the Chiostro Verde at Santa Maria Novella. He worked, too, for the Medici. The panels of his *Rout of San Romano,* which hung in Lorenzo's bedroom, are now divided among the Uffizi, the Louvre, and the National Gallery, London. He went to Padua in 1445, on the invitation of Donatello, and to Urbino in 1467–69.

Patinir, Joachim

Flemish painter (Bouvignes, c. 1480–Antwerp, 1524). An early visit to Bruges, though uncertain, may have been the occasion of his meeting with Gerard David, whose division of background landscape into three spatial colour planes–brown-violet, green, and blue-green–he was to adopt and amplify. In 1515 he was registered as a member of the painters' guild of Antwerp, a town whose humanist climate suited him. He was especially interested in the geographical discoveries of the time, and artistic circles there were among the first in the Low Countries to welcome the Renaissance culture of Italy and the beginnings of Mannerism. Another influence on Patinir was that of his friend Dürer's engravings. The chronology of his pictures is difficult to determine, and they are for the most part variations of a few themes, such as the Flight into Egypt, Crossing the Styx, or Saint Jerome in the Wilderness. Those in which figures are more important than landscape are usually taken to be early works, while as he grows older landscape becomes dominant and his colouring more exotic.

Pellizza da Volpedo, Giuseppe

Italian painter (Volpedo, 1868–1907). Studied at the academies of Milan, Rome, and Florence–where he was taught by Fattori–and Bologna, under Cesare Talloni. In 1889 he went for further experience to Paris. He adopted the Divisionist technique and was from the first a realistic painter, whose work was socialist in tone (he was peasant-born and a confirmed Socialist). His political pictures culminate in *The Fourth Estate* (1901, Galleria d'Arte Moderna, Milan). After this he concentrated on landscape, in the style of the Barbizon school or in the styles of Divisionists, Symbolists, and Neo-Impressionists *(Clothes in the Sun,* Sacerdoti Collection, Milan). In Rome, at the end of his life, he had considerable influence on Balla and Boccioni.

Permeke, Constant

Belgian painter, draftsman, and sculptor (Antwerp, 1886–Jabbeke, 1952). Studied at the academies of Bruges and Ghent and, together with the brothers Léon and Gustave de Smet, was among the first Belgian Expressionists. By 1912 his work already had overtones of existentialism and humanitarian protest. After World War I he developed a very personal style, still Expressionist, with essential forms and a few sober colours. He painted peasants, sailors, labourers, miners–always working-class subjects–dramatized as monumental figures in their appropriate landscape settings.

Perugino, Pietro (Pietro Vannucci)

Italian painter (Città della Pieve, 1445–Fontignano, near Perugia, 1523). He was trained, first in Umbria and The Marches, probably in contact with Piero della Francesca and those around him, and then in Florence, where he worked as an independent painter in 1472. Tradition makes him an assistant of Andrea Verrocchio's and the friend of Botticelli. He was in Rome in 1478 and two years later was employed on frescoes for the Sistine Chapel, where his *Delivery of the Keys to Saint Peter* remains, others having been destroyed to make way for Michelangelo's *Last Judgment.* Here, together with other Florentine artists engaged with him on the scheme, he aimed at a synthesis of all that had been discovered and taught by the masters of the first half of the century, with line and drawing as the chief end and object. From 1482 he was busily occupied between Florence and Perugia, painting frescoes and altarpieces such as the *Galitzine Triptych* (c. 1482) now in the National Gallery, Washington, and even venturing into the realms of mythology with *Apollo and Marsyas* (c. 1495, in the Louvre). In or about 1496 the thirteen-year-old Raphael came to him as pupil and assistant.

Picasso, Pablo

Spanish painter, sculptor, and etcher (Malaga, 1881–Mougins, 1973). His father, an art teacher, gave him his first drawing lessons, and he subsequently stud-

ied in Barcelona and Madrid. Between 1900 and 1902 he went several times to Paris, eagerly absorbing avant-garde ideas and injecting into them his Spanish realism. The stylized line and colour of his Blue Period portraits of 1901–04 are markedly "aesthetic," and the same is true of the clown pictures of the Rose Period, 1905–06. He had moved permanently to Paris in 1904 and there, among the Fauves, influenced by Negro and other primitive art, and by Cézanne, he started the experiments with form and spatial articulation that led to an entirely new way of looking at reality. The normal processes of vision were suspended and reality was achieved by an intellectual reconstruction of the three dimensions. His first work in this style, the 1907 *Demoiselles d'Avignon* now in the New York Museum of Modern Art, was followed in 1910 by the portraits and landscapes through which he and Braque were to arrive at Cubism, the fragmentation of form into planes. From 1925 onwards, when Cubism was exhausted and an Italian journey in 1917 had attracted him back to classicism, Picasso launched into his enormous production of sculpture and pottery and lithographs, etchings, and engravings. He remained apart from the new avant-gardes as they came and went, and continued an endless search for fresh forms of expression, ranging from the classical to the barbaric.

Piccio, Il *(Giovanni Carnovali)*

Italian painter and draftsman (Montegrino, Varese, 1804–Cremona, 1873). Took lessons at the Academy in Bergamo from Giuseppe Diotti, who directed his attention to the sixteenth-century artists of Lombardy and Emilio Romagna–Luini, Lotto, Correggio, and Parmigianino. He visited Rome for the first

time in 1831, then settled at Cremona, opening a second studio in Milan. He and Giacomo Trecourt went to Paris together in 1845, where he was more interested in the Old Masters than in French Romantic painting. He went to Rome twice more, in 1848 and again, with Federico Faruffini, in 1855, but preferred to work in Cremona and keep aloof from artistic circles in Milan, rejecting academic art with its neoclassical roots, and trying to achieve greater realism by means of colour. Typically, he treated sketches as works in their own right, and had a Romantic's devotion to the heritage of the Renaissance. He painted altarpieces, pictures of historical and mythological subjects, and portraits, as well as landscape. His landscapes, always of the country or the River Po, are very different from the conventional "views" then in vogue in Lombardy.

Piero della Francesca

Italian painter and art theorist (Borgo San Sepolcro, 1410/20–92). He was probably apprenticed in Florence, where he would study the work of Masaccio and Fra Angelico, and there is evidence that he was there in 1439 as assistant to Domenico Veneziano. Over the next ten years he worked in his native town *(The Baptism of Christ* in the National Gallery belongs to this period), and had his first contacts with the Montefeltro court at Urbino. A *Flagellation* painted sometime after 1444 is in the Galleria Nazionale delle Marche in the ducal palace, and his intellectual style, based on the scientific application to painting of the rules of mathematics and geometry through drawing and the use of light, was just the thing for the sophisticated humanists of that society. After stays at Ferrara, perhaps in 1449, and Rimini in 1451 (where

he may have met Leon Baptista Alberti), he began the frescoes of *The Legend of the True Cross* in the church of San Francesco at Arezzo. These were certainly finished by 1466, but he had been in Rome meanwhile, though his Vatican frescoes of 1459 have not survived. In the following years he worked in Borgo San Sepolcro, Arezzo, and Urbino. (See the diptych of *The Duke and Duchess of Urbino* in the Uffizi, and an altarpiece for San Bernardino, now in the Brera Gallery, Milan.) Between 1474 and 1482 he also wrote a treatise on perspective, *De Prospectiva pingendi,* and another, the *Libellus de quinque corporibus regolaribus,* on the proportions of the human body.

Piero di Cosimo *(Piero di Lorenzo)*

Italian painter (Florence, 1461/62–1521). He was apprenticed in 1480 to Cosimo Rosselli, whose name he took and with whom he worked on the frescoes of the Sistine Chapel, painting the landscape background for *The Sermon on the Mount.* Little is known of his life and we can only guess at the dating of his pictures, but he is assumed to have had some early acquaintance with Filippino Lippi. The elegant style and accurately observed landscape suggest several influences, from Leonardo to Hugo van der Goes and other Flemish masters, and Botticelli. For private patrons he painted tondi and altarpieces, but at the turn of the century his decorative pictures and panels with mythological and literary subjects were much in demand. Examples are the series on *Primitive Life* and the *Legend of Silenus,* now broken up and distributed among various museums; the National Gallery's *Death of Procris;* and *Venus, Cupid, and Mars* in the Staatliche Museen, Dahlem, Berlin.

Pissarro, Camille

French painter and engraver (St. Thomas, Virgin Islands, 1830–Paris, 1903). He came to Paris in 1855, attending classes at the Beaux-Arts and the Académie Suisse together with Monet and Cézanne, and at the beginning of his career was influenced by Corot and Manet. He lightened his palette progressively after 1868 and a stay in London with Manet (avoiding the Franco-Prussian War of 1870–71) made him, through his profound admiration for Turner and Constable, a leading Impressionist. His favourite subjects were street and garden scenes, but he also painted portraits. Between 1887 and 1890 he was using the Divisionist technique, and though he returned to Impressionism, remained a determined supporter of Seurat, Signac, and the young artists in general, including his pupil Paul Gauguin.

Poussin, Nicolas

French painter (Les Andelys, 1594–Rome, 1665). We do not know exactly who taught him, but he had lessons in Rouen and Paris and certainly studied for a time at Fontainebleau. He was in Paris in 1622–23, working with Philippe de Champaigne on the decoration of the Luxembourg Palace. He arrived in Rome in 1624, having perhaps stayed briefly in Venice on the way, and at first he painted large religious and history pictures, under the patronage of Cardinal Francesco Barberini, the pope's nephew. These were highly praised as combining classicism with French and Italian Mannerist influence and Titianesque colour, but after 1640 he abandoned them in favour of easel pictures for collectors and amateurs. His biblical and mythological subjects appealed to collectors in France as well as to French connoisseurs living in Rome. Reluctantly, he spent the years 1640–

44 in Paris, where Richelieu procured him the post of First Painter to the King and he found himself in charge of all decorative projects for the royal residences and had to design a scheme for the Grande Galerie at the Louvre. Poussin greatly admired Annibale Carracci, and his own work, too, developed in the direction of classical severity. He is primarily a draftsman, the antithesis of the Baroque painters, who were colourists first and foremost. His balanced compositions depend on their drawing, with the subject, rationally idealized, framed in the balanced, graphic pattern. From the 1630's he gradually reversed this relationship; and landscape, assembled and arranged as an intellectual exercise, becomes more important than the action shown.

Rembrandt (Rembrandt Harmenszoon van Rijn)

Dutch painter, etcher, and draftsman (Leiden, 1606–Amsterdam, 1669). For a short time he was a student at Leiden University, then apprenticed to the painter Jacob van Swanenburgh before going to Amsterdam as a pupil of Pieter Lastman. He and Jan Lievens opened a studio in Leiden in 1626, but some four years later he settled permanently in Amsterdam and was soon a successful teacher and portrait painter. He even set up as an art dealer, though the trade was chiefly useful in his later years when he had fallen out of favour with the public. From the first he adapted an Italianate classicism to the canons of contemporary art, always in a very individual fashion and with enormous sensitivity to the inner meaning of his subject; his portraiture grew more realistic and he used motifs from Rubens in his religious and mythological

pictures. A radical change of style is evident in 1642, when he painted *The Night Watch,* now in the Rijksmuseum, Amsterdam. He restricts his palette almost entirely to tones of golden brown, laid on in thick, soft strokes that bring out the mingled, complementary masses of light and shade on which he bases his compositions. The emphasis of his work, too, changes profoundly. The relatively bright and comfortable vision of his early days gives way to an intensely spiritual humility before the works of God; the portraits are uncompromising, yet full of understanding. The landscapes he began to paint in 1636 are of two kinds, one realistic and the other, more fantastic and owing something to Hercules Seghers, in which nature consists of wild forces quite indifferent to man. As well as his paintings, Rembrandt produced at the same time numerous etchings with the same subject matter, and these, too, explore the relation of light and shadow. His copperplate engraving and, above all, his etching have never been surpassed, and he always considered these arts as separate from painting and as equally important means of expression.

Renoir, Pierre Auguste

French painter (Limoges, 1841–Cagnes-sur-Mer, 1919). His family moved to Paris in 1844 and he was apprenticed to a firm in the Marais as a decorator of porcelain, and later also painted textiles and fans, teaching himself meanwhile by visits to the Louvre. In 1862 he had lessons at the Beaux-Arts and with Charles Gleyre, in whose studio he met Sisley, Monet, and Bazille. With them he began to work in the open air in the forest of Fontainebleau. His first portraits and mythological pictures, influ-

enced by Ingres and Delacroix, Corot and Courbet, were traditional and realistic, but by 1869 his scenes of urban life and the pictures he painted with Monet in the country and the riverside villages near Paris were Impressionist. As a result of visits to Algeria and Italy in 1881–82 his aesthetic ideas were somewhat modified, and he tried to give more solidity to his compositions and greater three-dimensional value to his forms. This was his so-called *manière aigre,* as he turned towards Greco-Roman painting and the Renaissance, to Raphael and the art of Pompeii. His last twenty years saw the complete synthesis of all he had done and learned, and he attained a perfect balance of plastic and colour values in landscape and still life, and with the monumental nudes in voluptuously observed settings, where colour in the end becomes a riot of rich and brilliant fantasy.

Ricci, Marco

Italian painter and etcher (Belluno, 1676–Venice, 1730). Was probably a pupil of his uncle Sebastiano though on stylistic grounds it may be deduced that he was more influenced by the landscape painting of central and southern Italy, by Salvator Rosa and Magnasco. His contemporary Carlevaris was also important, as was Titian. Moreover, it is certain that as a young man—we do not know exactly when—he was in Florence, perhaps working with Sebastiano on the frescoes in Palazzo Maruccelli, and in Rome. From 1708 to 1710 he lived in London, being already known in England from pictures sold there by Lord Irwin, and he painted scenery for the Italian opera at the Haymarket Theatre. He was back again with his uncle in 1712, and stayed for four years. He painted and etched imaginary landscapes

with ruins and other architectural elements—the sort of thing that appealed to the coming taste for the "picturesque." He is looked upon as the founder of the Venetian landscape school, and often furnished landscape backgrounds to to his uncle's altarpieces, while Sebastiano in return added "character" figures to Marco's work.

Robert, Hubert

French painter (Paris, 1733–1808). First trained as a sculptor, he was a pupil of Charles Nattoire at the French Academy in Rome from 1753 to 1765, and became a firm friend of Fragonard's. They went together to Naples, Herculaneum, and Pompeii, a journey that confirmed his taste for landscape and archaeological painting. He borrowed the monumental style of Pannini and Piranesi for his ruin pieces and *capricci,* softening them with accurate natural detail and a sort of pre-romantic atmosphere. On his return to Paris he began to paint townscapes, often as a setting for contemporary or historical events. He also held a royal appointment as a designer of gardens and planned, among other things, the Bassin d'Apollon at Versailles in 1777–81.

Robinson, Theodore

American painter (Irasburg, Vermont, 1852–New York, 1896). He was taught by the realist Winslow Homer, but his style was determined by visits to Paris between 1876 and 1892. In 1886 Monet weaned him away from academic painting by getting him to work from nature in the open air, and he returned to America a convinced and early supporter of the Impressionists in general and Monet in particular.

Rosa, Salvator

Italian painter, engraver, and poet (Naples, 1615–Rome, 1673). His earliest teacher was his father-in-law, Francesco Fracanzano. From 1632 to 1635 he studied with José de Ribera, and later with Aniello Falcone, emerging as a painter of landscape, marine, and battle pieces. When he first went to Rome in 1635 he greatly admired Michelangelo Cerquozzi and the *bambocciati* genre painters, but the main influence, as is evident in his pictures of 1639–41, came from Poussin and Claude Lorrain. From 1640 to 1649 he lived in Tuscany as painter to the grand duke's uncle, Prince Mattia de' Medici, and there developed a classical landscape style. He illustrated philosophical themes in allegories that pleased the prince and his companions, and painted dramatic scenes of witchcraft, apparently appreciated in intellectual circles; they enjoyed a surprising vogue at the time, and seem partly derived from German engravings. He worked in Rome from 1649, and, after a "sublime" phase whose high style went very well with baroque taste, turned, in the 1660's, to depicting wild nature in dark and complex compositions, such as those he also used in the engravings he produced at the same time.

Rosai, Ottone

Italian painter, engraver, and writer (Florence, 1895–Ivrea, 1957). After halfhearted studies at the Institute of Decorative Art and at the Academy, and some experience as an engraver, he encountered the Futurists in 1931, when they held an exhibition at the headquarters in Florence of their magazine *La Voce*. He was himself a Futurist in the 1910's and then, like Carrà, Morandi, and Soffici, began new ex-

periments. His search for a synthesis of ways of conveying volume led him ten years later to the Novecento movement and a style of his own, with colour at once graduated and boldly layered. He was to become the poet of the Florentine working class and the peasants of the country round.

Rouault, Georges

French painter and engraver (Paris, 1871–1958). Apprenticed to a stained-glass restorer, Rouault attended the École des Arts Décoratifs and in 1890 also studied at the Beaux-Arts, taught by the Symbolist Gustave Moreau, with Matisse and other future Fauves as fellow pupils. He exhibited with the Fauves at their Autumn Salon of 1905, but was never one of the group. For a time his pictures were dedicated to themes of social protest, and he painted prostitutes, tragic clowns, and his 1913 *Men of Justice*. In 1915 his style changed. He sought to express pure colour within the field of biblical and religious subjects. A factor here, apart from Moreau's teaching and his early days with the stained-glass craftsman, was his friendship with two Catholic writers, the mystic Joris Karl Huysmans and the combative and intransigent Léon Bloy, met in 1901 and 1904 respectively. Religious commitment led him to see landscape as an integral element in the story of Christ's life on earth, and this is so even when the theme is not directly treated, in the "landscapes with figures" where Fauve and Expressionist meet and mingle in his incisive line and intense colour.

Rousseau, Henri (*Le Douanier Rousseau*)

French painter (Laval, 1844–Paris, 1910). From 1871 to 1884

Rousseau worked for the Customs and Excise Department in Paris–which is why he was nicknamed Le Douanier–and began to paint, without ever taking a lesson, in 1880. He had friends among the artists, but was unaffected by the various avantgarde currents of the time, though his tropical pictures are certainly linked with Symbolism. He perfected his own talent by painting from nature, and above all by copying in the Louvre. Le Douanier is always thought of as the first of the *naïfs*, or primitives, but by the end of the century he was technically accomplished and a subtle colourist, basing his effects on the contrast of unusual and very beautiful tones. He liked best to paint portraits, scenes of lower-middle-class Parisian life, and mythical, mysterious animals and people in exotic landscapes. (See *The Snake Charmer*, of 1907, Musée de l'Impressionnisme, Paris.)

Rousseau, Théodore

French painter and engraver (Paris, 1812–Barbizon, 1867). His teachers were academic painters, and he copied the seventeenth-century Dutch landscapists and Claude Lorrain, but his guiding star was Constable. In 1826 he began to work out of doors, first in the neighbourhood of Paris, then in the provinces. His pictures were refused at the Salon of 1835 and he went to live at Barbizon on the fringes of the forest at Fontainebleau, a rendezvous for young artists like himself, who were painting directly from nature. After 1848, in a more liberal climate, his work was shown again, and at the Universal Exhibition of 1905 he at last received public and critical recognition. He was always something of a Romantic, who looked for imaginative and

"picturesque" connections between different natural elements, yet the landscapes he saw in those terms already point the way to realistic and objective painting.

Rubens, Peter Paul

Flemish painter (Siegen, Westphalia, 1577–Antwerp, ·1640). His widowed mother, after many troubles, returned to her native Antwerp in 1587, and there, between 1591 and his admission to the painters' guild in 1598, he frequented the studios of such artists as Tobias Verhaecht, Adam van Noort, and Otto van Veen, receiving a "Romanist" training. He was himself in Italy from 1600 to 1608, working for noblemen in Venice, for the Duke of Mantua, and in Rome and Genoa. He studied classical art and sixteenth-century and contemporary masters–Michelangelo, Raphael, Correggio, Titian, Tintoretto, Veronese, the Carracci, and Caravaggio. At home in 1609, he was appointed court painter to the Archduke and Archduchess Albert and Isabella, regents of the Netherlands, and the ensuing years and growing fame brought commissions from the courts of England, France, and Spain. He was frequently sent abroad on diplomatic missions, and so came to know the royal collections of Europe and gain an exceptional knowledge of pictorial art. Rubens is the quintessential Baroque artist, the great model for European painting in the seventeenth century. His composition is a thing of rhetoric and theatre; his pictures are full of flourish and overflow with life. Such opulent, dynamic figures had never been seen before, or such a wealth of sensuous, glowing colour. His enormous output, on which he employed many assistants, comprises every branch of painting

then known, altarpieces, history, classical legends, portraits and hunting scenes. His landscapes are mostly the work of his later years.

Ruisdael (or Ruysdael), Jacob van

Dutch painter (Haarlem, c. 1628–Amsterdam, 1682). He was trained in Haarlem by his uncle Salomon, but knew and was influenced by the work of other landscapists, such as Jan van Goyen and Allart van Everdingen. Admitted to the painters' Guild of St. Luke in 1648, he visited France and Germany soon afterwards, and in 1656 opened a studio in Amsterdam. There he was a close friend of Rembrandt's, and learned from him to increase the warmth and drama of his own landscape and nature painting. He covered the whole range of landscape art then current in Holland–rural views, panoramic views of towns and river courses, seashores and riverbanks and storm-tossed trees–and produced effects of great beauty in tones of brown and green and silver-grey.

Ruisdael (or Ruysdael), Salomon van

Dutch painter (Naarden, 1600–Haarlem, 1670). He became a master painter in Haarlem in 1623, and was obviously much influenced in his early work by the naturalistic landscapes of Esaias van de Velde. In the 1630's he, like Van Goyen, developed a freer style and achieved the subtlest effects of atmosphere in colours and with a technique well suited to his favourite woodland and river scenes. In his last years, when his style grew to resemble that of his nephew Jacob, he painted still-life studies with game.

Rysselberghe, Théo van

Belgian painter, draftsman, and engraver (Ghent, 1862–St. Clair, 1926). After his student days, and visits to Spain, Morocco, and Algeria, he became one of the founders of the Symbolist group Les Vingt. Working between Paris and Brussels, he was much involved with the avant-garde, and from 1888 his style was Neo-Impressionist. In the 1890's, he joined Henri van de Velde in promoting a revival of the decorative arts and crafts, and played an important part in the Art Nouveau movement in Belgium.

Sakai Hōitsu

Japanese painter (Edo, 1761–1828). Son of the governor of Himeji, in the Harima region, he chose to dedicate himself to painting and the pursuit of many intellectual interests in the cultured circles of Edo (now called Tokyo). He studied under various masters and followed various schools, among them those of Kanō and *ukiyo-e* (the style of the "floating world"), but in his later years he painted landscapes and pictures with plants and flowers in the decorative fashion of Sōtatsu and Ogata Kōrin, enhancing his colours with the use of gold and silver.

Sano di Pietro

Italian painter and miniaturist (Siena, 1406–81). He was probably a fellow apprentice of Sassetta's, and was enrolled as a master painter in 1428, but none of his work can be dated before 1444. He paints composite altarpieces with grounds of gold, and devotional pictures for private use in the ordinary houses of Siena and the district round about, and his style remains basically

Gothic. It has been thought, though without sufficient evidence, that he might be the Master of the Osservanza, a Sienese follower of Sassetta in the first half of the fifteenth century.

Sassetta (*Stefano di Giovanni*)

Italian painter (Siena? early 1400's–1450). Of his youth nothing is known, but he may have been trained among the artists who decorated the sacristy of Siena Cathedral, and in the local tradition of the Lorenzetti and Simone Martini. His handling of space suggests that though his style is Late Gothic, he was familiar with the technical discoveries of Masolino, Masaccio, and Paolo Uccello in Florence. After 1428, in which year he appears on the roll of master painters, he worked in the cathedral–his altarpiece of 1430-32, *The Madonna of the Snow,* is in the Contini-Boncossi Collection, Florence–and painted polyptychs for churches in the region. (Parts of one for the Franciscans at Borgo San Sepolcro are to be found in various museums in Italy and abroad.) It is now thought that one of his pupils, the anonymous master who painted the triptych of the *Madonna and Saints,* of 1436, in the church of the Osservanza near Siena, may in fact have been responsible for some of the works traditionally attributed to Sassetta.

Schnorr von Carolsfeld, Julius

German painter and draftsman (Leipzig, 1794–Dresden, 1872). At the Vienna Academy his friends Joseph Anton Koch and Ferdinand Olivier aroused his interest in the Nazarene painters and their romantic approach to

nature. He knew this group well in Rome during his years in Italy (1817-27) and worked with them on, among other things, the frescoed scenes from *Orlando Furioso* they painted at the Casino Massimo in 1820-25. In 1827 he became a professor at the Academy in Munich and court painter to King Ludwig of Bavaria. He was director of the Dresden Academy in 1846. His religious works, portraits, and above all his pictures of the Siegfried legends make him an outstanding figure in the German Romantic movement.

Segantini, Giovanni

Italian painter (Arco, 1858–Schafberg, 1899). As a student at the Brera Academy in Milan he was much influenced by the Scapigliatura, or "Bohemian" Romantic group. From 1881 to 1886 he worked at Pusiano, in the Brianza, developing a style based on French realism and the naturalistic tradition of Lombardy, and recording nature and peasant life with no touch of sentimentality. (See *Alla stanga* [*At the Hitching Post*] of 1886, in the Galleria d'Arte Moderna, Rome.) He adopted the pointillist or Divisionist technique, and in 1886 moved to Grisons in Switzerland, painting the same social themes and inclining to a somewhat literary Symbolism. In his latter years a tendency to emphasize the emotive value of colour and the elegance of line produced a decorative style that resembles Art Nouveau. (See *The Angel of Life,* 1889, in the Galleria d'Arte Moderna, Milan, and the 1899 *Triptych* in the Musée Segantini, St. Moritz.)

Seghers, Hercules

Dutch painter and etcher (Haarlem, c. 1590–Amsterdam, c. 1638). A pupil of Gillis van Coninxloo at Haarlem, he was

enrolled in the Guild of St. Luke there in 1612. Subsequently he worked in Amsterdam in 1614–29, Utrecht in 1631, and at The Hague in 1632–33. Etching was his main activity, and he is said to have perfected a technique of printing on cloth and coloured paper. His subject was invariably landscape, and his compositions are built on contrasting zones of light and shadow. Of his paintings we have only some fifteen small examples, all landscapes, and all on wood. They are in near-monochrome, like the etchings, so dark as to be nearly black, with brown and golden lights, and date from after 1620.

Sesshū Toyo (Oda Toyo)

Japanese painter (Akahama, Bichu, 1420–Taikian, Masuda, 1506). Having served a novitiate in his native province, he entered the Zen monastery of Shokoku-ji at Kyoto, where Shūbun, who was a priest there, gave him lessons. Later he was also the pupil of another artist monk, Taiko Josetsu, who had taught Shūbun. In 1464 he went to live in the hermitage of Unkoku-an, and in about 1467 visited China. There he made a study of Chinese landscape art and himself did some wall paintings at the court of Peking. Returning to Japan in 1469, he founded the Unkoko school at Unkoku-an, and from 1476 lived and worked in monasteries in other parts of the country. Sesshū painted on paper in ink and watercolour with both brush and pen. His large body of work includes portraits and the two kinds of *suiboku,* or Chinese "black painting," of the beauties of nature, and of flowers, plants, and animals. To these he gave an entirely original and untraditional stamp with his novel construction and elegant "broken" line.

Sesson Shukei

Japanese painter (Ota, Hitachi, 1504–post-1589). Active in the Muromachi period, when the Ashikaga shoguns were in power, he was a follower, though he cannot actually have been the pupil, of Sesshū. He painted Chinese-style *suiboku* pictures of landscape and plants, flowers, and animals. The fact that he worked all his life in his native town in the northeast, far from the capital, proves that *suiboku,* introduced a hundred years before in the court and monasteries of Kyoto, had spread throughout the country by the sixteenth century.

Seurat, Georges

French painter (Paris, 1859–91). He attended the Beaux-Arts in Paris and admired the landscape tradition of the Barbizon painters—Millet and Corot, for instance—as well as the Impressionists, though he found the Impressionist way of working from nature somewhat too independent and undisciplined. Studying the latest positivist theories of optical and visual phenomena, he took Impressionism a step further with his strictly scientific method of breaking up colour on canvas. In 1886, after two years of experiment in the open air and of preparing drawings and oil sketches in the studio, he exhibited the grand manifesto of Pointillism, *La Grande Jatte,* now in the Chicago Art Institute: the first picture painted in the purely intellectual pointillist formula that would mean so much in avant-garde painting. Seurat was influenced by the Symbolists and was to anticipate Art Nouveau in an increasing stylization and dynamism of form and composition, and in the brilliance of his colour.

Severini, Gino

Italian painter and writer (Cortona, 1883–Paris, 1966). He went to Rome in about 1900 and became a friend of Boccioni's, with whom he took lessons from Giacomo Balla and went on drawing expeditions in the city and the surrounding countryside. In 1906 he moved to Paris, where he was much influenced by Neo-Impressionism and knew many of the younger artists, including Picasso, Braque, and Max Jacob. He signed the Futurist Manifesto of 1910, but within two years was experimenting with Cubism, and continued to do so until 1921. For some time thereafter he joined an almost general European movement away from the avantgarde, returning in 1959 to a modified form of Cubism, combined with abstraction, in painting and sculpture. His theoretical and critical writings form a commentary on his many artistic experiments.

Shūbun Tensho

Japanese painter and sculptor (active in the first half of the fifteenth century). Shūbun was a Zen Buddhist priest in the Shokoki-ji at Kyoto, and court painter to the Ashikaga shoguns, who proved enlightened patrons of the arts after the long wars between the dynasties of the Northern and Southern Sung, during which the cultural life of the country had practically ceased. Shūbun was a pupil of the monk Taiko Josetsu—one of the first to use the Chinese landscape style known as *suiboku*—and a visit to Korea in 1423 enabled him to see for himself original Chinese paintings of this school. While he abides by Zen principles, and treats the beauties of nature as symbols of man's spiritual inner life, he brings a new and individual style

to Japanese landscape. The suppression of perspective gives his painting, carried out in monochrome with simple, vigorous brushstrokes, a dynamic, abstract character. Many scrolls are attributed to him, though no undoubted works exist.

Signac, Paul

French painter and art critic (Paris, 1863–1935). His first work was done with the Impressionists at a time when Impressionism was already in its decline. The search for new directions led him to the Pointillism of his friend Seurat, and he painted landscape and marine subjects and wrote on the theory of the Divisionist technique. But he was a less rigid theorist than was Seurat and his pictures of the Nineties are more successful, with their fresh and imaginative pastel colouring.

Signorini, Telemaco

Italian painter (Florence, 1835–1901). Trained at the Florence Academy and in 1854–55 was associated with the Macchiaioli group, becoming their chief spokesman in his articles and critical reviews. He himself painted in "spots," as they did, after 1858, but he also made experiments in realism, probably under the influence of the Socialist Proudhon. His battle and genre pictures are not always successful—exceptions are *The Insane Ward* and *The Morning Toilette*—but his landscapes are altogether more consistent. The French flavour is slight, though he had been attracted by the work of Courbet, Corot, and their companions at Barbizon when he was in Paris in 1861. The Tuscan coast and countryside are studied from nature and shown with a vivid feeling for light and colour. Signorini was a

leading member of the Piagentina school, for whom outdoor painting was the way to "improved realism."

Sironi, Mario

Italian painter, sculptor, and graphic artist (Sassari, 1885– Milan, 1961). Abandoned his engineering course at Rome University to take up painting in 1905 and studied first at the Academy and then with Giacomo Balla, in whose studio he met Boccioni and Severini. He went to Milan in 1914, and there became a very individual Futurist, the dark, thick paint making dynamic shapes of trucks, bicycles, and trams in his street scenes. From 1922 he was active in the Novecento group, and his stark realism was at its most effective in his portraits, nudes, Alpine landscapes, and, of course, the street scenes. In the 1930's, in an attempt to reconcile the demands of reason with those of art as propounded by the Fascist party, he experimented with mosaic, with relief modelling and an archaic, monumental kind of painting. After the Second World War all this resulted in a new style, not unlike that of the avant-garde movements, with solid forms and brighter colours in which he painted landscape and imaginary architecture.

Sisley, Alfred

French painter of English origin (Paris, 1839–Moret-sur-Loing, 1899). He attended Gleyre's classes for some time in 1862, together with Renoir, Monet, and Bazille, and, like them, began to paint from nature in the forest of Fontainebleau. He modelled himself at first on Corot, then on Monet, painting by the Seine and at Le Havre. Two years in London after the Franco-Prus-

sian War introduced him to Constable and Turner. Though an Impressionist, he was never very close to the rest of the group, and stylistically his touch is lighter than theirs, as is his palette, based on the pastel tones with which he could render the play of light in sky and water, very much in the English manner.

Smithson, Robert

American artist (Passaic, 1938– Texas, 1973). He began as a sculptor in the Minimal or Primary Structure movement, then turned to ecological or Land Art, with assemblages of common substances–heaps of stones enclosed in metal structures, for example–and with direct intervention, i.e., building geometrical forms with local materials, such as his *Spiral Jetty* on the Great Salt Lake.

Sodoma, Il *(Giovanni Antonio Bazzi)*

Italian painter (Vercelli, 1477– Siena, 1549). A pupil of Martino Spanzotti, he was brought up in the Lombardo-Piedmontese tradition of the fifteenth century and influenced by Leonardo, whom he may have known personally in Milan. He went to Siena in the early 1500's, and worked for the city and for the Benedictines at Monte Oliveto Maggiore, where his frescoes in the cloister date from 1505–08. (Those for another Olivetan convent, Sant' Anna in Camprena, had been painted in 1503– 04.) Sodoma profited by the study of Perugino, Pinturicchio, and Luca Signorelli, and was in Rome for the first time in 1508, to fresco the ceiling of the Stanza della Segnatura in the Vatican. From 1512 to 1514 he was there again, painting historical and mythological frescoes in the

state bedroom of the Villa Farnesina for the Sienese banker Agostino Chigi. They include *The Wedding of Alexander and Roxana* and show the complete synthesis of Leonardo's colouring and the ideal forms of Raphael that characterizes Sodoma's later work. He was a prolific painter–too prolific occasionally for the good of his art–and lived mostly in Siena, producing frescoes for churches and public buildings, religious pictures, and processional banners. *The Scourging of Christ* in the Pinacoteca was painted in 1511 or 1512, the banner of Saint Sebastian in the Pitti Palace, Florence, in 1525–31. A *Lucretia* in the Galleria Sabauda at Turin is one of his infrequent classical and mythological pieces.

Soffici, Ardengo

Italian painter, engraver, and writer (Rignano sull' Arno, 1879–Forte dei Marmi, 1964). Having studied at the Academy in Florence, he lived in Paris from 1899 to 1907, among painters and writers of the avant-garde. He was a Futurist until 1914, when he began to paint more realistic landscapes and scenes of daily life that are influenced by the Macchiaioli and the Impressionists. After 1920 he was associated with the magazine *Valori Plastici* and the Novecento group, and his landscapes of Versilia on the coast near Viareggio combine Italian Renaissance tradition with the optical principles of Cézanne. His many writings include critical essays on Italian art of the nineteenth and twentieth centuries.

Strindberg, Johan August

Swedish writer, poet, and dramatist (Stockholm, 1849–1912). As

well as being the author of anguished and extraordinary plays and novels, Strindberg was a painter with a legitimate place in late nineteenth-century Swedish art; self-taught, but capable of rising to heights of poetical expression. His painting is like some ultimate manifestation of the literary development that took him from romanticism to realism in his search for transcendent experience and a knowledge of God. He liked painting the sea and the coast and uses light and colour in a way that recalls the Impressionists, whom he knew during his two stays in Paris, and in some respects anticipates the later nonformal styles. His pictures are in the National Gallery and Nordiska Museet at Stockholm and the Statens Museum for Kunst at Copenhagen.

Sutherland, Graham

English painter, etcher, and illustrator (London, 1903–80). After studying at the Goldsmiths' School of Art in London, his first works were visionary, Blake-like etchings and book illustrations, Surrealist in character. He began to paint in 1931, and a series of English and Welsh landscapes dates from 1935 to 1945. During the war he, like Henry Moore and others, was an official artist, recording the life and endurance of the British civilian population. He made frequent visits to Germany and Italy after 1945, often staying in Venice, and his subject matter, with its echoes of Surrealism, of Matisse and Picasso, was increasingly preoccupied with the theme of metamorphosis. His plants, trees, and animals, in the marvellous colours of nature, assume disturbing forms. Sutherland was also a portrait painter and a painter of religious pictures, and designed scenery, ceramics, and tapestries.

Tintoretto (Jacopo Robusti)

Italian painter (Venice, 1518-94). Active from the 1540's onwards. His early pictures are clearly influenced by the Mannerists, such as Pordenone and Bonifacio Veronese, who were then in Venice, and by Parmigianino and Michelangelo, whose work he would have known from prints. Unlike the great colourist Titian, Tintoretto uses a dark dramatic palette whose touches of gold and gleaming lights suit the agitated, elongated figures he derives from Michelangelo and underline his complex foreshortening. He painted many religious pictures (his *Creation of the Animals,* in the Accademia, Venice, dates from 1550-53), sacred "fables" (*Susanna and the Elders,* c. 1557, now in the Kunsthistorisches Museum, Vienna), and portraits. In addition there are cycles in the Doge's Palace and for several of the *scuole,* the headquarters of various guilds and brotherhoods in Venice. The greatest of these is in the Scuola Grande di San Rocco, where he worked at different times, painting in the Sala dell' Albergo in 1564-65, on the upper floor in 1576-81, and in the lower hall in 1583-87.

Titian (Tiziano Vecellio)

Italian painter (Pieve di Cadore, c. 1490-Venice, 1576). In 1508, though he must by then have completed his training in Bellini's studio, he was Giorgione's assistant in frescoing the facade of the Fondaco dei Tedeschi, headquarters of the German merchants in Venice. He painted frescoes of the miracles of Saint Anthony in the Scuola del Santo at Padua in 1511, and by the time of his first Venetian commissions was entirely independent of Giorgione's influence. (See the allegory *Sacred and Profane Love,* of 1515, in the

Borghese Gallery, Rome.) He was made official artist of the city in 1516, and into the 1530's produced many altarpieces, mythological pictures, and portraits. Some, such as the *Pesaro Altarpiece* of 1519-26, in the Frari church, were for private patrons; others for the ruling families of Este (the series of *Bacchanals* begun in 1518 and now in London and Madrid), Della Rovere (the *Venus of Urbino,* 1538, in the Uffizi), and Gonzaga, and for Emperor Charles V. In these years he combines the monumentality of Romano-Tuscan painting with the pictorial quality of the Venetians and a northern realism adopted from Dürer. In the next he leans a little to Mannerism, as is evident in, for example, *Christ Crowned with Thorns,* of 1542, in the Louvre. Then comes the mature style, the pure colour freely laid on and perfectly adapted to the magnificence or sensuality of what he paints—the style of *Charles V at the Battle of Mühlberg,* of 1548, and *Saint Margaret and the Dragon,* both in the Prado. In his old age Titian almost abandons form, which is barely indicated by rich colour and scattered highlights, as in *The Flaying of Marsyas* (c. 1570), in the National Museum at Kromeriz, Czechoslovakia.

Tosa, Mitsuyoshi

Japanese painter (active in the second half of the sixteenth century). His family, who were painters from the thirteenth to the seventeenth centuries, were, from the fifteenth to sixteenth, officially appointed to the court of the Ashikaga shoguns at Kyoto. Mitsuyoshi worked in the family style, a combination of the *yamato-e* tradition—brightly coloured genre and literary scenes—with that of Chinese landscape.

Tosi, Arturo

Italian painter (Busto Arsizio, 1871-Milan, 1956). Trained in Milan as a student of the famous Vittore Grubicy. Rejecting the Divisionist theories then dominant there, he turned instead to the anticlassical, realistic Scapigliati movement, and especially to the work of Daniele Ranzoni. For a time he painted portraits, then concentrated almost exclusively on landscape, using at first the glowing palette of Antonio Mancini and Adolphe Monticelli. Later his tones became sober, clear, and luminous, admirably catching those of the places he liked—Rovetta in Val Seriana, Zoagli, and the country around Lago d'Iseo. Though he was never an avant-garde artist, the solidity and colour of his pictures give them something in common with those of Cézanne and Bonnard.

Troyon, Constant

French painter (Sèvres, 1810-Paris, 1865). Early experience with his father in a porcelain factory gave him a liking for the rich, lustrous impasto used in the landscapes he painted with the artists of Barbizon in the forest of Fontainebleau. This phase began when he made the acquaintance of Théodore Rousseau in 1840 and became friendly with Jules Dupré. Having seen Dutch animal pictures on a visit to Holland in 1847, he took to making animal studies with notable success, though he continued painting landscape, especially on the Normandy coast.

Tung Yüan (Tung Pei-yüan)

Chinese painter (born in Chungning, Kiang; active in the second half of the tenth century). A high-ranking official in the imperial administration, he worked

in the Yangtze valley and at Nanking at the end of the period of the Five Dynasties and after the Sung conquest. He used ink and colour wash on paper scrolls, as did all artists of the time, and painted *shan-shui,* or "mountains and water," as landscape was termed. His compositions are flawlessly balanced; his line is precise and faithful to nature yet delicately shaded for lyrical effects of cloud on the peaks or mist in the valleys. To convey atmosphere and a sense of distance he also developed an old technique of dots and minute brushstrokes. The pictures we have are probably not by his hand, but copies made much later.

Turner, Joseph Mallord William

English painter, watercolourist, draftsman, and engraver (London, 1775-1851). He began to study at the Academy schools in 1789, and in 1791 made the first of the journeys about England, Scotland, and Wales to gather material that were to continue for forty years, varied after 1801 with trips to France, Switzerland, the Netherlands, Germany, and Italy. In 1802 he was elected to the Royal Academy and became its professor of perspective in 1807, an appointment he held until 1837. He first painted in oils, as well as watercolour, in 1796, modelling himself, to start with, on Richard Wilson for landscape and Willem van de Velde for marine subjects. The Old Masters of whose work he was able to learn more abroad—Poussin, Claude Lorrain, Titian, and Salvator Rosa—inspired him to paint their kind of ideal landscape, in increasingly clear and luminous colours. But Turner was a Romantic, and when he paints a classical picture there are

overtones of Milton, Byron, Shakespeare, or the poet James Thomson; or his history and mythology will allude to contemporary events. As he developed his oil technique, working at times directly from nature, his landscape style grew less and less restrained from the 1830's onwards, until form was finally dissolved in colour, incandescent and ever more brilliant. In emulation of Claude Lorrain and the *Liber Veritatis,* he, too, published his *Liber Studiorum:* a collection of engravings, some of which he did himself, taken from his most successful works and issued between 1806 and 1819.

Velázquez, Diego Rodríguez de Silva y

Spanish painter (Seville, 1599–Madrid, 1660). He was trained in the Late Mannerist tradition and his earliest works are realistic genre scenes of popular life, but from 1623, as Philip IV's court painter, he specialized in portraiture. A first visit to Italy in 1629–30 confirmed his taste for the Venetian palette and Caravaggian realism, and as a result he combines ceaseless experiment with colour and a minute, often pitiless scrutiny of his model. In the free style of his maturity he dabs the paint on, and ranges from glowing tints set side by side to the most sober and muted tonal schemes. Save for the two views of the gardens of the Villa Medici in Rome, probably dating from 1630, his landscapes are always accessory to the portraits, adding to their ceremonious atmosphere. That in the background of *The Surrender of Breda* in the Prado, painted in 1634–35, is in fact as idealized as any of them, despite the impression it gives of topographical truth.

Velde, Willem van de, the Younger

Dutch painter (Leiden, 1633–Greenwich, 1707). He was taught by his father Willem the Elder, a Mannerist whose subject was naval battles, and by the noted marine painter Simon de Vlieger. A master of sea pictures in the great Dutch tradition, he later developed a more sensitive style, responding to the changes of light and atmosphere, and seeing things in a "modern" way, rather as Turner and the outdoor artists of the early nineteenth century were to do. Like his father, who came to England after the Restoration, he worked for Charles II and became the most famous sea painter in the country.

Vernet, Claude Joseph

French painter (Avignon, 1714–Paris, 1789). His training began in Aix-en-Provence and was completed in Rome, where he lived from 1734 to 1753, painting the landscapes and Italian studies with classical ruins that collectors liked to buy. He returned to Paris to teach at the Académie and carry out many official commissions, including a series of views of the French seaports for Louis XV.

Veronese, Paolo *(Paolo Caliari)*

Italian painter (Verona, 1528–Venice, 1588). A pupil of Antonio Badile in Verona, he was first employed in Venice in 1553, when he painted pictures in the Sala del Consiglio dei Dieci, the Chamber of the Council of Ten, in the Doge's Palace. These were followed by frescoes in the church of San Sebastiano in 1555 and in the Libreria Vecchia in 1556. This work is still in the Roman and Emilian Mannerist style, but already there are signs of the clear, elegant colouring, so different from that of his contemporaries Titian and Tintoretto, that Veronese was to use later. He probably visited Rome in 1560, and it was after this that he carried out what were for almost two hundred years the undisputed masterpieces of non-religious fresco painting, his decorations in the Palladian Villa Barbaro at Maser. Over the next two decades he produced mostly large biblical scenes, contrived like superb theatrical spectacles. They have receding "wings" of architecture, as in the great banquet pictures–*The Feast in the House of Levi, The Marriage at Cana*–or backgrounds of fantasy landscape, as in his versions of *The Finding of Moses,* and all the people wear the gorgeous Venetian clothes of the sixteenth century. Towards the end of his life his style approximates more nearly to that of Titian, with darker and more ardent colours, and idealized landscape settings. (See *Saint Anthony Preaching to the Fishes,* of c. 1580, in the Borghese Gallery, Rome, and the *Rape of Europa,* of the same date, in the Anticollegio, or Waiting Room to the Collegio, in which the doge received ambassadors.)

Vlaminck, Maurice de

French painter (Paris, 1876–Rueil-la-Gadelière, 1958). He met and became friendly with Derain in 1900 and together they studied colour as Van Gogh had done, producing, between 1904 and 1907, the most violent and fiery landscapes of Fauvism. In the following years the desire for greater firmness and plasticity of form and composition attracted him to Cézanne and the Cubists, to African art and the unorthodox simplicities of the Douanier Rousseau. He held aloof from the avant-garde after 1925, painting landscape in a dramatic, Expressionist style of his own.

Waldmüller, Ferdinand

Austrian painter (Vienna, 1793–Baden, 1865). From 1814 to 1817 he painted portrait miniatures, and scenery for provincial theatres in Austria, before going on to portraits, genre pictures of peasant life, and–his chief love–landscape. His belief in the direct study of nature brought him into conflict with the idealists and Romantics, and with the Vienna Academy, where he began to teach in 1830. His views of the Wienerwald, the wooded lakes of the Salzkammergut and of Sicily (he visited Italy, as well as London and Paris), earn him a place among the leading landscape artists of the Biedermeier period that lasted from the end of the Napoleonic wars to 1848.

Wang Mêng

Chinese painter (Huchow [now Wuhing], Chekiang Province, c. 1308–Nanking, 1385). Grandson of the artist and calligrapher Chao Meng-fu, he worked at the Mongol court of the Yüan emperors. In 1380 he was involved in a plot against the first Ming emperor, who had overthrown them, and ended his days in prison. Wang Mêng was one of the "Four Great Yüan Masters" who, following the example of Chao Meng-fu, painted in the Sung tradition, modified and developed to suit the taste of the Mongol dynasty. His beautifully decorative landscapes are full of convoluted lines, the nature details indicated by mere dots and the brushwork fantastically notched and indented.

Ward, James

English painter and engraver (London, 1769–Cheshunt, 1859). He was first articled to an engraver who taught him the new technique of mezzotint, beginning to paint in 1787, inspired by the work of his brother-in-law George Morland. He specialized in country scenes and animal portraits, and was appointed painter and mezzotint engraver to the Prince of Wales, later George IV. His mature landscapes, such as *Gordale Scar,* of 1811–15, in the Tate Gallery, and his Shakespeare illustrations, reveal a fervently romantic imagination.

Watteau, Antoine

French painter (Valenciennes, 1684–Nogent-sur-Seine, 1721). He went to Paris in about 1702, after an apprenticeship with Jacques Albert Gérin, and found work copying Dutch and Flemish pictures. Eventually he became known to the print dealer Mariette and his circle, who disapproved of the stately official style imposed on French art by Louis XIV, and encouraged him to join the painters Claude Gillot and Claude Audran. For the latter, who was keeper of the Luxembourg Palace, he designed schemes for the châteaux of Meudon and La Muette. After a brief stay in Valenciennes, where he painted pictures of military life, Watteau returned to the capital. He developed a light, unacademic style, with notes of Rubens and of sixteenth-century Venice, and painted actors and *fêtes galantes* in Elysian parks—beautiful pictures with undertones of melancholy. (See *The Embarkation for Cythera,* of 1717, in the Louvre, and *The French Comedians,* 1718, now in West Berlin.) This was his settled style, but the work of his last

years—the Louvre *Gilles* of 1718 and *Gersaint's Shop Sign* of 1720, also in West Berlin—probes more deeply beneath the surface of things.

Whistler, James Abbott McNeill

American painter, draftsman, and etcher (Lowell, Massachusetts, 1834–London, 1903). His boyhood was spent in Europe, for his father was a military engineer with a post in St. Petersburg, and it was at the Academy there that he first studied art. He learned the craft of etching during a brief stay in the United States and went to Paris in 1855 for lessons with Charles Gleyre, in whose studio he was to meet the future Impressionists. From 1859 he divided his time between London and Paris, travelled extensively in Europe, and even visited South America. Responsive to every artistic current, he was widely known for his portraits and landscapes and decorative schemes. His technique was more or less Impressionist, but he could create the dreamlike effects and atmosphere of Symbolism. A leading figure among the London aesthetes, he appeared as the champion of Art for Art's Sake when he successfully sued Ruskin for defamation in 1877.

Williams, William

English painter (first mentioned 1758, died 1797). He is first heard of as exhibiting in London in 1758, his name appears again from 1770 to 1792, and the last known picture is of 1797. He painted portraits and a group of Scottish and English landscapes composed in the manner of Claude Lorrain, in some of which we see, as often in early eighteenth-century views, those new features, the mills and factories of the Industrial Revolution.

Wilson, Richard

Welsh painter (Penegoes, Montgomeryshire, 1713–Llanberis, 1782). Arriving in London in 1729, he took lessons from the portraitist Thomas Wright, and himself produced portraits and conventional landscapes until he went to Italy. There, from 1750 to 1757, he studied Poussin and Claude Lorrain and Italian landscape painting and developed a more classical style. Up to the 1770's, when his fortunes declined, his views of famous beauty spots in England and Italy brought him much noble and intellectual patronage, and he had many pupils and imitators.

Wittel, Gaspar van (*Gaspare Vanvitelli,* or *degli Occhiali*)

Naturalized Italian painter of Dutch birth (Amersfoort, 1653–Rome, 1736). He studied in Amersfoort with the landscapist Mathias Withoos, who had spent two years in Italy, and soon after his twentieth birthday went to Rome, where in 1675 he was commissioned to do a set of topographical drawings of the Tiber. He worked in tempera more often than in oils, with a bold perspective and somewhat artificial clarity that anticipate the eighteenth-century view painters, especially Canaletto. After 1690 he made visits to Milan, Bologna, and Venice, to Naples and the south, and his panoramic Neapolitan landscapes and scenes of the Venetian lagoon are among the best things he did. He became a member of the Roman Guild of St. Luke in 1711.

Witz, Conrad

German painter (Rottweil, c. 1400–Basel, c. 1446). Docu-

ments prove that he was in Basel in 1431, but the panels of the *Redemption Heilsspiegel* executed in 1435 for the church of St. Leonard are now dispersed among the museums of Basel, Berlin, and Dijon; those of his altarpiece of *Saint Peter* (1444), including *The Miraculous Draught of Fishes,* are in the Musée d'Art et d'Histoire at Geneva. The solidity of the figures and the accurate natural detail in his pictures suggest a training in the tradition of Flanders and Burgundy, but he also had the opportunity of learning from the many foreign artists who came to Basel and Constance at the time of the Councils of 1415 and 1431. He is considered to have been the most original of German painters in the years before the art of the Renaissance spread north from Italy.

Wright, Joseph (*Wright of Derby*)

English painter (Derby, 1734–97). A pupil in London of Thomas Hudson, the portrait painter, Wright worked in Derby, producing portraits and night scenes of the scientific experiments that appealed to the current taste for discovery and invention. Other pictures, such as *Arkwright's Cotton Mills by Night* (1782–83, now in an English private collection), refer to the beginnings of the Industrial Revolution. From 1772 he also painted the landscape of English tradition, sometimes ruin pieces and sometimes factual views, incorporating the striking effects of light he had noted when in Italy in 1773–75 (e.g., *Fireworks at Castel Sant' Angelo,* of 1774 or 1775, in the Birmingham City Museum and Art Gallery).

Zuccarelli, Francesco

Italian painter (Pitigliano,

1702–Florence, 1788). He is thought to have been trained first in Florence, then in Rome, under the influence of view painters such as Giovanni Paolo Panini and Andrea Locatelli. After a short spell in Florence he made his home in Venice in 1732, collaborating with Bellotto and Antonio Visentini, as well as producing landscapes and historical, mythological, and, occasionally, religious pictures. Francesco Algarotti and the English consul Joseph Smith were his patrons, and he worked for the court of Dresden and various English noblemen. He was in London from 1752 to about 1763, and again in 1765–67, where he enjoyed great success and was a founder member of the Royal Academy. The Accademia of Venice elected him a member in 1772, and his Arcadian and pastoral landscapes were eagerly sought after by the cosmopolitan aristocracy of the time.

Bibliography

Benoit, F., H. Bouchot, R. Bouyer, C. Diehl, L. Deshairs, T. Duret, L. Gillet, P. Marcel, L. Rosenthal, E. Saradin, and C. Sunier, *Histoire du paysage en France,* Paris, 1908.

Born, W., *American Landscape Painting,* Yale University Press, New Haven, 1948.

Buscaroli, R., *La Pittura di paesaggio in Italia,* Bologna, 1935.

Carli, E., *The Beginning of Landscape Painting in Italy,* in *Graphis,* a.ii, n. 61, 1965, pp. 378–385, 450, 454–459.

Clark, K., *Landscape into Art,* London, 1949; new edition 1976.

Dawson, C. M., *Romano-Campanian Mythological Landscape Painting,* New Haven, 1944.

Dorbec, P., *L'Art du paysage en France. Essai sur son évolution de la fin du XVIII^e siècle à la fin du Second Empire,* Paris, 1925.

Fischer, O., *Chinesische Landschaftsmalerei,* Berlin, 1943.

Franz, H. G., *Niederländische Landschaftsmalerei im Zeitalter des Manierismus,* Graz, 1969, 2 vols. (Forschungen und Berichte des Kunsthistorischen Institutes der Universität Graz, II).

Garbini, G., S. Bosticcio, K. Schefold, K. Clark, H. Goetz, and A. Priori, article "Paesaggio" in *Enciclopedia Universale dell'Arte,* Venice/Rome, 1963, vol. X.

Gaunt, W., *Bandits in a Landscape: A Study of Romantic Painting from Caravaggio to Delacroix,* London, 1937.

Gerstenberg, K., *Die ideale Landschaftsmalerei,* Halle, 1923.

Grant, M. H., *A Chronological History of the Old English Landscape Painters (in oil) from the XVIth Century to the XIXth Century,* London, 1926. 2 vols.; supplementary vol. 3, 1947; new edition, revised and amplified, Leigh-on-Sea, 1957–61, 8 vols.

Grigson, G., *Britain Observed: The Landscape Through Artists' Eyes,* London, 1975.

Hasumi, T., *Zen in Japanese Art,* London, 1962.

Hind, C. L., *Landscape Painting from Giotto to the Present Day,* London, 1923–24, 2 vols.

L'ideale classico del Seicento in Italia e la pittura di paesaggio, exhibition catalogue, Bologna, 1962.

Jamot, P., *Sur la Naissance du paysage dans l'art moderne: du paysage abstrait au paysage humaniste,* Paris, 1938.

Kil, H., and Neri, D., *Paesaggi inattesti nella pittura del Rinascimento,* with preface by Bernard Berenson, Milan/Florence, 1952.

Leclere, F., *Hubert Robert et les paysagistes français du XVIII^e siècle,* Paris, 1913.

Lee, S. E., *Chinese Landscape Painting,* exhibition catalogue, Cleveland Museum of Art, Cleveland, 1954.

Lemaître, H., *Le Paysage anglais à l'acquerelle, 1760–1851,* Paris, 1955.

Lothe, M., *Traité du paysage,* Paris, 1939 (Écrits d'artistes). New edition, Paris, 1946.

Magnin, J., *Le Paysage français des enlumineurs à Corot,* Paris, 1928.

Munsterberg, H., *The Landscape Painting of China and Japan,* Tokyo, 1956.

Peters, W. J., *Landscape in Romano-Campanian Natural Painting,* Assen, 1963.

Ragghianti, C. L., *Classicismo e paesaggio nel Seicento,* in *Critica d'Arte,* X, 55, Jan.–Feb. 1963, pp. 1–51.

Ruskin, J., *Lectures on Landscape Delivered at Oxford,* London, 1897.

Rutten, M., *Le Paysage dans l'art de la Mésopotamie ancienne,* in *Syria,* 1941, fasc. 2.

Sakanashi, S., *An Essay on Landscape Painting,* London, 1935.

Sereni, E., *Storia del paesaggio agrario italiano,* Bari, 1961.

Stechow, W., *Dutch Landscape Painting of the Seventeenth Century,* London, 1966 (*Studies in the History of European Art,* Kress Foundation, National Gallery of Art, Washington).

Sullivan, M., *The Birth of Landscape Painting in China,* London, 1961.

Thiery, Y., *Le Paysage flamand au XVII^e siècle,* Paris/Brussels, 1953.

Valsecchi, M., *I paesaggi dell' 800,* 1969.

Waddingham, M. R., *I paesaggisti nordici italianizzanti del XVII secolo,* Milan, 1966, 2 fasc. (*I maestri del colore,* nos. 217, 218).

Index of Illustrations

Index of Names

Contents

Illustration Sources

Albright-Knox Art Gallery, Buffalo, 239t
Ugo Allegri, Brescia, 214t
Ampliaciones y Reproducciones MAS, Barcelona, 89, 136, 139, 161b
Foto Anders, 82
Archives Centrales Iconographiques, Brussels, 240
Arte fotografica, Rome, 154b
Art Institute, Chicago, 62
Armando Barellini, Siena, 40–41, 42–43, 47, 56, 98b, 99b, 167b
Ferdinando Barsotti, Florence, 270
Emenegildo Bianchi, 259t
Biblioteca Apostolica Vaticana, Rome, 33
Biblioteca Imperiale, Teheran, 183
Bibliothèque Nationale, Paris, 34–35, 85
Joachim Blauel, Monaco, 118–119, 135, 137, 155, 216
Osvaldo Böhm, Venice, 32, 108, 165
British Museum, London, 16–17, 110, 134, 209b
Bulloz, Paris, 6, 20b, 70–71b, 87, 95, 101b, 107, 226–227, 228
Burkard, Winterthur, 200
CARIPLO, Servizio Marketing e Propaganda, Milan, 103
Courtauld Institute Galleries, London, 246–247
Pasquale De Antonis, Rome, 30, 235
Documentation photographique de la Réunion des Musées Nationaux, Paris, 231
Walter Dräyer, Zurich, 229, 257
Emmer, Venice, 104
Fratelli Fabbri Editori, Milan, 28, 50, 156, 184b, 187, 256t, 258, 264t, 268, 272–273, 276
John Freeman & Co. Ltd., London, 58–59, 204
Galleria Civica d'Arte Moderna, Turin, 214b, 242b
Gemeentemuseum, The Hague, 241
The Thomas Gilcrease Institute of American History and Art, Tulsa, Oklahoma, 222–223
Fototecnica Giovetti, Novara, 259b
Photographie Giraudon, Paris, 52, 60–61, 86
Colorphoto Hans Hinz, Allschwil, 230t, 243, 254, 260b
Fotoarchiv Hirmer, Monaco, 36
Holle Bildarchiv, Baden-Baden, 184t, 189tl, 189b
Gerhard Howald, Bern, 250
Jeu de Paume, Paris, 244
Kodansha, Ltd., Tokyo, 12, 14b, 54b, 125, 142, 147b, 150b, 151, 153, 185, 186, 188, 189tr, 190, 193, 194–195, 196, 197, 280b
Georges Kriloff, Lyons, 210–211
Kunsthaus, Zurich, 232–233
Kunsthistorisches Museum, Vienna, 26, 100
Photographie Lauros/Giraudon, Paris, 101t
Léon Legrain, *Mémoires de la Delegation en Perse,* 14t
Lessing-Magnum, 252
Galleria Lorenzilli, Bergamo, 279
Louvre, Paris, 68, 212–213, 224
Metropolitan Museum of Art, New York, jacket, 55, 109, 238, 239b, 249
Günther Meyer, Pforzheim, 90
Foto Meyer, Vienna, 111, 114, 115, 116–117

Museo Nazionale Archeologico, Athens, 20–21, 21
Museo Poldi-Pezzoli, Milan, 164
Museo Segantini, St. Moritz, property of the Commissione Federale della Fondazione Gottfried Keller, Switzerland, 242t
National Gallery, London, 64, 72, 76–77, 80t, 91, 130, 150t, 167t
National Gallery of Art, Washington, 69, 78, 126–127, 161t, 174–175, 208t
National Museum, New Delhi, 178
Nationalmuseum, Stockholm, 220t, 221t
Fondazione Emil Nolde, Seebüll, 10–11
Foto Nou, Paris, 180
Umberto Orlandini, Modena, 80b
Österreichische Nationalbibliothek, Vienna, 53
Fabrizio Parisio, Naples, 24
Mario Perotti, Milan, 81, 83, 106, 166, 267, 271
Philadelphia Museum of Art, Pennsylvania, 245
Philipson Studio, Newcastle-upon-Tyne, 205
Photo Precision Ltd., 176b
Gerhard Reinhold, Leipzig, 221b
Rijksmuseum, Amsterdam, 140–141, 145, 146
Saarlandmuseum, Saarbrücken, 263
Foto Saporetti, Milan, 168–169
Scala, Florence, 7, 23, 29, 37, 38, 39, 44–45, 46, 48–49, 54t, 59, 63, 67, 70–71t, 73, 74, 79, 94, 98–99, 112–113, 138, 148, 162–163, 170–171, 215, 230b, 234, 264
Ilton Schnellbacher, Pittsburgh, 261
Shunk-Kender, New York, 280t
Siaca, Cento, 122
Fabio Simion/Ricciarini, Milan, 97, 120, 123, 129
Yves Siza, Geneva, 92–93
Staatliche Kunsthalle, Karlsruhe, 262
Staatliche Kunstsammlungen, Dresden, 147t
Staatliche Museen Preussischer Kulturbesitz, West Berlin, 15
Photographie Telarci/Giraudon, Paris, 132–133, 158–159
Tomsich/Ricciarini, Milan, 22
Top, Paris, 260t
Topkapi Sarayi Müzesi, Istanbul, 182
Harry Torczyner collection, New York, 277
Jean Vertut, through the courtesy of Mazenod, Paris, 18–19
Wadsworth Atheneum, Hartford, 274–275
Wallraf-Richartz Museum, Cologne, 154t
Walter Art Gallery, Liverpool, 176t
John Webb, London, 8, 172–173, 206–207, 209t, 236
Zauho Press, 199
Regine Zweig, Essen, 218–219
Archivio Arnoldo Mondadori Editore, Milan, 2, 256b, 265, 266; Piera Frai, 269; Walter Mori, 43, 177, 203, 278

The quotations on pages 13, 65, and 179 are from the following sources: F. Coarelli, *Roma,* Arnoldo Mondadori Editore, 1971, p. 122 ("Grandi Monumenti"); E. G. Holt, *Storia documentaria dell'arte,* Feltrinelli Editore, 1972, p. 207; G. Argentieri, *Pittor cinesi,* Arnoldo Mondadori Editore, 1967, p. 89.